The Digital Photography Workflow Handbook

Uwe Steinmueller, a native of Germany, has been a photographer since 1973. His first exhibitions were in 1978 in Bremen, Germany with photos from Venice, South Tirol, Germany and France. He shares a joint copyright with his wife Bettina.

He moved to California in 1997 and began working seriously in digital photography in 1999. He currently lives in and works as a photographer in Hollister, CA. He has written a number of books, two of which won the prestigious "Fotobuchpreis" in 2004/05 in Germany. Uwe is the man behind outbackphoto.com, a popular website covering quality outdoor photography using digital cameras.

Juergen Gulbins has extensive experience in writing, technology, desktop publishing, designing high-end document archival systems, and digital photography. He is a profilic author who has written and translated books on topics such as CAD, Unix, Linux, DTP, typography, Internet, document management, and various aspects of digital photography. He has been a passionate photographer most of his life.

The Digital Photography Workflow Handbook

From Import to Output

Uwe Steinmueller • **Juergen Gulbins**

rockynook

Uwe Steinmueller, ustein_outback@yahoo.com
Juergen Gulbins, jg@gulbins.de

Editor: Gerhard Rossbach
Translator: Jeremy Cloot
Copy Editor: Cynthia Anderson, Proofreader: James Johnson
Layout and Type: Juergen Gulbins
Cover Design: Helmut Kraus, www.exclam.de
Printer: Himmer AG, Augsburg
Printed in Germany
ISBN 987-1-933952-71-0
© 2011 by Juergen Gulbins and Uwe Steinmueller
Rocky Nook Inc.
26 West Mission Street Ste 3
Santa Barbara, CA 93101
www.rockynook.com

Library of Congress Cataloging-in-Publictaion Data

Steinmueller, Uwe.
 [Handbuch digitale Dunkelkammer. English]
 The digital photography workflow handbook : from import to output / Uwe Steinmueller, Juergen Gulbins.
 -- 1st ed.
 p. cm.
 Includes bibliographical references and index.
 ISBN 978-1-933952-71-0 (hardbound : alk. paper)
 1. Photography--Digital techniques. I. Gulbins, Jürgen. II. Title.
 TR267.S74313 2010
 775--dc22
 2010028203

First published under the title "Handbuch digitale Dunkelkammer.
Vom Kamera-File zum perfekten Print. Arbeitsschritte und Werkzeuge in der Digitalfotografie."
© dpunkt.verlag GmbH, Heidelberg, Germany

Distributed by O'Reilly Media
1005 Gravenstein Highway North
Sebastopol, CA 95472

Contents

Contents

Foreword

Digital photography can be a lot of fun, but there is a lot to learn if you really want to master the medium. A lot has changed since the days of traditional analog photography.

Most modern digital single-lens reflex cameras (DSLRs) and many bridge cameras support RAW shooting formats. RAW image files contain virtually all of the digital information captured by the camera's CCD or CMOS image sensor, and enable you to get the best possible image quality from your camera – provided you are familiar with the steps involved in an efficient RAW processing workflow.

This book is a complete introduction to processing JPEG and RAW digital image files. It describes the entire workflow using step-by-step instructions that will help you to get the best possible results from your equipment.

In the course of the book, we will be concentrating on the steps involved in processing RAW image files, but most of the methods described can be just as easily applied to JPEG or TIFF files.

The workflow we describe is one that suits the way we work. Once you have learned the basic steps, you will be able to adapt the individual tools and techniques to suit your own personal needs.

There is an overview of the book's contents and the topics covered in the individual chapters at the end of this introduction.

The Basic Tools

The choice of tools available for processing digital images is huge and can be confusing, even for experts. In order to keep things as simple as possible, we will be using two main tools in the course of the book. The first is Adobe Photoshop CS5* (with Bridge), and the second is Photoshop Lightroom, also by Adobe. The workflow sometimes involves both tools, while some aspects of the work only involve one or the other.

*The "CS" in "Photoshop CS" stands for the "Creative Suite" of programs of which Photoshop is a part. The CS4 version of the program is also known as "Photoshop 11", and the CS5 version is also called "Photoshop 12".

Most of the techniques we describe also apply to the CS4, CS3 and CS2 versions of Photoshop and while the user interface has changed visually from version to version (especially from version 3 to version 4), the handling remains largely unchanged. The current Photoshop CS5 and Lightroom 3.0 versions don't change the fundamental workflow, but rather simplify some of the processes involved while reducing the need for additional software plug-ins.

We will be introducing a number of other tools in the course of the book, but these are only recommendations. The additional tools are either more detailed or easier to use than the equivalent functions in the current version of Photoshop, and they are usually available as free trial versions that you can "try before you buy".

Digital photography is an art (and a craft) with enormous potential, and is rapidly replacing analog photography all over the world. Digital camera and image processing technology have also been developing at lightning speed, and this book offers you a comprehensive introduction to the techniques involved in producing high quality digital images. We aim to introduce you to the joys of digital photography while simultaneously speeding up your learning process and helping you to avoid some common mistakes.

And why do we use Photoshop and Lightroom to get our message across? Because (nearly) everyone else does?

Wrong! We have used many programs over the years and we have found that Photoshop is simply the best program available for a majority of the tasks involved in our workflow. Photoshop's toolset is more extensive and its processing speed faster than most of its competitors. CS5 is the current Photoshop version, but the steps described here also apply to CS4, CS3 and CS2. We have deliberately avoided covering earlier versions in order to keep the text clear and straightforward.

Books are static and are difficult to update regularly. We also have to keep an eye on costs when deciding what to include, which is why we often refer to material that is available (for free) at our website: www.outbackphoto.com.*

*The URLs and sitemaps of our websites are listed in appendix A on page 513.

You can find additional files and information, along with corrections and updates for the book at: ebooks.outbackphoto.com/resources/DWF/.

We manage our website on a long-term basis, so you are guaranteed to find the listed content even when this book is no longer in print.

Additional Books

A detailed look at the individual phases of the workflow would make this book even bigger and probably less easy to follow, which is why we often refer to our other, more specialized books:

1. *The Art of Raw Conversion* Dedicated to the use of RAW image editing software. Various professional-grade tools are described and compared. Also includes a chapter on generating color profiles for digital cameras. This book [25] is a detailed approach to the first stage of professional image processing.

2. *Fine Art Printing for Photographers* Dedicated to techniques for producing gallery-grade digital prints. Addresses choice of printer, types of paper and ink (and their compatibility), as well as printer profiling. Print preparation and actual printing are covered using various printers as examples. The book [16] also looks at how to frame prints.

 The Fine Art Printing book is reproduced in heavily abridged form in chapter 12.

3. *Photographic Multishot Techniques* This book [18] looks at various ways to combine multiple exposures in a single image in order to extend dynamic range, depth of focus, resolution, or angle of view.

 The Multishot Techniques book is reproduced in abridged form in chapter 9.

We try to make our individual books as comprehensive as possible, so there will always be some duplication of content. Almost every book we write contains a section on basic color management and color management in relation to the specific theme of the book. For example, the RAW book explains how to profile your camera, while the Fine Art Printing book tells you where to find printer profiles and how to generate your own. Image optimization is a subject covered by all three books, albeit with differing emphasis and differing degrees of detail.

→ We often refer to external resources, most of which can be found at our website. This helps to keep the book clear, concise, and affordable. Internet content is easier to update than the contents of a book. References to content at the dpunkt website are usually to German-language material.

Conventions Used in this Book

The majority of the usages in this book should be self-explanatory. The combination Filter ▸ Sharpening ▸ Unsharp Mask, for example, represents the menu sequence Filter followed by Sharpening and the menu item Unsharp Mask. Keystroke combinations are designated using the Ctrl-A notation. The hyphen means both keys should be pressed simultaneously. Menu entries and action buttons are written using the File or *OK* typefaces, and list elements to be selected and new terms are written in *italics*.

 The Windows and Mac OS X versions of the programs referenced in this book almost always use the same keystroke combinations, although the Windows Alt key is replaced by the ⌥ (option)* key in the Mac OS. The Windows Ctrl key is replaced by the ⌘ key in the Mac.** ⇧ means shift in both systems (⇧-A represents a capital A). ⏎ represents the return or enter key. The Ctrl/⌘ combination signifies use of Ctrl in the case of a PC, and ⌘ for a Mac. The same logic applies to the Alt/⌥ notation.

 We will occasionally mention functions that require a right click to activate a context menu. Macintosh users who use a single-button mouse

Windows key: Mac OS X key:
Ctrl ⌘
Alt ⌥

⇧ represents the Shift key.
⏎ represents the Enter key.
Ctrl/⌘ indicates a press of the Windows
Ctrl or the Mac OS ⌘ key.

* The ⌥ key is also often labeled alt.
** This is also called the Command key and is labeled either cmd or ⌘ (or both).

need to hold down the `ctrl` key and left click once to simulate a right click of a multi-button mouse. We recommend that Mac users invest in a two- or three-button mouse with a scroll wheel. This (not necessarily large) investment will help you a great deal when using this book.

We have cropped some of the screenshots in order to keep them down to a manageable size, and we have reduced the use of whitespace in some places to keep things clear.

The numbers in square brackets (e.g., [2]) refer to information listed in appendix A.

What We Expect from our Readers

We assume that you are a serious amateur, or even professional, photographer and that you use either a DSLR or a bridge camera. We also assume that you are skilled in the use of your camera (and, if necessary, the camera manual). You should be familiar with your computer and how to handle programs and dialog boxes. You should also be familiar with the basic principles of Photoshop.

The Contents of this Book

→ This book is not intended as a substitute for any user manuals, and you will sometimes have to refer to your camera's manual or the online help for Photoshop, Lightroom, or whatever other program we might be using. The procedures, the relationships between the individual steps, and the overall workflow are what this book is all about!

Chapter 1 describes the general workflow, split into sections covering *what*, *how*, and *how to do things better*. It includes descriptions of the RAW format and what it actually is, as well as efficient data transfer, file naming, and cataloging. There is also a glossary of buzzwords that will crop up throughout the book.

Chapter 2 addresses the five main phases of the workflow and the individual tasks involved in each phase. Alternative methods and tools for some tasks are described.

Because digital photography is largely a color-based medium, chapter 3 introduces you to photographic color and color management. The material is sometimes heavy going, and you don't have to read it all before you proceed to the other chapters, but you will need to refer to it a fair amount later on.

Chapter 4 discusses the basic steps involved in processing digital images – in this case, basic Photoshop CS4/CS5 techniques. The methods described here are the basis of our digital workflow and are essential in helping you to understand the following chapters.

Chapter 5 concerns itself with converting RAW image files to suitable image processing formats. We will use either Lightroom or the Adobe Camera Raw 5.x component of Photoshop, but we will also discuss alternative software.

Chapter 6 addresses the new generation of all-in-one RAW editing, image processing, and image management programs.

The use of Photoshop Layers is an extremely versatile image processing technique that we will cover in chapter 7. Thereafter, our workflow will be based exclusively on Layers techniques. Chapter 8 then delves further into

advanced image processing, and includes a discussion of masking techniques and correcting perspective distortion.

Digital technology allows us to merge multiple images in ways that were either impossible or at least extremely complicated in the analog world. Chapter 9 is all about such multishot techniques, some of which will be new even to "old hands".

Although digital exposures take place almost exclusively in color, monochrome photos are still an important part of a contemporary photographer's repertoire. In chapter 10, we will show you some of the many different ways to convert your color material to black-and-white.

Chapter 11 describes how to print your photos or publish them on the Internet. Producing a presentable image is, after all, what the previous chapters are all about.

Chapter 12 summarizes some of the additional plug-ins and add-ons available for enhancing and automating existing Photoshop tools.

Chapter 13 winds up the book and tells you how best to save, manage, and archive your images.

We have used a large number of our own images throughout the book. They are intended to remind you that the book is not only about the purely technical side of digital photography, but also about producing great images. We have tried to communicate an overall vision rather than attempt to produce perfect (but probably dull) images. There is no "right" or "wrong" way to process an image; the goal is to produce an image that pleases you and anyone else who views it, regardless of the technical processes involved.

Keep your vision fresh!

Thanks to …

… everyone who has supported us, but also to all those who have influenced and encouraged us with ideas, information, constructive criticism, and suggestions for improvements. These people include Bill Atkinson, Paul Caldwell, Jim Collum, Charles Cramer, Antonio Dias, Katrin Eismann, Martin Evening, Rainer Gulbins, Mac Holbert, Brad Hinkel, Harald Johnsen, Michael Jonsson, Ed Jourdenais, Thomas Knoll, Phil Lindsay, Dr. Ellen Rudolph, and Ben Willmore. We would also like to thank the companies who lent us product photos and those who gave us trial software, especially Adobe, Apple, Microsoft, and Lightcraft as well as Bibble Labs, Phase One, Nikon, and the many others mentioned in the course of the book.

Very special thanks are also due to our publisher, Gerhard Rossbach, whose love of photography made this book (and its German counterpart) possible.

Uwe Steinmüller, Hollister (California) August 2010
Jürgen Gulbins, Keltern (Germany)

➜ In the interest of clarity, and also to save space, we have cropped some screenshots and reduced whitespace in others. This means that some of the illustrated screenshots and dialog boxes will look slightly different than your own.

➜ You can find a number of free scripts and other information mentioned in this book at: http://books.outbackphoto.com/DOP2010_03/.
However, not all of the scripts will run with the 64-bit version of Photoshop.

Introducing the Digital Photo Workflow

1

So what is a photo workflow exactly? All we really want to do is take great pictures and reproduce them in the best way possible. But doing so actually involves a whole series of steps, from transferring the image files to a computer, to file naming, file format conversion, image optimization, and finally preparing the images for printing or other forms of presentation.

These steps are the basic components of a digital photo workflow, and will ideally be:

▸ *Fast*
▸ *Affordable*
▸ *Capable of delivering optimum image quality*

A workflow requires knowledge, experience, and planning to function properly. Because different images require different treatment, it needs to be adaptable too. A photographer's equipment, ideas and personal style all influence the choice of steps involved in the workflow. Here, we will show you the basic concepts and specific steps involved, and give you the necessary know-how to adapt the digital photo workflow to your own needs and shooting style. We will begin with a brief description of our aims and follow that with a discussion of how to proceed and which tools to use.

1.1 The Basic Digital Photo Workflow

The workflow includes every step of the photographic process, from the moment you release the shutter to the moment when you hold a print in your hand or save your image to an archive.

Unfortunately, there is no golden rule for achieving consistently great results but what we aim to do in the course of this book is to present you with a proven workflow that will help you to:

▸ Improve the quality of your digital images and
▸ Save time and costly trial runs

We will use the simplest possible methods to help you achieve these aims. We don't intend to turn you into a Photoshop expert, but we do intend to show you how to use the tools you need to process your images effectively – with a little practice, but without too much experimentation. We will be using our own experience along the way, and we will sometimes make value judgements. You should nevertheless consider whether our judgements are relevant to your own situation and experiences.

The overview that follows will help you to better understand the later chapters. The digital photo workflow has three major creative phases:

A) Composition and shooting
B) Digital image processing
C) Presentation (print, slideshow, Web gallery, etc.)

This book is mainly dedicated to discussing phases B and C, and only addresses phase A when technical aspects of composition and shooting affect our approach to phase B. Alongside creativity, technical aspects are highly relevant to the whole process – although if phase A is not successful, these too become irrelevant, in spite of the fact that they themselves contribute to the overall success of phase A! The emphasis of this book is on the technical aspects of the process, but don't forget to be creative along the way.

You can, of course, leave phase C to others (a photo lab or an online print service), but if you do, you will waste another chance to be creative.

The "What": Basic Steps

Figure 1-1 is an overview of the basic steps involved in our workflow. It lists some of the things you must bear in mind if you want to consistently create high-quality photos. Not all of the steps listed are necessary for every single image, so don't be discouraged. We will introduce you to the entire process step by step. One of the great advantages of the digital photographic medium is that you can continually improve your technique but still produce great images while you are learning.

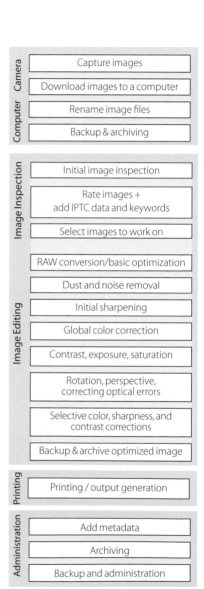

Figure 1-1: The basic workflow
steps, i.e., the "What"

Important Image Processing Know-how

Once you know *what* you have to do, the next step is learning *how* to do it (figure 1-2).

There are usually several "right" ways to approach your work, and you will have to adapt the way you work to account for the job itself, your aims, the available tools, and your own personal preferences.

Our workflow illustrates the aspects of the process that have helped us to achieve great results. You can use these as a basis for developing your own methods.

New tools and new versions of older tools also require you to adapt your methods. Using new tools and learning from the experiences of others helps to keep your work fresh.

Advanced Image Processing Techniques

There are many techniques that you don't yet know and which you don't yet need. We will address these later as part of the iterative learning process. You should learn the workflow step by step (figure 1-3).

Including all currently available image processing techniques would make this book impossibly large and expensive. Once you have learned to use the techniques we do describe, you will be able to use these as a basis for your own experiments with techniques you can pick up from the Web, from other books, and from talking to like-minded people. The www.outbackphoto.com website [1] is also full of new ideas for you to try out.

Figure 1-2: Important know-how, i.e., the "How"

Figure 1-3: Advanced techniques, i.e., "Making things even better"

1.2 Computer Equipment

PC or Mac?

Discussions of whether PCs or Macs are "better" for use with a digital photo workflow are basically a waste of time. We (the authors) currently use Mac desktops and PC notebooks. Fortunately, the current version of Photoshop is, apart from a couple of keystrokes and menu item names, identical for both systems. This means that everything we mention concerning Photoshop

➔ We usually describe the appropriate Windows and Mac keystrokes. When in doubt, please use the keystrokes listed on page xiii.

is valid for both systems. Some of the Photoshop plug-ins we discuss are only available for Windows PCs, but there are usually equivalent tools available for Mac.

Processing large and/or high-resolution images makes serious demands on a computer, so we recommend that your system fulfills the following baseline criteria:

➜ Even if you are a Mac user, you should purchase a two-button scroll mouse. Many important operations in Photoshop (and other programs) are controlled by using a right-click, making a good multi-buttonmouse a real time-saver.

▶ 2 GB of memory is the absolute minimum. More is always better. If your machine and your budget allow it, we recommend that you use 4 GB or more. Professionals use 8–32 GB on 64-bit systems.

▶ A high-quality monitor with a minimum 1280 × 1024 resolution. Here too, larger monitors and higher resolutions are an advantage. We both use two monitors each: a 24" EIZO with 1920 × 1200 resolution for image processing and an additional 21" monitor for displaying program menus and preview images.

➜ Mac USB 2.0 interfaces are notoriously slow. FireWire or eSATA (the fastest currently available) connections are much better for Mac users.

▶ USB 2.0, FireWire, or eSATA connections are an advantage but are not strictly necessary. They are a great help for attaching high-speed card readers or external disk or DVD drives to your system.

▶ A fast CPU. The faster the better. Some Photoshop functions are capable of using multiple processors and multi-processor systems are also an advantage if you are importing large amounts of data.

▶ Hard disk space. We recommend at least:
 – 200 GB for the operating system and programs
 – 100–200 GB for your working environment and temporary memory usage

NAS means "Network Attached Storage", which is storage space attached to a computer via a network.

 – 1–4 Terabytes (TB) for your image archive and working library. This can be an external USB, FireWire, eSATA drive, or a NAS system.

▶ An external card reader for CompactFlash or SD/XD memory cards. If you are thinking of purchasing a new reader, make sure it is at least USB 2.0 compatible (the even faster USB 3.0 standard is currently being introduced) or FireWire-based. USB 1.x is much too slow.

▶ Monitor calibration equipment (more on this subject later)

An office printer is a four-color (CMYK) laser or inkjet printer used mostly for printing text or presentations. This type of printer is only moderately useful for printing digital images. High-end printers use between eight and 12 different colored inks and are well suited to photographic applications. Printing documents using a high-end printer is very expensive.

▶ An office printer and (optionally) a separate high-end printer

More and *faster* are generally better. With better gear, you can work more quickly and complex operations function more smoothly. This makes the entire process more fun. Treat yourself to the best equipment you can afford.

Be especially careful when choosing your monitor if you plan to spend a lot of time processing images. A high-quality monitor will usually outlive a computer, and earlier reservations about questionable color rendition in LCD monitors are nowadays no longer an issue. If you plan to purchase

a new monitor, we recommend that you go for one with a diagonal of at least 19". The larger your monitor, the better it is for your eyes and your general fatigue levels. A large monitor also helps you to retain an overview of your work. We no longer recommend the use of CRT monitors.

64-bit platforms: 64-bit systems are currently not mature enough to be genuinely reliable. The 64-bit versions of Windows Vista and Windows 7 still have problems with the availability and stability of appropriate drivers, and the first 64-bit Mac version of Photoshop (CS5) has only just been released. In spite of these considerations, 64-bit systems will be the better option in the long term.

Although 32-bit Macs have been able to address 4 GB of memory for a while now, Windows can only address no more than 3.2 GB of memory in its 32-bit version. The increasing size of image files and the increasing complexity of the processing steps we apply makes the availability of large amounts of memory essential to the workflow. If you are planning to purchase a new computer, we recommend that you look at a model with a 64-bit processor and the advanced memory capacity described above. Windows is available in separate 32-bit and 64-bit versions, but all newer Mac computers are 64-bit compatible.

Multi-core systems: Lightroom, Photoshop, and, increasingly, other programs mentioned here are capable of addressing multi-core processors and thus accelerating some imaging processes. Again, if you are planning a purchase, a multi-core machine is the way to go.

➜ As of version 2, Lightroom is delivered with 32-bit and 64-bit Windows and Mac versions on a single CD or DVD. Windows Photoshop versions have been delivered in 32-bit and 64-bit versions since the release of CS4, and for Mac since the release of CS5. The 64-bit versions are faster when processing large images files if used on a computer with appropriately configured memory.

1.3 What are RAW Files?

Working with analog and digital cameras is similar in many ways, but you need to understand the differences in order to provide yourself with the best possible material for feeding your digital workflow. Good framing and correct exposure are critical to the success of any photo, and the old maxim "garbage in, garbage out" is still relevant in the digital age. This doesn't mean you should trash your snapshots, but it does mean that turning a sloppily-shot photo into a great image will involve a lot of work in the digital darkroom.

JPEG is currently the most commonly used digital image format and produces highly compressed image files. Unfortunately, the JPEG format produces an appreciable loss of image quality, even at lower compression rates.* With JPEGs the camera adjusts white balance, sharpness, noise, and contrast in the camera. This is useful for hobby photographers who want to produce an image as simply as possible, but it robs others of the opportunity to correct their images in a controlled fashion later. These automatic adjustments reduce image quality before we even begin our own processing.

JPEG stands for the "Joint Photographic Experts Group" that invented the format.

* There is also a "lossless" version of JPEG available, but this is seldom used. "Image quality loss" means that the image data is simplified in order to save memory space. Every time a JPEG image is saved, it loses additional image data that cannot be accurately rescued later.

JPEG is fine for images that are not due for much further processing. This is often the case in the consumer market, but seldom the case for ambitious hobby or professional photographers – although there are situations when even a professional needs to resort to a quick JPEG solution.

Some digital cameras use the alternative TIFF format or a proprietary RAW format in order to produce the best possible image quality. In the course of the book, we will demonstrate how RAW provides the best material for flexible image processing.

If you end up using JPEG or TIFF for your images (e.g., if your camera offers bad or no RAW support), you can still use most of the steps described here to process your images. Only the RAW conversion step is no longer relevant, as this is performed automatically in-camera. All of the remaining steps apply to both JPEG and TIFF image files. Even if you don't shoot RAW images yourself, you should understand the concept of RAW.

What are the Advantages of RAW Format?

In order to understand the advantages of RAW, you need to understand how most modern digital cameras work. All new digital cameras capture color photos, right? Well, not exactly. While you ultimately get color images from a digital camera, most modern digital cameras use sensors that record only grayscale (brightness or luminance) values. (The Foveon X3 sensor, some digital scanning backs, and multishot digital backs are exceptions.)

Figure 1-4: Full color sample target

Let's take a box of Crayola crayons as an example (figure 1-4). A grayscale sensor would see the subject as it looks in figure 1-5; that is, it would see only shades of gray. But how do you use a grayscale sensor to capture color photos? Engineers at Kodak came up with the color filter array configuration illustrated in figure 1-6. This configuration is called the *Bayer pattern* after the scientist who invented it back in the 1980s. (Other pattern variations are used as well, but this is the basic technology used in most CCD and CMOS image sensors.) The yellow squares in the grid shown in figure 1-6 are the photoreceptors that make up the sensor; each receptor represents one pixel in the final image. Each receptor sees only the red, green, or blue part of the light that passes through the color filter just above the sensor element.

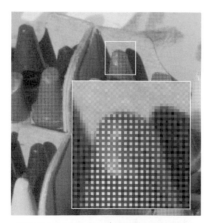

Figure 1-5: A grayscale image, as seen by
the camera's image sensor

B-G-B-G-B-G
G-R-G-R-G-R
B-G-B-G-B-G
G-R-G-R-G-R

Protective cover and
low-pass filter
Color filter array

Sensor elements
Sensor

Figure 1-6: The Bayer pattern is produced by using a
matrix of colored filters

You will notice that 50 percent of the filter elements (and thus the receptor elements) are green, while half of the remainder (25 percent each) are red and blue. This pattern works because the human eye can differentiate between many more shades of green than it can red or blue, which is not surprising when you consider the number of shades of green in nature. Green also covers the widest part of the visible spectrum. Each receptor in the sensor captures the brightness values of the light passing through its color filter (see figure 1-5), and each pixel therefore contains the information for just one color (like a mosaic). However, we want our photo to have full color information (red, green, and blue) for every pixel. How does that magic happen? A software trick called *Bayer pattern demosaicing,* or *color interpolation,* adds the missing RGB information using estimates garnered from the color information in neighboring pixels.

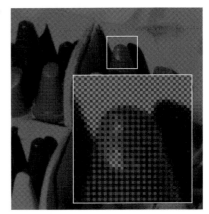

Figure 1-7: Colored mosaic as seen through the color filters

Demosaicing is the method used to turn RAW data into a full-color image. A good demosaicing algorithm is quite complicated, and there are many proprietary solutions on the market.

The challenge is also to resolve detail while at the same time maintaining correct color rendition. For example, imagine capturing an image of a small black-and-white checkered pattern that is small enough to overlay the sensor cells, as in figure 1-8.

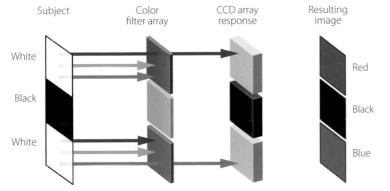

Figure 1-8: A Bayer pattern image sensor with its erroneous color interpretation. An AA filter is positioned in front of the color filter array in order to correct this problem.

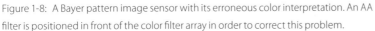
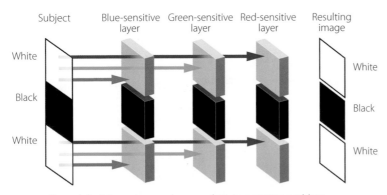

Figure 1-9: A Foveon sensor has no color interpretation problem.

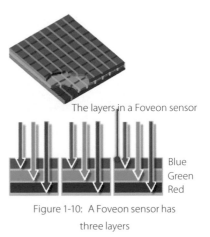

The layers in a Foveon sensor

Figure 1-10: A Foveon sensor has three layers

White light consists of red, green, and blue rays, and the white squares in our example correspond exactly to the red- and blue-filtered photoreceptors in the sensor array. The black squares, which have no color information, correspond to the green-filtered photoreceptors. So for the white squares that are aligned with red photoreceptors, only red light passes through the filter to be recorded as a pixel.* The same is true for the blue photoreceptors.**

* Where white light hits the red filter
** Where white light hits the blue filter.

Color interpolation cannot correct these pixels because their neighboring green-filtered photoreceptors do not add any new information. The interpolation algorithm would not know whether what appears to be a red pixel is really some kind of "red" (if white light hits the red filter) or "blue" (if white light hits the blue filter).

Contrast this with the Foveon sensor technology illustrated in figure 1-10. Instead of a Bayer pattern, where individual photoreceptors are filtered to record a single color each, the Foveon technology uses three layers of receptors so that all three color channels are captured at the same photosite. This allows the Foveon sensor to capture white and black correctly without the need for interpolation.

The resolution captured by a Bayer sensor would decrease if the subject consisted of only red and blue tones because the pixels for the green channel could not add any information. In the case of monochromatic red or blue tones (those with very short wavelengths), the green photosites receive absolutely no information. However, such colors are rare in real life, and even when the sensor samples very bright, saturated reds, some information is still recorded in both the green and (to a much lesser extent) the blue channels.

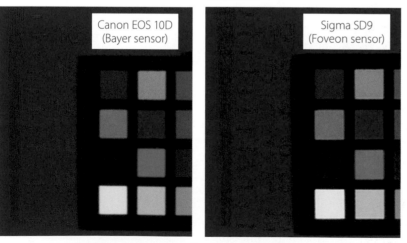

Canon EOS 10D (Bayer sensor)

Sigma SD9 (Foveon sensor)

Figure 1-11: Fooling a Bayer pattern sensor (left)

A Bayer pattern sensor needs a certain amount of spatial information in order to correctly estimate a color. If only a single photosite samples red information, there will be no way to reconstruct the correct color for that particular photosite.

Figure 1-11 illustrates a test we made in a studio to demonstrate the loss of resolution that a Bayer sensor causes when capturing monochrome colors. Notice how blurred the text in the Canon image is compared to that in the Sigma image. These test photos show an extreme situation because a Bayer sensor cannot really capture the transition from blue to red at a pixel level. Although this type of error is less dramatic in real-world situations, it is still visible and cannot be ignored. Increasing sensor resolution helps to diminish the effect.

Some of the challenges that interpolation algorithms face include image artifacts, such as moirés and color aliasing (displayed as unrelated green, red, and blue pixels or discolored image areas). Most camera manufacturers combat aliasing problems by positioning an *anti-aliasing* (AA) filter in front of the sensor. This filter, also called low-pass filter, blurs the image and distributes color information to neighboring photosites. Needless to say, deliberate blurring and high-quality photography are strange bedfellows, and finding the right balance between blurring and aliasing is a true challenge for camera design engineers.

AA filtering reduces the effective resolution of a sensor, so some fairly strong sharpening is often needed during the RAW workflow. Re-sharpening performed after anti-aliasing is known as *compensatory sharpening.*

The task of creating a high-quality image from the data recorded by a sensor is a complicated one, but it works surprisingly well.* Every technology has to struggle with its inherent limitations, and digital photography is nowadays superior to analog photography in some respects due to the fact that analog techniques also have their own limitations.

Now we know that RAW data is the representation of the grayscale values captured by the individual elements in an image sensor**. The data then has to be interpolated and transformed to produce a color image. For JPEG and TIFF images, the conversion of RAW data is performed by the camera's firmware before the image is saved to the memory card.

What are the limitations of shooting in JPEG instead of RAW format?

▸ JPEG artifacts caused by data compression

▸ Although many high-quality image sensors deliver 12-bit or 14-bit per pixel image data, JPEG image files only record 8-bit data

▸ Although RAW data conversion requires a lot of computing power, the power of the camera's CPU is limited. Using a computer is therefore a more powerful and flexible approach to RAW conversion, especially considering that computers are getting faster all the time, while a camera's CPU cannot be enhanced or updated. Conversion algorithms are improving too, and a software update on a computer is easier to perform than a camera firmware update.

▸ A great many automatic and manual settings (such as white balance, contrast, tonal value corrections, sharpness, and color interpolation) are automatically built into the image data by the camera. This limits later correction potential because each automatic correction reduces image quality. This is especially true if you are working with 8 bits per color channel.

Various RAW image formats can now be defined. A RAW file saves the raw data from the image sensor as well as the file's EXIF metadata. EXIF data includes information about the camera and lens used to shoot the image, as

** Experience shows that some high-end Canon and Nikon DSLRs do this job very well.*

*** for a normal sensor with colored filters*

Firmware is hard-coded (i.e., non-changeable) software. Most cameras allow you to update their firmware.

well as information about the aperture, the shutter speed, the ISO value, and various other aspects of the camera settings that were used. This information helps us to make adjustments to our image manually that would otherwise be made automatically in the camera.

The advantages of shooting in RAW format are:

▸ No loss of image quality due to JPEG compression

▸ Full use of the 12-bit or 14-bit image data captured by the camera's sensor

▸ Potentially much more sophisticated RAW conversion (for example, using Adobe Camera Raw, Lightroom, or other specialized software)

▸ Corrections to white balance, color rendition, sharpness, noise, and dynamic range can be made later in a controlled, computer-based environment

A RAW file is largely equivalent to an undeveloped analog negative and can be similarly *pushed* at the "development" stage in order to compensate for exposure errors. RAW conversion software is continually improving, helping us to improve our results.

A JPEG image produced in a camera is like a Polaroid photo – you can see the results immediately but you can't change anything. High-quality RAW editors, such as Capture One Pro, Lightroom, Adobe Camera Raw, or RAW Developer can be configured to work something like your own secret chemical recipe for developing analog film.

What are the advantages of 14-bit color depth? When you perform major corrections to white balance, color, contrast, or perspective, every operation causes a loss of data bits due to rounding errors. These errors are additive, so the more image data you have in the first place, the better you can compensate for data loss during processing.

What happens if you shoot your images in TIFF format? TIFF image files behave basically just like JPEG files, but are not subject to the image quality loss caused by JPEG compression. Image data is reduced to 8-bit, but the image files are nevertheless larger than equivalent RAW files because RAW saves 12-14 bit grayscale pixel data, whereas TIFF saves 24 (3 × 8) bits of color data per pixel. The other advantages of RAW don't apply to TIFF images. We are of the opinion that an 8-bit TIFF file produced in-camera offers no advantages over a mildly compressed JPEG file.

Digital Artifacts

Today's image sensors usually interpolate color information using a Bayer pattern sensor and do not capture full RGB image data for every pixel. This results in a slight loss of image sharpness. The Foveon X3 sensor described above shows that other solutions are possible.

| Structural information |
| JPEG preview image |
| EXIF data |
| Manufacturer-specific data |
| Raw image data |

Figure 1-12: Typical structure of a RAW file

➜ Overexposure is much more difficult to correct.

Most output devices can only reproduce 8 bits per color channel anyway.

➜ Although cameras only capture 10- to 14-bit per pixel image data, within the computer these data are saved and processed as 16-bit values.

Color Anti-aliasing/Moiré Artifacts

What happens when a fine red line passes through a green image area and doesn't touch any of the neighboring sensor photosites? The line wouldn't appear at all in a RAW image file. Most digital cameras combat this type of phenomenon by using an AA filter placed in front of the image sensor. An AA filter diverts the light reaching the sensor slightly so that it is also registered by neighboring photosites. In our case, neighboring photosites would then *see* parts of the red line.

An AA filter therefore cures one problem and creates another in the form of reduced image sharpness. Such images have to be more strongly sharpened in the course of the RAW workflow.* Detail that is lost due to an AA filter cannot be reconstructed later, regardless of how clever your sharpening tool is. AA techniques nevertheless deliver results that are generally better than our description of the problem might lead you to believe.

* This effect is also just as evident if you shoot in JPEG or TIFF formats.

1.4 JPEG Instead of RAW?

There are still situations in which JPEG is a useful format, in spite of all the advantages that RAW offers. For example:

▸ Your camera offers limited or no RAW support

▸ You need ready-processed images direct from the camera

▸ RAW processing is too complex and time-consuming for you

▸ RAW files use too much camera and computer memory capacity

Although we generally advocate the use of RAW, you can still produce great images using JPEG. You can simply use the automatic RAW conversion software built into the camera rather than performing the processing yourself. Apart from the actual RAW conversion stage, all of the other steps in our workflow are just as applicable to JPEG or TIFF images. Because adjusting white balance and exposure later cause appreciable image quality loss, you will need to watch out for the following points while shooting JPEG or TIFF images:

▸ Try to use the most appropriate white balance setting while shooting. Many cameras produce more than adequate results if white balance is set to Auto (at least when shooting in natural light).

Many cameras allow you to use a custom white balance setting based on a photo of a white or neutrally colored object in your image. This photo is than used for the white balance of the photos that follow.

▸ Avoid overexposing your image with the help of the camera's histogram display. Some cameras even have a live histogram display that shows the distribution of tonal values within the frame before you press the shutter release.

Some camera settings have a greater effect on JPEG images than they do on RAW images, so you should, if possible:

▸ Deactivate automatic sharpening or select a low sharpening value

▸ Set contrast correction to *low* or *normal*

▸ Set color to *neutral* and saturation to *low*. Saturation can be corrected later anyway.

▸ Use the Adobe RGB (1998) rather than the sRGB color space

▸ Use the highest possible resolution and lowest possible compression settings

Your first step in processing a JPEG image should be to convert it to TIFF so that the following steps don't cause exponential image quality loss due to the additive JPEG quantization process*.

*Quantization is part of the JPEG compression process.

Our tip: Use RAW once you are familiar with it and whenever you want to squeeze the last drop of image quality from your camera. You can, however, still produce great JPEG and TIFF images if you concentrate on your exposure while shooting and follow the rest of the workflow diligently.

Most cameras produced since 2007 support simultaneous saving of JPEG and RAW files for each image. This gives you the freedom to choose between "ready-made" JPEG images and RAW images for later processing.

1.5 Camera Settings

CF = CompactFlash, SD = Secure Digital, SDHC = Secure Digital High Capacity. These are the most common memory card technologies in current use.

Select either RAW mode (check your camera manual to see how) or JPEG with the highest possible resolution and the lowest possible compression rate. RAW files use much more memory than JPEG files, regardless of whether your camera uses CF, SD, xD, or Memory Stick cards.

1.5.1 Using Histograms as an Exposure Aid

➜ Digital image sensors are more sensitive to overexposure than film and clip highlights much more drastically.

Correct exposure is the key to great photos. Overexposure should be avoided at all costs, as washed-out highlight detail cannot be recovered at any stage during the workflow.

In order to help you judge exposure, digital cameras allow you to check your exposure visually on the monitor immediately after shooting. Nearly all digital cameras – at least all DSLR cameras – have a histogram display that shows the distribution of tonal values within the image from 0 (black, on the left) to 255 (white, on the right).

On the next page are four sample histograms produced using Photoshop that show three typical curves.

The histogram in figure 1-13 shows an overexposed image with obviously clipped highlights at the right end of the graph. This image will lack highlight detail. Images that display a histogram like this are generally only good for deletion. Some photographers recommend using the Photoshop Burn tool to darken images like this, but the tool only simulates detail that wasn't actually present in the original image.

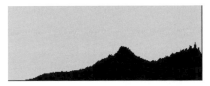

Figure 1-13: Histogram showing distinct overexposure

The histogram in figure 1-14 shows only a small overexposed peak on the far right. The actual subject will dictate whether this amount of highlight clipping is acceptable or not. If the clipped highlight is pure white or represents a less important image detail, the photo might be OK. Otherwise, it may be safer to ditch it and re-shoot.

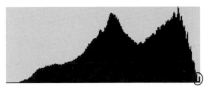

Figure 1-14: Histogram showing potential overexposure (red circle)

The histogram in figure 1-15 is of a balanced exposure. The missing tonal values at the white end of the scale can be reconstructed using Photoshop. You should always aim to produce images with histograms that look similar to this one – i.e., with an even, unclipped grayscale "mountain" as far towards the right-hand end of the graph as possible. This approach is often described as "exposure to the right".

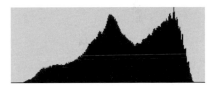

Figure 1-15: Histogram of a well-exposed shot

The next section will clarify why it is better to underexpose than to risk losing highlight detail, especially as it is often difficult to view and judge a histogram correctly in bright light or on the road.

→ Remember that the monitor image and the image represented by the camera histogram are in JPEG quality and have already been subjected to a RAW-to-JPEG conversion by the camera's firmware. If you are shooting in RAW mode, your computer-generated histograms and the resulting images (e.g., in a RAW editor) will often look different from the ones the camera displays while shooting.

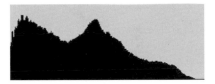

Figure 1-16: Histogram of an underexposed shot

1.5.2 Clipping in Individual Color Channels

A good luminance histogram displays only the distribution of brightness values and can belie detail clipping for individual colors. Histograms for the separate color channels help in such situations – a feature offered only by a few high-end cameras.

The histogram in figure 1-17 is of an image shot using a Canon EOS 10D and shows the typical color saturation problems associated with yellow, orange, or blue flowers. Such subjects will generally not use the entire range of tonal values in a luminance histogram. The color histogram in figure 1-17 (produced using Adobe Camera Raw) clearly shows the clipping that occurs at the right end of the blue curve.

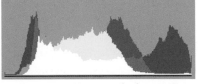

Figure 1-17: Histogram for figure 1-18

Figure 1-18: An image that will be prone to blue channel clipping

The Capture One multi-channel histogram in figure 1-19 also indicates clipped colors. The blue clipping was not visible in the camera histogram

Figure 1-19: Histogram for the image in figure 1-18, produced using Capture One

because it only shows the average (luminance) values for all three color channels.

→ Always make sure the colors in your image aren't clipped in one or more color channels.

A color histogram only helps if you are in a position to re-shoot your image using different exposure values. This is often possible for nature photos (with the exception of birds or other animals). Unfortunately, even the most sophisticated automatic exposure systems cannot guarantee optimum exposures. Histograms offer a more reliable way to judge exposure, even for experienced "old-school" photographers who are used to using light meters. You can compensate for overexposure by adjusting your exposure value (EV) setting and repeating your shot. You should always keep an eye on the histogram, and we strongly recommend that you set your camera to display a histogram automatically after each exposure.

EV = Exposure Value

If you use a tripod, it is easier to use your own manual exposure settings than the camera's exposure compensation dial. The correct settings for a particular scene don't usually change that often, and automatic exposure metering systems often adjust exposure randomly for differently lit objects within a single frame.

1.5.3 Using White Balance Settings to Produce Optimum Color Quality

White balance (WB) settings are the key to correct color reproduction. They have to allow for direct and indirect (reflected) light sources.

Analog photographers adjust white balance either by changing the film they use or by attaching colored filters to the camera lens. This compensates for differing lighting conditions (indoors, outdoors, cloudy sky, flash, etc.).

If you shoot in RAW format, you can adjust white balance later during processing. Fine art photographers are not necessarily interested in absolute color reproduction anyway (why else would you want to use Velvia slide film, with its over-the-top candy colors?), but most of us are interested in the subjective mood of a photo, which is often carried by the colors.

DSLRs allow you to select your preferred white balance setting while shooting.* This is a great feature, but it is not always practical to use in real-life situations. We recommend that you set white balance to automatic and correct it later (if necessary) during the workflow.

* Using automatic or manual white balance settings

An alternative method of ensuring consistent white balance is to photograph a gray card** in the same light as your subject and use the resulting image as a reference for your white balance setting.

** A color card (such as the X-Rite ColorChecker) with neutral gray color fields is even better.

Getting white balance right is a tricky and largely subjective process, but you will get better at judging color and color settings with increasing experience.

Color value judgements depend on the overall mood of an image. Images that show too many cold (blue) tones can benefit from additional warm (yellow or red) tones, although you may find yourself wishing that a warm image includes more neutral (blue or green) tones. Color experiments and corrections involve time and effort during the image optimization process.

1.5.4 Objective and Subjective White Balance

There is a big difference between correct colors and pleasing colors. There are only few situations in which we want to reproduce colors completely faithfully – for example, if we are photographing textiles or products for publication in catalogs. In most other cases, we aim to produce a pleasing color composition. The most frequently discussed (and culturally influenced) aspect of color is skin tone. In Europe and the USA, people generally prefer skin tones that have been shifted slightly towards brown, whereas Asian photographers tend to prefer paler skin tones.

Select a white balance setting that you like and correct contrast and color selectively and only where genuinely necessary. This might involve correcting skin tones, but can also mean changing the dull blue of a sky or the blue tones in shadows that are often produced when you shoot in bright sun.

Color perception is subjective and depends to a great extent on personal taste. The default settings in different RAW editors produce different results from the same source image, which is why some people prefer one particular software package over another. These types of differences are also evident in JPEG images produced by the camera, as they too are subject to the manufacturer's proprietary, firmware-based RAW conversion.

This is why many newer RAW editing programs offer multiple camera color profiles,* so that every user can select his/her favorite (with stronger or weaker or more neutral colors) as the default. These profiles nevertheless only form the basis for subsequent optimization.

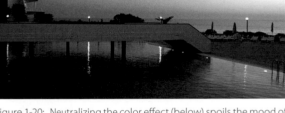

Figure 1-20: Neutralizing the color effect (below) spoils the mood of this image (above).

* For example, Adobe Camera Raw from version 5 and Lightroom from version 2 onwards.

1.5.5 Choosing the Right ISO Sensitivity Setting

Modern digital cameras allow you to select the ISO value for each situation using a dial or a button. This is a great advantage over analog photography, which requires either a film change or special development in order to alter the sensitivity base.

Figure 1-21: Detail of an image shot
at ISO 200

Figure 1-22: Detail of the same subject
shot at ISO 6400

➜ Always select the lowest possible ISO
setting and use a tripod whenever you can.

Generally, the lower your ISO value, the less noise your photos will display, resulting in better image quality. Higher ISO values always produce more noise, which takes on various forms and is usually more evident in darker image areas. Image noise is caused by charge differences between the individual elements of the image sensor that result from static, manufacturing tolerances, signal amplification, and other, similar factors.

High sensor temperatures also increase noise. If you are shooting in high ambient temperatures, keep your camera cool and don't leave it switched on for longer than absolutely necessary. The levels of noise a camera produces also depend on the type of sensor it uses. Small image sensors produce more noise than larger sensors, and CCD sensors produce more noise than their CMOS counterparts because they use more power and therefore have higher operating temperatures. Greater sensor resolution for a similar sized sensor reduces the per pixel sensor area, which also leads to increased noise – technical advances in recent years have helped to keep noise levels down in spite of increasing sensor resolution.

Grainy, "salt and pepper" noise effects are generally more acceptable to us because they look similar to the grain effects we know from analog film material.

If you find yourself needing to use higher ISO values (for instance, in low light or for fast-moving subjects) we advise you to use the best possible noise reduction tools during processing. (See also section 12.3, page 475 onwards.) We usually deactivate in-camera noise reduction, as it not only slows down in-camera image processing but also tends to blot out fine image detail. If noise reduction is really necessary, you can perform it in a much more selective and controlled fashion by using a RAW editor or Photoshop plug-ins.

We also nearly always deactivate Auto ISO. This feature allows the camera to automatically increase the ISO value if it thinks the situation demands it. This can be useful for sports photography or other fast-moving subjects, but it often produces unexpected, unwanted noise effects.

1.6 From the Camera to the Computer

Here, we are going to address part of chapter 2's second phase (P2) step of image data transfer and organization. This will help us to clarify the background and incentives behind some of the topics that we will be discussing later in this chapter.

Transferring the data from a full memory card to your computer after a long session often uses a large amount of disk space, especially if you convert some of your images to 16-bit TIFF format. You will quickly learn to think in gigabytes (GB) or terabytes (TB). Our network already has more than 6,000 GB (6 TB) of disk space attached to it in various forms. Such large amounts of data require serious organization if we are to be able to find specific images, and if we want to avoid duplicating data and retain an

Basic image management	
Downloading from card to computer	
Storage organization	
Renaming	
Inspection + rating	
Grouping and tagging	
Backup and archiving	

Figure 1-23: Our first workflow steps on the
computer: image transfer and management

overview of the current versions of the images we have. A good basic setup includes a 300 GB hard disk in your notebook and 750 GB – 2 TB in your desktop. You will also need a similar amount of disk space on external drives for your backups.*

* Nowadays, external drives are connected to computers via FireWire, USB 2.0, eSATA, or high-speed NAS systems.

1.6.1 Downloading and Organizing Your Images

Most modern digital cameras have either a USB or a FireWire interface. Wireless interfaces are either optional or expensive (or both). Many systems automatically download images as soon as a camera or a card in a card reader are attached to a computer. We don't use this option because we use multiple memory cards, and because most cameras don't make very effective card readers. Direct downloads also quickly exhaust your camera's batteries. We use a card reader attached to one of our laptops or workstations to download the day's images to a new, dated folder. We use several different cameras, so we try to name our image files in such a way that they are all easily attributable to a particular camera, even if we are using more than one camera of the same type.

At this point it is important to keep control of how your saved images are organized and how you name your individual image files.

A note about our use of the term "RAW": The term "RAW" (in capitals) refers to images shot in one of the many available RAW formats, whereas the term "raw" refers to unprocessed image data in any format (RAW, JPEG, or TIFF).

A) Make sure you know where to find your new images and where they are to be stored if the download location is not their final destination. Original images and processed versions of the same image don't always end up being stored in the same place.

B) Make sure you organize your images clearly and simply so that you can always quickly find any originals or copies.

C) Your personal system should be compatible with your image management software.

D) All images and additional data should be backed up regularly and should be easy to reproduce should a system failure occur.

E) Make sure that your image files and your backups are easily identifiable.

The way you order your images is fundamental to the way you store all of your future work. The two most obvious ways to sort images are either chronologically or according to individual topics or jobs. We recommend the chronological approach. Images sorted by topic quickly become unmanageable.

➜ Our tip: only arrange your images according to themes in virtual folders or collections based on image metadata and not on the location of the original image file.

Filenames should be chosen according to the following rules:

A) A filename should only occur once in your entire database (apart from backups, of course).

B) A filename should give some clues as to its contents (date, image type, subject, or job number).

➜ Resist the temptation to include too much information in your file names. This quickly leads to complications and naming system breakdowns.

C) A filename should be short and must be compatible with your database and/or image management software. Don't use special characters. We recommend that you use the following guidelines when naming your files:

– Maximum 31-character length (plus a 3-character file extension separated from the filename by a dot). Remember that filenames often get longer (for example, with the addition of a version number).

– The only special characters should be underscores, hyphens, and the dot that separates the extension from the filename.*

– Don't use unusual language-based characters (such as é, ë, or â). Although most modern systems can decipher these types of characters, they still often cause problems, especially if you change systems or programs.

D) The file extension should make it obvious what type of file it is describing. References to the processing steps you used or other characteristics of a file can be included in the filename itself.**

You can apply most of these criteria to your folder names, too – especially avoiding folder names that are too long or use special characters. It is important to consider what information is really relevant and what is better to leave out when naming files and folders.

Our File and Folder Naming Conventions

Figure 1-24 illustrates the system we use for naming files and folders. This system is chronological and is built on two or three levels. We use one folder for each year, and the folder's name always includes the year. The year folders contain subfolders organized according to shoots. If we use only one camera, all the images from a shoot are stored in a single subfolder. If we use multiple cameras for a shoot, the images from each camera are stored in a separate subfolder.

<div style="float:left; width:35%;">

* It is safest to use dots exclusively for separating the filename and the file extension.

** For example, "BW" for a black-and-white conversion

Figure 1-24:
Our system for storing original images downloaded from the camera

</div>

▶ **2010:** All source images shot with all of our cameras in the year 2010 are stored here in appropriate subfolders.

▸ **20100325_5DII_Church_NB:** This folder contains the images we shot at the church in Niebelsbach on March 25, 2010.
The individual image files are named as follows:
Date_Camera_#_Shoot_image#:

- – The date format is *jjjjmmdd*,[*] to make sorting easier
- – 5DII stands for the *Canon 5D Mark II* camera
- – Options "_01", "_02", ..., are used if we shot and saved images using more than one memory card (not shown in figure 1-24).
- – The name of the shoot or the broad subject (here "church") or a customer or job number.
- – The image number that the image receives on the memory card (usually between 0000 and 9999)

We rename all of the downloaded images according to these rules immediately after downloading. Ideally, the renaming process takes place during downloading.

If you have more than one camera of a particular type, you still need to uniquely identify each image. Once it has reached 9999, the camera starts numbering again at 0000. The *jjjjmmdd* suffix nevertheless allows you to create unique filenames.

We save the images we process in Photoshop as TIFF files. These files contain the original *Date_Camera_Shoot_mmm* data in their filenames and also receive an additional sequential number and possibly a code that identifies the processing involved, for example:

Original: 20100325_5DII_Church_1114.CR2
Processed image: 20100325_5DII_Church_1114#02BW.tif

This way, we can always find the original image based on the information contained in the name of the processed image[*]. Lightroom automatically saves a RAW image and its derivatives as a stack.

* We will call all processed and converted RAW images "processed images" or "derivative images".

1.6.2 Renaming Your Files

Once we have downloaded our images to a hard disk, we rename them according to the system we have just described and thereby ensure that every image is uniquely named. We use the Adobe Bridge Photo Downloader or the (even better) Lightroom Import tools, both of which are capable of renaming files during download and which can also be programmed to save a backup copy of each (already renamed) file to a separate location. You can also use these tools to apply metadata to files, which, in the case of RAW images, is saved in a separate XMP file.

The Bridge Downloader is opened using the File ▸ Get Photos from command, and the dialog in figure 1-25 then appears. Select the image source Ⓐ, the target folder Ⓑ, and, optionally, the backup location Ⓒ.

➔ This step is only necessary if you haven't already renamed your files during the download process. This section demonstrates the system, regardless of when it is applied.

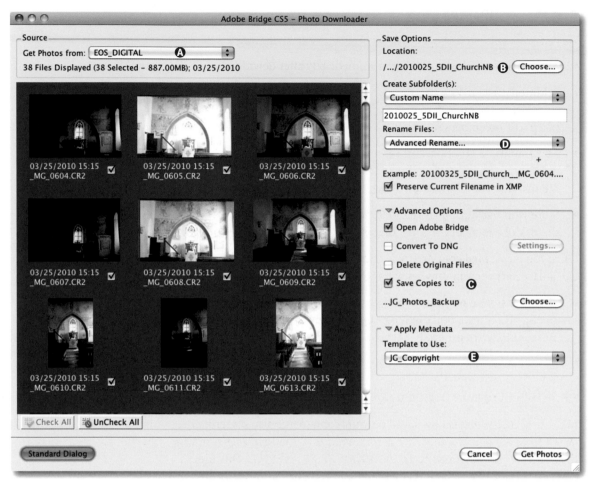

Figure 1-25: Adobe Bridge CS5 Photo Downloader showing the extended dialog options

You can then use the Rename menu Ⓓ to define your renaming system. The settings shown in figure 1-25 produce images named using the system we described above.

The Bridge downloader also includes an option Ⓔ for applying an IPTC metadata template to the images you are downloading. The menu Ⓔ also includes an option for creating or editing the template before you apply it.

1.6.3 Backup

Once you have downloaded your images, you should back them up immediately to either a separate hard disk, a DVD, or a Blu-ray disc. The Bridge and Lightroom import tools both have an automatic backup option that we always use if possible. Once you have backed up your images, you can delete them from the memory card or, preferably, format your memory card using the camera's built-in format command. We don't recommend that you format memory cards using your computer!

Don't Forget: Backup – Backup – Archive

We can't repeat it often enough. Always backup your image files:

▸ As soon as possible, i.e., during or immediately after download.

▸ Additionally to DVD, Blu-ray, or an external hard disk. Don't back up your files to the same hard disk as your originals and don't back them up to a partition on the same disk.

▸ Make multiple DVD backup copies using different brands of disc. If a disc from a particular batch or manufacturer is defective, the chances are that other similar discs will also be defective.

▸ Store your backup copies in different locations. This way, you minimize the risk of a total loss of your images due to fire, water damage or theft.

Once you have saved your originals and backup copies of your images, you can at last start work in the digital darkroom.

➜ If the file system on your memory card should become corrupted, don't panic!* There are a range of recovery programs available (such as Photo-Rescue) that are generally capable of reconstructing and saving your files.

➜ Some download tools (e.g., Photo Mechanic, Adobe Bridge, or Lightroom, for example) allow you to create a backup copy of your image files automatically during download.

➜ There are also tools available (such as Apple's Time Machine) that constantly check your system for new or updated files and automatically back them up to an external storage location. This an effective backup method, but it is not sufficiently safe on its own. You can find more information on backup and data security in section 13.2.

* This can easily happen if your camera battery dies while it is writing a file, or if you open the memory card door of your camera too soon.

1.6.4 Handling Your Digital Originals

The source image that is now saved on your computer is also sometimes referred to as a *digital negative*. We recommend that you save a copy of this file in its current, renamed form (be it RAW, TIFF, or JPEG). This file contains all the available image data without any loss due to processing and including all the metadata recorded by the camera. You will often need to refer back to your original file, for example if:

▸ You have improved your technique and want to have another try at perfecting a particular image.

▸ Better RAW editors hit the market. We have seen radical improvements in image processing software in recent years, and we expect these to continue.

▸ Your processed images become lost or damaged due to disk failure, virus action, or accidental deletion.

A source image is a type of latent image, and the processing steps you make are equivalent to your own special analog darkroom development formula. The major difference between analog and digital images is that you can develop the same negative (i.e., the RAW image) multiple times. If you use JPEG or TIFF files as your source, you should be working exclusively with copies of the originals. RAW editing software doesn't alter the RAW file itself, but instead saves the changes you make as a separate data set or file.

The default Bridge workspace is divided into four main panels (figure 1-26):

Ⓐ **Folders:** This is where you select the folder for the images you want to view or manage, depending on which mode you are using.*

* The Folders window also contains a Favorites tab, where you can put folders that you use regularly for fast retrieval.

Ⓑ **Content:** This is usually shown as thumbnail previews, whose size is adjustable using a slider at the bottom of the panel. You can also view your content as a list (showing some file details) or as a detail view (showing all file details). The default settings highlight the currently selected item.

Ⓒ **Enlarged preview:** This helps when making selections, especially if the list icon is too small to judge adequately. The size of the preview image can be adjusted.

➜ EXIF metadata are written to the image file by all modern digital cameras. These include information regarding the camera model and the lens used, as well as the shutter speed and the aperture. This information is very useful when it comes to selecting and processing images later.

Ⓓ **Metadata:** This includes the filename, the shooting and last processing dates, and EXIF and IPTC data (we will describe these in detail later). EXIF data cannot usually be edited, whereas most image browsers include IPTC editing functionality.

Bridge has a very flexible user interface. You can show or hide most of the individual panels, providing more desktop space and a clear overview of the work you are doing.

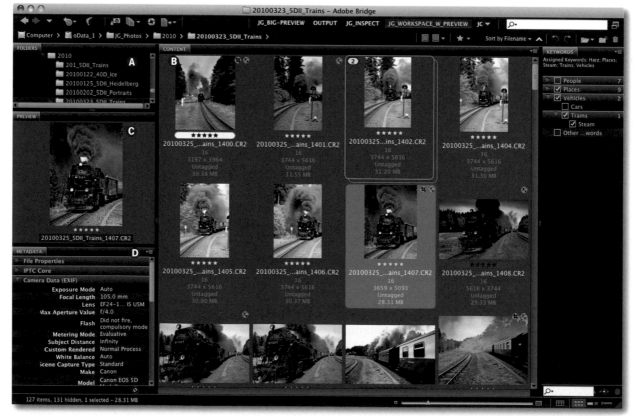

Figure 1-26: Using Adobe Bridge as an image browser. Here you can see the various configurable panels.

The first time you open a folder in Bridge (or most other image browsers), the program will use generic icons (like , or similar) as placeholders for your images while it generates thumbnails. Bridge uses the Adobe Camera Raw (ACR) module to produce thumbnails of RAW images and saves them in a separate cache so they don't have to be regenerated the next time you look in that folder.

Images are opened using a double click, and you can usually select which application your browser uses to open and process your images in the program preferences. Bridge automatically opens ACR to process RAW images and Photoshop to process all other compatible image formats.[*] Most image browsers also offer a choice of programs via a context menu (usually accessed via a right click).

You can also drag images directly from your browser into your image processing program. In Mac OS X, you can drag images to applications that are open in the Dock, such as a RAW editor other than ACR.

* You can configure ACR/Bridge to open TIFFs and JPEGs using ACR. This is done in ACR Preferences.

1.8.1 The Bridge "Review" Mode

The new (as of CS4) Review mode is designed with photographers in mind and is ideal for initial selection and later, more detailed selection processes.

First, select the images you want to preview in the content window, then activate Review mode.[**] Bridge then switches to full-screen, virtual light

** This mode can also be activated using Ctrl-B or ⌘-B.

Figure 1-27: Review mode offers a fast and efficient way to view, select, and mark your images for processing.

1.9 Metadata

Metadata describes other data and, in the case of digital images, provides additional information for each photo. Image metadata is either embedded in the image file itself or is stored separately in a file or a database. RAW, TIFF, and JPEG files contain various types of metadata:

▸ File Properties
▸ EXIF data
▸ IPTC data
▸ Additional metadata, such as RAW editing settings stored in an XMP file or image classification data stored in a database

File Properties • File systems store metadata for every file that includes the filename, file type and size, access rights, and creation and last access dates. In a digital camera, this data is saved by the camera and is updated either by the computer's operating system, a RAW editor, or other applications. Apart from the filename and the creation date, this data is not very important to a photographer. Some cameras also include the shooting date automatically in the filename.

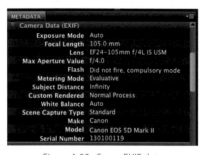

Figure 1-29: The Bridge File Properties tab

EXIF Data • EXIF stands for "Exchangeable Image File Format", and EXIF data is embedded automatically in JPEG, TIFF, and RAW image files when they are saved. It includes information about the camera manufacturer, camera model, the aperture and shutter speed used for the shot, the ISO setting, the lens used, and flash settings. The date and time the photo was taken, the exposure mode used, and image resolution and white balance settings are also included. EXIF can store a multitude of other information and can be customized to save different proprietary information depending on the manufacturer's particular needs.

Figure 1-30: Some EXIF data

EXIF serves not only as a source of information for the photographer, but also serves as a database for RAW editors, image optimization and optical correction tools (such as PTLens [92] or DxO [68]), as well as automatic image optimization tools built into print firmware.

IPTC Data • Press photographers have used IPTC (International Press Telecommunication Council) standards for years to record data concerning copyright and author rights, as well as image titles, short descriptions and keywords for images. IPTC data is a useful DRM (Digital Rights Management) tool, but it does not create its own embedded watermarks.

Most cameras automatically create an empty IPTC entry in the image data that is then filled out by the user. Photoshop and Bridge both have dedicated tools for editing IPTC, as do most other image browsers. Some cameras allow you to insert an IPTC watermark into your image files while shooting.

Figure 1-31: A selection of IPTC data. You can configure Bridge to show or hide individual items.

Because most IPTC data are the same for all images in a shoot, many image browsers (including Bridge and Lightroom) allow you to create IPTC presets that can be applied to batches of images. Once you have applied a

preset, you only need to amend details for individual images where necessary. (For Bridge, see figure 1-25 Ⓔ on page 20.)

Additional Metadata • As well as the established and well-documented EXIF and IPTC metadata formats, there is a wide range of other, less well-known types of metadata available for inclusion in your files.

Adobe created its own XMP (Extensible Metadata Platform) format in order to allow its applications to exchange metadata in a predefined fashion. XMP is an open standard based on the XML markup language, and is now supported by nearly all Adobe applications as well as publicly by the IETF (Internet Engineering Task Force). XMP data can be embedded in object data or saved separately and is designed to include standard and custom data fields. Adobe Camera Raw saves details of image corrections in XMP format and Photoshop can even save image processing and version history in the XMP portion of the image data file.

Most image browsers nowadays have a star-based rating tool (as described above), but the data these produce is not saved in a standardized place, making image data transfer sometimes more difficult than it might otherwise be. Color coding is another useful metadata application. Bridge and Lightroom offer six different colors with user-definable text labels (see figure 1-33). You can apply color codes in the Labels section of the Bridge Preferences dialog. We use these labels to signify the current processing state of our images and assign a custom keystroke to each label. Adobe saves star ratings, delete flags, and color codes alongside other metadata in XMP format.

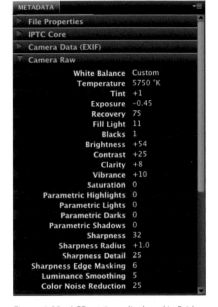

Figure 1-32: ACR settings displayed in Bridge

Other quality RAW editors use still other formats for saving metadata. Capture One, for example, saves its metadata in a binary file with the field extension ".cos" in a subfolder called "./CaptureOne/Settingsxx" in the appropriate image file folder. Nikon's RAW editor Capture NX embeds conversion and correction data directly in its proprietary NEF-format image files.

Expression Media, Portfolio, Photo Mechanic all support the XMP metadata format, and Adobe Lightroom is (naturally) the very best example of smooth XMP integration.

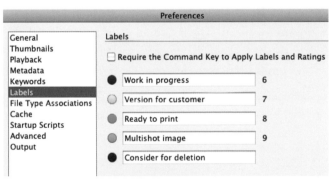

Figure 1-33: You can create colored label sets (including label text) in the Bridge Preferences dialog. We prefer to assign labels using keyboard shortcuts.

Writing and Saving Metadata

Where is all this useful and carefully created metadata saved? Some metadata (such as EXIF data) is automatically embedded in the image data and is therefore automatically moved or copied with the image file.

However, some file formats (such as GIF or PNG) are not capable of embedding additional data. This is partly due to manufacturers wanting to make it impossible to alter the original image file, and partly due to the complexity and missing documentation associated with many RAW formats.

* Or in the Photoshop "Camera Raw" settings

Photoshop, Bridge, and Adobe Camera Raw write metadata either to a database or to a so-called *sidecar file* that is saved in the same folder and has the same name as the image file, but with the ".xmp" file extension. You can select which method you use in the Camera Raw Preferences dialog (figure 1-34.* In both cases, XMP is the format used for saving the data.

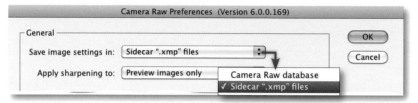

Figure 1-34:
Part of the Bridge Camera Raw Preferences dialog. This is where you decide where and how to save metadata.

Figure 1-35: A RAW file and its associated XMP sidecar file

The advantage of sidecar files is that other applications can access them too, although only a few (such as Photo Mechanic or Adobe Lightroom) actually do. Image files and their associated sidecar files can also – with a little care – be moved or renamed. However, if you are using the Bridge database and you change file names or locations outside of Bridge, your applications will no longer be able to find your image data or its XMP information.

Unfortunately, the manufacturers of image browsers and RAW editors have yet to form a unified strategy regarding formats, filenames and data locations. We would like to see a much greater degree of cooperation and standardization, and Adobe's XMP format would be a great basis for just that.

1.10 Views

Once your collection of images reaches a certain size, you will nearly always need to view only a part of your collection: for example, your last shoot, images for a particular customer, vacation 2008, or images that you have rated with two or more stars. We use metadata to set these limits – or better put, to make these choices. A View has two basic components:

▸ **The basic collection** that we are looking in (e.g., our last shoot or *Wedding_2009)*

▸ **One or more filter criteria,** such as a period of time, images shot using a particular camera, or IPTC keywords

Selecting images is like putting the basic collection through a filter based on our choices, and that is exactly what Adobe calls its selection tool. Filters can be more or less complex, depending on which application you are using. An example of a complex filter could be: "all images shot in 2008 using a Nikon D300 and a 16mm Nikkor fisheye lens". Individual criteria can be compounded using logical AND/OR operations.

Nearly all image browsers allow you to form views in this or similar ways and, provided that your images are tagged with appropriate metadata,

➡ Selecting a collection actually represents an initial image selection step, but it is nevertheless useful to separate these two steps – at least in theory.

views are the tools that make an image library usable and practical. The file attributes and the EXIF data are "gifts" that are automatically attached to our image files without us having to make any additional effort.

If your image management application is based on a "real" database (as are Apple Aperture, Adobe Lightroom, and Microsoft Expression Media), searching through large numbers of images can be a speedy process. The application imports the image metadata and stores a reference to the image file location but usually leaves the image files themselves stored in their usual location.

Other image browsers store the image metadata in a cache file in order to speed up the search process, or they simply search through all the available image files, which is much slower. If the cache is full, older data is simply deleted and has to be regenerated during the next search.

Most image browsers also allow you to name and save filter sets you use regularly (all images flagged for deletion, for instance).[*]

* Lightroom and Aperture have this functionality, but Bridge doesn't (yet).

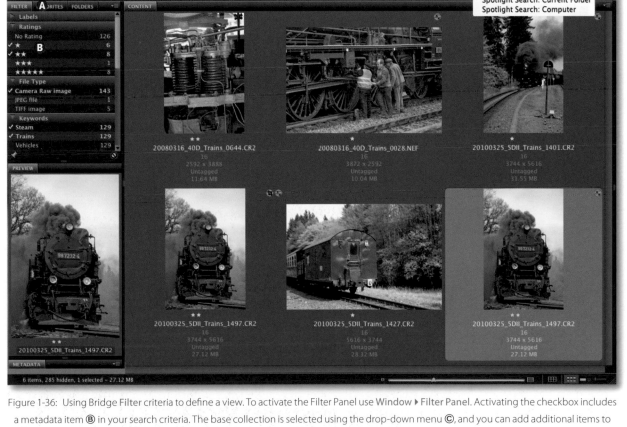

Figure 1-36: Using Bridge Filter criteria to define a view. To activate the Filter Panel use Window ▶ Filter Panel. Activating the checkbox includes a metadata item ⑧ in your search criteria. The base collection is selected using the drop-down menu ⓒ, and you can add additional items to the list manually. Bridge will then display only those images that fulfill your selected criteria.

Virtual Folders

You will often find that you need to place a single image in multiple groups – for example, an image of a rose could belong in the original shoot, a separate group called Roses, and a group selected for a slideshow on the subject of flowers. A simple solution would be to make several copies of the image and save them in separate folders. But that would use a lot of disk space and changes to one of the copies would not be automatically applied to the others.

A more elegant solution is to use the *virtual folders* feature included (under various names) with most contemporary image database programs. Aperture calls them Albums, Adobe calls them Collections, and Microsoft's Expression Media 2 calls them Catalogs.

➜ If you don't make copies of it, an image can only be physically present in a single folder. Nevertheless it can be included in multiple "virtual folders".

Once you have created a virtual folder using the appropriate program commands, you can usually drag image files to it in the usual way, although the images will neither be copied nor moved. A virtual folder is a simple list of references to the actual locations of the images it contains. This is an elegant way to save disk space, and deleting an image from a virtual folder doesn't affect the original image file in any way. If you delete the original, it will automatically disappear from all the virtual folders that include it.

Some applications, such as Lightroom, allow you to build hierarchies of virtual folders and subfolders.

"Intelligent" Virtual Folders

The virtual folders we have described so far are static, which means you have to add or delete images manually. It is, however, sometimes useful if images that fulfill certain criteria are automatically added to specific folders.

Figure 1-37:
Creating metadata rules for our "Trains"
Smart Collection in Adobe Lightroom.

And that is exactly what Adobe's Smart Collections or Apple's Smart Albums do. Our example shows the Adobe Create Smart Collection dialog for our sample smart collection called *Trains*, which will contain all images that are tagged using the keyword "trains". If we delete the keyword "trains" from the metadata of a specific image, that image will automatically be deleted from the Smart Collection. Expression Media achieves the same effect using saved, named searches.

1.11 **Buzzwords You Should Know**

The following section contains explanations of some important terms you will encounter in the course of this book: *non-destructive processing, non-modal editing, selective correction, all-in-one programs,* and *image attributes.*

Non-destructive Processing

This term refers to image editing and processing steps that are not immediately saved to the actual image data, but that are saved separately as a set of parameters that can be applied to the image. The correction concerned will be applied visually to the preview image but is saved separately, either in a database, in a special segment of the image data, or in a separate file. Some programs use a combination of these techniques, such as Adobe Lightroom. All RAW editors are non-destructive, and some image processing software allows you to work non-destructively with JPEG, TIFF, or PSD image files, too.

The major advantage of this concept is that individual image processing steps can be altered or deleted without affecting the quality of the final image. Rounding errors during resampling are also reduced using this type of process. Non-destructive editing methods also produce much smaller image files due to the fact that processing steps are saved as simple protocol lists and not as memory-intensive image layers. Multiple versions of a single image also use much less disk space, as you only have to save the original image once, along with the much smaller processing parameter files. This type of memory management is becoming increasingly important with increasingly powerful image sensors and the larger image files they create.

Individual corrections can also be saved for later application to multiple images, which can speed up batch processing enormously – especially if you use your preset corrections as a basis for further image fine-tuning. Your corrections are only actually embedded in the image data when you export your image or convert it to a different format.

➡ Non-destructive processing is also known as "parametric image editing" (PIE) because the parameters of each correction, and not the correction itself, are saved.

But non-destructive processing does have its limits, especially when an image is subjected to multiple, complex corrections such as adjustments to perspective or lens distortion. Selective editing steps made in specific image areas can only be saved in simple form if the parameter files are to remain small enough to be practical. Non-destructive processing requires a lot of processing power if it is to remain useful. Slower systems tend to redraw preview images slowly, making it all too easy to over-correct images based on "old" preview information.

Ever-increasing computer power combined with increasing availability of cheap memory and better editing algorithms is sure to give us better and better processing functionality in the coming months and years.

Non-modal Editing

The usual method for applying a correction to a digital image is to use either menu items or keystrokes to call up a dialog. The next correction step is then only possible once you explicitly end the last one, usually with a click on an OK button.

Because images are often corrected using multiple processing steps, and because it is often necessary to return to earlier image states during processing, this type of "modal" processing can be complicated and time-consuming.

Non-modal editing does not require you to explicitly close one dialog before starting another. The open dialog is either automatically closed (and the correction applied) or it simply remains open and active during the other process. Most contemporary RAW editors and all-in-one image processing programs work on this principle.

Selective Correction

Global corrections (i.e., those which affect the entire image) usually belong to the initial processing steps, while later fine-tuning often requires us to make *local* or *selective* corrections to certain tonal values, colors, or forms within an image. These types of corrections are equivalent to the adjustments made using masks, dodging, or burning in a traditional darkroom.

The spatial limitations of such corrections can be selected manually or by using explicit and implicit masks for:

▸ Geometric shapes (with or without transitions)
▸ Specific areas of color, brightness, or saturation
▸ Pixel masks made with brush tools and techniques
▸ Control points (à la Viveza)[*]

* See section 7.16, page 282 on this technique.

These selections can be adjusted later if you are working non-destructively, as described above.

Photoshop still uses its versatile selection tools and layer masks to edit selectively, but creating masks can be a complex (and destructive) process. Photoshop masks are also difficult to alter once they have been created.

Nikon Capture NX [47] introduced the new U-Point control point selection technique. This process allows very selective editing, but it is difficult to judge accurately – which is why Capture NX still includes traditional masking tools such as brushes and gradients. Nik Software [75] also offers U-Point technology as a plug-in (called Viveza) for Photoshop and Lightroom.

LightZone [46] uses geometric techniques to select so-called *Regions* within an image. These are easy to edit, and the precise image areas they affect are easily identifiable.

All-in-One Programs

In its infancy, the digital photo workflow consisted of separate programs for downloading, browsing, RAW editing, image processing, image management, and output management. The first major evolutionary step saw the integration of download modules and image browsers in RAW editors, but this still left us having to switch from program to program with all the interface and data incompatibilities implied.

Apple Aperture and Adobe Lightroom were the first all-in-one programs that combined all the above-mentioned functionality in a single package. Bibble [39] has also used an all-in-one concept since version 5. These applications allow the user to switch quickly and smoothly from function to function and phase to phase of the workflow, and also provide a unified user interface. The all-in-one approach also helps to avoid data incompatibility and simplifies the workflow while reducing the software licensing costs involved in purchasing multiple programs. We will look more closely at all-in-one packages in chapter 6.

Image Attributes

The term *attributes* is probably already familiar to readers with an IT background. Attributes are additional data that describe other data. In the case of digital image data files, attributes are the formal and technical details known as *metadata*, which we described in detail earlier in section 1.9.

In the analog photographic world, recorded image attributes were kept to a minimum, but digital technology makes them easy and often extremely practical to use.

Figure 1-38: There is always something to talk about when photographers get together.

The Basic Workflow

2

This chapter is the real core of the book. This is where we will go into more detail regarding the structure of the workflow and where we will consider what steps you will need to take to adapt the workflow to your own skills, aims, and equipment.

There is no single way to process an image, and there are various ways to perform many of the steps along the way. You will need to develop your own style, and you should periodically check to determine whether that style is still compatible with your current needs and tools.

This chapter illustrates the basic framework. The following chapters each state an aim that we will then discuss with a view to developing strategies for achieving those aims. Remember, your own personal workflow will develop with increasing experience and will change as you introduce new software, hardware and objectives into the mix.

Our cross-reference system will help you to find more detailed information on specific subjects in other chapters.

2.1 The Five Phases of the Workflow

The digital photo workflow can be divided into five major phases (figure 2-1). The transitions between phases are often flexible:

1. The workflow begins in the camera, before and during shooting. Composition, framing, exposure, lighting and the choice of a single or multiple exposure (for subsequent merging) all influence the type and amount of work you will have to do later. Working methodically at the shooting stage can save you a lot of unnecessary work later on.

2. Once you have shot your images, you will have to download and organize them. This includes naming your image files and tagging them with appropriate descriptive and technical metadata. An initial backup should also be part of this phase.

3. This is where we optimize our images. This can range from a quick check to hours of painstaking work, depending on the quality of the original image and its intended purpose. You will generally only perform complex optimization on a handful of images.

 This phase is usually divided into two subphases: basic optimization followed by fine-tuning. Once you are happy with the general look of your image, you can perform output-specific optimization, depending on whether the image is going to be published on the Web, in a book, or as an art print. This then takes us (almost) seamlessly to the next phase.

4. Here is where you actually produce your output – whether you are making your own inkjet prints (not always as simple as it sounds), publishing on the Web or producing other types of output.

5. The finale phase, administration, is where you organize your material. We already started organizing and saving our material in phase 2, but that is not the end of the story. The new image versions and processing stages produced by the phases that followed need to be organized and saved too. Backups have to include all peripheral data and not just your image files.

2.2 Phase 1: Shooting

We are assuming that you are already familiar with basic photographic techniques, either from using an analog camera or from your existing digital experience. We will not discuss basic photographic technique in detail, and we hope it is obvious that careful shooting saves time and effort at the processing stage.

Figure 2-1: The five main phases of the digital photo workflow

Figure 2-2: The shooting phase of the workflow

In the following sections, we will address only the aspects of shooting that affect the rest of the workflow directly.

Before Shooting

One-off settings • Some camera settings only need to be made at irregular intervals or even just once per shoot. These include:

▸ **Image quality** (JPEG or RAW). If you shoot in JPEG format, you should set the highest possible resolution and the lowest possible compression rate in order to minimize compression artifacts.

Some RAW-capable cameras also offer different resolution settings, but you will always get the best image quality by using the highest available resolution. Most cameras allow you to simultaneously save a JPEG and a RAW version of each image. You can then use the JPEG version for your initial sorting or for sending out to interested parties while you optimize the RAW version for presentation later.

▸ **Color Space.** Most cameras offer the choice of either sRGB or Adobe RGB (1998). The latter is only relevant if you are shooting in JPEG format. The Adobe RGB color space is larger, and most current cameras are capable of capturing a greater range of colors that is sampled down to sRGB or Adobe RGB quality in the finished JPEG image.* We recommend that you use Adobe RGB unless you just want to post your unprocessed images on the Web. If this is the case, sRGB is just as good.

* See section 3.3 on page 68.

▸ **Image numbering.** This is where you decide whether to allow the camera to number your images sequentially, even if you change the memory card. This setting helps avoid duplicate image numbers, making it easier to keep an overview of your images before you rename them during (or after) downloading.

➔ This setting varies from camera to camera and manufacturer to manufacturer. Check your camera manual for details.

▸ **Author tag.** Some cameras allow you to set the photographer's name as part of an EXIF or IPTC metadata field. The method for doing this varies from camera to camera. Some Canon cameras have a software based IPTC function in the EOS Utility software delivered with the camera, which is accessible if you attach the camera to your computer via USB. We recommend you use this setting if it is available in your camera.

▸ **Exposure mode.** As well as the usual preset scene modes (Sports, Portrait, Landscape etc.), you can usually choose between:

P (Programmed Auto). The camera selects the aperture, the shutter speed, and sometimes even the ISO sensitivity automatically. Here, you can only influence the exposure settings by setting exposure compensation values.

Av (Aperture-priority mode). You select the aperture value, and the camera automatically selects an appropriate shutter speed.

➔ Some manufacturers use an "A" label instead of "Av" and "T" instead of "Tv".

Tv (Shutter-priority mode). You select the shutter speed, and the camera automatically selects the appropriate aperture setting.

M (Manual). Aperture and shutter speed are selected by the photographer.

→ You can change the white balance
setting for a RAW image without losing
image quality.

▶ **White balance.** Selecting the correct white balance setting is especially important if you are shooting JPEG images. Correcting white balance later always results in a loss of image quality that is especially obvious in 8-bit JPEG images.

White balance can be set manually or automatically. Auto often leads to incorrect results for JPEG images. For RAW image files, white balance values are stored with the image but are not embedded in the actual image data. These values are then used as the default by RAW editors, but they can be changed at any time without losing image quality.

→ We shoot as often as possible in RAW
mode and shoot a gray reference frame
in critical situations. We can then use an
eyedropper tool to insert the reference in
an appropriate position in the image. There
is a detailed description of this method on
page 160.

You can also set white balance manually in the camera, either by entering a Kelvin (K) value or by selecting an appropriate menu item, such as *flash, cloudy, sunny,* etc. (figure 2-3). The quality of the final image will depend on the decision you make (or the camera makes).

▶ **ISO values.** Higher ISO values allow you to use shorter shutter speeds or a larger aperture, but tend to produce more image noise. However, a slightly noisy image is always better than a blurred image. We always use the lowest possible ISO value that each individual situation allows. You will develop a feeling for which ISO values produce noise in which kind of situation for your particular camera. Make test shots to see how your camera's noise behavior actually looks.

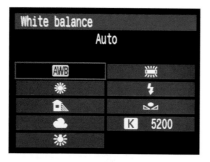

Figure 2-3: The white balance presets offered by a Canon 40D DSLR.

▶ **Highlight-priority.** Some newer DSLRs include a highlight-priority mode that exposes to optimize highlight detail. This can reduce the risk of producing washed-out highlights, but it reduces the camera's available dynamic range by approximately 1 to 1.5 EV.

▶ **Focusing mode.** Most DSLRs allow you to choose between manual focus and autofocus modes. A good autofocus system is a great help in many situations, but we often use the more controllable manual focus when we are shooting static subjects such as landscapes. Manual focus is usually essential for shooting macro photos. If you use autofocus, make sure that you are using the right focus mode for the situation at hand, and that you have activated an appropriate focus area (not always in the center of the frame).*

* Check your camera manual for information
on the available focus modes and how to
select a different focus area.

In addition to the settings described above, there are also a number of other settings that you can make that depend on the situation at hand, such as the camera's metering mode (spot, center-weighted, or matrix).

Some cameras also have Auto ISO functionality that adjusts the ISO value within a certain range and according to a number of different criteria. This can be useful for some types of action shots, but it can produce

inconsistent results in others. Avoid Auto ISO if you are shooting material for use with multishot techniques.*

* See the descriptions in section 9.1.

The playback review delay and the additional information the camera displays for each image also need to be set up according to your needs. We usually set our cameras to display a slightly reduced size preview image and the histogram. We will go into more details on histograms later.

For Every Shot

▶ **Exposure compensation.** This function allows you to adjust the exposure values selected by automatic exposure modes up to ± 2 LV. We use these settings either based on experience or when the histogram indicates that our exposure needs tweaking. Also check if your ISO, aperture and shutter speed settings fit the scene, subject, light and situation.

➜ We don't know of any contemporary DSLR that doesn't allow this type of personalization.

Here too, it is always a good idea to check whether the individual settings you have made (such as focus mode or focus area) are appropriate for the subject and the situation.

You will often find yourself cycling through a series of steps: select settings > shoot > review your preview image and check histogram > adjust settings > shoot … until you have found the right settings for your shoot. Assign the settings you use most often to the main camera dials or to easily accessible menus.

During and After Shooting

▶ Check your exposure using the camera's histogram. The most critical part of the histogram is the right-hand (highlight) end of the scale, so always activate your camera's highlight warning system if it has one. This feature displays burned-out highlights as blinking white or red areas in the monitor's preview (view finder).

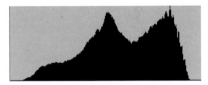

Figure 2-4: If possible, use your camera's histogram to check your exposure.

 If your camera can also display RGB histograms, these are preferable to simple luminance histograms, as they give a more detailed overview of which color channels (if any) have been clipped.

▶ Don't forget to check white balance. If necessary, use a reference photo of a color target shot under the same conditions as the rest of your shoot. You can use a gray card or a color card (such as the X-Rite "Mini Color-Checker"). You can then employ the eyedropper tool for the gray reference (the third box from bottom left in our illustration) and set the white balance for your image. See also the description of this method in section 5.3.1 on page 160.

Figure 2-5: A test shot of a color reference target (here, the X-Rite Mini ColorChecker).

▶ Avoid hard or high contrast and take a sequence of differently exposed shots if you are not sure of your lighting. You can then either select your best shot or merge multiple shots into a single well-exposed image (using one of a number of techniques) later. Built-in bracketing functional-

➜ Use Av mode for these types of bracketing sequences. I.e., keep the aperture constant and vary the shutter speed.

ity can help here, but it is often better to make your own manual settings in order to keep control of the situation.

▶ Avoid high ISO values wherever possible, they produce increased image noise. However, a noisy image is always preferable to a blurred one caused by a slow shutter speed.

▶ Use a tripod whenever possible. This increases your exposure range and allows you to use longer shutter speeds without increasing the ISO value in low light situations.

* These techniques are described in detail in chapter 9.

▶ Take multiple shots if you are planning to merge your photos into a panorama, a high dynamic range (HDR), or super-resolution image.*

RAW, JPEG and TIFF Processing

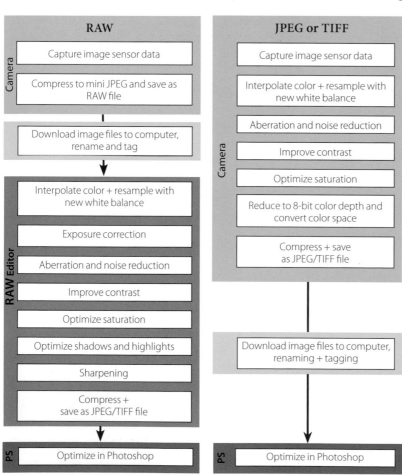

Figure 2-6: Comparison of a RAW and a JPEG/TIFF workflow. The RAW workflow generally comprises fewer Photoshop optimization steps than the illustration infers, but the borders between the two processing areas are flexible.

We described the advantages of the RAW shooting format in section 1.3. Here is a schematic comparison of RAW, JPEG, and TIFF and the differences (and similarities) between the two types of workflow. Image processing takes place in one of three places:

1. In the camera with few user-controlled settings
2. In a RAW editor or all-in-one imaging program
3. In an image processing program such as Photoshop

Some download tools also allow you to rename, back up, rotate, or make simple corrections to image files from your memory card. We don't recommend use of these simple image correction tools as the results are often of poor quality.

The functions we use in all five phases often overlap. Some cameras have built-in anti-vignetting functionality, while some RAW editors include many of the functions (cropping, rotating, tonal value adjustments, sharpening, and even some selective retouching) that used to be

the exclusive preserve of high-end image processors such as Photoshop. The latest generation of photo workflow tools, such as Apple Aperture, Adobe Lightroom, or Bibble 5, further blurs the borders between RAW conversion and image processing and allows you to process TIFF and JPEG images non-destructively using the same tools as you would to process RAW images.

Figure 2-6 shows the basic differences between working with RAW and JPEG/TIFF image files. The RAW workflow has much more scope for swapping and overlapping functionality between your RAW editor and Photoshop.

2.3 Phase 2: Image Transfer and Management

2.3.1 Transferring Image Files from a Memory Card to a Computer

There are various ways to transfer image files to a computer. The most common way is to take the memory card out of the camera and insert it into a USB or FireWire card reader attached to a computer.

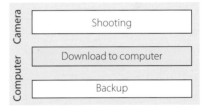

Another popular method is *tethered shooting*, which involves attaching the camera directly to a computer and controlling the transfer either partially or completely via your PC. Both methods transfer images directly to the computer and allow you to view your images immediately on the computer's monitor. This is ideal for studio shoots and other critical situations. Tethered shooting can even be enhanced using radio or Wi-Fi, allowing you to move freely with your camera while still transferring your images directly to your computer. Wireless connections also allow image transfer via FTP.

If you transfer your tethered shooting image files to an import folder or "hot folder", you can open them in applications that do not directly support tethered mode but support hot folders (e.g., Lightroom 2 or Aperture).

If you copy your images manually via the Finder or Windows Explorer from memory card to the computer, copy the entire folder from the memory card to disk before renaming to include the date of the shoot. Then rename the individual files as previously described.

Most download tools included in RAW editing or image processing software* allow you to rename your files while downloading them. Don't underestimate the need for a clear, consistent file naming system and image folder structure! We try not to use solutions that automatically create their own folders, and we prefer to store our images in our own, manually created folder system.

Add author and basic shooting metadata (place and date, for example) to your images during download if your software allows it. A couple of basic keywords are also useful. The download tools included in Bridge, Lightroom, and Aperture all allow you to add metadata to your files. This saves time and effort later when tagging your images.

* Lightroom, Aperture, and Photoshop Elements are all examples that do. Bridge also includes this functionality since the CS2 version of Photoshop.

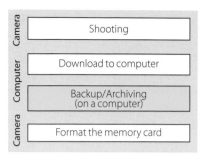

2.3.2 Saving Your Image Files Safely

It is quite possible for your hard disk to fail or catch a virus after you have transferred your images to it and reformatted your memory card. In this scenario, if you haven't already backed up your images, you will lose them forever. The chance of losing a main copy and an external backup copy of your data is extremely small, and we always create an automatically synchronized backup copy of our images on an external hard drive immediately after downloading.

Some downloaders have built-in functionality for making backups, and saving to an external disk offers additional security. Dedicated digital asset management (DAM) software usually has built-in backup functionality.

We only format our memory cards in the camera once we have made a backup copy of our image data. Formatting ensures that the card's memory modules remain clean and efficient and avoids file system fragmentation. Formatting in the camera also ensures that the file system created is suited to the camera you are using.

2.3.3 Image Inspection

Inspecting your images is an important part of the workflow. A missed image can be lost forever, and every poor quality image that you keep or process is a waste of time and disk space. An important part of the inspection process involves deleting unusable image files.

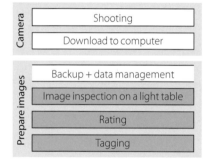

We used to use the Photoshop image browser (which has now become Bridge) to view our images, but you can use any of the image browsers we mention here as long as they support your particular RAW format. Bridge has great support for downloading, renaming, and browsing image files, although we now use Lightroom for downloading, as it allows us to systematically rename our files and to create a backup copy of our data while downloading. We also use Lightroom to add complex keywords and other metadata to our files during download. Lightroom produces high-quality thumbnails quickly and in user-selectable resolution and allows us to rate our images as well as adding additional metadata. It also allows to delete unwanted files.

If you shoot your images in JPEG or TIFF format, you can use just about any image browser to view them; however, it should be capable of deleting unwanted images and rotating other images losslessly. The current workflow phase consists of three major tasks:

1. Initial image inspection and flagging for deletion

2. Prioritizing remaining images for processing and a second round deletion

3. Adding metadata and keywords for use in later searches

Figure 2-7: The Photoshop "Bridge" image browser (CS5 in Mac OS X), showing thumbnails (center) and a large preview image on the right

A good browser will also display large preview thumbnails and will be capable of producing even larger preview images for use during the actual selection process. An ideal browser can display full-screen preview images or automatically load a preview in Photoshop (although starting Photoshop can take time). You will need to zoom in and out of your preview regularly or use the loupe function of your browser to compare images properly. A side-by-side comparison window is also a great aid to image selection.

Color management functionality that takes into account the color space of the source image as well as that of your monitor is essential. Many image database software packages are unfortunately not up to the job.

You can now delete all images that do not pass your quality control run. Substandard images cost disk space and time. We use a mini-workflow for deleting images during the initial inspection. First, we flag all the images we think we want to delete and display just these images in a separate view. We then check our images once more, flag the images we really don't want and then delete them permanently. Only save the images that are really worth processing.

The browsers we recommend all allow you to rate, flag, and add metadata to multiple images, which is also a great time-saver!

It is important to set up your image browser properly if you want to be able to view and select your images efficiently.* Get to know the keystrokes for zooming in and out, adding ratings, and for deleting or adding metadata. If necessary, write a crib sheet and keep it next to your keyboard.

* Bridge allows you to save individually configured Workspaces, which you can then call up using custom keystrokes.

you can access and process layers and channels, and you add EXIF, IPTC, and XMP metadata to your files. LZW compression produces slightly larger files than ZIP, but it is compatible with more third-party applications.

If we are working on TIFF data (from a scan, for example), we compress the file using ZIP or LZW and embed the appropriate color profile if it has not already been assigned.

We then apply all necessary correction steps for RAW files as described above and in chapter 4, using either your RAW editor or Photoshop.

Fine-Tuning an Image Using Photoshop

➜ Viveza is described in section 7.16, page 282 and most of the other programs and plug-ins mentioned here in chapters 8 and 12. Multishot techniques and software are described in chapter 9.

Here, we perform the image optimization steps that are either not possible using our RAW editor, or that are simpler to perform (or produce better results) using a conventional image processor or specialized plug-ins. Appropriate plug-ins are PTLens [92] for correcting lens distortion, Viveza for performing non-destructive color corrections, and a range of Uwe Steinmueller's scripts for sharpening (EasyS Plus), for improving local contrast (DOP_EasyD_Plus_DetailResolver), or for reducing the effects of burned-out highlights (DOP_HighlightResolver).

We also use some standalone applications for specific tasks. We use Photomatix Pro [77], FDRTools [72] or HDR PhotoStudio [105] for producing and tone mapping HDRI images, PhotoAcute [81] or Helicon Focus [76] for focus stacking (extended depth of field), and Autopano Pro [57] for stitching panoramas. Photoshop CS4 and CS5 include similar functionality in all three areas, but the programs mentioned all produce better results and are easier to use.

We nevertheless recommend that you start out using just Photoshop and decide later whether you want to spend the time and money to acquire additional functionality.

Where the Philosophy Starts ...

If you shoot RAW images you will be faced with the philosphical question of whether you want to process your image as non-destructively as possible using a RAW editor, or whether you simply prefer to use Photoshop or some other image processor. This question will be answered to a certain degree by the functionality and the quality of the results your RAW editor offers. There are virtually no RAW editors currently available that can correct lens distortion or perspective errors (here, DxO and Silkypix are the exceptions that confirm the rule). Noise reduction functionality is also not up to scratch in many RAW editors.

But the software manufacturers are not playing wait-and-see, and every major release sees great improvements in functionality. Lightroom and ACR as well as Capture NX, LightZone and Apple Aperture, all include selective correction for RAW images. Bibble has included the Noise Ninja noise reduction plug-in and profile-based lens distortion correction since

version 4.x. DxO has also been refining its lens distortion functionality for quite a while now.

We have already mentioned the advantages of working with RAW editors (non-destructive processing and small image files), and non-modal functionality is also a great aid to effective image processing. The major disadvantage of RAW editing is the sheer amount of computing power you need, which can lead to over-correction due to the long delays between preview refresh cycles. Always equip your computer with as much memory as possible.

If you use an all-in-one editor that has good Web presentation, slideshow, and print functionality, it can be a good idea to follow these three steps:

A) Use your editor to perform basic optimization

B) Convert your image to TIFF and hand it over to Photoshop (or another image processor) for fine-tuning

C) Return your processed image in TIFF format to your all-in-one program in order to manage your images and prepare them for output "under one roof"

This can be a useful strategy for TIFF and JPEG images too, as increasing numbers of RAW editors (e.g., ACR, Capture One, Capture NX, and Bibble) are capable of processing other image formats. If we are processing TIFFs or JPEGs downloaded directly from the camera, we treat them like RAW originals and only work on copies. This way, we always have access to the original image data in the form it was captured by the camera.

Whether you save your originals and copies to the same folder or to separate locations is up to you – there are arguments for and against both approaches which also affect the overall workflow. We will address this subject in detail in section 13.1.6, page 497.

2.5 Phase 4: Output

Presentation is the ultimate goal of the entire workflow, whether in the form of prints made at a lab, your own prints, a digital slideshow, or an online Web gallery.

Each type of presentation requires you to prepare your images slightly differently. If you need to scale an image, first make a copy that you can then reduce to 8-bit color depth and flatten the layers to the background. You can then scale and sharpen the image. Sharpening is a highly output-specific process. A matte art paper, for example, will require more sharpening than a print made on glossy paper.

Output itself is also accompanied by a range of more or less critical settings, and printing especially will require you to make a number of trial

P4: Produce Output

- Create a copy to work on
- Scaling
- Output sharpening
- Select output format
- Check results and publish
- Backup and media management

Figure 2-9: Output production steps

Color Management Know-How

3

Color is one of the central elements of the photo-graphic process. Rendering colors properly on a monitor or in a digital (or photographic) print is a complex subject that is extremely important to the success of the workflow. In order to work with color, you will need some grassroots knowledge about color itself and color models, and you will need to consider how to get your hardware to reproduce colors correctly. The monitor is the first and probably most important link in the chain and is the window on our images for most of the workflow.

This chapter addresses color, color models, and color reproduction while attempting to keep theory to a minimum.

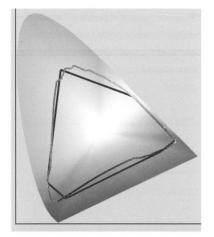

Figure 3-9: The red line shows the simplified gamut, while the multicolored line shows the gamut in more detail. Both plots show the gamut of Epson Premium Semigloss paper on an Epson R2400 using K3 inks.

(i.e., combinations of printer, inks, and paper), diagrams like the ones in figure 3-7 and figure 3-8 allow you to compare the gamut and thus the color richness you can achieve using different papers.

Figure 3-7 and figure 3-8 were plotted using a Yxy plot where the Y axis represents luminance. In figure 3-8, the Y axis is perpendicular to the plotted plane that shows the gamut at a lightness value of 50% of maximum brightness (50% white). The gamut outlines in figure 3-8 are simplified. Figure 3-9 shows the gamut of Epson Premium Semigloss paper using a simplified (red) and a more detailed (multicolored) outline.

Although Yxy diagrams are a common way to plot the gamut of color spaces, there are a number of other 2D and 3D plots in general use. A brightness value of 50% is standard for 2D plots. Another popular plot uses the a* and b* axes from the L*a*b* model, with the L* axis perpendicular to the plotted plane. Figure 3-10 shows such a plot, comparing the gamut of Adobe RGB (1998) (orange outline) with that of Epson Premium Semigloss paper on an Epson R2400 printer using Epson K3 inks and specific driver settings. L*a*b* plots are quite good for comparing different gamuts, and ColorThink Pro [61] (used to create this plot) is a great tool for producing color space plots. You can also use ColorThink to inspect and correct ICC profiles.

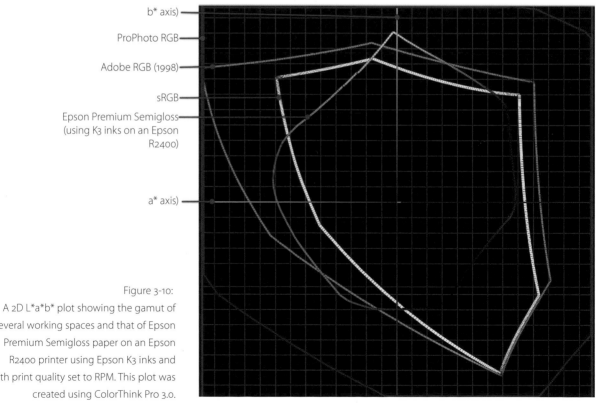

Figure 3-10:
A 2D L*a*b* plot showing the gamut of several working spaces and that of Epson Premium Semigloss paper on an Epson R2400 printer using Epson K3 inks and with print quality set to RPM. This plot was created using ColorThink Pro 3.0.

Figure 3-11 shows a 2D plot that uses CIE-L*a*b* coordinates (Lightness + chroma a and b). The vertical (invisible) axis is the lightness axis.

The plot in figure 3-10 also shows that there are a few colors (such as saturated yellows and some saturated cyans) that this printer + paper combination could print that lie outside of the Adobe RGB (1998) color space. If you shoot a digital image in RAW and convert it to Adobe RGB (1998), these colors will be clipped (i.e., they will be mapped to colors that are available in the gamut of Adobe RGB; section 3.3 explains how this is done). If you shoot your images in JPEG format, the conversion and color mapping from the camera's gamut to the color space of the JPEG image will be performed automatically by the camera, either using Adobe RGB (1998) (which we consider to be the better solution) or sRGB as the target space. This depends on your in-camera settings. For JPEG and TIFF images, advanced digital cameras allow you to select either sRGB or Adobe RGB (1998) as your target color space. We recommend using Adobe RGB (1998).

If you want to retain as much gamut as possible for editing, you should shoot in RAW format and use ProPhoto RGB when converting the image to an external RGB color space. However, as the gamut your monitor can reproduce is probably even smaller than Adobe RGB (1998), you won't be able to see these colors on your monitor. Photoshop (or whatever color-managed application you are using) will map those colors to colors the monitor can reproduce using the relative colorimetric mapping algorithm described in the next section. This sounds bad, but it is in fact a practical (though not ideal) solution.

At some point along the way from the camera or scanner to the print, the colors of your image have to be mapped to the colors that your printer, your inks, and your paper can reproduce. The same is true when reproducing colors on a monitor for viewing or editing. Quality applications, such as Photoshop, Lightroom, and many other color-managed viewers and image editors, allow you to define how colors are mapped for printing (see also section 3.3).

If you can't reproduce the rich gamut that your camera or scanner can capture on your monitor, why bother preserving the full gamut using a large color space like ProPhoto RGB or Adobe RGB (1998)? There are several reasons why this can be useful:

1. Devices are always going to improve. In the past, most monitors could only reproduce (roughly) the gamut of sRGB, which is why sRGB was defined in the first place. Today, monitors are available that cover almost the entire Adobe RGB (1998) color space. This development is sure to continue. Printer technology is improving too, and new ink sets that use 10 or more different colors further extend the reproducible color space.

2. While editing, you can selectively reduce or shift colors and also gain new colors by using various editing operations. It is therefore practical to start with a rich set of colors and a large color space and use 16-bit color depth for as long as possible.

ProPhoto RGB
Adobe RGB (1998)
sRGB
Epson Premium Semigloss

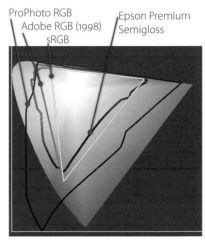

Figure 3-11: A plot using LUV coordinates (the L axis is perpendicular to the plotted plane). The CIELuv color space is a perceptually uniform derivation of the standard CIE Yxy space. "Perceptually uniform" means that two colors that are equally distant in the color space (specified by the standard Cartesian distance function of the square root of color offsets) are also equally distant perceptually.

Figure 3-18: Recommended monitor calibration settings

Figure 3-20: Use your monitor's controls to position the contrast marker near zero.

Figure 3-21: If your monitor has RGB controls, use them to set your target white point.

Figure 3-22: Set luminance to a target value of 120–140 cd/m² using the monitor brightness control.

4. Select your target calibration settings. We recommend the values shown in figure 3-18. Click ▷ to proceed to the next step.

5. Attach the sensor to your monitor using either the suction-cup (if calibrating a CRT) or by attaching the lead weights provided to the sensor cable and letting them dangle at the rear of your monitor. If you are calibrating an LCD, you may have to tilt the monitor back to ensure that the sensor lies flat on the screen.

Figure 3-19: Eye-One Display 2 colorimeter

6. Begin calibration using the your monitor's controls (if available). Skip this step if you are calibrating a notebook or LCD without controls and continue with step 9.

 Set contrast to maximum and then slowly reduce it until the indicator lies within the green area and close to 0. The software will guide you through these steps.

 If possible, place your on-screen display (OSD) menu off-center so that it doesn't interfere with the Eye-One Match window.

7. Press Start to begin measuring contrast, then Stop and ▷ to begin calibrating the RGB controls. This step will set the control dials so that the monitor's white point is close to the intended color temperature (6500 K or 5000 K).

 You can set your monitor's white point to 6500 K by using the on-screen displays or the monitor's RGB controls (if available). All three colored bars should lie within the green area for optimum calibration. The Eye-One Match window provides useful visual feedback during the process (figure 3-21).

 If you are using the monitor's three RGB controls to adjust the white point, and if setting one of the individual color sliders to maximum still doesn't produce satisfactory results, you can reduce the values of the other two sliders to help get the color balance right.

8. Next, set luminance using your monitor's brightness controls. A luminance of 100–140 cd/m² is recommended for LCD monitors. If you are calibrating a notebook display, you may have to reduce the value to 100–120 cd/m². You will probably also have to select 100 cd/m² for dimmer CRT monitors.

9. Calibration is now complete. Eye-One Match will start the actual characterization, displaying a number of color patches and measuring their values. This process lasts about 10 minutes and requires no user input.

10. Once characterization is finished, Eye-One Match will display the values used and a diagram of the resulting color space (figure 3-23).

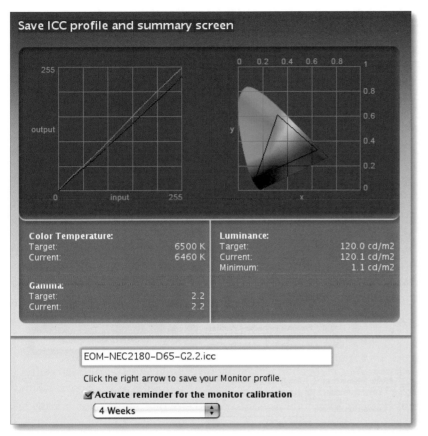

Figure 3-23:
The monitor profiling values and color space display. Give your profile an appropriate name.

The software will prompt you for a profile name. Choose a name that reflects the tool used, the brand of monitor, and the calibration values. For example, if you are using EOM to calibrate an NEC 2180 monitor with determined values, your profile could be called "EOM-NEC2180-D65-G2.2." You may also want to include the date.

Eye-One Match will save the ICC profile to an appropriate folder and will immediately make it the default monitor profile. If you have Adobe Gamma installed in Windows, you should move Adobe Gamma from the startup folder to keep it from interfering with the new monitor profile when Windows starts up.

Once you have completed these profiling steps, do not change any monitor settings without re-calibrating. We recommend that you re-calibrate and re-profile LCD monitors about every four weeks. If you are using a CRT monitor, every second week is preferable.

Figure 3-28: We usually leave these two options unchecked.

Advanced Controls

Leave these settings unchecked as shown in figure 3-28.

Setting your Monitor profile

Photoshop is not particularly intuitive when it comes to finding the current monitor profile. The following methods are the simplest that we know:

Windows XP: Right-click on the desktop and select *Properties*. Select the *Settings* tab in the dialog that appears and click the *Advanced* button. Selecting the *Color Management* tab then displays a dialog containing all installed monitor profiles. The currently active profile is highlighted (see figure 3-29 for the Windows XP version).

Figure 3-29: Finding the System Monitor profile in Windows XP

Here, you can add additional monitor profiles, delete installed ones, and change the default profile. You may have to restart your image processing program to apply any changes you make.

If you are running Windows XP and have MS Color Control Panel installed ([97]), you can use the *Displays* option in the *WinColor* Devices tab to view the profile associated with your display.

Windows Vista, Windows 7: Activate Control Panel *Color Management*, select tab *Devices,* and choose *Display* in the *Device* menu. Windows will show a dialog similar to that of figure 3-29, where you can select your monitor's profile. Also use this Control Panel to install and uninstall color profiles.

Mac OS X: Open System Preferences by clicking the icon in the dock. Select *Displays* and activate the *Color* tab. The dialog will list all installed monitor profiles and highlight the currently active one (figure 3-30).

Figure 3-30:
Displaying the active monitor profile in Mac OS X

→ Photoshop and most other color-managed applications use the monitor profiles provided by the Mac OS X or Windows system settings.

3.7 Printer Profiles

Once you have set up your Photoshop CMS settings and calibrated and pro-
filed your monitor, it's time to look for profiles for your printers and papers.
You will need a separate profile for each combination of printer, printer
driver settings, paper, and ink. Assuming you use just one printer (an Epson
R2400, for example) and that you only use standard Epson inks, you will
still need a separate ICC profile for each type of paper and for each quality
or resolution setting you make.

There are several ways to obtain a profile for your printer+ink+paper set:

1. **The profile is included with the printer's software or can be down-
 loaded from the printer manufacturer's website**.
 These profiles only cover the original maker's inks and some proprietary
 paper types. These "canned profiles" are often quite good and can deliver
 quality prints, depending on the manufacturer, the printer, and the
 available printer model variants. The printer manufacturer's own pro-
 files – at least those for the fine art printers mentioned on page 426 – will
 give you about 95 percent print quality compared with what you could
 achieve using a custom profile.

2. Third-party paper manufacturers often provide profiles for their papers
 and better-known high-end printers.* It usually takes a few months after
 the release of a new printer model before profiles are uploaded to the
 paper manufacturer's website.

3. Some suppliers of third-party inks provide profiles for their inks when
 used with popular papers and well-established printers. For example,
 Lyson [118] offers profiles for several Epson and HP printers for their
 inks and their papers.

4. There are various companies selling profiles for different printers and
 inks.

5. There are several online services available that create custom profiles if
 you follow these steps:

 A) Download a print target from the service's website.

 B) Print the target using your specific printer, ink, paper, and printer
 settings, and send the print to the service provider by regular
 mail.

 C) The provider evaluates your target print, generates the profile, and
 emails it to you.

 D) Install the profile.

 These types of services cost between $30 and $80 for an RGB profile.**
 Discounts are often available for multiple orders. This is a great way to
 get hold of custom profiles, and it avoids the expense of buying your own

* For examples, see Hahnemuehle [128],
Moab [131], or Tetenal [136]. You will find more
manufacturers of fine art papers on page 520.
Most of them provide ICC profiles for some
or all of their papers and several high-end HP,
Epson, and Canon printers at their websites.

** CMYK profiles (often used for press work)
are more expensive. Photographers who print
using inkjet, LightJet, or direct photo printers
rarely use CMYK profiles.

profiling equipment while ensuring that your profile is produced by experienced personnel. Some companies restrict their services to specific printers or manufacturers.

6. **Build your own custom profile**.
 The next section describes how to do this.

Profiling Your Printer

Profiling a printer involves the following basic steps:

Most printer profiling packages offer several different print targets. The more color fields a target provides, the more precise your profile will be. However, this also involves more effort. Some profiling devices (such as DTP-41, DTP-70, or i1iO by X-Rite [52]) can read printed targets automatically, but these are usually prohibitively expensive for most photographers.

A standard spectrophotometer and ruler (like those provided with the i1XTrme kit by X-Rite) is usually sufficient for producing satisfactory results.

1. Select an appropriate, provided target (containing color patches with known color values), and print it using the printer, paper, and ink you want to profile.

 Use the same printer settings for resolution, paper type, etc. that you want to profile, but don't make any print or Photoshop color corrections at this point. We recommend that you save these settings using a descriptive name.

2. Let your print dry for between one and 24 hours.

3. Evaluate the print's colors and use your profiling software to create an ICC profile. Most profiling software installs new profiles automatically, but you might have to install manually (section 3.8).

There are several ways to evaluate the colors in your target print:

A) **Spectrophotometer**
 This is the most accurate method, but a good photospectrometer costs between $800 and $1000. We recommend the Eye-One Photo kit or the Color Munki kit by X-Rite, and we also achieved good results using the $550 Datacolor Spider3Print SR ([48]).

B) **Dedicated chart reader**
 A chart reader is a small, dedicated scanner that reads the patches in a target print (like the one in the PrintFIX kit by Datacolor [48]).[*] A chart reader is much cheaper than a spectrophotometer, but is much less accurate.

* We recommend that you spend a little extra on the PrintFIX PRO version, which includes a spectrocolorimeter and produces much better profiles.

C) **Standard flatbed scanner for acquiring the patch values**
 This is probably the cheapest way to scan a chart. The accuracy of this method depends very much on the color quality of the scanner. The scanner itself needs to be profiled too, and profiling packages (such as MonacoEZcolor) scan a scanner target together with the printed target and internally profile the scanner first. This "profile-enabled scanner" then interprets the color values of the target chart's patches.

 This is less expensive but also less accurate than method A. Its accuracy can be compared to that of canned printer profiles and is a cheap source of profiles if you are using a third-party ink or paper set that has no generic profile.

D) Send your a print of a specified target to a profiling service. Make sure you follow the instructions at the service provider's website accurately.

This is a reliable way to get high-quality profiles produced by experienced personnel. Processing usually takes two to three days plus mail turnaround, time and the cost per profile is usually between $35 and $80.

You can also optimize your profile with a profile editor, which is often included with profiling hardware (such as X-Rite Eye-One Proof* and ProfileMaker Pro, or DoctorPro by Datacolor). Only edit profiles once you know what you are doing.

* As of version 3.3, all Eye-One packages include the Eye-One Match software which you can use to edit profiles.

3.8 Installing and Uninstalling Profiles

Most profiling software automatically installs freshly generated profiles, but you will have to install many downloaded profiles manually.

Mac OS X Profiles have the file extension ".icc".** Simply move or copy the profile to one (or all) of the following locations:

** You can use Windows ".icm" profiles, too.

Mac OS X	System/Library/ColorSync/Profiles/[1]
	~*user*/Library/ColorSync/Profiles/ [2]
	Library/ColorSync/Profiles/ [3]

[1] These profiles are accessible to all users, but you will need administrator privileges to add or delete them.

Adobe applications use an additional location (*Library/Application Support/Adobe/Color/Profiles/*) for some general use profiles and new profiles for working spaces (for example, when adding eciRGB as a general work space).

[2] These profiles are only accessible to the specific user and can be added or deleted by the user.

To uninstall a profile, simply delete it or move it to another location.

[3] These profiles are managed by the operating system and should be left alone.

Windows Windows profiles use both ".icm" and ".icc" file extensions. Right-clicking on a profile name calls up a context menu in which you simply select Install Profile. Profiles are stored in the following locations:

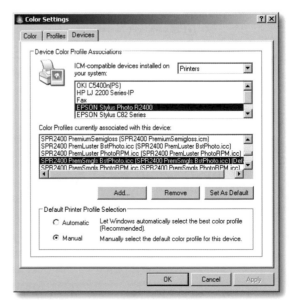

Windows 7	c:\windows\system32\spool\drivers\color\
Windows Vista	c:\windows\system32\spool\drivers\color\
Windows XP	c:\windows\system32\spool\drivers\color\
Window 2K	c:\winnt\system32\spool\

(The "c:" drive is assumed to be the system drive.)

You can uninstall profiles by selecting Uninstall Profile in the same menu. Avoid installing too many profiles, but keep copies of profiles you are not currently using.

You can download the Microsoft Color Control Panel or WinColor utilities from [97] (for XP only). This can be used to install and uninstall ICC profiles, as well as display and compare the gamut color spaces and profiles.

Figure 3-31: The Windows XP Color Control Panel

Image Processing Basics

4

Nowadays, digital darkrooms have almost completely replaced traditional, chemical-based darkrooms with their enlargers and manual masking techniques. Even photographers who still shoot on analog stock often scan their negatives and process them digitally. Digital post-processing offers distinct advantages when it comes to getting the optimum out of your images. Although digital techniques often imitate traditional processing techniques, they make a degree of perfection possible that would be extremely difficult to achieve in an analog darkroom.

This chapter deals with basic processing techniques that are important to the discussions that follow, regardless of whether you shoot in RAW or other digital formats. These formats are also an integral part of the grassroots knowledge we will be discussing. This chapter is based on a number of Photoshop techniques that we use regularly as part of our own workflow. These techniques are largely independent of any individual workflow structures, unless you prefer to use one of the all-in-one workflow tools that we will describe later.

If you work with RAW images, you will perform some of the steps described in this chapter using your RAW editor or an all-in-one program, but our descriptions will nevertheless assist your learning process. If you work with JPEG or TIFF images, the following will be a part of your everyday processing workflow.

Monitors have a resolution of between 72 and 100 pixels per inch (72–100 ppi).

© **Resolution** is stated in *pixels per inch* (ppi). An uncropped photo print shot using a Nikon D70 and printed at 300 ppi results in a print size of:

$$3\,008/300 \times 2000/300 = 10.02" \times 6.66" \; (24.46 \text{ cm} \times 16.93 \text{ cm})$$

If you print the same image on an inkjet printer at 180 ppi, the image size would be:

$$3\,008/240 \times 2000/240 = 12.53" \times 8.33" \; (31.83 \text{ cm} \times 21.17 \text{ cm})$$

Printers (and other output devices) have resolution that is stated in (ink) dots per inch (dpi). Inkjet printer resolution is typically between 1400 and 5760 dpi. However, inkjet printers simulate halftones using closely grouped collections of extremely small dots and thus print many fewer dots (180–300 ppi) than the image actually has. We therefore recommend that you print on inkjet printers at resolutions between 180 and 360 dpi. The correct input resolution (in ppi) depends on the type of output device you are using (see also section 11.2.1, page 413).

→ Halftones are simulated using collections of tiny printed dots and a process called "dithering".

We have produced acceptable results at resolutions of 180–360 ppi using our high-end printers.

Pre-press applications still use the *lines per inch* (lpi) unit. This term is explained in section 11.2.1, page 413.

Adjusting Image Size

What happens if we use the Photoshop Image Size dialog to adjust the width, height, or resolution of an image? The results depend on the settings you make (see figure 4-6):

Ⓓ **Constrain Proportions**: Always use this option if you want to avoid skewing your image.

→ **Never** resample an image if you don't have to!

Ⓔ **Resample Image:** This option is used to produce larger or smaller versions of your image, but causes image quality loss in the process – especially if you enlarge your image. Resampling changes the number of pixels in your image. If you deactivate resampling, the image data remains unchanged, and only the physical output size (of your print, for example) changes.

Scaling an Image

Scaling is one of the most common (and critical) changes made to digital images, and it should be performed with care and forethought.

Adjusting Image Resolution (ppi)

If you only adjust the ppi resolution © (with option Ⓔ deactivated) you won't alter the actual image data, but only the fictional pixels per inch value. This operation is therefore simple and reversible, and requires virtually no

computing power. The output size changes without affecting the number of pixels in the image.

We can reduce the output resolution to 200 ppi/dpi for our Epson inkjet printers without affecting the quality of the results too much. If, however, you reduce resolution too far, your results will become grainy.

Note also that appropriate print resolution depends on the print medium. Normal paper is very absorbent and thus requires a lower resolution if you want to avoid the individual pixels running into each other and smearing. Finer papers and photo papers (glossy, premium, or better) allow you to use higher resolutions and thus achieve more detailed prints without visible pixelation effects.

Figure 4-6: The Photoshop Image Size dialog

Resampling Images

If you enlarge an image for printing, your program will produce (i.e., invent) new pixels.[*] Although enlargements can produce surprisingly good results, the effect of the invented pixels is still not the same as if you took the photo with a higher pixel resolution. Only enlarge images as much and as often as you have to. Photoshop offers three different ways to scale images:

* These are usually calculated from the average values of neighboring pixels using special algorithms.

- **Nearest Neighbor**: This method is not suitable for photographic applications. We do, however, use it for preserving the pixelated effect in screenshots enlarged for book use.

- **Bilinear**: This is also unsuitable for photographic use

- **Bicubic**: This can be used for enlargements with a factor of up to 1.5

- **Bicubic Smoother**: This is the best choice for significant enlargement.

- **Bicubic Sharper**: This method is great for reducing images, thanks to its slight built-in sharpening effect.

There are also a number of other specialized commercial and noncommercial scaling tools available. The Photoshop tools we have mentioned are, however, a good starting point for achieving great results without having to spend money on additional software. If you need to enlarge lots of images on a regular basis, it is worth taking a look at some of the specialized tools on the market to see if they better suit your needs.

Our own DOP-Upsizing Photoshop plug-in can be used to make effective moderate enlargements and is available as a free download at [73]. There is also an interesting article on the subject by Jack Flesher at the same website.

We recommend that you set the Image Interpolation setting to *Bicubic* in the *General* section of the Photoshop Preferences dialog. This ensures

Other tools for enlarging images while minimizing quality loss are pxl SmartScale from onOne Software (www.ononesoftware.com), or the freeware imageN (www.pixoid.com).

that the bicubic method is applied if no other explicit settings are made (figure 4-7).

Preferences		
General	Color Picker: Adobe ▼	OK
Interface	HUD Color Picker: Hue Strip ▼	Cancel
File Handling	Image Interpolation: Bicubic (best for smooth gradients) ▼	Prev
Performance		Next
Cursors		

Options
- ☐ Auto-Update Open Documents ☑ Animated Zoom
- ☑ Beep When Done ☑ Zoom Resizes Windows
- ☑ Dynamic Color Sliders ☑ Zoom with Scroll Wheel
- ☑ Export Clipboard ☐ Zoom Clicked Point to Center
- ☑ Use Shift Key for Tool Switch ☑ Enable Flick Panning
- ☑ Resize Image During Paste/Place ☑ Place or Drag Raster Images as Smart Objects

☑ History Log
Save Log Items To: ◉ Metadata
 ○ Text File (Choose...)
 ○ Both
Edit Log Items: Detailed ▼

(Reset All Warning Dialogs)

(Side panel also lists: Transparency & Gamut, Units & Rulers, Guides, Grid & Slices, Plug-Ins, Type, 3D)

Figure 4-7: Selecting the default interpolation (scaling) method.

4.4 Choosing a File Format

→ Embed a color profile in your image file wherever possible and avoid using formats that don't allow embedding (GIF, for example).

Photoshop supports a wide range of image file formats, but here we will be sticking to useful photo file formats. Some formats don't support 16-bit color depth and others don't allow you to embed color profiles or preserve selections or layers (chapter 7). It is important to select the right file format for your application.

→ To preserve the greatest possible compatibility with other (especially DTP) programs, save TIFF files in 8-bit, non-compressed format.

TIFF • *Tagged Image File Format* is an old, proven image file format and can be used to save 8-bit, 16-bit, and even 32-bit image data. TIFF is a lossless format, so you can open and save TIFF images as often as you like without any loss of image quality.

TIFF files can be compressed losslessly. Photoshop (and many other image processing programs) can open and process compressed TIFF images. However, some programs still have problems processing images that are compressed using certain algorithms.

* Only a few programs support this TIFF version of the compression process.

Photoshop supports LZW and ZIP compression. ZIP is slightly slower than LZW, but both methods achieve similar compression rates, with ZIP taking the lead when it comes to 16-bit image file size. Photoshop also offers JPEG compression for TIFF images, but we never use it.[*]

Photoshop can save multiple layers, color profiles, metadata (EXIF and IPTC), transparency settings, and clipping paths in TIFF files, making TIFF the best choice for flexible, high-quality image processing.

Note: Canon calls the RAW files produced by the 1D and 1Ds cameras TIFF, although the format is actually proprietary and can only be handled by a few programs, such as Adobe Camera Raw. This situation has been the cause of some confusion among photographers and imaging software manufacturers.

JPEG • This format allows high data compression rates. While LZW and ZIP are capable of producing 80% to 60% compression in TIFF files, JPEG often reduces files to between 20% and 5% of their original size (depending on the amount of image quality loss you are prepared to accept). JPEG is therefore the right choice for Web presentation or for transmitting images over slow connections or networks. A lossless version of JPEG does exist, but it is only capable of slight compression. Normal JPEG is the format of choice for applications where image quality loss is acceptable. This quality loss increases with the compression rate and also with how often an image is opened and saved. JPEG format only supports 8-bit color depth and cannot be used to saved layered images.

Photoshop offers JPEG compression rates that produce approximately the following effects::

▶ 12–11 produce high quality images with little quality loss, but low compression

▶ 10–9 produce greater compression with usable image quality

▶ 8–7 increase compression, and image quality begins to suffer

▶ 6–1 delivers very high compression rates with quality loss that is no longer acceptable for photo work

➜ JPEG is not suitable for saving important images that you wish to process thoroughly.

JPEG 2000 • This is a relatively new format with a number of improvements over conventional JPEG. It includes a usable, lossless compression method that produces better compression rates than TIFF compressed with LZW or ZIP. Its lossy compression results are better than conventional JPEG results at similar image quality levels, and the format also supports 8-bit, 16-bit, and 32-bit color depth. Photoshop supports JPEG 2000 using a plug-in, and a few other programs support it too, although most Web browsers don't recognize the format without a special plug-in. JPEG 2000 hasn't yet established itself on a broad basis, and it is still something of a niche format.

Photoshop PSD • PSD (Photoshop Data) used to be our format of choice for saving multi-layer images. Since the release of Photoshop CS, we use TIFF for the same purpose because TIFF produces smaller files when we compress multilayer images using ZIP. This is especially advantageous for processing 16-bit images.

➜ TIFF files can also include proprietary data. Proprietary data segments can, however, cause problems during processing.

➜ JPEG can only save exactly 8 bits of data per color channel (24 bits per pixel) and cannot save layers or alpha channels. Images that contain layers and alpha channels must be flattened to a single layer before saving.

Figure 4-8: Photoshop JPEG options when saving a JPEG file. In section A you choose your compression (image quality).

➜ Photoshop 7 and Photoshop Elements are JPEG 2000 compatible,. You can find a free plug-in at www.fnordware.com. Photoshop CS2 supports the format without using a plug-in.

Because Photoshop is the de facto image processing program on today's market, the PSD format enjoys a high level of compatibility as a transfer format between imaging applications in general. This is especially useful when you need to transfer and process layers, color profiles, and clipping paths (although some programs cannot recognize all of these image attributes).

Photoshop PSB • PSB (Photoshop Big Data format) is designed for use with large image formats (up to 300,000 pixels wide or high), and it can be used to save image files that are up to 2 GB. This special format is not supported by any other mainstream programs and is of no practical use in the photo workflow.

Table 4.1: Image Formats and Their Options for Saving Information

Format/File Extension	Compression	Color Depth (per Channel)	Meta-data	Trans-parency	Layers	Color Profile	Vector Layers	Alpha Channels	Notes
RAW Various	No/slight	8–16 bits	+	–	–	+	–	–	Most RAW formats are proprietary.
TIFF .tif .tiff	Various: No / LZW/ZIP/ RLE/JPEG	Various, 1–32 bits	+	+	+	+	+	+	Multifaceted. Not all programs support all TIFF variants.
JPEG .jpg, .jif, .jpeg	Lossy	8/16 bits	+	+	–	+	–	–	Storage optimized. High lossy compression is possible.
JPEG 2000 .jp2, .j2c	Lossless and lossy	8/16/32 bits	+	+	–	+	–	+	As yet, little support in DTP programs. Very compact.
PNG .png	Lossless	8/24/48 bits total[c]	(+)[a]	+	–	(+)[b]	–	–	Compact, no CMYK.
GIF .gif	LZW, lossy because of 8-bit limit	2–8 bits total[c]	–	+	–	+	–	–	Internet graphics with 8-bit indexed colors.
PDF .pdf	Various methods LZW, JPEG …	1–16 bits	–	+	+	+	+	+	There is a special Photoshop PDF variant.
PSD .psd	LZW for layers	1–32 bits	+	+	+	+	+	+	Native Photoshop format. Recognized by other image editing programs.
PSB .psb	LZW for layers	1–32 bits	+	+	+	+	+	+	Photoshop format for very large files.

a. With limitations, i.e., no EXIF data b. Since PDF 1.5 with limitations
b. PNG color profiles are not saved in Photoshop
c. This number of bits is used not per color channel but for all bits of the index encoded data (per pixel).

Other Image File Formats

In addition to the formats already mentioned, there is a wide range of other formats available, including the GIF Web and presentation graphics format. This format has a total of 255 reproducible colors and results in very small files, but it is only suited for use with the smallest photos. To present photos on the Web, we prefer highly compressed JPEGs.

PNG supports a greater range of color depth (up to 32 bits per color channel), but it doesn't support embedded color profiles and layers. Therefore, we don't use the PNG format for photos.

EPS and DCS are relevant for transferring data to some DTP applications, but they are not part of our workflow.

Compatibility Settings

To achieve better compatibility with Lightroom and other applications, we recommend that you set *Maximize PSD and PSB File Compatibility* to *Always* in the *File Handling* section of Photoshop's Preferences. This setting is effective when you save TIFF images. It causes Photoshop to create an invisible virtual layer where the detail from all other visible layers is saved. Other applications then use this additional layer to display the visual parts of the image file without having to be completely compatible with the complex Photoshop layers mechanism.

The aspects and characteristics of various file formats make a difference to their practical applications; for instance, whether color profiles can be embedded or alpha channels can be saved*. Table 4-1 lists some file formats and their main characteristics.

Figure 4-9: We don't use all the formats supported by Photoshop in the course of our workflow.

* Alpha channels are used to save selection information.

4.5 File Information and Logs

The Photoshop file information box (File ▸ File Info: ⇧-Alt-Ctrl-I or ⇧-⌥-⌘-I) contains a wide range of useful information for the active image. The *Camera Data* tab contains (among other things) the image EXIF data embedded in the file by the camera. You can enter author tags, image titles, and copyright information in the IPTC tab, as well as keywords for later searches in Bridge or Lightroom. You can also include other descriptive data or comments here.

Check the other types of file information too, and don't worry if some entries turn up multiple times in different places – different camera manufacturers use different tag names for various camera parameters.

Figure 4-10: EXIF data is displayed in the "Camera Data" tab.

History Log

We set up Photoshop to record all processing steps in the image metadata using the Preferences ▸ General dialog. We check the *History Log* option and select *Metadata* under *Save Log items* (Ⓐ).

Figure 4-11: Use the general preferences to select which steps are recorded in the file's log.

Use option Ⓑ to select the degree of detail for your log. If you select *Detailed,* you can later scrutinize all the processing steps performed on the image via File ▸ File Info ▸ History. This super-useful functionality was introduced with Photoshop CS.

Figure 4-12:
The log of processing steps performed on an image. This feature increases the file size a little, but is a great record of what has been done to an image and when.

Photoshop uses XML or XMP format to save metadata internally. We will be coming across XMP quite often in the course of the workflow. XMP data can be embedded in image files (which helps to preserve congruency when images are moved, renamed, or copied), or in a separate XMP file (selectable in menu Ⓑ in figure 4-11). This file has the same name as the image file it is associated with and the file extension ".xmp". XMP data can be read by all Adobe applications and also by some other manufacturers. It is useful during later processing stages.

XMP stands for "Extensible Metadata Platform", which is an ISO standard used for storing and exchanging metadata in all Adobe applications.

4.6 Image Alignment

The basic rule of thumb when processing images is, "Correct major errors first and minor errors later". One of the first major corrections we perform is aligning the dominant vertical or horizontal lines in an image.

You should, of course, take care to photograph the horizon so that it appears horizontal, but you will nevertheless need to make corrections every now and again. Make this your first step, as it nearly always involves a subsequent crop.

You can rotate your image in one of three ways:

1. Use Image ▸ Image Rotation ▸ Arbitrary. Judging the correct degree of rotation can be tricky, but you can first drag the Ruler tool (✐) along a line or edge to measure its angle precisely. The Image ▸ Image Rotation ▸ Arbitrary dialog then displays the angle Photoshop has determined (figure 4-13). Clicking OK straightens your image perfectly.

Figure 4-13: If you measure the angle of a line using the ruler, the "Arbitrary" dialog automatically displays the determined degree value.

2. Select the entire image using Ctrl-A and then use Edit ▸ Free Transform (Ctrl-T or ⌘-T for a Mac) to rotate it.

 You can also drag guidelines out of the rulers at the edges of the active image by using your mouse.* The rulers are activated using Ctrl-R (Mac: ⌘-R). Now reduce the image so that it is surrounded by blank space on the canvas.

* Guidelines are only visible on the monitor image, not in the final print.

3. Then activate Free Transform. You can now rotate the image freely using the handles at the corners. You have to confirm any changes you make by double-clicking within the image area or by pressing the ↵ key, so don't be afraid to experiment first.

 You can also enter a degree value for your rotation manually in the Transform options bar (figure 4-14).

| ▦ ▾ | ▦ | X: 2808.0 px | △ Y: 1872.0 px | | W: 100.0% | ⊗ H: 100.0% | | ∠ 0.00 ° | H: 0.0 ° | V: 0.0 ° | ⚞ | ⊘ | ✔ |

Once you have rotated your image, either crop the resulting empty borders or fill them in using the Clone Stamp tool.

Figure 4-14: Entering a rotation degree value manually in the Transform options bar.

Figure 4-15: Our misaligned, perspective-
distorted source image

Figure 4-16: Selecting a rectangle

Figure 4-17: Drag the corners of the
marquee to the edges of the target area.

Figure 4-18: The aligned, cropped,
perspective-corrected image

4. This process combines rotation with use of the Crop tool ⌖,which you can also use to correct perspective distortion in one (fairly complex) step. These are the necessary steps applied to the image in figure 4-15:

4a Select the Crop tool ⌖ and crop your image to leave plenty of space around the cropping marquee without actually applying the crop. Now check the *Perspective* box in the Crop options bar.

4b Move the corners of the cropping marquee while pressing the Alt key to form a rectangle (figure 4-16). This doesn't have to cover the entire area of the image you want to keep, but it serves to define the perspective parameters that you will apply later.

4c Now drag the edges of the rectangle (without pressing the Alt key) to their final cropping positions. They will automatically move parallel to their previous positions (figure 4-17).

4d Pressing ⏎ applies the crop and simultaneous perspective correction. The result is shown in figure 4-18. Here, the slight grade of the street makes the image look a little tilted, although it no longer is.

If your results aren't perfect, undo the rotation and try again using different parameters. Rotating the processed image repeatedly (without undoing your previous attempt) compounds rounding errors and introduces unwanted artifacts into the image.

4.7 Simple Corrections

Optimizing tonal range, contrast, brightness, and shadows/highlights are some of the most important elements of our workflow. The following is a description of the basic correction techniques for each of these tasks. We will address image fine-tuning and more sophisticated correction techniques later.

→ We will perform all of the following corrections on adjustment or pixel layers, not on the background layer.

Basic Considerations

We always correct errors that affect the entire image before we address minor and selective, local imperfections. We will discuss selective correction in more detail in chapter 7.

4.7.1 Optimizing Tonal Range

Most images require some optimization of tonal range and contrast. The appropriate Photoshop tool can be found under Image ▸ Adjustments ▸ Levels. (You will be using this dialog a lot, so learn the keystroke Ctrl-L (Mac: ⌥-L) now!) This is one of the most important Photoshop functions; it allows us to alter the contrast in our images by setting the black point (figure 4-20, slider Ⓐ), the white point (slider Ⓑ), and the overall brightness (slider Ⓒ).

The dialog displays the distribution of brightness (luminance) values within the image from black (0, on the left) to white (255, on the right). The height of the curve represents the frequency with which each luminance value occurs.

If an image contains all luminance values between black and white, the histogram curve will stretch from the far left almost all the way to the far right of the diagram.

The histogram curve in our example is empty below 10 and above 220, which means that not all possible luminance values occur. We can improve image contrast by shifting the black point (slider Ⓐ) to the right until it sits at the edge of the curve (here with a value of approximately 10). We then shift the white point towards the 220 value in a similar way using slider Ⓑ. This significantly increases image contrast, as shown by the changes in the preview

Figure 4-19: Our source image

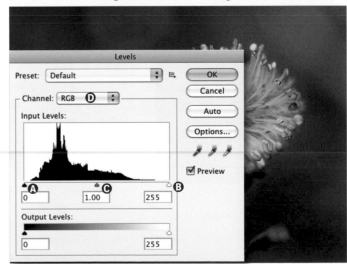

Figure 4-20: The "Levels" dialog initially displays the image histogram.

image. The colors also appear richer. All pixels that have luminance values below the black point are now displayed as pure black, and all that are above the white point are displayed as pure white.

This step maximizes the tonal range of your image. You should check to see whether the changes actually make a visual improvement.

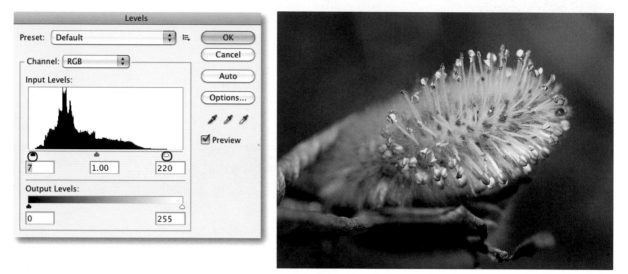

Figure 4-21: We start by setting the black point and the white point.

Phil Lindsay gave us this tip: Be especially careful when setting the white point, as it is all too easy to cut off fine detail in highlight areas (recognizable by a fine black line towards the right of the histogram curve).

Don't increase contrast too much, as it is much more difficult to reduce contrast later than it is to increase it in small steps. Psychologically, a version of an image with higher contrast will attract your attention more easily than a low-contrast version of the same image, whether it is actually better or not. Printing on matte paper produces lower contrast images than printing on glossy paper. Personal and regional taste also plays a role, and Europeans generally prefer slightly less rich colors than Americans. Smaller prints (up to A3 size) are generally printed on glossy paper worldwide, while most people prefer to use matte paper for large-format prints.

Figure 4-22: Pressing the Alt/⌥ key while moving the white and black point sliders shows the detail that will be clipped in the preview image.

Moving the white or black point sliders while holding down the Alt key produces a real-time preview of just the clipping in the image – all other image data is masked. Generally, it is better not to clip any image data at all (except for the odd pure white or pure black pixel).

The central slider in figure 4-20 (Ⓒ) adjusts overall brightness in your image and is also known as the *Gamma slider*. Use this slider with moderation and great care.

You can adjust tonal range simultaneously in all color channels or individually for red, green, and blue via the drop-down *Channel* menu Ⓓ. Individual channel adjustments can lead to color shifts and should therefore be applied carefully.

Figure 4-23 shows our image before and after setting the black and white points.

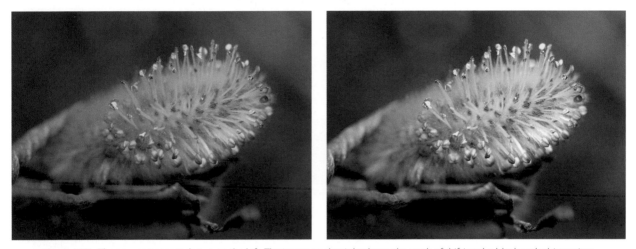

Figure 4-23: The source image is shown on the left. The image on the right shows the result of shifting the black and white points.

Clipping

Clipping is a term that we will come across regularly. It describes image areas where changes in tone or color cause the differences between neighboring pixels, and thus image detail, to disappear. If we were to shift the white point in our example too far to the left (i.e., into rather than just up to the curve), we would most likely clip the image highlights, leading to burned-out highlight detail. Clipping is less obvious (and sometimes acceptable) in shadow areas, but highlight clipping is generally taboo. Always use the clipping preview ([Alt] or [⌥] key) to check the effects of your black and white point adjustments.

4.7.2 Flexibility through Curves

Curves is one of Photoshop's most powerful tools. While the Levels tool only allows you to make linear corrections to the whole image, the Curves tool allows you to make extremely selective adjustments to shadow, midtone, and highlight detail. Using Curves is not particularly intuitive, but it is worth taking the trouble to learn.

Here, we will describe some of the simple but useful aspects of the Curves tool. You can adjust the color channels together or individually. Curves can be found under Image ▸ Adjustments ▸ Curves (or via [Ctrl]-[M] (Mac: [⌘]-[M]). Photoshop CS3 introduced the option of displaying a histogram with the curve, making it possible to perform changes to tonal range using the Curves tool.

Improving Contrast using the S-Curve

The slight "S" form of this curve improves (i.e., increases) image contrast in the midtones and usually makes additional increases in saturation redundant. You can also reduce image contrast by applying an S-curve with the opposite curvature.

Always activate the Preview option when making corrections to your images (figure 4-24 Ⓐ). This allows you to view the effects your changes will have without actually changing the image data.

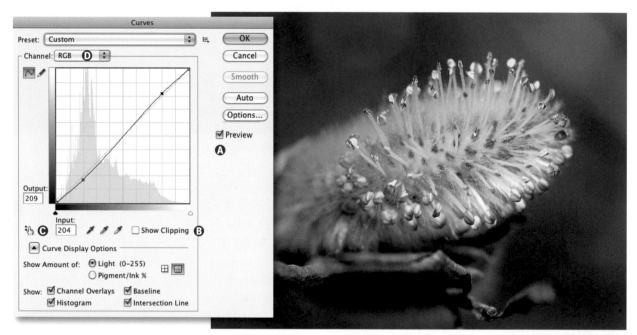

Figure 4-24: A slight increase in contrast using a moderate S-curve

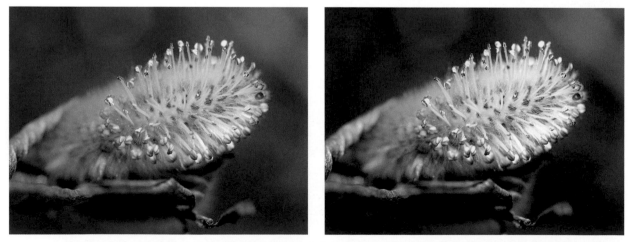

Figure 4-25: The original image is on the left. The image on the right shows the subtle) effects of applying the S-curve.

Applying an S-curve can cause color shifts, but you can counteract this effect by applying the Edit ▸ Fade tool immediately after applying the S-curve in *Luminosity* mode (figure 4-26) or by applying the S-curve in *Luminosity* mode on an adjustment layer (section 7.3, page 251). The Fade tool effects the last correction that was applied to the image. *Mode* settings are explained in section 7.2.2, page 250.

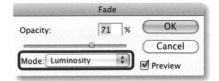

Figure 4-26: The Fade tool reduces the effect of the last image adjustment.

You can show or hide the Curves histogram and the diagonal baseline (from bottom left to top right in the curves diagram) using the checkboxes in the Curves display options (figure 4-24). Potential clipping is displayed by checking the *Show Clipping* checkbox.

Correcting Brightness

You can also use Curves to adjust brightness and the distribution of brightness values in an image. We use the Curves illustrated here to do this, but feel free to experiment with the forms – even the smallest changes to the position of the control points can have quite radical effects on the look of an image.

➡ **Please note:** All our Curves are set up so that dark is at bottom left!

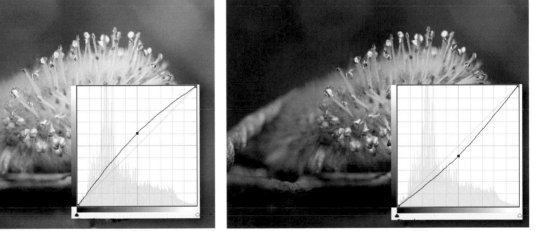

Figure 4-27: On the left is the curve for brightening midtones, and on the right is the curve for deadening midtones.

➡ Clicking on a bright image area while the Curves dialog is open automatically marks the brightness of that area on the curve. You can lock the curve to this new control point by pressing Ctrl/⌘. This helps avoid losing highlight detail by over-correcting the image (i.e., by making it too bright).

➡ If you want to adjust the tonal value of an area directly in the image, activate the 👆 option (figure 4-24 ©), click on the appropriate point in your image, and drag the cursor up or down with the mouse button pressed. Photoshop then sets a control point with the same value as the pixel at the current cursor position. The curve can now be shifted around the new control point. This type of correction is intuitive and can also be performed on the Curves adjustment layer.

slider makes it possible to increase saturation for only the selected brightness value areas within the image.

The Shadows/Highlights tool is best used in 16-bit mode. It tends to produce halo effects at high contrast edges. You can counteract this effect by keeping your *radius* value low.

Unfortunately, Shadows/Highlights cannot be applied as an adjustment layer and can only be used on normal pixel layers.* We use the tool almost exclusively on our own, specially constructed assistance layer that we create using Ctrl-Alt-⇧-E (Mac: ⌘-⌥-⇧-E). For more details see section 7.5 on page 264.

* This is also the case for all Photoshop Filter functions.

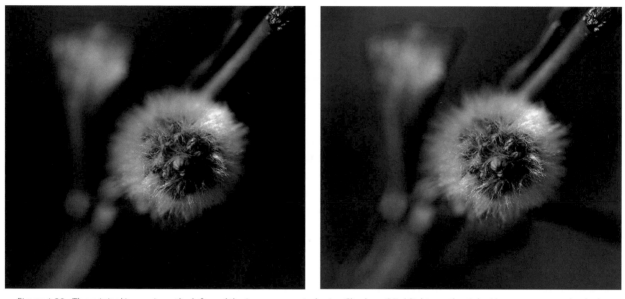

Figure 4-30: The original image is on the left, and the image corrected using Shadows/Highlights on the right. Here, we corrected only the shadows using Amount 29, Tonal Width 30, and Radius 25.

4.8 The Art of Sharpening

Nearly all digital photos must be artificially sharpened due to the effects of the *anti-aliasing* filter used in most DSLRs (as explained on page 6).

Skillful sharpening is an art form of its own and requires a lot of experience to be performed successfully. Interpreting the results of sharpening is also very subjective. This is why the many sharpening tools and techniques available are constantly being improved.

Sharpening is slightly self-contradictory, as it simultaneously improves the overall look of an image while destroying some fine detail. Allow for the distance your finished image will be viewed from when sharpening – the greater the distance, the more you can sharpen, as fine detail won't be visible anyway.

➜ Zoom in to a 100% view (i.e., each monitor pixel represents one image pixel) while sharpening. If the tool you are using has a 100% preview window (like the Photoshop USM filter), zoom the normal preview window to exactly 50%. This way, you can see the 100% view in the tool interface while the normal preview shows (approximately) how your image will look when printed.

4.8.1 The Three Most Common Types of Sharpening

Experienced imaging specialists usually use up to three types of sharpening on their images:

1. **Capture sharpening**. This uses a RAW editor to compensate for color interpolation and anti-aliasing effects. This type of sharpening does not apply if you shoot in JPEG format.[*]

2. **Creative sharpening.** Sharpening is used as a creative tool according to your personal taste and preferences. Some people like to sharpen some areas of an image more than others, or not at all (usually using layer masks).

3. **Output sharpening.** This type of sharpening is applied according to the specific output purpose of an image. Images that are to be presented on a monitor don't need to be sharpened as much as those destined for offset or inkjet printing. Output sharpening is usually applied to a copy of the original image that has already been scaled and converted for printing.

You can also increase local contrast to perform a kind of *color sharpening*, which accentuates. The color differences between neighboring pixels of different colors. If you want to apply this type of sharpening to your images, we advise you to do so before step 2 above (once most other corrections have taken place). Generally, creative sharpening should be applied less if it is performed after increasing local contrast. We will discuss how to increase local contrast in detail in section 8.12, page 334.

Once you understand the basic principles of sharpening, you can take a look at some of the specialized sharpening tools and plug-ins available for use with Photoshop. You can find some recommendations for sharpening tools that we use as part of our workflow at our *Digital Outback Photo* website (www.outbackphoto.com). Section 8.8 looks at some of these tools and describes sharpening techniques in detail.

4.8.2 Unsharp Mask

Unsharp Mask (USM) is the classic Photoshop sharpening tool. Remember that it is not always easy to judge the effects of sharpening accurately on a monitor. An image that appears hopelessly oversharpened on a monitor can look ideal when printed on an inkjet printer.

The main types of artifacts caused by sharpening should be kept to a minimum:

▸ Halo effects (black or white lines at object edges)
▸ Image noise (amplified by sharpening)

There are a great number of sharpening tools available, and it is up to you to decide which is the best for you with regard to functionality and your wallet.[**]

* In that case, the camera will have already performed an internal RAW-to-JPEG conversion using its own firmware algorithm, and it will also have applied some capture sharpening.

** See also section 12.4, page 477).

Figure 4-31: Image before sharpening

Figure 4-33: Image after sharpening using "Unsharp Mask"

4.8.3 Unsharp Mask Filter (USM)

Of all the options Photoshop offers for sharpening digital images, Unsharp Mask (USM) is probably the most widely used. Most other sharpening tools are variations on the same theme. In order to sharpen your images effectively you need to understand the unsharp mask technique and its limitations. The filter can be found under Filter ▸ Sharpen ▸ Unsharp Mask, and the dialog (figure 4-32) has three controls: *Amount*, *Radius,* and *Threshold*, which function as follows.

Amount • This value determines how strongly edge contrast is increased. Start by trying values between 90 and 120 percent. Usable values can reach as much as 150 to 250 percent.

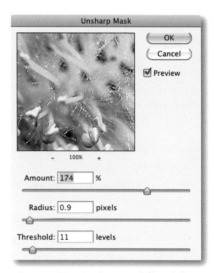

Figure 4-32: : Unsharp Mask filter dialog.

You can see the effects different values have in the image preview. The greater your image resolution, the higher the value you can effectively use.

Radius • This value determines the number of neighboring pixels that are affected by the sharpening process. Values of 0.5 to 1.0 are often sufficient to achieve effective results; too, the higher your image resolution, the larger the radius value you can effectively use. Too large a radius value can lead to hard-looking contrast effects and to the formation of image artifacts.

Threshold • This value defines how many pixels to consider as an "edge". Start at 0 and work up; larger values produce effective edge sharpening without accentuating image imperfections too much. For images with smooth gradients (e.g., skies), we usually use a value of 5–10.

Unfortunately, it is easy to sharpen too little or too much. Too much sharpening can cause significant image quality loss, especially in the form of black or white halo effects. We recommend that you start small and sharpen only a little until you get a feel for how sharpening affects your images.

The effects of sharpening depend on how an image is to be used (e.g., print or Web,), and it can take some time and a lot of experimenting to find the right settings. This is where the main limitation of the USM process comes in to play: all USM corrections affect the entire image. It is often

desirable to sharpen different parts of an image to different degrees (e.g., the face and the hair in a portrait). It is difficult to avoid amplifying minor noise effects when using USM.

This is why there are a large number of specialized sharpening programs and plug-ins available for making sharpening easier and more effective. Most of these tools are based on edge masking techniques.

There is no single, universal solution to the problem of sharpening, so you will have to experiment to find out the best techniques and tools to use in each individual situation.

Figure 4-34: This image has been over-sharpened and displays obvious sharpening artifacts.

4.8.4 Enhanced Sharpening Using Smart Sharpen

The CS2 version of Photoshop introduced an enhanced sharpening process called Smart Sharpen. This process uses *Amount* and *Radius* values like USM and includes an additional *Remove* control (figure 4-35 Ⓑ). We nearly always select *Gaussian Blur*. You can also compensate for slight camera shake using the *Motion Blur* option; here, you need to experiment to find the appropriate *Angle* setting for the supposed angle of movement of the camera relative to the subject.

If you activate the Advanced option (Ⓐ), you can sharpen shadows and highlights separately. The settings you make on the *Sharpen* tab then apply to the midtones.

Generally, you shouldn't sharpen as much in the shadows as in the highlights in order to avoid strengthening any noise artifacts that may already be present. If you are working on a bright sky with mainly soft edges, you should sharpen less there and concentrate on the midtones. We always check the *More Accurate* option, even if it costs us some computing power.

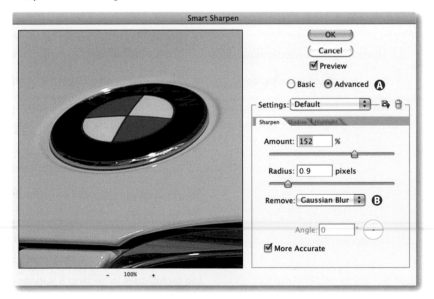

Figure 4-35: The Smart Sharpen filter, available since Photoshop CS2

▸ Filter-based simulation of warmer or cooler colors
▸ Specialized Photoshop white balance and color correction plug-ins (iCorrect EditLab or Color Mechanic, for example)

Automatic camera-based white balance is a good place to start, but it often produces substandard results in artificial light. You can also set the color temperature manually in the camera menu or take a reference shot of a gray or white surface for use in the following shot(s) either by manually entering a color temperature value or by selecting a preset shooting mode.

Most DSLRs allow you to set white balance manually by pointing at a pure white or bright gray surface and pressing the white balance (WB) button.

If you are shooting in RAW format, it is usually easier to adjust white balance using your RAW editor.

Automatic White Balance

Virtually all image processors offer automatic white balance functionality. Photoshop's can be found under Image ▸ Adjustments ▸ Auto Color. Automatic tools don't always produce the best results, but you can undo the effects they produce, so it's worth a try.

White Balance using a Gray Image Element

If the frame contains a neutral gray element, you can use this as a reference color for setting white balance in your shot. The element you choose shouldn't be too white (i.e., detail-free) or too dark.

Figure 4-36:
White balance using
iCorrect EditLab Pro from
the PictoColor Corporation:
www.pictocolor.com

We use iCorrect EditLab Pro (available for Windows and Mac OS X) to set the correct white balance with a single mouse click. All to do is use an eyedropper to select a neutral gray area. Clicking on it then automatically adjusts white balance for the whole image. Keep trying until you get the right result.

Another sure-fire method for use in critical situations is to photograph a reference card (the X-Rite ColorChecker, for example). The "mini" version of the ColorChecker fits in most photo bags, and we always carry one with us. (We switched to X-Rite's ColorChecker Passport recently). The card includes pure white and neutral gray color fields – a click on the second gray field from the left gives you a perfectly neutral reference color for setting white balance. Once you correct your test image, you can use the resulting white balance value for all other images you shoot in the same lighting.

Figure 4-37: The left image shows a yellow color cast. We used the ➤ marked gray patch (bottom line) of the X-Rite "ColorChecker" reference card as neutral gray reference to achieve a good white balance (right image).

There are other good quality neutral gray cards available that you can use for making semi-manual in-camera white balance and exposure settings. The trick with gray field selection using an eyedropper works well in most RAW editors, as you will see later. Setting white balance in a RAW editor is especially useful if you want to process your images in 8-bit mode afterwards.

4.9.2 Making Corrections to Color Temperature

Color Temperature sliders are, unfortunately, usually only available in RAW editors such as Adobe Camera Raw, Capture One, Nikon Capture, or Lightroom. Raw image data is not influenced by the white balance settings made in the camera and the unaltered colors are transferred straight to the program (with the exception of Nikon D1 RAW images). We will describe RAW editors in detail in section 5.3, page 156.

Figure 4-38: Setting white balance in Adobe Camera Raw (Version 6.0)

4.9.3 Software Filters for Warmer or Cooler Colors

* See www.powerretouche.com

If there is no suitable gray object in your image and you are working with TIFF or JPEG images, the White-Balance Corrector Photoshop plug-in from Power Retouche. is a good alternative solution.*

Figure 4-39:
Setting white
balance using the
Photoshop plug-in
White-Balance
Corrector from
Power Retouche

Figure 4-40:
Before/after comparison. The difference
between the original image (left) and the
adjusted version is obvious.

It is easiest to see the difference the adjustment makes if you save a copy of your original image for comparison.

As already mentioned, the purpose of these types of adjustments is to produce pleasing *colors*, rather than an absolute 100 percent faithful reproduction of the original scene. If the colors in the original image are too cool, adjusting them to look warmer is not necessarily realistic, but it can nevertheless produce agreeable results. In addition to the automatic eyedropper function, the White-Balance Corrector includes manual filters for simulating conventional photo filter effects.

4.9.4 Adjustments Using Hue/Saturation

Understanding the HSB Color Model

We often use the Color Picker, one of the basic Photoshop tools, to select a color for a brush or a fill function. Color Picker makes it easy to understand the relationships between

The Color Picker is activated by double clicking on the foreground or the background in the Photoshop tool panel.

▸ Hue,
▸ Saturation, and
▸ Brightness

The HSB (Hue, Saturation and Brightness) color model is not explicitly offered for use in Photoshop, but is often indirectly available through the Color Picker interface or by way of the Hue/Saturation tool.

The colored area on the left (figure 4-41) represents the color spectrum of a particular tone, or *Hue*. This basic tone can be altered by using the color slider Ⓐ or by entering color values manually. The H value represents an angle between 0 and 360 degrees; 0 degrees represents red, 90 degrees represents green, 180 degrees represents cyan, and 360 degrees brings us back to red.

The circular cursor Ⓑ is used to set saturation (S) and brightness (B) for each tone. The farther you move the cursor to the right, the more saturated your color will be, with values ranging from 0 (no saturation, or nearly gray) to 100. The farther you position the cursor towards the top of the diagram, the brighter your tone will be. These values also range between 0 and 100. This color model is more intuitive to use than most others.

The color value boxes on the right allow you to define your hue for use in other color models: using the HSB model Ⓒ as an RGB value Ⓓ, a L*a*b* value Ⓔ, or a CMYK value Ⓕ. The field at Ⓖ displays the color as a Web-safe indexed color.

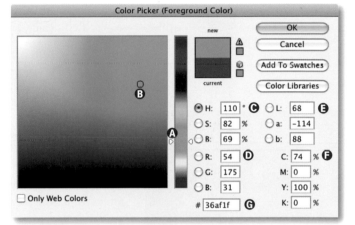

Figure 4-41: Photoshop Color Picker. Cursor Ⓑ denotes the current selection. The warning icon ⚠ at top right indicates that the selected color is not available in the currently active color space (here Adobe RGB).

Color Corrections Using Hue/Saturation

Once you have set white balance for your image, you will probably want to adjust colors for individual image elements, such as:

▸ The blue of the sky
▸ Skin tones (e.g., if they display too much magenta)
▸ Green tones in natural settings

The Photoshop Hue/Saturation tool is ideal for applying these selective (a particular range of tones) color corrections.

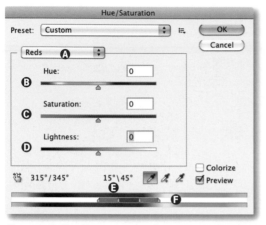

Figure 4-42: Hue/Saturation also allows you to edit colors selectively (i.e., within a certain range).

Figure 4-43: If you set menu Ⓐ to *Master* and you temporarily adjust Saturation to +100, you can clearly see which tones are actually present in the image.

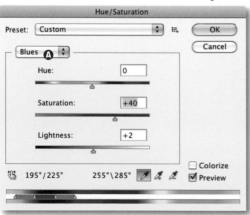

Figure 4-44: Hue/Saturation settings for intensifying blue tones

The tool is versatile, but it can be complicated to use. It uses the HSB model described above to make corrections to selected tonal ranges Ⓐ rather than to the entire image. The *Hue* slider Ⓑ determines the basic tone (the farther to the right, the cooler the color). The saturation and lightness for the selected hue can then be adjusted using the other two sliders. The the three steps are:

▸ Adjust the hue using slider Ⓑ

▸ Adjust saturation using slider Ⓒ (higher to the right). If menu Ⓐ is set to *Master* and you move the slider all the way to the left, the image is effectively de-colored, i.e., transformed to black-and-white.

▸ Adjust the lightness of all colors in the selected range up or down using slider Ⓓ. Darker but not oversaturated colors tend to look more intense.

The tool also includes two additional fine-tuning sliders:

▸ Vertical sliders ▮▯▮ (Ⓔ)
▸ Left and right triangular sliders ◿ and ◺ (Ⓕ)

All colors that lie in the range denoted by the vertical sliders will be adjusted 100 percent according to the settings made with the Ⓑ, Ⓒ, and Ⓓ sliders, whereas colors in the range between the two triangular sliders (and outside the range defined by ▮▯▮) will be less strongly influenced – decreasing with increased distance from the central area. We use these sliders to produce smooth transitions between different colors in an image.

Tip: In order to gain an impression of the colors present in your image, move the saturation slider all the way to the right in *Default* mode (figure 4-43). The colors will look terrible, but you will clearly see which tones are present. (Using a de-saturated view can sometimes help you to judge image quality. For this, temporarily push Saturation all to the left.) You can then adjust saturation back to 0 or close the tool dialog.

For the water lily image in figure 4-45, we wanted to intensify the reflected blue sky while leaving the other colors unchanged. We selected the *Blues* setting in the Ⓐ menu of the Hue/Saturation tool and increased saturation to a relatively high value (figure 4-44). We also slightly increased Lightness. Too much lightness would have had the opposite effect. We then used the additional sliders described above to define the range of the blue spectrum that we wanted to alter.

The bright green leaf at top right spoiled the overall look of the image, so we switched to Greens in menu Ⓐ, limited the tonal range to bright greens, and reduced the lightness and saturation values, You can view the final result in figure 4-46.

Figure 4-45: The source image. We want to intensify the blues.

Figure 4-46: The result of intensifying the blues and dimming the bright greens using Hue/Saturation

4.9.5 Color Adjustments Using Photo Filter

Photoshop CS1 introduced the very useful Photo Filter* command, which we often use to make colors slightly warmer or cooler, or to transform images to black-and-white. As its name suggests, the effect the tool produces is very similar to the effects produced by using lens filters or different film types with an analog camera.

Use low *Density* values (between 5 and 10 percent) if you want to keep your effects subtle. If you want to apply stronger effects, do so at the white balance stage, as described earlier. It is rare that you will want to change the luminosity in your image. We generaly activate the *Preserve Luminosity* option (figure 4-47) when using this command.

* In spite of its name, this tool is not included in the Filter menu, but instead under Image ▸ Adjustments ▸ Photo Filter.

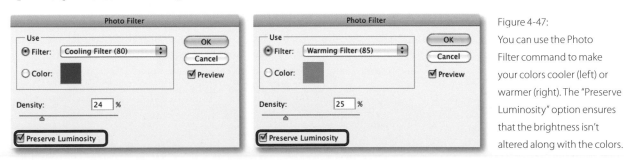

Figure 4-47:
You can use the Photo Filter command to make your colors cooler (left) or warmer (right). The "Preserve Luminosity" option ensures that the brightness isn't altered along with the colors.

The blue correction has made our water lily look a little cold (figure 4-46), so we use the Photo Filter with the Warming Filter setting shown above to achieve the result shown in figure 4-48. The blue of the reflected sky is less intense, but the pink of the water lily is now much warmer and the green of its leaves is more pleasing, too. Figure 4-49 show the effect of applying the cooling filter – the image is much too blue!

Figure 4-48: The water lily from figure 4-46 after applying the Warming Filter

Figure 4-49: The water lily from figure 4-46 after applying the Cooling Filter

Notes on Color Saturation in Digital Photos

Weak color saturation is one of the general criticisms often levelled at digital photos. The fact of the matter is that most analog slide and negative films produce results with artificially intense color saturation. Digital photos are actually more faithful to real world colors.

Always adjust contrast settings before you explicitly increase saturation – this usually improves saturation anyway. Only use the tools described in section 8.1, page 292 if changes in contrast don't produce the desired saturation effects.

4.10 Selection Tools

Selection tools are some of the most heavily used during image processing, especially when it comes to applying corrections to selected images areas. Accurate selection is a real art and can be quite time-consuming. Here, we will describe the most important selection methods and a few of the tools available for assisting the process.

Photoshop offers many ways to select image areas that go way beyond just including or excluding parts of an image. It is even possible to partially affect pixels in a selection – the corrections you then make are only applied to a predetermined degree.

* The values listed here are the grayscale tonal values of the pixels.

A selection is really a grayscale mask with the following characteristics:*

▸ White (255): These pixels are included 100 percent in the selection.
▸ Black (0): These pixels are not included in the selection.
▸ 50 percent gray (128): These pixels are "half-selected".

▸ All other pixels are included in the selection to the degree determined by their grayscale tonal values.

What is all this good for? "Hard" edges in a selection produce abrupt, visible transitions within an image – a situation we want to avoid. Partial selection allows us to produce much softer, less visible transitions from our modified image area to our unmodified image area.

4.10.1 The Marquee Tools

You can use the Marquee tools to select rectangles, squares, circles, and ellipses, as well as single rows or columns of pixels. The Marquee tools are often used to select image areas for cropping, copying, deleting, or selective processing.

If you want to select the entire image area for copying, it is often faster to use Ctrl-A (Mac: ⌘-A) instead of using the mouse to create the appropriate frame. You can just as easily deselect your selection using Ctrl-D (Mac: ⌘-D) or reverse it using ⇧-Ctrl-I (Mac: ⇧-⌘-I).

Making a Selection Larger or Smaller

It is often useful to create a compound selection from multiple areas of an image. All you have to do to automatically combine selections is press the shift ⇧ key between individual selections.

Figure 4-50: Photoshop marks the active selection using a dotted line.

You can also "subtract" a new selection from an existing one using the Alt (⌥) key.

Pressing ⇧-Alt (Mac: ⇧-⌥) creates the intersected selection and you can use Ctrl-⇧-I to invert it (i.e., select everything that was not included in the previous selection).

The combined selection described above can also be further combined with selections made using the other tools described below.

You can give a selection a hard or a soft edge and you can round its corners using the options listed in the options bar. We will use the Lasso tool as an example.

You will use selection tools so often that you will automatically learn the necessary keystrokes. The tables in the margin on this page are designed to help you, too. The 🔲🔳🔲🔳 icons in the tool bar have the same effects as the listed keystrokes.

⊞ Photoshop: extend or reduce selection:

Add:	⇧ (Shift)
Subtract:	Alt
Intersect:	⇧-Alt
Invert:	⇧-Ctrl-I
Deselect:	Ctrl-D
Soft/hard edge:	Alt-Ctrl-D
Select All:	Ctrl-A

 Photoshop: extend or reduce selection:

Add:	⇧ (Shift)
Subtract:	⌥
Intersect:	⇧-⌥
Invert:	⇧-⌘-I
Deselect:	⌘-D
Soft/hard edge:	⌘-⌥-D
Select All:	⌘-A

Figure 4-51: A Lasso selection

4.10.2 The Lasso Tools

The Lasso tool is more flexible than the Rectangular Marquee tool and can be used to select almost any shape. You can then give your selection a soft edge to smooth the transitions between selections and the rest of an image. The *Feather* option is found in the Lasso options bar. You can close the shape you form with the Lasso by using a double click, by pressing Return ⏎, or simply by closing the shape with the Lasso line itself. The Lasso requires a little more dexterity than the Rectangular Marquee, but it's a simpler way to select complex or asymmetric shapes. Working with the Lasso is easier if you use a graphics tablet instead of a mouse. The Lasso tool has three basic variants:

Normal Lasso • The form follows your mouse movements closely, making it simple to draw fine lines and shapes while holding down the mouse button.

Polygonal Lasso • Mouse clicks define the corners of a polygon. This is a very quick way to mirror straight edges in an image.

Magnetic Lasso • This version functions the same way as the normal Lasso, but it has an additional built-in functionality that automatically looks for areas of contrast and color transitions near the cursor position, and leads the mouse accordingly. To change direction, click to create a corner and move on. Clicking while pressing the shift ⇧ key draws a straight line between the last corner and the current cursor position.

You can select the width of the soft edge in the Lasso options bar. The *Antialias* option rounds off the transitions between the selection and the rest of the image when using normal or polygonal Lassos. All Lassos include the *Refine Edge* button that opens the dialog shown in figure 4-52. Here, you can adjust not only the width of your soft edge, but also round your edge and adjust its radius and contrast, as well as expanding or contracting the entire selection.

The icons at the bottom of the CS4 dialog allow you to select various views of your selection: e.g., as a mask within the image, or as a free-standing selection with the rest of the image faded out. Try them all out. CS5 has its own *View* menu to perform the same function. Use the zoom tool 🔍 help check your selection. More details on this dialog can be found in section 7.4.1 on page 259.

The Refine Edge function is also available with the Rectangular and Elliptical Marquee tools.

Figure 4-52: The "Refine Edge" dialog in
Photoshop CS5

4.10.3 The Magic Wand

The Magic Wand is another useful selection tool. Here, all pixels of a similar color that are near the cursor are selected when the wand is clicked. The degree of similarity between the selected pixels is determined by the *Tolerance* parameter in the options bar. The higher the Tolerance value, the more the color of the selected pixels can vary from that of the pixel you have clicked.

It's usually better to work with a low tolerance value and to expand your selection by making multiple small selections while keeping the shift key pressed. This way, you can accurately select all similarly colored areas. If you deactivate the *Contiguous* option, all areas of similar color in the entire image are selected. You can reset your selection using Ctrl-D if you need to start again using a different Tolerance value.

We will address the *Sample All Layers* option in section 7.2, page 249, as it only applies to corrections based on multiple image layers.

Figure 4-53: Tolerance-based Magic Wand selection

4.10.4 The Quick Selection Tool

This tool is a further development of the Magic Wand introduced with Photoshop CS3. It works as if it were a selection brush that automatically finds the edges of the selected area. Selected areas can be subtracted or added using the same Alt/⌥ and ⇧ keys as the other selection tools. This is often the quickest tool to use for color gradients and soft transitions. The choices in the options bar are self-explanatory.

4.10.5 Selection Using a Color Range

We often use the Eyedropper 🖊 tool under Select ▸ Color Range to sample a color in the original image, and the *Fuzziness* slider to determine the degree of color precision.

We then use the Eyedropper 🖊 to add or 🖊 to subtract additional selections. We will explain *Localized Color Clusters* (only available since CS4) in section 7.4.1, page 256.

The dialog previews the selected area in the form of a grayscale mask preview. The *Selection Preview* drop-down menu offers various ways to preview your selection in the original image. We use either *None* (no marking in the original) or *Quick Mask*, which marks the selection with the active mask color. The default color is a strong pink tone, but this can be changed in the Photoshop Preferences dialog.

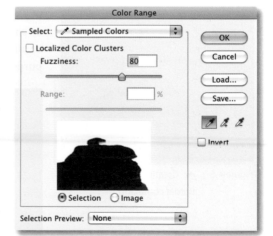

Figure 4-54: Making a selection using a color range.

retouch single points or stripes in an image. To repair a stripe, use an Alt/⌥-click to select your source pixels. Then click on the start of the area you want to cover, paint in the pixels while holding the mouse button down and shift-click to end the operation.*

Removing Dust Spots Using the Healing Brush

Dust often gets stuck to a camera's image sensor, especially if you have to change lenses in dusty environments. Sensor dust is often very obvious in the brighter parts of an image (e.g., sky or clouds). In such cases, you can easily copy a piece of neighboring sky into the offending area using the Clone Stamp ⏹.

Figure 4-61: Spot caused by dust on the sensor.

Photoshop 7 introduced the even better Healing Brush 🖊. This tool merges the source area with the target area and even adjusts the color of the source pixels accordingly, producing even more convincing results than the simple Clone Stamp.

Select the Healing Brush 🖊 in the tool panel and press the Alt key (Mac: ⌥). The cursor for selecting source pixels then appears (although it can be difficult to see if its color is similar to that of the pixels surrounding it). A click then selects the pixels in the cursor position for transfer to the area that you want to repair. Make sure that the source pixels you choose are similar in color and texture to those in the area you want to retouch.

Figure 4-62: Selecting the source pixels for retouching

Now choose a brush size that is large enough to cover the dust spot, move the cursor over the spot and click again.

Our example is not as trivial as it might appear, as the dust spot was located on a cloud with obvious texture and color.

We have rarely used the Clone Stamp for retouching since the

Figure 4-63: Using the Healing Brush

Healing Brush was introduced. However, there are still situations where the Clone Stamp can produce better results; e.g., when the colors of the source and repair pixels are significantly different.

Figure 4-64: The corrected image area

The Spot Healing Brush 🖊 works very much like the Healing Brush 🖊. However, you don't need to select a source area. Simply brush over the area to want to correct, and Photoshop will remove small disturbances in your image. It only works with small defects (see also section 8.13, page 340).

Using the Patch Tool

The Patch Tool 🔵 is based on the same algorithms as the Healing Brush an. It is also useful for removing unwanted specks and for transferring groups of pixels to other parts of an image. In our next example, we will use the Patch tool to remove the same dust spot we retouched in our last example:

1. Select the area to be retouched (figure 4-65). This works very much like the Lasso tool.

2. Drag the selected area to the area whose structure you want to use to retouch your speck (figure 4-66).

Figure 4-66: Selecting the repair pixels

Figure 4-65: Selecting the area to be retouched.

The result shown in figure 4-67 is very similar to the one we achieved using the Healing Brush, but this time we were able to select a freeform area for the repair. Sometimes, you will need to use the Healing Brush to make the finishing touches to a repair made with the Patch tool.

Over time, you will develop a feel for which of the retouching tools is better and more efficient for dealing with various types of situations. We use all of these tools in the course of our workflow.

Figure 4-67: Retouched area

Combined Use of a Selection and the Clone Stamp

The image on the right (figure 4-68) was affected by dust on the camera's image sensor. The image was a bit overcorrected and displays too much contrast, making it impossible to use the Healing Brush. We solved this problem with the following method:

1. First, we zoomed right in to a 400% view.

2. We corrected the image in three small steps: the wall, the window frame, and finally the window itself. We selected the area we wanted to repair and then inverted the selection for the following steps.

3. The selection limits the area the Healing Brush affects. In our example, the parts of the wall outside the selected area are not altered (figure 4-69).

4. The three repair steps described above led to the result in figure 4-70. This isn't perfect, but the dust speck is no longer visible in medium- or large-sized prints.

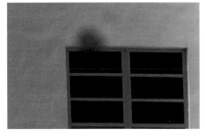

Figure 4-68: The offending dust speck

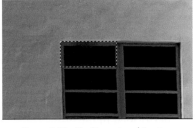

Figure 4-69: Limiting retouching to a selection

Figure 4-70: Detail of the repaired image

Limiting correction or other operations using a selection is common practice. Use a soft edge to smooth the transitions between affected areas.

Selections are great for making small corrections, but larger repairs are more controllable if you use adjustment layers and layer masks. This technique is described in section 7.3, page 251.

Saving and Loading Action Sets

Action sets are only useful if you save them for later use. You can do this via the arrow icon at top right in the Actions panel ⬜. It is best to name the file the same as your action set. The resulting file will have a ".atn" file extension and will be saved by default to the .../*Photoshop/Presets/Actions* folder. You can save them to other locations too.

Saved actions and action sets can be used later on any computer. There is a wide range of free and commercial action sets available on the Internet (and on our web page).

Load actions using: ⬜ ▸ Load Actions. This is also where the Save Actions command is located.

Since you will surely adjust and perfect your actions over time, it is often useful to save older versions separately under their own names, e.g., *Uwe's Sharpening V1.2*.

➔ Avoid using "Clear All Actions" as this does exactly what it says!

Adding Steps to an Action

If you want to extend an action later, use the following steps:

1. Move your mouse over the Actions panel to the position within the action where you want to insert a new step

2. Click ⬤ to start recording the additional steps. In our example, it's a simple *Levels* command.

3. Stop recording by clicking the ◼ button. Our extended "*Brighten Image*" action now looks like figure 4-77.

Figure 4-77: Our extended action

Reorder or Delete Action Steps

You can reorder the steps within an action using drag-and-drop. Individual steps can be deleted by selecting them and dragging them to the trash 🗑.

Changing Settings for Individual Action Steps

If you want to change the settings for an individual step, double-click the step to open the appropriate dialog. Change the settings and click OK to confirm your changes. This automatically runs the changed step, which you can undo using ⌃Ctrl/⌘-Z. You can also reset the step using the History panel, which is described below.

Figure 4-78: Action with reordered steps

* See the dialog in figure 4-74 on page 131 for how to assign a function key.

You can assign actions you use regularly to function keys (F-keys),* and you can also use scripts written in a number of scripting languages to perform even more complex sequences of steps and actions. However, detail on the subject of scripts would go beyond the scope of this book.

4.13 Photoshop's History Panel

Working with the History panel is a bit like *Try-before-you-buy*. You try something out, and if you don't like the result, you simply give it back. Photoshop has very sophisticated mechanisms for undoing things you have just done.

Photoshop notes the last n steps you have made, according to settings you make in the general Preferences. We usually select a value of 25. You can then undo (and, if you don't change any settings, redo) each of the last n steps sequentially. You can use the History panel not only to reset your work to an earlier state, but also to compare earlier versions of your image with the current state.

In order to return to a particular state, simply click on the appropriate state in the History panel or move the History state slider to the appropriate point using your mouse.

In order to undo the last step, use Ctrl/⌘-Z. You can then undo additional steps using Alt-Ctrl-Z (Mac: ⌥-⌘-Z), right back to the beginning of the current history log.

You can select more than 25 History states, but they use additional memory and temporary disk space which can make Photoshop noticeably slower.

The History panel icons 🖫 📷 🗑 function as follows:

🖫 Save a new document for the current state

📷 Take new snapshot (see the next section)

🗑 Delete the current state

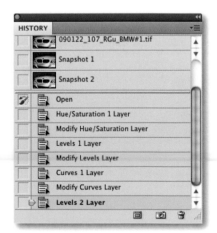

Figure 4-79: The History panel

➔ You can set the detail level and save location for the History log in the general section and the number of states to note in the Performance section of the Photoshop Preferences dialog. There are more options available in the drop-down menu 📰 at the top of the History panel.

Snapshots

If you want to preserve a particular state for a longer period of time, click the 📷 button to take a *Snapshot*. A snapshot is not automatically deleted once more than the selected n steps have been made, and it can be reloaded later. You can edit the name of a snapshot by double-clicking on its name in the History panel.

To return to a particular snapshot state, simply click on the appropriate snapshot in the History panel. Snapshots are great for trying out different multi-step variations of an image.

Deleting Snapshots and the History Log

The history log uses quite a lot of memory and temporary disk space, so you will sometimes need to delete snapshots to regain lost performance, especially if you are working on large image files. You can delete individual snapshots (irreversibly) by dragging them to the trash 🗑. The changes you have made to your image are not affected, but they can no longer be undone.

Figure 4-80: Here, we have taken three Snapshots: the initial state and two later ones.

Figure 4-81: Selecting History handling
preferences

Figure 4-82: The CS5 Navigator window

Figure 4-84: Photoshop not only offers an
RGB histogram, but can also show individual
color channels as well as luminosity.

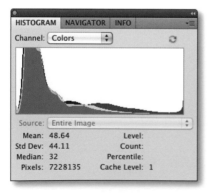

Figure 4-85: The Histogram panel in Colors
mode, showing the different color channels
and channel combinations

The history log and all current snapshots are deleted when you close Photoshop. Since the introduction of Photoshop CS4, you can save the log to a text file during a session.

The preferences for this function are located in the *General* section of the Photoshop Preferences dialog (figure 4-81).

4.14 Additional Information and Overviews

If you are working on a zoomed portion of a large image, it is easy to lose track of where you are. To get back on track, you can either zoom in or out using Ctrl-+ and Ctrl-- (Mac: ⌘-+ and ⌘--) or press the space bar to activate the Hand tool and shift the detail window. You can also use the combination of the Alt (or ⌥) key and the scroll wheel on your mouse to zoom in and out (CS3 and higher).

The Navigator window (Window ▸ Navigator) is a useful orientation tool. The navigator displays the current selection in a red frame, and you can shift the detail frame around the main frame using your mouse. The Navigator window also includes a zoom slider for zooming in and out of the main window. You can enlarge or reduce the Navigator window itself by dragging its corner handles.

We usually keep the Histogram window (Window ▸ Histogram) open while we are processing images in order to keep an eye on the state of our image or the layer we are working on. We usually place the Histogram and Navigator panels, and the Information panel (see below) on our second, subsidiary monitor to avoid covering important details in the image we are processing. The ⚠ icon (figure 4-83) indicates that the histogram isn't updated to show your latest changes and needs to be refreshed by clicking on the ⚠ icon.

Figure 4-83: Histogram in Luminosity mode

The Histogram panel includes a number of different settings. *Colors* mode is similar to the view we see in our RAW editor (figure 4-85). The red, green, and blue curves are self-explanatory, and the other curves have the following meanings: The yellow curve combines the green and red curves, the magenta (■) curve combines the blue and red curves, and the cyan (■) curve combines the green and blue curves. These three colors represent C, M, and Y in the CMYK color space. The other, gray curve is the combined luminance histogram for the active image.

The most comprehensive histogram view is displayed if you select the *All Channels View* setting in the ▾☰ menu. This view does, however, take up a lot of space on the desktop.

Refreshing the histogram window (by clicking on the ⚠ icon) uses a fair amount of computing power, so it is often a good idea to close the histogram window before you run large or complex actions.

The Info panel (Window ▸ Info or F8) is another source of image information and displays the color values at the current cursor position (figure 4-86). Clicking one of the 🖋 icons opens a pop-up menu for selecting the color mode of the display. This tab also displays the size of any current selections and the names of currently active tools.

The display options for the Info panel can be set in the drop-down menu ▾☰ under Panel Options (figure 4-87).

Figure 4-86: Information window showing various types of color values at the current cursor position

Figure 4-87:
Info panel options

We often use the L*a*b* values as our second display value because we find the L (Lightness) value of a color to be useful during processing.

If you click in your image with the normal Eyedropper tool while holding the shift ⇧ key down, the resulting color value will also appear in the Info panel. You can select up to four such color control points, and you can shift the points with a second click on the shift ⇧ key. These control points help you keep your corrections within your own specified range, e.g., to help you avoid over-brightening highlights.

All of the information windows we have described take up space on the desktop, so we only show them if necessary when we are working on single monitor systems. We usually position them on our secondary monitor in our two-monitor setup.

RAW Editing and Conversion

5

If you shoot photos in RAW format, the first significant step in the digital photo workflow is RAW conversion. This is usually done using Photoshop plug-ins that are supplied with the camera, or using specialized standalone programs. Some of these, such as Nikon Capture NX, Phase One's Capture One Pro, or RAW Developer, have to be purchased separately. Photoshop includes its own Adobe Camera Raw conversion software.

RAW conversion involves interpolating the Bayer pattern produced by the camera's image sensor using a camera color profile and a gradation curve that distributes the linear tonal values in a way that is pleasing to the eye. The process also includes ensuring that the image has correct white balance. Once this has taken place, all other image optimization steps can be performed using a conventional image processing program, such as Photoshop.

However, today's RAW converters are capable of much more than just conversion – to the point where they can be used for virtually all image optimization processes. This chapter discusses the concepts and practical use of RAW converters, as well as the advantages and disadvantages of the alternative tools available.

We will start by addressing RAW converters in general, and then Adobe Camera Raw (ACR) and other converters in detail. All-in-one workflow tools are discussed in chapter 6.

You should ensure that your monitor is carefully calibrated and profiled (as described in section 3.5) before you start processing your RAW images.

5.1 Some Initial Thoughts

RAW image files cannot be processed by conventional image processing software. This is because RAW data has not been interpreted, and it possesses neither a color profile nor a tone curve. Additionally, virtually every camera manufacturer uses its own proprietary RAW format, and each individual camera model uses its own variation of the base format.

Image editing programs that support multiple RAW formats therefore convert RAW images to a temporary, internal, camera-independent pixel format. To do this, they employ a core conversion module in combination with camera-specific color profiles and tone curves. All other operations then function identically for all converted files. This basic process is the same even for manufacturer-specific RAW converters, such as Nikon's Capture NX or Canon's Digital Photo Professional, as they handle different RAW formats for individual camera models. Such RAW converters are subject to two different types of updates:

1. Updates that introduce support for new camera models
2. Updates that enhance the software's overall functionality

The functionality of RAW converters has advanced enormously in the past few years, and most now include:

A) Support for multiple formats

B) Improved color interpolation

C) An image browser with an extensive range of functions, including smart downloading, a light table, metadata management, etc.

D) Support for core image optimization functionality, such as corrections for vignetting, chromatic aberrations, lens distortion, and noise reduction, as well as creative sharpening tools and a choice of color profiles. Most RAW converters also include complex export functions for applying different formats and color profiles to exported images.

E) Support for extended functionality that is traditionally part of editing software, including: monochrome conversion, extended sharpening, image alignment, cropping, selective (brush-based) tonal and color corrections, blemish removal, perspective correction, and printing

F) Integrated image management and Web/slideshow output

These improvements have led to the creation of all-in-one workflow tools and raise two fundamental questions:

1. To what extent should I optimize my images using my RAW converter?
2. What is the right RAW converter or all-in-one application for me?

5.1.1 How Much Editing in the RAW Converter?

We have already addressed this question in section 2.4.1. The answer depends on the intended use of the finished images, how quickly you need to produce your results, how many images need work, and the degree of perfection required. The quicker you need to work and the more images you are processing, the more likely you are to use your RAW converter. This is, of course, also dependent on the variety and quality of the tools your RAW converter offers.

5.1.2 Integrating RAW Editors/Converters into the Workflow

We already discussed some possible combinations of tools for processing RAW images in section 2.7. There are, in turn, various approaches to integrating RAW converters into the overall workflow. We will only consider tools that add functionality to that offered by Bridge/Photoshop/Adobe Camera Raw:

A) If your RAW converter includes browsing and download functionality, you can perform the initial download, renaming, viewing, and rating steps in the converter's browser module, followed by image optimization.

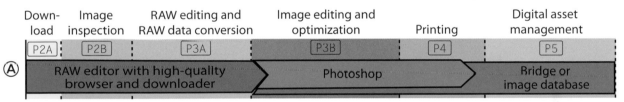

Ideally, the browser module will support the XMP/IPTC format, so that metadata and image ratings can be captured and transferred to the image management module as early in the workflow as possible.

 The simplest image manager available is Adobe Bridge, although true database image managers tend to capture image metadata more effectively and with less potential data loss. Data transfer occurs via the RAW converter's export folder and should preserve the original RAW filename in order to simplify later identification.

Figure 5-1: RAW converters with downloading and browsing functionality as part of the workflow.

B) Alternatively, you can use an all-in-one program such as Aperture or Lightroom as your basic download and image management tool.

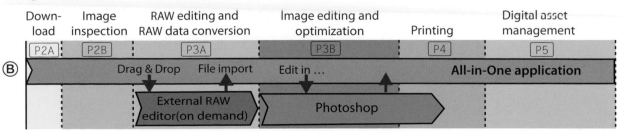

Figure 5-2: All-in-one (or database-based) RAW converters in the workflow

You will then probably optimize most of your images using your all-in-one's RAW conversion tools and only hand over selected images to other applications for fine-tuning. Under Mac OS X, you simply drag your selected images to the RAW converter in the Dock, which then starts automatically. Under Windows, the program has to be running in an open window before you can drag images to it.

Processed images are then reimported into your image management module as TIFF, JPEG, or PSD files. It is important that your image manager's RAW preview data interpretation is not too different from that produced by your RAW converter. You will also need to create a system for storing your converted images and reimporting them as quickly and easily as possible into your image management system – for example, using a hot folder that is under constant surveillance by your image manager. If a new image arrives in the hot folder, the image manager automatically starts the import process.

Another variation involves configuring Photoshop as your default image processor in your image manager and using it to process and print converted images. In this case, remember to always open images via your image management module, not via your RAW converter or your image browser.

Here, we need to consider whether it makes sense to process JPEGs and TIFFs using our RAW converter (if this is possible). One advantage of this approach is that a RAW converter can save multiple versions of a single image without using too much disk space and without modifying the original image file. Some RAW-based programs also offer better processing tools, especially with respect to profile-based lens correction functionality (e.g., DxO, Capture NX, Lightroom 3, or ACR 6.1). Non-destructive editing is also an advantage if you are processing large numbers of similar images.

Limiting yourself to just one or to a small number of RAW converters will save you licence fees and learning time. Using more than two simultaneously is seldom genuinely useful. We recommend that you use ACR, Lightroom, Aperture, or Bibble 5 in combination with a second converter that covers your special needs. Nikon photographers often use Capture NX or Capture One as their secondary RAW tool.

The borders between these two basic approaches are blurred. You can always download, rename, view, delete, and keyword your images using your image management module and then use your RAW converter to convert or process your images (either singly or in batch mode). You can then hand your processed images back to your management module for organization and administration.

Another important question concerns whether to store RAW images and finished, processed versions in the same or separate folders. Both approaches have advantages and disadvantages. See section 13.1 for further discussion on this topic.

5.1.3 Choosing the Right RAW Converter

Nowadays, most image processing and image management software includes RAW conversion functionality.* Even the image browsing modules in today's operating systems can display a range of RAW formats – either as thumbnails or as full-size preview images. The Mac Preview application, and the Vista and Windows 7 Explorers are compatible with a number of Canon and Nikon RAW formats. Image Thumbnailer and Viewer [98] can be used to make earlier Windows versions RAW-compatible, too.

Different RAW converters have widely differing feature sets and performance, especially with regard to the quality of the images they produce, the range of RAW formats they support, and the speed with which they can convert and display image previews. You will often find that software that appears to be behind the times in one version is suddenly right up to date in its newest release. Improved workflow integration is at the top of many manufacturers' to-do lists.

Different manufacturers also have different product philosophies. Image browsers with built-in RAW conversion functionality generally concentrate on producing usable preview images and less on true image conversion. Converters such as Nikon's Capture NX or Canon's DPP only support their own camera brands, but always support the very latest models, whereas third-party converters such as Adobe Camera Raw, Lightroom, Capture One, RAW Developer, and Bibble try to support as wide a range of cameras as possible.

This chapter uses Adobe Camera Raw 6.1 as its reference tool. This program is a fast, solid converter that is supplied free with Photoshop and Photoshop Elements. It is not the best available in every respect, but it is nevertheless a useful yardstick.

The decision to use (or not to use) an all-in-one tool will also affect your approach to some aspects of the workflow. Even if you choose to use an all-in-one, you can always hand over images to other image processing applications, which then return processed TIFF, PSD, or JPEG files to your all-in-one for management.

We use Adobe Lightroom for basic workflow tasks, but nevertheless sometimes switch to Capture One when better highlight and shadow detail is critical to the job at hand. Capture NX often produces better results than Lightroom or Adobe Camera Raw with Nikon's proprietary NEF image format, and the same is also true of Canon's DPP and Canon RAW images.

Judging RAW converter quality is, of course, subjective – especially with respect to color interpretation. Some programs deliver better results than others when used with specific cameras. You might even find that a particular converter produces more pleasing results for a particular type of image.

* Including Photoshop, Photoshop Elements, Paint Shop Pro, PhotoImpact, PhotoLine 32, and GIMP

➜ The features we discuss for particular RAW converters are likely to be available in others soon.

The number and complexity of the image correction features built into RAW converters is increasing all the time – rotation, cropping, and even retouching functions are nowadays standard.

While this book focuses on Adobe Camera Raw, it also provides an overview of several other RAW converters. We will discuss the programs we like and hope you will find a suitable tool among them. We will use the following abbreviations in the course of the chapter:

ACR	Adobe Camera Raw [29]
LR	Adobe Lightroom [32]
AA	Apple Aperture [34]
C1	Capture One [43]
DxO	DxO Optics Pro [68]
LZ	LightZone [46]
CNX	Capture NX [47].
DPP	Canon Digital Photo Professional [41]
B5	Bibble Version 5.x [39]
RD	RAW Developer [45]
SDS	SilkyPix Developer Studio [44]

5.1.4 RAW Conversion Workflow

Figure 5-3 details the steps involved in converting RAW image files to a suitable processing format. It is debatable whether certain functions (such as image download) need to take place in the RAW converter. All RAW editors mentioned here (or their image browsers) can load images from various sources, e.g., from a folder of the file system, from the memory card in your camera or from the memory card in a card reader.

All current mid-range and high-end digital compacts and DSLRs are capable of recording images in JPEG (sometimes TIFF) and RAW formats. RAW image files contain all of the data captured by the camera's image sensor in an almost completely unprocessed form.

Many processing steps, such as white balance adjustment, tonal value corrections, and compensatory sharpening, are performed on JPEG and TIFF images automatically in the camera. With RAW images, these steps can be performed optionally and in a controlled fashion later using a RAW converter. In-camera RAW image data is not yet demosaiced to form an image made of full-color, RGB pixels.

RAW image data contains the full color depth in the captured scene, whereas JPEG images only deliver 8 bits of color information per color channel. Most DSLRs capture 12, 14, or even 16 bits of color information per channel; so RAW shooting formats can produce optimum image results using all the available data.

Image download

Preview and thumbnail generation

RAW / color interpolation, apply camera profile

Rotate images if necessary

Straighten + rough cropping (if necessary)

White balance

Adjust exposure

Tonality tuning

Contrast, brightness, and saturation corrections

Reduce noise, correct aberrations and other artifacts

Color adjustments (first globally, then locally)

Retouching

Lens corrections

Black-and-white conversion (optional)

Up- or downsizing (optional)

Sharpening (optional)

Convert/export to a standard format (JPEG, TIFF, PSD, etc.)

Figure 5-3: Steps in RAW conversion

5.2 **Important Aspects of RAW Processing**

Non-destructive Editing

All of the RAW converters listed here edit non-destructively. This means that they do not alter the original image file, but instead store changes made to the image in a separate file or in a database for all managed images (or both).[*] This not only preserves the original data, but also makes it simple to produce a new version of an image for processing. This is an important aspect of working with RAW image files, and the principle has now been adopted by some image processing programs for other file formats. Most of the RAW converters mentioned here can also process JPEG and TIFF files non-destructively.

The additional settings files are very small – typically between 5 and 15 kB per image or image version – and can thus be used to save multiple versions of a single image using very little disk space. This capability has been turned into an explicit feature in some programs – Lightroom calls image versions stored this way *virtual copies* and Capture NX simply calls them *versions*.

However, non-destructive editing does have its limits. It is not easy to permanently incorporate copyright information or other metadata into a RAW image file, and some RAW converters simply aren't capable of writing additional data to RAW files. In this case, additional data ends up in the file's separate "sidecar" parameter file. Apart from sharpening tools, RAW converters seldom include correction tools (such as Photoshop's Shadows/Highlights command) that alter multiple, neighboring pixels. Recent changes in Aperture, Lightroom, Bibble, and other converters lead us to think that this situation will change fairly soon.

* Some converters now store metadata and correction parameters directly in the RAW image file. The image data supposedly remains untouched, but the risk of damage to the original data is nevertheless increased using this method.

➜ If a file is available in DNG format, ACR saves metadata directly to the DNG file.

5.2.1 **Which Processing Steps are Performed Where?**

RAW conversion processes are largely divided into two different approaches, both of which have their followers:

▸ **Simple conversion with only a few additional processing steps**
 Here, the RAW converter converts an image to its processing format, interpolates the RGB pixel values, adjusts exposure and white balance, and possibly reduces image noise, vignetting and chromatic aberrations. All other processing steps are then performed either manually or using the tools, actions, plug-ins, and filters built into your preferred image processing program (e.g., Photoshop).

▸ **Complete conversion and processing in the RAW converter**
 Here, the user attempts to perform RAW conversion and as many of the corrections listed above using one and the same program. Photoshop (or other programs) are only used for a few fine-tuning steps. This approach is continually gaining new fans as RAW converters add new image editing functions and tools.

* In reality, cameras deliver images with only
12 or 14 bit color depth. Only a few medium
format cameras provide true 16 bit color
depth.

Of course, compromises are possible. The actual steps you perform using your RAW converter depend on the nature of the image you are processing and on whether you are processing a single image in detail or a batch of images with similar settings. If you are processing 8-bit images using Photoshop, we recommend that you make your more important, global corrections using your RAW converter, as 16-bit processing leads to less image quality loss than subsequent 8-bit processing*.

Pure (Linear) RAW Conversion

The term *linear conversion* has become the norm for describing pure RAW conversion. We don't see the need for this type of conversion in everyday photographic situations, but every RAW converter nevertheless has to be able to perform it internally.

A linear conversion converts the manufacturer/camera-specific RAW image data into RGB pixel data and alters the white balance and EV (*Exposure Value*) settings if necessary.

Figure 5-4: Linearly converted image

The result of a linear conversion is usually a very dark-looking image (figure 5-4), but this is the way **all**(!) interpolated RAW images look when the Bayer pattern has just been demosaiced.

In order to make such an image usable (figure 5-6), a tone curve like the one shown in figure 5-5 is applied. This is not the type of curve you would apply under normal circumstances, but it is the right one to use here. Such a curve can be adjusted to suit individual cameras and situations, but the basic form remains the same.

Figure 5-5: Typical DSLR tone curve

Figure 5-6: Image after applying the camera tone curve

5.2.2 What to Look for When Choosing a RAW Converter

Let's first take a look at the fundamental aspects of RAW conversion.

Color Interpolation or Demosaicing the Bayer Pattern

This is the single most important step in the RAW conversion process for cameras that work on the Bayer pattern principle.** With only few exceptions, this means all digital cameras. The Foveon sensors used in Sigma SD series DSLRs capture three colors of image data per pixel. There are large numbers of demosaicing algorithms available for interpolating Bayer pattern image data, and they produce results of widely differing quality. Generally, algorithm quality – and consequently image quality – is constantly improving.

The balancing act between preserving image detail and reducing noise is a difficult one, and no single RAW converter has the ideal solution. We are prepared to let fine details go for the sake of producing clean, sharp images shot at moderate ISO speeds. Most RAW converters on today's market are capable of producing acceptable results.

Camera Profiles and Tone Curves

RAW converters generally include usable generic camera profiles for all supported camera models. Camera profiles (section 3.4) describe the individual color characteristics of a camera. The most precisely formulated camera profiles do not necessarily produce the best images, and the newest versions of ACR have several profiles for each supported camera model – including one that simulates each manufacturer's own JPEG output.

A good tone curve will brighten shadow detail without sacrificing too much contrast or making shadow noise too obvious.

Some RAW converters allow you to add your own profiles or edit the ones they supply. Generating camera profiles requires additional software and a lot of know-how.

➜ Capture One and RAW Developer support the use of custom camera profiles. Our book [25] describes how to generate camera profiles.

There are two basic schools of thought regarding the use of camera profiles:

▸ Generalists believe that generic profiles produce adequate results.

▸ Perfectionists claim that you can only produce really great results using individually generated, camera-specific profiles.

We usually use the generic profiles supplied with our software, and we expect future versions of the programs we use to include profiles that are tailored to specific shooting situations. Generating custom profiles is complex, time-consuming, and usually not worth the effort, even for professional photographers. Adobe's DNG Profile Editor [31] is designed to make generating and editing camera profiles for ACR and Lightroom simpler, and it is available for free download at the Adobe website.

➜ You can buy or generate your own additional profiles for use with Capture One and ACR 5.x (and later).

White Balance (WB)

Suitable white balance settings are critical to the RAW conversion process. There are four basic ways to set white balance:

A) Using software sliders, usually based on a predefined base values and color temperatures (figure 5-8)

B) By gray balancing a neutral gray-colored area. This can usually be selected using an eyedropper tool. Examples of this method follow later in the chapter.

Figure 5-8: : White Balance in ACR

Figure 5-7: : Capture One white balance tool panel

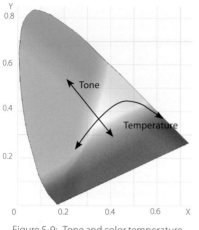

Figure 5-9: Tone and color temperature curves

➡ A histogram is a great source of visual information regarding the current state of your image.

➡ We will discuss Contrast later on. In most cases, we do not touch it.

C) Using presets that relate to typical lighting situations (figure 5-10).

D) Using the Auto WB function of the RAW editor (we usually avoid this)

Setting white balance is not a trivial task, and a good RAW converter will update all changes to the preview image in real time.

Figure 5-10: White balance preset offered by the ACR WB menu

Exposure

Correct exposure is vital in a digital image, so an essential part of a RAW converter's toolset is a histogram display that can show under- and overexposure warnings in all three color channels. Overexposure is much harder to correct than underexposure, so burned-out highlight detail is usually irretrievably lost. Expose carefully, and avoid overexposure at all costs. All of the RAW converters we use have functional exposure correction tools.

Figure 5-11: Exposure sliders in ACR 6

You can see in figure 5-11 that ACR's exposure sliders are arranged in a logical sequence that we usually follow when adjusting our images. We hardly ever adjust contrast here. We use the *Exposure* and *Recovery* sliders to set the white point and *Blacks* (also available Lightroom) to set the black point for our image. *Recovery* and *Fill Light* sliders are generally a standard RAW converter feature, even if they have slightly different names from program to program. *Recovery* tools are designed to recover burned-out highlight detail as far as is possible. *Fill Light* brightens shadows selectively without lightening highlights and midtones. We generally reduce the *Blacks* value before making *Fill Light* adjustments.

One of the RAW format's major advantages is that you can often rescue slightly under- or overexposed images using the *Exposure, Brightness,* and *Recovery* sliders. While *Brightness* slider settings affect the whole image, *Recovery* only darkens the highlights. Play with both sliders to see what results you get.

The degree to which you can recover overexposed image areas depends on your camera, how powerful your converter's tools are and the nature of the overexposure itself. High-end cameras often have a whole f-stop exposure reserve, or even 1.5 stops if only a single color channel is overexposed.

The left-hand histogram in figure 5-12 shows a strongly overexposed image shot using the default camera settings. The right-hand histogram shows a better exposure curve that we produced by reducing the *Exposure* value by 0.41 and adding a *Recovery* value of 37 (in Lightroom). The image

is rescued – if this had been a JPEG image, we wouldn't have been able to alter the burned-out highlights.

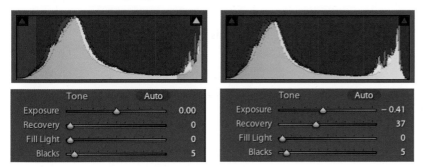

Figure 5-12:
The burned-out highlights in the left-hand histogram were eliminated using the Lightroom *Recovery* and *Exposure* sliders-

Most RAW converters include under- and overexposure warning functionality, allowing you to directly optimize exposure without risking additional color clipping. Activate the exposure warning and keep a careful eye on the image preview while you adjust your sliders. If you want to process an image later using Photoshop, be careful not to set restrictive black and white points – always leave some adjustment leeway at both ends of the histogram curve.

Histograms

In order to judge exposure and white balance correctly, a RAW converter's histogram needs to include individual red, green, and blue color channel displays that can be shown separately or simultaneously. The ACR histogram display includes two triangle icons at top left and top right that indicate when shadow and highlight clipping is present. The display also includes basic exposure

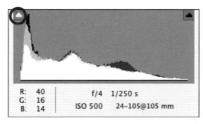

Figure 5-14: An ACR histogram. The non-black triangle at top left indicates that the image has clipped shadows.

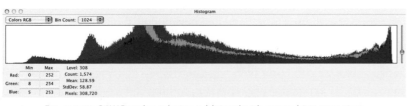

Figure 5-13: ACR overexposure (■) and underexposure (■) warnings

data and the RGB value at the current cursor position. ACR and Lightroom allow you to set the image black and white points directly in the histogram window, should you feel this is necessary.

RAW Developer [45] has particularly extensive built-in histogram functionality that includes a tool for adjusting the vertical scale of the histogram display (figure 5-15).

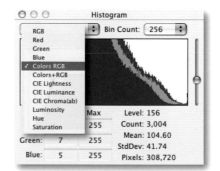

Figure 5-15: RAW Developer's histogram display, with the scaling slider on the right

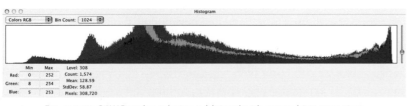

Figure 5-16: RAW Developer has an additional wide screen histogram view.

Figure 5-17: Capture One can display the histogram in line form.

This makes it easier to identify smaller burned-out highlight details. The RD histogram can also be "stretched" in order to make judging the shadow and highlight ends of the curve easier (figure 5-16).

The Capture One and RAW Developer histograms can be displayed as simple line curves, rather than as filled in curves, which can help you to judge finer exposure details.

Noise Reduction

RAW image noise should be reduced as soon as possible in the workflow (i.e., using your RAW converter) before it can be intensified by other correction steps. Although the quality of noise reduction offered by Photoshop plug-ins such as Noise Ninja [80] or Dfine [75] is better than that provided by most RAW converters, performing slight noise reduction early on in the workflow still helps to produce better overall results.

Some noise reduction algorithms are based on ISO and camera model EXIF data. Bibble has Noise Ninja's excellent noise reduction functionality built in. The quality of the noise reduction tools built into RAW converters is improving rapidly.

Reducing image noise usually reduces overall image sharpness (to some extent), resulting in close interaction between sharpening and noise reduction processes.

Removing Moiré and Chromatic Aberration Effects

Noise reduction and artifact removal are often lumped together as similar phenomena. The truth of the matter is:

▸ Image noise is caused during image capture by the image sensor, and is more pronounced in shadow areas.

▸ Image artifacts are caused by color limitations in the image sensor's Bayer pattern and the subsequent in-camera color interpolation. Other artifacts can also be produced by oversharpening.

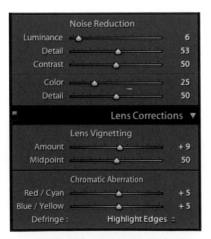

Figure 5-18: Lightroom 3 Noise Reduction and Chromatic Aberration correction tools

It is often difficult (or even impossible) to remove moiré effects using a RAW converter, so we often resort to using Photoshop instead (section 7.7, page 267). It is best to remove other lens-based artifacts, such as chromatic aberrations and vignetting, at the RAW conversion stage. ACR, Adobe Lightroom, Capture One, and Nikon Capture NX are all strong in this area. Lightroom and ACR even have separate *Luminance Noise*, *Color Noise*, *Chromatic Aberration*, and *Defringe* tools (figure 5-18). The latter is used to remove blooming effects caused by sensor elements overloading at high-contrast edges.

You can also reduce moiré effects in ACR and Lightroom by using the Adjustment Brush with a negative Clarity value. Capture One has its own dedicated moiré reduction tool.

5.2.3 Other Features of RAW Converters

We consider the following features essential in a good RAW converter:

Graphical User Interface (GUI)

The better the interaction between the software and the user, the better the results a RAW converter will produce. All of the tools listed here have fast-reacting, interactive user interfaces. Non-modal processes (page 34), as offered by Lightroom, ACR, and LightZone, are an advantage. Nikon Capture, for example, requires you to close one dialog before opening another. This is time-consuming and sometimes annoying, and makes this otherwise powerful tool less popular in some circles.

Color Management

All of the RAW converters we describe have full color management support. This includes:

▸ Support for monitor ICC profiles for preview images. A RAW converter should be capable of automatically loading the monitor profile installed in the system preferences.

▸ Support for embedding ICC profiles in output files. The minimum requirement should be a choice of sRGB, Adobe RGB (1998), and ProPhoto RGB target profiles. For output, the application either embeds the user-defined profile in the image file or converts the image to one of the other available profiles. The number of available output profiles varies widely from program to program, but ideally, your converter will support all color spaces installed on your host system.

Figure 5-19: RAW Developer includes a range of standard profiles and can convert data to all color spaces installed on its host system.

RAW Browser

Nearly all RAW converters include browser functionality for viewing RAW image files before they are converted. Photoshop, Bridge, and ACR form a complete RAW processing toolset (section 2.7, page 51) in which ACR generates the preview images that are displayed in Bridge. If necessary, Bridge can be set up to display only RAW images. RAW browsers are also useful for transferring selected conversion settings from RAW-edited image files to other, similarly exposed images.

RAW Developer, Apple Aperture, Lightroom, and Capture NX allow you to view and compare images side by side, and others are sure to add similar functionality soon. A loupe function is nowadays a standard feature, helping you to view image details without changing magnification of the entire preview. Bridge introduced a loupe function in version CS5 (figure 5-20), and Apple Aperture has the best implementation of this feature that we have seen so far.

Figure 5-20: A loupe helps you view individual image details even in the smallest preview window.

Preview Image Size

Typical Preview thumbnails are not large enough to allow you to judge the quality of an image. You need a larger preview window in order to correctly judge image sharpness, contrast, saturation, and color. ACR/Bridge, Capture One, RD, and several other programs provide preview images that are large enough so you can make an initial judgement regarding the quality of your images. Preview images should have at least the same resolution as your monitor.

A real-time preview of image corrections saves time during the work-flow, but large preview images do use more disk space. You can set your program preferences to delete preview images after a certain period of time, but saving preview images permanently saves time and improves overall performance. Preview images are usually saved in a compressed JPEG format. Deleted preview images have to be regenerated from RAW image files, which takes time and requires a lot of computing power for large collections of images.

Saving and Applying Image Settings

Quality RAW converters allow you to save your conversion or adjustment settings in order to apply them to other images.

The programs listed in this book all allow you to cut and paste selected settings from one image to another (with varying degrees of simplicity). All-in-one tools also allow you to apply RAW image settings to images saved in other formats. Some programs include functionality for cutting and pasting metadata and keywords, which saves time when you are cataloging your stock of images.

Selective Image Corrections

Selective corrections – such as creative sharpening or brightening of shadow areas – can be applied using very little disk space in a RAW converter. Removing blemishes caused by dust particles on the image sensor by copying neighboring pixels is a selective correction that we apply regularly. Because these types of corrections are applied non-destructively using parameters that are saved separately from the image data, they are easy to save and apply to other images, too. (If there are dust particles on your image sensor, they will probably be visible in all the images from a particular shoot.) You can then fine-tune each image separately if the transferred settings don't suit your other images.

Aperture, Lightroom, ACR, LightZone, Nikon Capture NX, and most other up-to-date RAW editors allow you to simply retouch small blemishes using brush tools or soft-edged, lasso-style selections.

These types of correction require a lot of computing power in order to refresh image previews in real time. If you can't immediately see the effects of your corrections, you will tend to over-correct, which is frustrating and

| Sync Metadata | Sync Settings |

Figure 5-21: Lightroom allows you to apply image adjustments and metadata to other image files.

time-consuming. So, be patient when performing image corrections. Photoshop *Layers* techniques (chapter 7) are one way of working around such limitations. As computing power increases, future RAW converters are sure to include increasingly complex correction tools.

Batch Processing

Many jobs produce sequences of images that require the same white balance and exposure settings (and similar corrections). In such cases, batch conversion can save time and effort. The very simplest approach is to convert all images in a shoot to TIFFs or JPEGs using your RAW converter's default settings. A more advanced approach is to correct a prototype image of a sequence, apply its settings to all the other images, and finally batch-convert them.

Batch processes usually run in the background, but nevertheless can use up a lot of computing power. If you are using a laptop or other less powerful computer, it is better to run batch processes once you have finished making other, processor-hungry corrections. RAW Developer has specific settings for controlling batch processes, but these are not yet available in ACR. We often need to produce multiple versions of an image in different formats or resolutions during conversion – functionality that is supported by Capture One, Bibble, and Capture NX as part of the batch conversion settings.

All-in-one tools generally leave RAW images in RAW format, and applying settings from other images only involves a set of previously saved parameters – a process that doesn't cost too much processing power. Image export is a CPU-hungry process and should therefore be set up either as a background process or as a set of parallel processes. For this reason, most all-in-one programs farm out batch processes to their export modules.

➡ Images can be optimized in ACR without having to open them in Photoshop first. You can convert your images simply by selecting them in Bridge and applying the Tools ▸ Photoshop ▸ Image Processor command.

Printing from a RAW Converter

A powerful print module is an essential part of any all-in-one workflow tool. Whether you use your RAW converter for making anything more complex than a test print depends on the way you work. Most high-end prints that you want to optimize and add a frame or a signature will require you to use Photoshop or some other high-end image processor. With the exception of Lightroom and Aperture, we only make prints in Photoshop or a specialized print application or RIP (RIP, see section 11.7, page 451).

Integration in the Workflow

We consider the degree to which we can integrate a RAW converter into our workflow critical to its value. This view is, of course, subjective, but we consider Capture One Pro (with its fast, real time preview and background processing support) to be the best currently available converter. ACR's in-

➡ Keyboard shortcuts and scroll wheel-based zooming and editing are essential tools for an efficient workflow.

tegration with Photoshop and Bridge makes it a powerful tool too. RAW Developer is our current favorite among Mac-based converters.

Image Browser Integration

Most of today's RAW converters and browser tools with RAW support (such as Photo Mechanic, Breeze, Extensis Portfolio, iMatch, and Phase One's Expression Media DAM systems) allow you to preview RAW images before you convert them. All-in-one tools offer the best integration of image browsers and databases.

We would like to see better image management integration for RAW converters and functionality that logically groups image versions that only differ from each other in respect to their current adjustment state. (Deleting an image version does not and must not delete the associated original!)

Multi-Core Processing

➜ Photoshop has supported some multi-core processors since the release of CS. Lightroom uses separate processes for importing and exporting images, and for generating image previews – an indicator in the main program window then tells you which background processes are currently in progress. We would like to see more multi-processors support in future.

Since early 2006, nearly all new notebook and desktop computers are equipped with multi-core processors (and sometimes even with multiple processors). Multi-core processors counteract the endless spiral of ever-increasing processor speeds and the associated increased heat generation. Multi-core processors are an advantage for performing CPU-hungry image processing tasks. Provided that your RAW converter and your image processing software are capable of taking full advantage of the new technology, multi-core processors refresh preview images faster and allow you to process images while others are still being imported in the background.

Multi-core support also makes other background processes (such as RAW conversion itself) faster without limiting overall processing power. Multi-core processors make image correction processes perceptibly faster. Capture NX and Canon Digital Photo Professional do not yet support multi-core processors and are relatively slow as a result. But Lightroom and Aperture still have room to improve in this respect – here, too, we hope that future releases will address these issues.

Arguments For and Against Auto Correction

The auto functions built into many of today's RAW converters have advantages and disadvantages, but we generally avoid using them.

The main advantage is that auto settings quickly produce generally usable images that you can either apply directly or as a basis for further corrections.

The disadvantage is that the algorithms that drive auto functions cannot be adjusted and sometimes produce results that don't suit the image purpose at all. For this reason, we usually deactivate ACR's auto correct functionality (page 158).

Figure 5-22: ACR includes a number of Auto corrections.

5.2.4 Other Useful Features

Many of the correction tools that used to be the exclusive preserve of
Photoshop or image processing plug-ins are now an integral part of today's
RAW converters. You will have to decide for yourself whether these are use-
ful to your own personal workflow, but you can always simply ignore them
if they are not what you need. If you intend to convert your RAW images to
8-bit JPEG rather than to 16-bit TIFF, editing the RAW version will usually
lead to less image quality loss than if you correct your JPEGs later.

Image versions and snapshots • You will often want to try out different
conversion settings or work on multiple versions of the same image. Only a
few RAW converters offer versioning functionality, among them Nikon
Capture NX, Aperture, Lightroom, and Bibble 5. Lightroom addresses this
issue with its elegant *virtual copy* system. Here, the original image remains
untouched, and each copy consists of an additional set of separately stored
correction and settings parameters.

Figure 5-23: Two versions of an image. The
image file itself is only present once, but it
has two stored sets of correction parameters.
These are Lightroom preview thumbnails.

The Photoshop *snapshot* system makes a temporary copy of a particu-
lar image state that you can then recall at any time during a session.
Lightroom, LightZone, ACR, and Capture NX have similar functions.

Some converters allow you to step back through the corrections you
have made (usually using ⇧-Ctrl-Z / ⇧-⌘-Z).

Image upsizing • If you want to print your images in large formats, enlarg-
ing (or *upsizing*) them at the conversion stage often produces better results
than subsequent enlarging. Some RAW converters have upsizing function-
ality built into their conversion processes – Adobe Camera Raw and RAW
Developer both produce very good upsizing results.

Cropping and rotating • Cropping an image at the conversion stage pro-
duces a smaller image file that is then easier to handle during subsequent
correction processes. All RAW converters have crop and rotate tools.

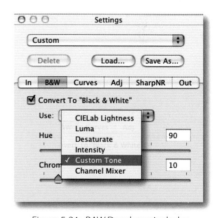

Figure 5-24: RAW Developer includes
six different black-and-white conversion
variations.

Black-and-white conversion • We love monochrome images, but we al-
ways shoot them in color, even if our camera has a dedicated black-and-
white shooting mode. Most RAW converters have built-in monochrome
conversion functionality, and ACR and Lightroom have the best of the
bunch. RAW Developer includes a total of six different black-and-white
conversion variants. Black-and-white RAW conversion is discussed in more
detail in section 10.7, page 406.

Tone curves • RAW converters often include tone curve functionality like
that found in Photoshop. This often includes a range of preset curves with a
more or less pronounced S-curve for adjusting midtone contrast.

Using Color Samplers • It is very useful to see the effect of a particular
color adjustment on other colors in an image. ACR allows you to place up to
nine *color samplers* in a preview image, whose RGB values are then dis-
played and adjusted in real time.

Figure 5-25: : ACR allows you to place up to
nine color samplers using 🗛.

Adaptive tonal value adjustments • Tone curves are not always the most intuitive method for making selective tonal adjustments. Adaptive tools (similar to the Photoshop Shadows/highlights tool) that take neighboring pixels into account are often easier to use. The *Fill Light* and *Recovery* sliders found in ACR, Lightroom, and most other converters are good examples of easy-to-apply adjustments.

Lens corrections • Even the best photographic lenses produce visible optical errors. You can correct them using your RAW converter or later in Photoshop. These errors include:

▸ Vignetting (darkened image edges)
▸ Distortion (usually in "barrel" or "pincushion" form)*
▸ Chromatic aberrations
▸ Perspective distortion due to acute shooting angles or ultra-wide-angle (or fisheye) lenses

* Bibble, Canon DPP, Nikon Capture NX, DxO, Lightroom 3, and ACR (as of 6.1) all include this type of function.

The decision regarding what to correct and where depends on the availability and quality of the tools at your disposal. Built-in, profile-based lens correction tools are still rare in RAW converters.

Vignetting is seldom a critical factor with our own lenses, but where it is present, we perform the basic correction for this and chromatic aberrations using our RAW converter. We then perform other, finer corrections using Photoshop or specialized plug-ins.

➡ DxO Optics Pro [68] is a highly specialized lens correction program that includes a good quality RAW converter. The program is based on specially generated camera/lens profiles and corrects perspective distortion cleanly and effectively. Silkypix also includes perspective distortion correction tools.

The range of correction tools available in RAW converters is continually expanding to meet demand. The most flexibility is required if you want to produce finished images for Web, slideshow, or print output directly in an all-in-one environment. The advantages of all-in-one tools are non-destructive image editing, effective use of disk space, and the fact that you don't have to switch programs to complete image processing. Most all-in-one implementations are not as intuitive as Photoshop layers and masks – at least, not for those of us who are used to the "old way" of doing things.

We would still like to see better integration of panorama and HDR tools into the workflow. Lightroom and Photoshop are made by the same manufacturer, and as a consequence, the newest versions are increasingly well integrated concerning the HDRI and panorama functions of Photoshop.

➡ Selective corrections and sharpening require a lot of computing power in order to function smoothly and produce real time preview updates.

Multiple monitor support • Multiple monitor setups are the norm on most professional and semi-professional digital photographic desktops. Most image browsers allow you to place the preview window on your main monitor while placing your tool panels and other settings windows on a secondary screen. RAW converters are still not as capable, mostly offering single-screen solutions like the one found in ACR. Aperture, Bibble 5, Lightroom, and Capture One allow you to place the preview window on a second monitor, while Aperture and SilkyPix allow you to place the tool panels elsewhere on the desktop. RAW Developer, Bibble, and Capture NX are full-fledged multi-monitor applications. Again, we hope that future versions will introduce improvements in this arena.

RAW Conversion Workflow Sequence

Figure 5-26 illustrates the basic corrections, steps, and settings involved in the RAW conversion process. The sequence is not set in stone and can be varied to suit the image(s) being processed. The demosaicing step is only included for completeness' sake, as it happens automatically and doesn't involve any user intervention.

The "correct" sequence for straightening and correcting white balance or exposure is widely debated. We prefer to straighten and crop our images first, as this often eliminates image areas that no longer need to be corrected. If a strong exposure correction is required, we often perform a preliminary correction in order to gain a better overall impression of our image before we adjust white balance.

Most RAW converters perform automatic compensatory sharpening in order to give the user an idea of the "real" look of an image. If your converter doesn't sharpen automatically, you may have to bring the sharpening step forward in the conversion sequence.

The sequence illustrated in figure 5-26 doesn't completely account for the selective corrections that are becoming increasingly available in RAW converters. For example, if we are processing an image that includes an overexposed sky, we use ACR or Lightroom to add a graduated filter relatively early in the workflow. We then perform all our other adjustments on the corrected version of the image.

We only perform the final sharpening, scaling, and conversion/export steps when we are sure that we don't want to make any further adjustments (e.g., in Photoshop or LightZone). If you use an all-in-one program, these steps usually don't apply, as you simply leave your image files and their accompanying corrections and settings in their native RAW format and only convert (render) images on demand, e.g., to work on them in Photoshop, to pass them on to another application, to print them outside the all-in-one application or to pass them on to another user or customer.

Non-modal application architecture (as explained on page 34) helps to keep the workflow smooth if we need to switch between multiple image versions or states during complex editing processes.

Figure 5-26: Steps involved in optimizing and converting RAW image files

5.3 Adobe Camera Raw (ACR)

Adobe Camera Raw (ACR for short) is Adobe's own RAW converter and has been included with Photoshop since CS1 was released. It is probably the most widely used RAW converter on today's market. It is fast and effective, and produces great results for a broad range of camera models. The program is, of course, very well integrated with Bridge and Photoshop. ACR and Lightroom are based on the same core software, and both programs are updated simultaneously when new improvements are introduced. This also means, that what you learn about ACR can directly be applied to the operation of Lightroom. ACR is also part of Photoshop Elements, but in a version that doesn't include all of the settings available in its sister program.

This section explains a typical RAW conversion workflow using ACR. The basic steps are the same as those used in most other converters, and ACR includes most of Lightroom's conversion features, albeit packed into a different user interface.

You can use the Camera Raw options in Bridge or Photoshop to configure ACR to process JPEG and TIFF images non-destructively. ACR can process a wide range of RAW formats when used in conjunction with Photoshop and Bridge – a range that is quickly updated by Adobe whenever new DSLRs hit the market. None of the other RAW converters discussed here supports more. Adobe is always very quick to release updates to support newly released cameras manufactured by Canon, Fuji, Kodak, Nikon, Olympus, and Sony, as well as those from niche manufacturers such as Leaf, Leica, Panasonic, Pentax, and Sigma.[*]

Adobe Camera Raw has full color management support that automatically extracts monitor profiles from the system settings and uses generic camera profiles for all supported camera models. As of version 5, ACR also supports custom (DNG) camera profiles that can be created and edited using Adobe's free DNG Profile Editor (page 184).

The ACR window is divided into five main areas (figure 5-27):

Ⓐ Main preview window
Ⓑ Image adjustment tabs
Ⓒ Toolbar
Ⓓ Zoom level settings
Ⓔ Workflow Options button
Ⓕ Filmstrip (only present when multiple images are opened)

Most interaction with the program occurs via the image adjustment tabs Ⓑ. These are arranged to represent a usable workflow sequence, with the functions used less often at the right. The tabs are labelled as follows:

→ ACR 5.x only works with Photoshop CS4 or Photoshop Elements 5 and later. ACR 6 only works with Photoshop CS5.

* A list of all supported cameras can be found at www.adobe.com/products/ photoshop/cameraraw.html.

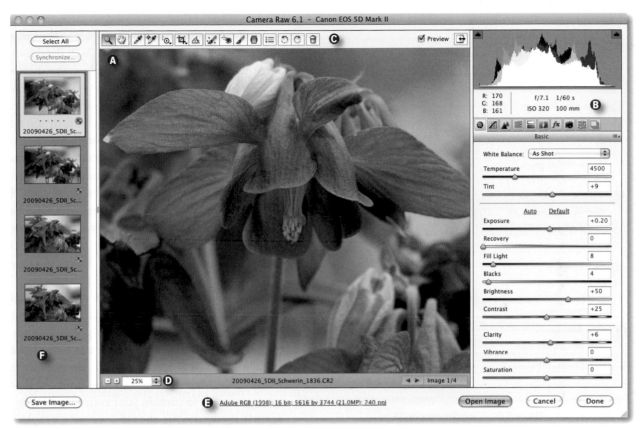

Figure 5-27: The ACR 6.x main window shows the *Basic* panel and four automatically opened RAW Images.

- *Basic*
- *Tone Curve*
- *Detail* (for sharpening and noise reduction)
- *HSL/Grayscale* (for selective color tuning and grayscale conversion)
- *Split Toning* (mainly for tinting grayscale images)
- *Lens Corrections* (Lens distortion, chromatic aberrations, fringing, vignetting, perspective*)*
- *Effects* (for adding grain and post-crop vignetting)
- *Camera Calibration* (for loading alternate camera profiles)
- *Presets*
- *Snapshots*

We will describe each toolset in detail, starting with the default *Basic* tab.

ACR Preferences

You can set your ACR preferences in Photoshop (Preferences ▸ Camera Raw), in Bridge (Edit ▸ Camera Raw Preferences), or in ACR itself by clicking the Preferences button ▤ in the toolbar ©. The resulting dialog is always the one shown in figure 5-28 (next page).

work through the entire session in the ACR environment without having to return to Bridge to open each image individually. This also makes it easier to copy and apply settings from one image to another – we will explain how later.

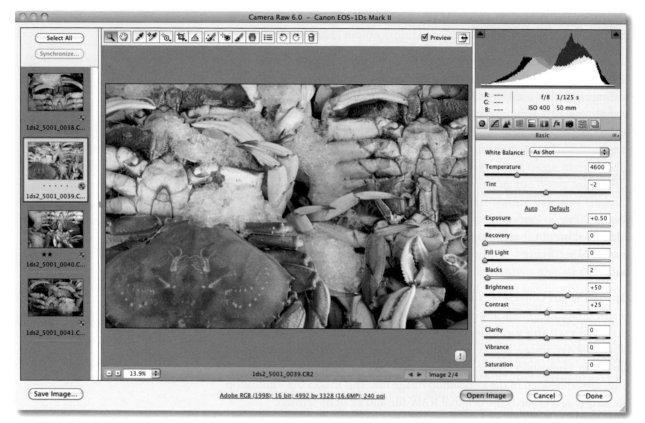

Figure 5-33: ACR 6.0 in *Filmstrip* mode. This image was shot in the shade, and the camera's auto white balance has given it a blue cast.

ACR's Filmstrip mode gives us fast, direct access to all images in a shoot via the ACR interface. We can view our images consecutively at full-screen size without having to wait for the previews to generate.

Initial White Balance Adjustments

Adjusting white balance is usually the first step we take in our RAW workflow. Adjusting white balance (with RAW files) at this stage does not involve any additional image quality loss.

We shot the crab image in figure 5-33 in the shade using auto white balance. Most digital cameras cannot compensate for this type of situation and our image ended up with a blue cast. ACR displays the image using the *As Shot* white balance setting.

If circumstances allow, we try to take a second shot of a Mini Color-Checker (or some other gray reference card). It wasn't possible, so we have to use other methods to get our image back on track. Fortunately, this type

Figure 5-34: ACR White Balance setting
for figure 5-33

of image doesn't demand that we make a physically correct white balance setting, but only that we adjust the colors until they look right. We use the eyedropper ✒ to select the ice in the preview image as our reference white (figure 5-36). Figure 5-35 shows the resulting White Balance settings.

Figure 5-35: The White Balance settings after selecting the ice using the eyedropper

Figure 5-36:
The same image after using ACR's White Balance eyedropper to select the slightly gray ice as a white reference

Our eyedropper white balance setting gives us a good starting point for further adjustments- We now set color temperature to 5800 K (Kelvin) in order to slightly reduce the yellow tones.*

* This is, of course, a subjective adjustment and reflects our own personal taste.

Figure 5-37:
The image from figure 5-36 after setting *Temperature* to 5800 K

Use the *Temperature* slider to set the color temperature that should have been used to take the photo. Higher values result in warmer tones, although they actually represent colder colors. This situation is slightly counterintuitive, but relatively easy to get used to.

5.3.2 Synchronizing Image Adjustments

Figure 5-38:
The image with the
blue frame is our
master image.

Because the rest of our crab pho-
tos were shot in identical light, we
would like to apply the same white
balance settings to them. This is
where the *Synchronize* tool comes
into play.

We leave our reference image
selected and select the others we
want by ⇧-clicking them. The
master image is indicated by its
blue border (figure 5-38).

We then click the Synchronize
button (figure 5-38), which dis-
plays the dialog shown in figure
5-39. We select *White Balance* as
the only setting to synchronize
and click *OK*. This transfers the
master white balance setting to
the other selected images while
leaving all other settings un-
touched.

It is, of course, possible to add
any mix of settings to your selec-
tion, and we make regular use of
this feature during our workflow.

You can save selected combi-

Figure 5-39: Synchronize defines which
settings you want to transfer.

nations of settings using the *Save Settings* option in the flyout menu at the
right of the *Basic* tab title bar (figure 5-40). The *Save Settings* dialog is al-
most identical to the one shown in figure 5-39). You can then select the in-
dividual settings that you want to save and give them an appropriate name.
Once saved, your new preset will appear in the flyout menu alongside the
program's standard settings options and can be applied to any image(s) in
the filmstrip.

Presets are saved as XMP files, and we recommend that you save them
to the default location suggested by ACR.

Figure 5-40: This is the flyout menu
used to save and recall image settings.

5.3.3 Optimizing Dynamic Range

Although we usually avoid using any tools with the prefix "Auto" in their
names, we do use ACR's Auto adjustments to provide us with a basis for ad-
justing tonal values. This tool can produce usable results and is toggled on
and off using Ctrl/⌘-U.

This time, we use the third in our sequence of crab shots. This image is
a little underexposed, as you can see in figure 5-41.

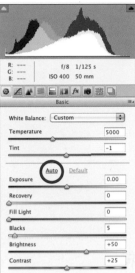

Figure 5-41: Our image before applying Auto adjustment

Auto adjustment produces the result that you see in figure 5-42. This version of the image is a good starting point for additional fine-tuning.

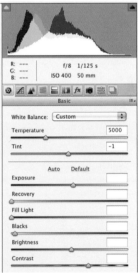

Figure 5-42: Our image after applying Auto adjustment

We then increase the *Exposure*, *Blacks*, *Brightness*, and *Contrast* values manually. The aim of our adjustments is to retain as much shadow detail as possible while keeping contrast low enough to leave us some leeway for fine-tuning later using Photoshop.

For this image, we also brighten the shadow areas slightly using the *Fill Light* slider. If the histogram shows shadow clipping, we adjust the *Blacks* slider while holding down the Alt/⌥ key to see where clipping starts and

whether it actually spoils the image. Reducing the *Blacks* value slightly often helps to reduce shadow clipping.

We now slowly increase the *Fill Light* value while keeping an eye on potential clipping using the Alt/⌥ key. Too much *Fill Light* quickly makes and image dull and lifeless. Figure 5-43 shows our image before and after applying some *Fill Light*.

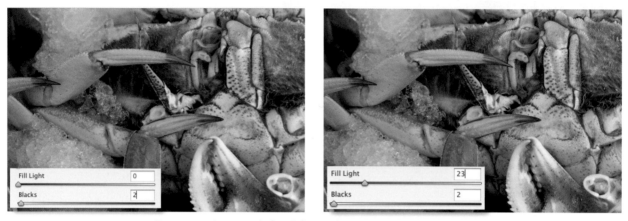

Figure 5-43: Our image before (left) and after (right) adding some *Fill Light*

Adjusting the *Saturation* and *Clarity* values in the *Basic* tab can improve an image, but we usually make these adjustments after we have fine-tuned the tone curve in the 📈 tab – or later in Photoshop.

5.3.4 Image Optimization Using Tone Curves

You can further refine the tonal range of your image using the *Tone Curve* 📈 tool (figure 5-45, page 165). ACR offers a choice of *Parametric* and *Point* curves. Point curves can be adjusted using presets from the tool's menu or manually, the same way we do when we are using the Photoshop *Curves* tool (figure 5-44). We often use the default *Medium Contrast* preset or select the *Linear* preset if we want to make additional corrections later in Photoshop.

The point curve tool is more powerful than the parametric curve, and you can even use negative gradients to produce tone inversions. But be careful as it is very easy to skew colors using curves. For this reason, we usually limit ourselves to using the parametric curve (if we use curves at all).

In our crab image, we use the *Highlights* slider to brighten the image slightly. Additionally, we shift the right-hand marker (located beneath the curve display) slightly to the right to limit the range of values the change is applied to. This makes the ice in our image slightly brighter. The triangular markers beneath the display also limit the range of values the *Highlights*, *Lights*, *Darks*, and *Shadows* sliders affect.

We can now return to the *Basic* tab to make our final adjustments to the *Contrast* and *Clarity* values.

Figure 5-44: *Medium Contrast*
point curve

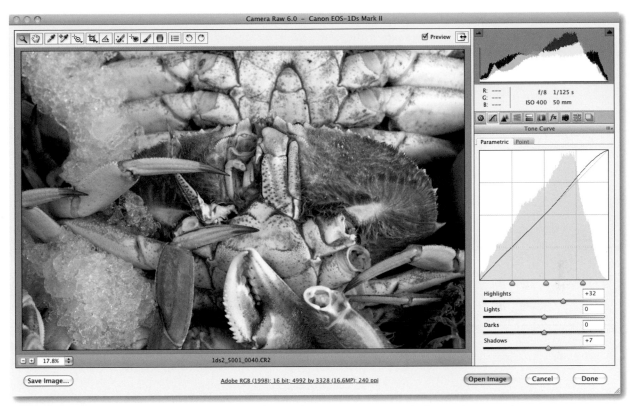

Figure 5-45: Brightening the highlights within a narrow range using the *Parametric* curve tool

5.3.5 Selective Tonal Corrections

Skipping the *Detail* tab for now, we intensify the red of the crab's claws using the tools included in the *HSL/Grayscale* tab ≣ (figure 5-47). Here, we perform three simple corrections:

▸ We increase the saturation of the red in the crab's claws.
▸ We increase the luminance of the brown tones.
▸ We slightly reduce the blue saturation in the ice.

To do this, we switch to the *Saturation* tab and select the *Saturation* option in the *Targeted Adjustment* ⊙ tool menu (figure 5-46). The mouse cursor then displays a small cross adjacent to the bullseye (⊙).

We place the cursor on the red of the crab's claw and drag it upward (holding down the mouse button). This increases the saturation of the selected red tone. We then do the same for the blue of the ice, but this time, we move the cursor downward to reduce saturation. ACR automatically adjusts the appropriate sliders when you make this type of adjustment.

Figure 5-46: The flyout menu for the *Targeted Adjustment* tool includes several options.

Figure 5-47: These sliders limit the effects of adjustments to particular tonal ranges.

Finally, we switch to the *Luminance* tab and move the cursor to a brown area on the crab's shell, where we increase luminance by dragging the mouse up. Figure 5-47 shows the resulting slider positions in the *Saturation* tab, and figure 5-48 shows our image before and after making the corrections we have just described. The difference is subtle but effective.

Don't forget to deactivate the *Targeted Adjustment* tool once you have finished using it (e.g., by activating the loupe). If you do forget, the curious results of using your mouse will quickly remind you of your oversight.

Figure 5-48: Our image before and after making tone corrections in the HSL/Grayscale tab. The red of the crab's claw has been intensified.

5.3.6 Saving and Discarding Changes

* If there are multiple images displayed in the filmstrip, the button text changes to Save Images and Open Images.

We have now finished making adjustments, so we close ACR using the Save Image, Open Image, Cancel, or Done buttons.* These buttons have the following effects:

Figure 5-49: ACR's four basic action buttons

Figure 5-50: Defining the output format, the filenames, and the location of converted files

Save Image... • Starts background conversion of the selected image(s), allowing you to continue to work on other images. The images are saved using settings you make in the dialog shown in figure 5-50. Clicking this button does not close ACR.

Stop! Make sure you have selected the appropriate color space, color depth, and resolution settings before saving your images (see *Workflow Options*, page 158). Only then should you click

Save Image and make the settings shown in figure 5-50 before clicking *Save* to start the actual conversion process.

Done • Confirms all adjustments (including image deletions) and saves them to the ACR database or your files' XMP sidecar files (section 1.9, page 30). When you click Done, images are not converted to other formats.

Open Image • Functions the same as the Done button but converts your images and automatically opens them in Photoshop. Pressing the ⬆ key while pressing the button converts it into the Open Object button – this then automatically opens the selected image as a Smart Object. (See section 7.12, page 274 for more details on Smart Objects).

Cancel • Discards all adjustments you have made. If you press the Alt key, Cancel will switch to Reset, allowing you to undo all your adjustments without closing ACR.

1ds2_5001_0038.CR2	Jan 10, 2009 7:48 PM	16.2 MB	Canon Camera Raw file
1ds2_5001_0038.xmp	Jan 11, 2009 3:01 PM	8 KB	Text
1ds2_5001_0039.CR2	Jan 10, 2009 7:48 PM	16.9 MB	Canon Camera Raw file
1ds2_5001_0039.xmp	Jan 11, 2009 3:01 PM	8 KB	Text
1ds2_5001_0040.CR2	Jan 10, 2009 7:48 PM	15.1 MB	Canon Camera Raw file

Figure 5-51:
A folder showing RAW images and their accompanying XMP files

You can now continue to optimize your images either individually or as a batch using Photoshop.

Pressing the Alt/⌥ key switches the Open Image button to Open Copy and Save Image (with its options dialog) to a version of Save Image that converts your image(s) without making any further settings. The Alt/⌥ key also switches the Cancel button to Reset – this resets all adjustment tools to their default values.

5.3.7 An Overview of the ACR Interface

This section addresses a number of tools that we didn't use in our example.

The ACR interface is clearly structured and easy to use. The *Toggle full screen mode* button (figure 5-52 Ⓐ 🔁), introduced with Photoshop CS4, does exactly what it says.

Preview refresh in full-screen mode can be slightly slower than normal, but it also depends on how powerful your computer is. We don't usually have any problems with preview lag, even when we are using a large window.

Temporarily deactivating the *Preview* option in the toolbar (to the left of Ⓐ) allows you to switch between before and after image views.

The ACR filmstrip panel is only visible if you are processing multiple images. You can hide it temporarily by dragging its right-hand frame bar.

➜ As with most selective adjustment tools, the preview image refreshes slowly, requiring you to work slowly and methodically. The more selective adjustments you make, the longer the refresh times will become.

Red Eye Removal Tool • This tool is self-explanatory. Once you have drawn a circle around your subject's pupil, you can adjust *Pupil Size* and the *Darken* parameter (figure 5-59). The tool only functions if enough red is present, and it doesn't work for the yellow-eye effects that sometimes appears when you are photographing animals.

Figure 5-59: Red Eye Removal Tool's controls

Adjustment Brush Tool • Available since ACR 5, this tool allows you to selectively paint multiple adjustments into an image from the selection shown in figure 5-60. The sliders also allow negative values, making it possible to darken a specific image area, or to apply deliberate defocusing effects using negative *Clarity* values. The latter is very effective for disguising pores in portrait shots.

The *Color* slider is used for adding color selected in the color picker field on the right. A zero saturation value makes the color transparent.

The brush tool has the same *Size*, *Feather*, *Density* (*Opacity*), and *Flow* parameters as Photoshop's Brush tool. The breadth of the *Feather* setting is shown by a second, concentric circle in the cursor icon (see also the description of the Photoshop Brush tool, page 288). You can adjust the brush size by right-clicking and moving your mouse left or right. Adding the ⇧ key to the mix allows you to adjust the *Feather* setting.

We recommend that you use a *Density* setting of less than 100% in order to apply your effects more subtly. You can always apply an effect again if it is not sufficiently strong. You can apply multiple brush strokes using the same settings. If you have a pressure-sensitive graphics tablet, you can adjust the *Density* setting by increasing stylus pressure.

If you click the *New* button to start a new adjustment, ACR places a pin in the preview where your last adjustment was made.

The settings that belong to a pin can be adjusted for as long as a pin is active by clicking on it and moving the sliders. Deactivating the *Show Pins* option hides the pin icons in the preview display but doesn't undo the corrections.

The *Auto Mask* option searches for edges within the adjustment area and confines brush strokes to areas of a similar color. The *Show Mask* option displays the automatically masked areas in gray.

You can erase adjustments you have made by selecting the *Erase* button or by pressing the Alt key and applying the brush.

As with all selective adjustments, using the Adjustment Brush requires a lot of computing power, so you will have to work methodically if you want to avoid overadjusting while you wait for the image preview to refresh.

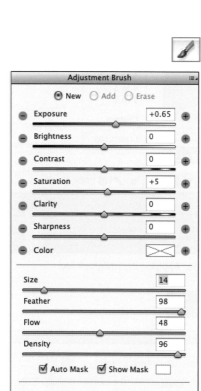

Figure 5-60: The Adjustment Brush Tool has a large number of controls.

The Adjustment Brush and the Graduated Filter tools described in the next section are very useful but still cannot be quite as selectively or subtly applied as Photoshop layer masks. We usually use the Adjustment Brush to darken overexposed highlights, brighten shadows, or selectively improve microcontrast (using a positive *Clarity* value).

Graduated Filter Tool • This tool , introduced with ACR 5, applies effects gradually across all or part of an image (figure 5-62). In addition to the other settings that we already know from the Adjustment Brush, this tool has start, end, and direction parameters.

The most common uses for this type of adjustment are for darkening skies that are too bright or for brightening shadows that are too dark in comparison to the rest of an image. In order to darken a bright sky, we position the cursor at top center of the frame and drag it down to just below the horizon. You can add multiple filters by clicking the *New* button once you make your first setting.

The cherub in figure 5-61 is too darkly lit from below. To cure this we place an inverted graduated filter with an increased *Exposure* value at the bottom of the frame (figure 5-62).

→ Using the Adjustment Brush Tool requires some practice before you can apply it effectively.

Figure 5-61: The cherub is too dark at the bottom.

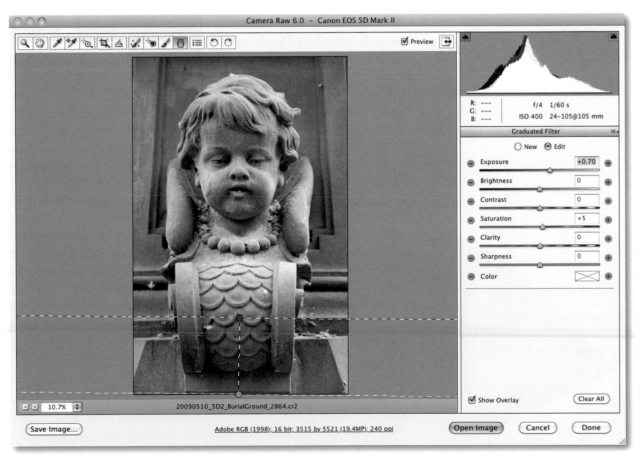

Figure 5-62: Settings for a vertical graduated filter, from bottom (the green dot) to top (the red dot)

Figure 5-66: ACR's Basic tab

Figure 5-67: Clipped highlight warning (in red)

→ Exposure and Recovery function additively. The amount of overexposure that you can repair depends on whether all channels are affected, on your camera model, and on the effectiveness of its ACR profile.

Adobe Camera RAW does, of course, offer white balance adjustment at the click of a mouse. Simply click the white balance eyedropper button 🖊 (found in ACR's toolbar) and then use it to click on a white or neutral gray image area. Make sure that you don't select a detail-free, burned-out highlight. ACR will automatically set the correct color temperature and tint.

If possible, we make a test shot of a color or gray reference card under the same lighting conditions as the rest of the shoot. We can then use this as a basis for correcting all images shot under the same conditions. We then save the resulting white balance settings for use with other images (we describe how to do this later).

Even if they don't quite produce the results you are looking for, the white balance presets built into ACR are nevertheless a good starting point for your own manual adjustments. The *Auto* setting is always worth a try, but remember to reactivate the eyedropper before making a new selection. Please also read our notes on the subjectivity of white balance settings (section 1.5.4, page 15).

Exposure, Recovery, Blacks, and Fill Light Sliders

Exposure • This slider helps you find the right setting for your image highlights and affects the entire image area. ACR includes the extremely useful clipping warning feature.

Figure 5-68: When you activate clipping warning (click the small triangle), ACR will mark clipped areas in your preview window.

If shadow or highlight clipping is present, clicking the two small triangles at the top left and right of the histogram display (figure 5-68) causes the icons to switch to the color of the channel that is clipped. The program also colors clipped shadows blue and clipped highlights red in the preview image.

Pressing Alt/⌥ while shifting the *Exposure*, *Recovery*, *Blacks*, or *Brightness* sliders has the same effect, but displays only the affected areas, not the preview image itself – you then simply shift the sliders until no more clipped areas are visible in the preview window.

Recovery • This slider is designed to repair overexposed highlights without affecting the brightness of the rest of the image. *Exposure* and *Recovery* settings are additive, and setting the *Exposure* value too high can make an image look dull and lifeless.

Blacks • This is used to determine the color of the darkest parts of the image – i.e., where detail no longer needs to be visible. The resulting tonal value, the so-called *black point*, should equate to the darkest black that your printer can produce. The default black point in some cameras is set too high (e.g., the Canon EOS 5D Mark II). You can work around this by setting a new

default value for that particular camera model. To do this, open a new image, set its black point, and save the setting using the Save New Camera Raw Defaults command in the ≡ menu.

Fill Light · *Fill Light* has the opposite effect of *Recovery* and improves detail in shadow areas (figure 5-69). As with *Recovery*, overuse of the *Fill Light* slider can make an image appear flat.

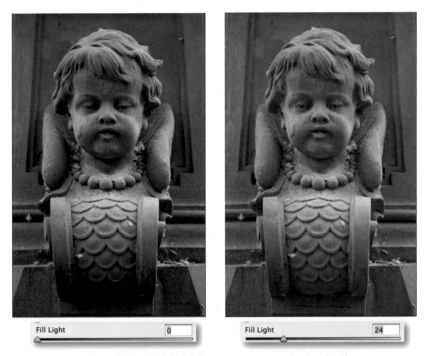

| Fill Light | 0 |
| Fill Light | 24 |

Figure 5-69: Fill Light brightens and improves shadow detail.

Brightness and **Contrast** · Once you have found the right settings for *Exposure* and *Blacks*, you can adjust *Brightness* and *Contrast* to match. We generally leave these two sliders set to their default values and make any necessary corrections later in Photoshop. Nikon NEF RAW files often need brightening, so optimizing overall dynamic range makes adjustments to brightness and contrast unavoidable. In this case, we create a slightly soft-looking image that has

▸ No burned-out highlights
▸ As few detail-free shadows as possible
▸ Medium to soft contrast

We prefer to perform selective corrections (such as graduated filters or adjustment brushes) or adaptive processes (such as Photoshop's Shadows/Highlights) in Photoshop itself. You will have to decide whether you prefer the handling and effects of your converter's tools, or whether an external image processor better suits your personal working style.

Basic	
White Balance:	Custom
Temperature	4050
Tint	+28
Auto Default	
Exposure	+0.30
Recovery	0
Fill Light	0
Blacks	5
Brightness	+54
Contrast	+23

Figure 5-70: Brightness and Contrast sliders in the Basic tab

Figure 5-71: Sliders for adjusting image contrast and saturation.

Saturation, Vibrance, and Clarity

ACR's *Saturation* slider is quite effective, although we still prefer to adjust saturation later (selectively) using Photoshop. If we do adjust saturation using ACR, we use the *Vibrance* slider (available since ACR 4.x). This tool ensures that already highly saturated colors (such as skin tones) aren't oversaturated by any adjustments we make. Combining *Vibrance* and *Saturation* adjustments can produce extreme results.

Figure 5-72: Using the Vibrance slider (center) prevents oversaturation of already saturated colors. The right-hand image shows the result of applying an increased Saturation value to the same image.

Clarity • This slider, introduced with ACR 4, increases local contrast – i.e., the contrast between neighboring pixels with similar tonal values. The effect is a bit similar to that produced by sharpening and helps to make images

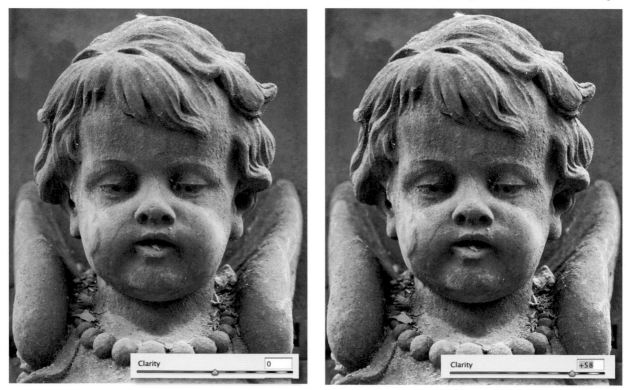

Figure 5-73: On the left is the effect of the default *Clarity* value, and on the right, the effect of a sharp increase.

look more lively. If you increase *Clarity*, you can probably apply less sharpening later. You can also use negative *Clarity* values to deliberately defocus an image – an effect that we often use in combination with graduated filters or brush effects to better accentuate a subject against the background. Figure 5-73 demonstrates the Clarity effect.*

* We usually prefer to use Uwe's DOP_EasyD_Plus_DetailResolver [67] Photoshop plug-in to improve local contrast (page 334).

Detail Tab

This is where ACR's sharpening and noise reduction tools are located. The *Sharpening* module was originally a reject from the Lightroom development department that Adobe has now improved to include four separate adjustment sliders.

There are three basic sharpening strategies that you can follow:

A) Perform all sharpening using the ACR tool (recommended for batch conversions).

B) Perform slight (approximately 10%) sharpening in ACR and fine-tune your sharpening in Photoshop.

C) Perform all sharpening using Photoshop's tools.

We prefer to use method B or C, using either the Photoshop Smart Sharpen command or our own EasyS sharpening tool.

The *Amount* and *Radius* sliders have just about the same effect as those in the Photoshop Unsharp Mask filter (section 4.8.3, page 112). The default settings for these two values depend on your camera model, the image format, and the amount (if any) of compensatory sharpening that is already factored into your image. Additionally, you can select one of three degrees of sharpening during image export (e.g., if you open your images in Photoshop). Output sharpening settings are made in the dialog shown in figure 5-29 , page 158. You can also sharpen selectively using the Adjustment Brush.

The *Detail* slider accentuates fine textures but quickly leads to the formation of halo effects at high-contrast edges. Halo effects and other unwanted image artifacts can be prevented if you use the subsidiary *Masking* slider. If you primarily want to sharpen edges, select a relatively high *Masking* value, which allows you to use higher *Amount* and *Detail* values.

You can check the extent of the effect produced by the *Masking* slider by holding down the [Alt] key while shifting the slider (figure 5-75). The areas that are shown black in the preview are then masked during processing. If you hold the [Alt] key down while shifting the *Detail* slider, the accentuated edges are shown in gray. Both of these effects only function at zoom settings of 100% or more. The [Alt] key grays over the preview image if used together with the *Amount* or *Radius* sliders, which can help to judge the effect of the settings you make. All of these [Alt] + keystroke tool extensions are also available in the Lightroom interface.

Figure 5-74: ACR 6 *Detail* sliders

Figure 5-75: The mask created using the *Masking* slider is displayed by pressing the [Alt] key with the zoom factor set to 100% or more

Figure 5-76 shows a cropped detail from an image shot using a Canon EOS 5D Mark II. The four close-ups (Ⓐ–Ⓓ) show the effects of applying different sharpening parameters to the same image.

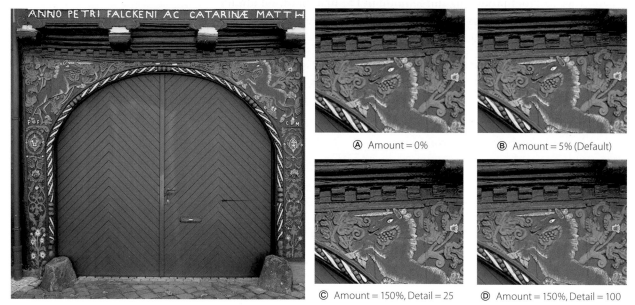

Ⓐ Amount = 0% Ⓑ Amount = 5% (Default)

Ⓒ Amount = 150%, Detail = 25 Ⓓ Amount = 150%, Detail = 100

Figure 5-76: Image details showing the effects of different sharpening values. *Masking* was set to 50% and *Radius* to 1.0 for all four examples.

Figure 5-77: You can select whether sharpening is applied to just the preview or to the exported images themselves in the ACR preferences dialog.

Figure 5-78: The panel indicates that only the image preview will be sharpened.

You can decide whether to apply sharpening to preview images only or to all images in the ACR preferences dialog (figure 5-77 and page 157). The *Preview images only* option helps you to judge the effects that subsequent sharpening will have on your image(s). The option settings are displayed in the *Detail* tab (figure 5-78).

Zooming in to 100% or more is necessary in order to assess the potential effects of sharpening, although you will have to zoom back out to 50% or less to see (approximately) how your image will look when it is printed.

ACR's global and export sharpening tools produce great results. As already mentioned, we prefer to leave ACR's sharpening tools at their default values and to sharpen selectively later using Photoshop.

We do, however, like to use ACR's *Noise Reduction* tool. The ACR 6 version is improved (figure 5-79) and offers five adjustment sliders:

▸ *Luminance*
▸ *Luminance Detail*
▸ *Luminance Contrast*
▸ *Color* (values between 20 and 30 produce our favorite results)
▸ *Color Detail*

The tool generally attempts to preserve edge sharpness while reducing noise for photos shot using high ISO values. Zooming to 100% or more can help you judge the effects of your adjustments.

In order to avoid producing image noise in the first place, we always shoot using the lowest possible ISO values. Like sharpening, there are three basic approaches to reducing image noise after shooting:

A) Perform all noise reduction in ACR. ACR can only reduce noise globally, so we only use this option for images with heavy noise.

B) Reduce noise slightly (up to 10%) in your RAW converter and perform any additional (selective or channel-specific) noise reduction during the subsequent Photoshop workflow using Reduce Noise filter, Noise Ninja, or any other quality noise reduction plug-in (section 8.10, page 328).

C) Perform all noise reduction in Photoshop using Filter ▸ Noise ▸ Reduce Noise or a noise reduction plug-in.

It is often difficult to strike the right compromise between preserving image detail and reducing image noise. Sharpening nearly always makes noise artifacts more visible. The higher you set your *Luminance* and *Color* sliders, the more fine details will be smoothed over, although the *Luminance Detail* and *Color Detail* sliders are designed to counteract these types of effects.

Figure 5-79: *Noise Reduction* sliders in the ACR 6.0 *Detail* tab

HSL/Grayscale Tab

This tab provides tools for selectively adjusting *Hue*, *Luminance*, and *Saturation* for each of eight different tonal ranges (figure 5-80). These adjustments affect the entire image. You can use them, for example, to emphasize a portrait subject's lips or eye color, or to subdue the greens in a landscape shot. We have already described how to apply these effects on page 165.

We only use these adjustments in combination with the *Targeted Adjustment* tool located in the ACR toolbar, as this offers us a much more intuitive way to play with the colors in our images. If you want to apply color changes to selected image areas, you use the *Graduated Filter* or *Adjustment Brush* tools.

You can also combine adjustments made using any of the three nested tabs. For example, if you reduce luminance for an overbright sky, you will probably have to reduce saturation, too, in order to keep the blue of the sky realistic-looking.

Activating the *Convert to Grayscale* option converts the active image to black-and-white and produces results that are much better than those you can achieve by simply reducing saturation to zero in all color channels. The resulting black-and-white image remains in RGB format when it is exported and provides a usable basis for further optimization. *Targeted Adjustment* is available in grayscale mode, too.

Figure 5-80: These are *Saturation* adjustments for specific color ranges.

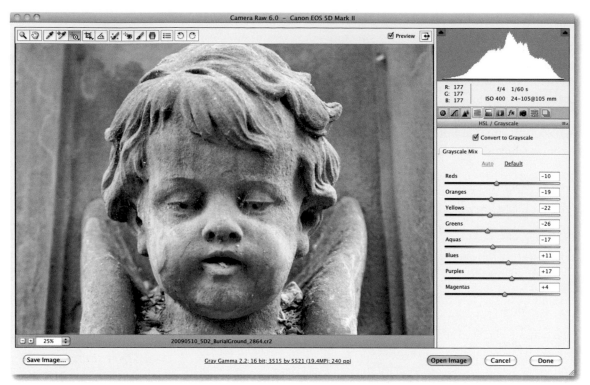

Figure 5-81: Black-and-white conversion using Convert to Grayscale. The result is a monochrome RGB image.

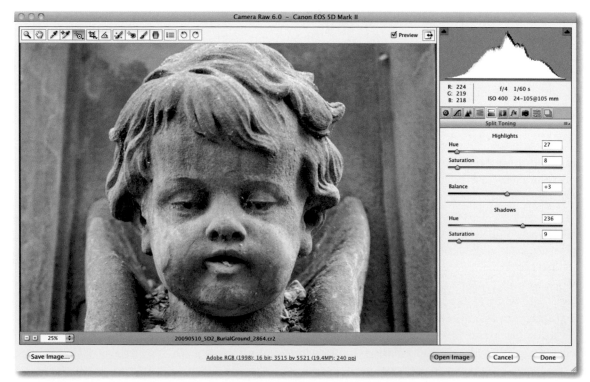

Figure 5-82: The Split Toning tool adds fine tones to RGB grayscale images.

Split Toning Tab

Split Toning is an effect that is primarily intended for use with monochrome images, but it can also be used to warm cold shadow tones in color images. In figure 5-82 (previous page), we use the tool to warm the highlights and give the shadow tones a cooler touch. Start by setting the *Saturation* slider to about 10%, and then shift the *Hue* slider to your desired value. Finish by fine-tuning your *Saturation* value. The *Balance* slider determines the tonal value at which shadows end and highlights begin.

Lens Corrections

ACR 6.1 was finalized shortly after the Photoshop CS5/ACR 6.0 bundle was released. This version of the program includes automatic, profile-based, and manual lens corrections options, as well as perspective correction functionality. The ACR 6.1 tool can correct:

▸ Chromatic aberrations (Red/Cyan or Blue/Yellow)
▸ Fringing
▸ Vignetting
▸ Lens distortion
▸ Perspective distortion

If you have a suitable profile for your particular camera/lens combination, we recommend that you try out the basic profile-based chromatic aberration, lens distortion, and vignetting corrections first. (See section 8.4.2, page 305, for more details on lens corrections profiles.) Switch to the *Automatic* tab (figure 5-83) and check the *Enable Lens Profile Corrections* option. Usually, ACR will extract the camera and lens EXIF data from your image file, but if these are not available, you can select appropriate settings from the drop-down menus. Sometimes, a similar camera and/or lens setting will suffice if your exact model isn't listed. Figures 5-84 and 5-85 illustrate the lens correction effect.

Figure 5-83: The ACR 6.1 Lens Corrections tab has two further nested tabs.

Figure 5-84: The original shot of a church interior

Figure 5-85: The same image after applying profile-based correction. Vignetting as well as distortion is reduced.

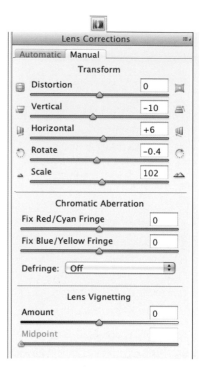

Figure 5-86: The *Manual* tab provides additional corrections.

Figure 5-87: We used the perspective correction values shown in figure 5-86 to produce an even better version of our image.

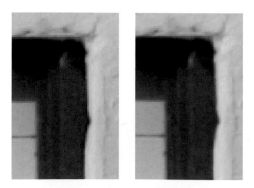

Figure 5-88: Before (left) and after (right) correcting chromatic aberrations in ACR

If no suitable profile is available, use the *Distortion*, *Chromatic Aberration*, and *Vignetting* manual sliders (figure 5-83) at a zoom setting that allows you to view the whole image. You may find that you need to use the sliders to fine-tune the results of a profile-based correction.

If necessary, you can switch to the *Manual* nested tab (figure 5-86) and correct perspective distortions using the *Vertical*, *Horizontal*, and *Distortion* sliders. The advantage of doing this here instead of in Photoshop (section 8.4.2, page 305) is that the ACR version of this adjustment is non-destructive. The *Rotate* tool allows you to perform custom rotations. You can then *Scale* your image to compensate for any white space that your other corrections have created.

We usually use the sliders to set rough values, and then click in the value box and use the ↑ and ↓ keys to fine-tune the results.

Figure 5-87 shows the result of applying manual corrections to the perspective distortion caused by the low camera angle.

Chromatic Aberration • Even high-end lenses can produce lateral chromatic aberrations when used with full-frame image sensors. Chromatic aberrations are especially prevalent in photos shot using wide-angle lenses or zooms used at wide-angle settings. These artifacts take the form of colored smears and tend to appear at the edges and corners of the frame, or at high-contrast edges. This is due to the fact that light of differing wavelengths is refracted differently by the lens and is consequently focused at a different point. Hence, one side of the lintel in our example appears green and the other purple.

ACR's tools allow you to remove (or at least reduce) these types of smears and follow the effects of your changes in real time in the preview window. Chromatic aberrations should always be corrected at the RAW stage of the workflow. You will need to zoom in to a 100% or 200% view to see what you are doing.

Defringe • Some cameras sensors can produce fringing (often purple fringing) at high-contrast edges, e.g., specular highlights in chrome or water surf. In these cases, the sensor data from one pixel is leaking into neighboring pixels. The result can be quite annoying, as illustrated in figure 5-90. Lightroom's tool allows you to remove or at least minimize these artifacts by choosing *Highlight Edges* or *All Edges* from the *Defringe* menu. There are three options:

▸ *Off* – Nothing is done.

▸ *Highlight Edges* – corrections are performed only for highlight edges (specular highlights).

▸ *All Edges* – This option will try to find fringing at other less bright edges. Be careful when using this option because it may remove too much color at all edges.

Figure 5-89: The Manual tab includes chromatic aberration, fringing, and vignetting correction tools.

Figure 5-90: The left image (a section of the total image) shows fringing. This was corrected using ACR's Defringe tool set to *Highlight Edges*.

Lens Vignetting • This effect often occurs in photos taken with wide-angle lenses or zoom settings; it causes darkening at the edges and corners of the frame. ACR's *Midpoint* slider determines where your correction starts in relation to the center of the frame. All settings affect the uncropped image.

If you want to create vignetting effects for stylistic purposes, use the tools in the *Effects* tab.

5.3.9 Effects Tab

This tab, with its *Grain* and *Post Crop Vignetting* tools, was introduced with ACR 6 (figure 5-91).

Digital photos often appear very slick, and experienced photographers sometimes miss the grain effects that are present in many analog photos. ACR allows you to add synthetic grain according to *Amount*, *Size*, and *Roughness* settings. As with certain other adjustments, we recommend that you zoom in a 100% view to get a proper impression of the changes you make. Adding a bit of grain can help disguise image noise artifacts.

Figure 5-91: The Effects tab includes tools for adding grain or vignetting effects.

Post Crop Vignetting allows you to add vignetting effects to images that have already been cropped. A high *Amount* value (+100, for example) will produce an effect similar to the ones present in antique studio shots, where detail fades almost entirely to white at the edges of the frame. We use this effect to draw attention to the cherub's face in figure 5-92.

Figure 5-92: The original image (*Amount* = 0) is shown on the left. The center image was processed using an *Amount* value of −54.
We applied a value of +100 to the right-hand version.

Figure 5-93: The sliders in the Camera Calibration tab

Camera Calibration Tab

Some people will love the *Camera Calibration* 📷 tab, and we are sure others will hate it. All RAW converters apply camera-specific profiles to RAW files, and some (such as Capture One) even allow you to add your own profiles to the list. This is a great solution as long as you are able to create high-quality profiles. But creating profiles it not easy, and it should really be left to professionals. We describe two profile-creation software packages in our RAW conversion book [25].

ACR's camera profiles are embedded in the program's software, and the sliders in the *Camera Calibration* tab can be used to make adjustments to them. The way these sliders work is not particularly intuitive. We generally leave the sliders at their default (zero) values, but we assume some photographers out there who will not be able to resist looking for new and useful settings for various camera models.

You can save your settings as the new default for your camera (see page 186 for instructions on how to do this). ACR only uses this profile if the camera model and serial number noted in a file's EXIF data match those saved in the profile.

ACR 5 introduced functionality that allows you to apply custom camera profiles, although these are not standardized ICC profiles but rather a special type of DNG profile called DCP (*Digital Camera Profiles*). These have the ".dcp" file extension. (ACR expects to find these in the folder located at …/Adobe/CameraRaw/CameraProfiles/Adobe Standard/.)

Adobe has created a series of color profiles (or, more accurately, color interpretations) based on the standard ACR profiles. These attempt to reproduce the color rendition of specific camera models. The list of currently loaded profiles can be found at the *Name* menu (figure 5-93 Ⓐ). The differences between the colors produced by individual profiles can be very subtle.

The free *DNG Profile Editor* allows you to edit existing profiles and to create new ones of your own. The basic profile creation process involves photographing the X-Rite ColorChecker [52] and using the resulting image as the basis for your profile. There are detailed instructions on how to do this at the DNG Profile Editor website. The editor software allows the photo-aware public to produce endless "correct" color renditions for specific camera models, and many user-generated profiles are available for download on the Internet. There is also a good article on creating DNG profiles for ACR and Lightroom using X-Rites Passport software on Uwe's website at: www.outbackphoto.com/CONTENT_2007_01/section_workflow_basics_2009/20090915_ColorCheckerPassport/index.html.

Adobe has implemented a new RAW interpolation algorithm in ACR 6 and Lightroom 3, and as a result, has added the *Process* menu to both programs. This gives you the option of opening your older RAW files using the old 2003 or the new 2010 method. New RAW files should always be (and by default are) converted using the newer method. You can even batch-update a whole folder of RAW files to this new 2010 version The easiest way to do this is in Lightroom, which provides a special function for that purpose.

➡ You can download Adobe's DNG Profile Editor and a selection of DCP profiles for free at: http://labs.adobe.com/wiki/index.php/DNG_Profiles.

Figure 5-94: You can decide whether to use the old or the new RAW interpolation algorithm.

5.3.10 ACR Presets

ACR has a presets feature for saving sets of settings that you want to apply to future images. To save a set of adjustments as a preset, open the options menu ▤ at the right-hand end of the adjustments panel title bar and select the Save Settings command. This opens the dialog shown in figure 5-95, where you can check the settings that you want to include in your preset. Clicking the *Save* button then adds your custom preset to the list in the menu.

To apply a preset to an image, select an image and then select a preset using the Apply Preset command in the Settings menu.

With Mac OS, presets are saved as XMP files in the user's folder .../ *Library/Application Support/Adobe/Camera RAW/Settings/*. For Vista and Windows 7 the path is *Users/User/AppData/Roaming/Adobe/CameraRaw/ Settings/* where User is the name of the logged-on user. You can also save presets from other sources in the same folder. There is a description of how to transfer presets in Bridge on page 189.

5.3.11 Batch Conversion

ACR has three different methods for batch converting multiple images:

A) Open an image in ACR via Photoshop or Bridge, make your settings, and save them. You can then apply these settings to other RAW images that were shot under similar circumstances.* Now select the images you want to process in Bridge and navigate to the Tools ▸ Photoshop ▸ Image Processor command to open the dialog shown in figure 5-99.

* As explained in section 5.3.2, page 162.

Image Processor

❶ Select the images to process
 Process files from Bridge only (2)
 ☐ Open first image to apply settings

 Run
 Cancel

❷ Select location to save processed images
 ◉ Save in Same Location
 ○ [Select Folder...] No folder has been selected

 Load...
 Save...

❸ File Type
 ☑ Save as JPEG ☑ Resize to Fit
 Quality: [5] W: [800] px
 ☑ Convert Profile to sRGB H: [800] px

 ☐ Save as PSD ☐ Resize to Fit
 ☑ Maximize Compatibility W: [] px
 H: [] px

 ☑ Save as TIFF ☐ Resize to Fit
 ☑ LZW Compression W: [] px
 H: [] px

❹ Preferences
 ☐ Run Action: [Default Actions ▾] [Vignette (selection ▾]
 Copyright Info: []
 ☑ Include ICC Profile

Figure 5-99:
The conversion options for images
selected in Bridge.

① These settings can be ignored in this case.
② This is where you select the location for your converted image(s).
③ This is where you select your output format, compression, and (optionally) image size settings.
④ This is where you select actions that you want to be automatically executed after conversion, such as conversion to CMYK or embedding copyright information.

Click *Run* to start your batch process. For all intents and purposes, ACR and Photoshop are blocked from other processes during batch processing.

You can save sets of batch conversion settings using the *Save* button and load saved settings via the *Load* button.

B) Record an appropriate Photoshop action and run it in Photoshop batch mode. The Photoshop user guide explains how to do this.

Photoshop actions typically open an image and convert it in ACR using previously selected settings before reopening it in Photoshop to perform additional tasks and save the image to its predefined format.

Go to File ▸ Automate ▸ Batch in Photoshop to select your action in the Action drop-down list as well as your image source and destination locations.

C) Use the Tools ▸ Photoshop ▸ Batch command on images selected in Bridge. In this case, ACR applies the current RAW conversion settings to the selected files.

You can also automate the entire process using scripts. Scripts are more powerful than Photoshop actions and allow the use of subroutine calls and complex arguments. Scripts can also call multiple applications, allowing you to automatically start Bridge for image selection, ACR for image settings, and Photoshop for displaying and optimizing the results. Adobe applications support Visual Basic, AppleScript, and JavaScript scripting languages. We recommend JavaScript as it is platform-independent.

➡ A number of Java-based scripts are supplied with Bridge. You can use them as they stand or edit them to suit your own purposes.

Scripts are powerful but complex, and require a great deal of know-how to be applied successfully.

Assigning Develop Presets in Bridge

ACR settings can be transferred from one image to another in Bridge using the following steps:

1. Select the image whose settings you want to copy.

2. Use Edit ▸ Develop Settings ▸ Copy Camera Raw Settings (or Ctrl-Alt-C/⌘-⌥-C) to copy your settings.

3. Now select all the images to which you want to apply your settings.

4. Apply the adjustments using Edit ▸ Develop Settings ▸ Paste Camera Raw Settings (or Ctrl-Alt-V/⌘-⌥-V). This will open a settings dialog similar to the one shown in figure 5-95, page 186, where you can select your desired options.

5.4 Other RAW Converters

Adobe Camera Raw is a modern, fast RAW converter, but it is by no means the only choice or the best solution for every image or task. The following sections aim to briefly introduce a selection of other RAW converters, including Canon and Nikon tools that support only their own, maker-specific RAW formats. All the other tools we describe here support a broad range of RAW formats. Although ACR is supplied free with Photoshop, there are a number of reasons for using other converters, too. These could be the unique functionalities, better (or different) detail rendering, or alternative color interpretations.

Our descriptions here concentrate on the differences between Adobe Camera Raw and the other programs, and how best to integrate them into the workflow.

5.4.1 Capture One Pro

Phase One's Capture One is a pioneer among today's RAW converters and has a great reputation. Capture One Pro is widely used in professional photographic circles, but at around $350 for the current 5.1 Pro version, it is one of the most expensive on today's market. Capture One's strengths lie in its support for a broad range of DSLRs, high image quality, fast conversion speeds, and a mature workflow with great batch processing functionality. The program supports full color management, including the use of user-generated camera profiles. Capture One can be used to process RAW, JPEG, and TIFF image files.

The program is constantly being upgraded to include support for new camera models, as well as new features and tools. Capture One includes all of the most important features we listed in section 5.2.2 and 5.2.3, as well as a few nice-to-haves such as cropping in zoom mode, a powerful color editor, sharpening masks, and direct control for a range of Nikon and Canon cameras via your computer (using tethered shooting). Regional, selective color adjustments are not yet available, but there is a tool for correcting dust spots and small blemishes.

Profile-based lens corrections, however, are restricted to just a few lenses used with some medium format cameras that have Phase One's digital backs. Perspective corrections are not yet supported.

Capture One's downloader, browser, and RAW converter (including batch conversion functionality) are well integrated, making the tool great for performing the first three phases of the workflow (figure 5-1, page 139). IPTC editing is well built. You will only need Photoshop for fine-tuning processes and for printing – and an image management tool for image administration.

→ Some cheaper converters support the latest camera models, making an expensive Photoshop upgrade a less attractive option when you purchase a new camera.

(🪟, 🍎) www.phaseone.com

→ Phase One also sells a cheaper basic version of the program for approximately $100. This is also available as a bundle with Expression Media 2 for about $150. Capture One has a multilingual user interface.

Figure 5-100: Capture One Pro 5.1's Edit view, showing all the available panels together in a single window

Capture One's handling is very similar to ACR and Photoshop in many respects. Basic functions such as zooming using the mouse scroll wheel or shifting the image detail using the space bar and the Pan tool (i.e., Adobe Hand) are identical.

Capture One Pro is a fast, highly functional RAW converter with great color calibration, a well-rounded workflow, and high-quality image conversion tools (especially with regard to detail reproduction). Professional photographers should definitely give it a try. The program is uncluttered and sticks to providing great basic adjustment tools that are comparable with all others on the market.

Capture One also supports hot folder functionality for instant image display during tethered shooting.

In 2010, Microsoft sold Expression Media 2 to Phase One. Therefore, we expect Phase One to build a database-integrating, all-in-one solution combining Expression Media and Capture One. This, however, may take a year or two. Right now, Phase One is offering Expression Media as an simple add-on to Capture One Pro.

➡ Capture One really deserves a chapter, or even a book of its own, but the 150-page online help files are very helpful for getting to know the program.

5.4.2 DxO Optics Pro

(⊞,) www.dxo.com

DxO Optics Pro, manufactured by DxO Labs, supports a wide range of cameras, with its main emphasis on Canon and Nikon. DxO Optics Pro is available in Standard and Elite versions; the Standard version supports most current consumer-level cameras, while the Elite version supports most current pro and semi-pro DSLRs.

DxO's main strength (apart from RAW conversion) is its profile-based lens correction functionality. This includes vignetting, distortion, and chromatic aberration, as well as sharpening and noise reduction. All of these tools are based on dedicated profiles, and even sharpening is performed selectively according to the known characteristics of profiled camera/lens combinations. Noise reduction is performed variably according to the ISO value set for each shot.

In order to perform these corrections successfully, the program needs access to full, correct EXIF data and a completely unedited image file. This means that if you use DxO, it has to be the first program in your workflow. DxO's tools can be applied to RAW, JPEG, and TIFF images downloaded directly from your camera, but the program's full correction functionality is only available if your particular camera/lens combination is supported by a corresponding profile. These profiles, called "modules", precisely describe the optical characteristics of specific camera/lens combinations and shouldn't be confused with ICC profiles. The results of DxO's automatic corrections can be used as the basis for further, slider-based adjustments – including perspective corrections. Like Adobe with its profile-based Lens Correction module, DxO not only supports a number of standard Nikon and Canon lenses, but also various third-party lenses for those cameras.[*]

* However, there is no tool that allows you to build custom profiles for lens corrections. You will have to turn to DxO Labs for this.

DxO Optics Pro is designed to function as a standalone but is also supplied with plug-in interfaces for Photoshop, Lightroom, and Aperture. This allows it to be used as an external editor or import filter tool. DxO produces TIFF, JPEG, or DNG output from RAW input files. The DxO workflow is largely the same as we know from using other standalone RAW converters: import and view using the *Select* module, correct using the *Customize* module, and export/convert using the *Process* module. On a Mac, you can drag RAW images from the Lightroom or Bridge window and drop them directly into the DxO Project pane. Lightroom hands over uncorrected copies of your original images to DxO, which hands corrected TIFF versions back for management and additional editing.

You can save edit settings and copy and paste them into other images in a project. Overall processing speed is very good, and the program's perspective correction tool is a real plus.

We like DxO's conversion results. Detail rendition is great, and many irritating lens errors really can be removed automatically. The profile-based tools are some of the best available. (You have to explicitly activate them.)

Figure 5-101: The DxO Editor window in *Customize* mode, with the Project pane at the bottom and the Editing palettes to the right.

Color corrections are technically very good, and there is even a built-in tool for removing dust spots. Like Nikon Capture NX, DxO stumbles slightly when it comes to refreshing the preview image during complex corrections.

DxO is an extremely effective tool, but it can only be considered as a single component in the overall workflow. In addition to DxO Optics Pro, you will need a downloader and a usable image management system for editing metadata, image browsing, and managing the entire image collection. DxO's project-based management system is OK for use during the initial phases of the workflow but is not suitable for long-term management of large image collections.

DxO also sells the optional FilmPack for simulating the tone and grain characteristics of a range of color and monochrome analog films. The monochrome profiles can be used to perform black-and-white conversions on color images and to fine-tune after conversion. This pack can be used as a plug-in to DxO Optics Pro as well as a plug-in to Photoshop.

Color Balance 🔘 tool complements the white balance tool ⬛ and helps to effectively remove color casts. The program also includes a fine black-and-white conversion function.

You can apply nearly all adjustments to regions defined using spline curves, and previously defined regions can be used to make multiple adjustments. Regions have an adjustable boundary that defines a soft transition of the adjustment. You can also easily invert that effect.

LightZone is the best RAW converter we have found so far for adjusting image tonality in RAW, TIFF, and JPEG images. We often use it instead of Photoshop for optimizing tonal values and then export the results to a new TIFF for further processing.

Figure 5-107: LightZone editing window. The *Styles* preview with its collapsible styles list is on the left, the control tools are at the top, and the tool stack is on the right. The small window at bottom right of the preview is the zoom detail indicator.

The flipside of all this functionality is a somewhat slow preview refresh when you apply selective corrections. But, as already mentioned, the same problem applies to Capture NX and Aperture, and to a lesser degree, to Lightroom and ACR as soon as you start to combine adjustments.

5.5 **Even More RAW Converters**

We have described a wide range of RAW converters in this chapter, and chapter 6 addresses Lightroom, Apple Aperture, and Bibble 5 in more detail. But these aren't the only options available. This section lists a few alternatives.

We have heard good things about SilverFast's DCPro (🪟, 🍎), Breeze-Browser (🪟), and the open source *DCRAW*, which acts as a base for a number of other tools. *dc* RAW-*X* is the GUI-based Linux version.

We have restricted our detailed descriptions to RAW converters that we use ourselves. Some of the tools that we have described in less detail simply don't fit into our workflow, or don't deliver sufficiently high-quality results. But both points are quite subjective.

Camera manufacturers such as Olympus, Kodak, Fujifilm EX, Pentax, Sigma, Leica, and Sony often include free Photoshop RAW plug-ins with their cameras – usually in both Windows and Mac versions.

There is also a good free RAW converter offered by Hasselblad, supporting not only Hasselblad's own DNG RAW format but also a number of other RAW formats.

These RAW converters are generally available as standalone programs for use with a separate image browser, or as Photoshop plug-ins. They usually install a plug-in automatically during the installation process.* If you want to handle third-party RAW files using ACR when you are browsing in Bridge or Photoshop, you will have to remove the plug-in.

* In the …/Plug-ins/File Formats/ folder

Adobe Photoshop Elements has a limited-functionality version of Adobe Camera Raw (🪟, 🍎) that is great for learning the ACR ropes. You can download and install the latest version of ACR in older versions of Photoshop Elements, whereas you need the latest version of Photoshop in order to install the newest ACR module.

In addition to Uwe's website [1], the URL in the margin is a great source of information on RAW converters and other RAW imaging tools.

www.raw-converter.com

All-in-One Workflow Tools

6 We have already discussed the main software components of our workflow in chapter 2. These include downloaders, RAW editors, various output modules, and data management software covering all the steps in the process. We call programs that combine these elements in a single application "all-in-one workflow tools".

The idea isn't entirely new – Apple iPhoto and Adobe Photoshop Elements are just two of the better-known pioneers in this field. In late 2005, Apple released Aperture, a program that was squarely aimed at the professional and prosumer market segments. Adobe followed suit in early 2006 with Lightroom, and Bibble Labs' Bibble 5 is one of the newer players in this market. What all these applications have in common is the high level of integration of their individual components, resulting in much better performance than a collection of individual applications can offer.

These attempts to build catch-all, "Swiss army knife" solutions do, of course, create challenges of their own: all-in-ones are complex and resource-hungry, and have inherent weaknesses in certain areas. Aperture, Lightroom, and Bibble 5 do, however, show that this approach has its benefits, even if they require the working photographer to resort to using separate plug-ins or Photoshop from time to time.

6.1 What We Expect of an All-in-One Tool

The minimum functionality of a useful all-in-one tool should cover the main aspects of the digital photo workflow as described in chapter 2. The aim of a good all-in-one is to keep program and interface switches to a minimum, but it should also support plug-ins and extension where necessary. The editing and data management modules should support all the most important data formats (i.e., RAW, JPEG, and TIFF), and more is always better. All-in-one tools need to be able to deal with large numbers of images (10,000 or more) and should offer a wide range of viewing and sorting options. They should also provide good printing functionality and tools for the most common output methods – Web galleries, slideshows and RAW conversion and file rendering using batch mode.

The three applications we introduce here – Apple Aperture, Adobe Lightroom, and Bibble 5 – all fulfill most of the requirements listed above. A number of plug-ins are already available for these programs, and the range on offer is continually expanding. All three have well-integrated image management, versioning, RAW conversion, and image optimization functionality; and they all treat RAW, TIFF and JPEG files largely as equals.

We are big fans of the all-in-one workflow approach. In the following sections, we will go into the strengths and weaknesses of these programs, based on the basic workflow steps we have already described.

Switching to an integrated, all-in-one application is a decision that you shouldn't take lightly. A subsequent migration of your image collection images and metadata is extremely complex. Image correction and optimization data are virtually impossible to migrate.

Even if you continue to use other tools for certain tasks, the decision to switch to an all-in-one program is a fundamental and far-reaching one. Once you have structured your data for use in a particular database, migration to a different database is a complex task. Migration tools are scarce and every image database has its own particular features and quirks that are virtually impossible to duplicate or migrate.

Using an all-in-one doesn't mean that you shouldn't use other tools, and some images and situations positively demand that you do. Final image fine-tuning and printing are often performed in separate applications such as Photoshop, but the basic workflow (including initial optimization and RAW conversion, if applicable) and data management will take place in your all-in-one. Good all-in-ones can also be used to create print, slideshow, or Web gallery output.

If you do optimize your images using other applications, be sure to return the processed image to your all-in-one for grouping, rating and storage. We would also like to see functionality for managing other types of

data in all-in-ones (e.g., CMYK image files),* but this is currently still the preserve of DAM tools, such as Extensis Portfolio or Expression Media.

All-in-one tools will continue to mature. Just as this book was going to press, Microsoft announced the sale of Expression Media 2 to Phase One, the manufacturer of Capture One. Bundling Capture One and Expression Media will provide a fine toolset in the short term, but long-term, we expect to see the two tools integrated into a full-fledged all-in-one solution.

When is the Best Time to Convert RAW Images?

Images that go off to customers naturally will also have to be converted or rendered. Even JPEG or TIFF images that you process using an all-in-one application need to be exported in order to resample any corrections you have made into the image data.

But if you don't need to hand an image over to another application for processing, or to a service provider for printing or publication, there is no pressing need to convert it to another format. The same way that not all analog negatives were printed (with the exception of contact sheets), not all digital images need to be converted during their lifetime. This is not only a normal, everyday aspect of the digital photo workflow, but it also saves a lot of disk space!

If you print directly from your all-in-one application, you won't have to generate a JPEG or TIFF version of your file first. The application will do it for you on the fly. Slideshows also require no special image conversion steps if you generate and display your show in the application itself. Web galleries generate additional JPEG thumbnails to assist online viewing.

Images that are merged (e.g., for panoramas or HDRI) or optimized using Photoshop are automatically stored in JPEG or TIFF format, and it makes sense to integrate these files into your overall image management workflow. The best location for such derivative files is a question we address in section 13.1.6, page 497.

Unfortunately even the most sophisticated all-in-ones still cannot handle certain processed formats, such as 32-bit HDR images, large panoramas, or CMYK and L*a*b* files.

6.2 Apple Aperture

🍎 www.apple.com/aperture/

* Apple also offers the simpler iPhoto photo software as part of the iLife suite.

➔ A current IT trend uses the computing power of graphics cards to support CPUs when performing complex image processing operations. Adobe has followed this trend since the introduction of Photoshop CS4 and Lightroom 2. These days, a powerful graphics card is a must-have.

** The list of RAW formats supported by Aperture can be found at: www.apple.com/aperture/specs.html

Introduced in late 2005 and now available in version 3, Aperture is Apple's "Professional Photography Application".* Aperture combines a downloader, a browser, a RAW converter, an image editor, and image management functionality. The program also includes print, slideshow, Web gallery, and photo book production tools.

Aperture requires a fast CPU and a powerful graphics card to work properly. We recommend that you use either a large monitor or a dual monitor setup (Aperture has comprehensive dual monitor support).

Like all Apple software, Aperture has a clear, intuitive user interface and a few innovations of its own, making it necessary to spend some time getting used to its handling. The 700-page online manual is a great help while you are learning the program.

Aperture supports JPEG, JPEG 2000, TIFF (with certain layer and alpha channel restrictions), PSD, GIF, PNG, and a wide range of RAW formats including all the formats also supported by iPhoto and Apple Preview.** Adobe Lightroom and Bibble support even more RAW formats, but Apple is constantly expanding its range with regular program updates. With Aperture, RAW encoding occurs in the operating system, not in the application itself.

Like Lightroom 3, Aperture 3 can not only import RGB mode files, but also CMYK images and HD video files. The editing of CMYK files, however, is done in RGB mode (the same way Lightroom does).

Aperture's Image Management Architecture

Along with a high degree of integration, Aperture also offers a range of useful image management tools and views called *Libraries*, *Projects*, *Folders* (not the same as operating system folders), *Albums*, and *Stacks*. Unlike conventional image browsers, Aperture requires you to import images into a separate Aperture *library*, even if they are already stored elsewhere in your computer's file system. They are then sorted into individual *projects*. You can store your actual image files in the library itself (where they can be directly accessed by other applications) or in your computer's file system. If your images are stored in your everyday file system, your library will contain a reference to each file's location but not the file itself.

➔ If your Aperture Library should become corrupted, you can rebuild it by pressing ⌥-⌘ while the application is starting.

Library • This is the Aperture database (or *repository*) that contains all management data relevant to your stock of images. All projects, folders, albums, masters, versions, and (optionally) image files are initially stored in a single library. The library is the core of the Aperture environment and is similar to the *catalogs* used by other image management programs. It is possible to create and switch between multiple libraries, although you can only search for images in the currently active library.

6.2

Ape
We
you
Ape
imp
(Yo
stac
ing
Ape
ups

can
nec
oth
ing

fro
figu

Figure 6-1: Aperture's main window in Browser mode. The Library inspector pane is on the left, and the Adjustments pane in the Inspector HUD (Heads-Up Display, a separate, free flowing panel) is on the right. You can add other HUDs at any time. The loupe is used to magnify image details.

A library is treated as a single, large Mac Package file by the Macintosh Finder, and the individual elements of a library (projects, albums, folders etc.) can be viewed only by using Aperture. With a little ingenuity, you can also create libraries that are larger than a single hard disk or partition.

Project • A project is a container for image information and (optionally) image files. An image must be imported into a project before it can be processed using Aperture. Such imported images are treated as "master" images and are themselves never modified.

You can download images directly from your camera, from a card reader, from conventional file folders, or from iPhoto albums.

Aperture also allows you to configure an external image processing program or plug-in (such as Photoshop or Nik Silver Efex Pro). If this is the case, Aperture hands over a TIFF or PSD copy of the image version or master. The resulting image is then stored as a new version. You can configure your chosen external editor in the Export section of the Preferences dialog (Aperture ▸ Preferences).

➔ An image can only reside in one project but it can be part of multiple folders or albums.

Folder • Folders are used to enhance the structure of the images that belong to a project, and they can also contain images from other projects without copying them. Folders can also contain subfolders.

 Create a new folder: ⌘-⇧-N

Figure 6-4: Metadata Inspector showing
image EXIF data

thumbnail view, single image, image comparison, full-resolution, etc.) that
you can select using your keyboard.

You can display two or more images for direct comparison and use the
loupe to get a close-up view of image details. A practical addition is that the
loupe size and zoom factor can be individually configured.

You can add IPTC data to your image in the metadata inspector pane,
and you can choose between vari-
ous types of metadata using the
tabs at the bottom of the pane.
Metadata (individual IPTC fields
and general image correction data)
can be copied to and from single or
multiple images using the Lift
and Stamp tools (figure 6-5). You
can also use the Lift & Stamp HUD
to copy keywords and apply them to
other images.

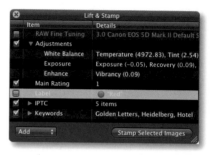

Figure 6-5: The Lift & Stamp tools are used
to define which image metadata to copy.

6.2.2 Editing Photos in Aperture

Aperture includes RAW conversion and image editing functionality. The
loupe and multiple image view features make it simple to copy corrections
from an edited reference image to other similarly exposed images using the
Lift and Stamp tools. Images optimized in this way can also be indi-
vidually fine-tuned later.

The histogram can be switched
between luminance and individual
or RGB color channel displays. The
EXIF exposure data and the *Exposure*,
Enhance, and *Highlights & Shadows*
adjustment tools are located beneath
the histogram display (figure 6-6).

Most of Aperture's adjustment
controls are located in the *Adjust-
ments* pane, where you can find
seven basic adjustment types (figure
6-6). You can add further adjust-
ments to the list using the drop-
down menu Ⓑ in the adjustments
inspector, or using user-configu-
rable keyboard shortcuts (figure 6-7).
You can also delete unwanted entries
from the list by selecting them and
pressing Del . Some tools are lo-
cated in the tool strip: . The *Quick Brushes* pop-up

Figure 6-7: You can add or remove items in
the Adjustments Inspector.

Figure 6-6: Adjustments panel with the
histogram and the seven basic adjustment
panes – here, all are collapsed.

menu found under 🖊️ is used for making brushed (selective) image adjustments. Aperture includes all the major adjustment tools that we like to see, and these are all available for all of the program's supported file formats.

The individual tools' sliders can be shown or hidden using the ▶ button, and you can set the inspector pane to be displayed as a high-contrast HUD (with a black background) that you can position anywhere on your desktop (including on a second monitor).

The 🔄 button resets an adjustment to its default values. You can use the *Adjustment Action* pop-up menu ⚙️ to choose a histogram view, remove selected adjustments, and choose whether to display color and camera information below the histogram. You can also choose the type of color values and the sample size from this pop-up menu. Click ☑️ to temporarily deactivate an adjustment. A second click will again enable the correction. Adjustments can be saved and reapplied using the *Presets* menu (figure 6-6 Ⓐ).

The *White Balance* adjustment (figure 6-8) includes color temperature (*Temp*) and *Tint* sliders, while *Exposure* has sliders for adjusting *Recovery*, *Black Point*, *Brightness*, and overall exposure. *Curves* adjustments can be applied to individual or all color channels. You can use eyedroppers to set black and white points, and you can set shadow, highlight, and midtone gray points – a function that is (as yet) not available in Adobe Camera Raw 6.1 or Lightroom 3.

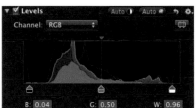

Figure 6-8: White Balance and Exposure

You can correct burned out highlights and lost shadow detail using the *Levels* tool (figure 6-9). Here, you can optimize image luminance and the individual color channels.

Figure 6-9: Aperture also includes a *Levels* adjustment.

Use the eyedropper in the *Color* adjustment to select and optimize individual tones (figure 6-10). Each of the six major tones has four individual sliders similar to those found in the *HSL* tab in ACR.

Figure 6-10: This is the panel for fine-tuning colors.

Aperture also includes basic sharpening and noise reduction controls, but these are not best-in-class. The sharpening tool has no adjustable threshold value, but it does include an edge sharpening facility. Noise reduction cannot be applied to individual color channels.

Aperture has a kind of Channel Mixer for monochrome conversions, and there are various color filters available in the *Presets* menu. Black-and-white RGB images can also be tinted using the *Color Monochrome* and *Sepia* controls.

Figure 6-11: Black & White conversion adjustment

6.3 Adobe Lightroom

⊞, ⌘ www.adobe.com/products/
photoshoplightroom/

Adobe's prompt answer to Aperture was the release of the first Beta version of Lightroom for Windows and OS X in early 2006. At the time of writing, we are working with Lightroom 3.

Just like Aperture, Lightroom combines a downloader, a browser, a RAW converter, an image editor, and an image management database in a single program. The core of the RAW converter and editor is the same module that can be found in Adobe Camera Raw, but with a new interface. Lightroom also includes print, Web gallery and slideshow output.

In order to function as efficiently as possible, Lightroom requires a high-performance CPU, as much memory as possible, and fast-access hard disks. We recommend that you use the largest monitor you can afford. Lightroom supports dual monitor setups and can display image preview, zoom, or thumbnail views on a second screen.

Library | Develop | Slideshow | Print | Web

Figure 6-19: The Lightroom interface has five modules.

Lightroom attempts to keep its interface simple and directly oriented towards a professional photo workflow – its five main modules are called *Library*, *Develop*, *Slideshow*, *Print* and *Web* (figure 6-19). *Library* is the browser and image management module, *Develop* is used for image processing and optimization, and *Slideshow*, *Print* and *Web* are designed for producing specific types of output. You can, however, also export files, thus creating another form of output. You can switch between modules either by clicking the tabs directly or by using keyboard shortcuts. Each mode has its own panels and tabs, and many of the features are similar to the ones available in Aperture.

Like Aperture (and unlike Bridge), Lightroom has its own database called the *Catalog*. This contains metadata and other image management information. Lightroom stores thumbnails and preview images in a separate file (containing all preview images) in the same location as the catalog and also creates a separate folder containing uncompressed backup copies of the catalog.* The image files themselves are located in the computer's file system according to settings made by the user during import. The structure of the user's folders is mirrored in the Lightroom browser (figure 6-20). Images have to be imported into Lightroom before they can be processed.

* Subsequently manually compressing these backup files reduces them to about one quarter of their original size.

Lightroom supports a wider range of RAW formats than Aperture and also supports non-destructive processing of DNG, PSD, TIFF, and JPEG formats.

Processing, searching, and image management are only possible within a single catalog, but it is relatively simple to create and switch between multiple catalogs. When you switch catalogs Lightroom is first terminated and then restarted with the new catalog open. You can create new subfolders within a catalog that are equivalent to conventional, physical folders. This means that an image file can only be stored in one folder.

Lightroom's logical folders are called *collections*, and are very similar to Aperture's *albums*. Collections only contain references to image file locations, making it possible for one image to reside in multiple collections.

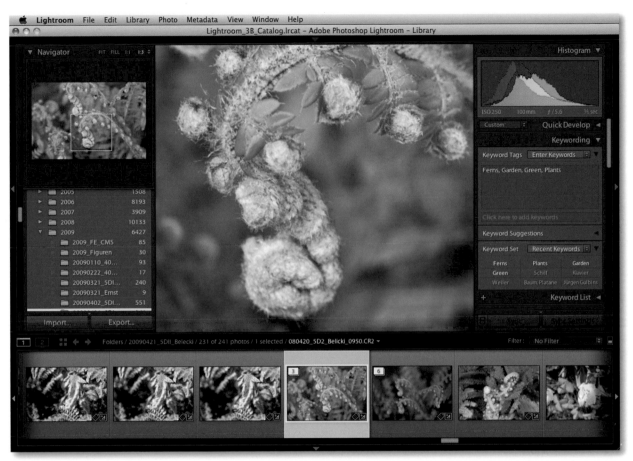

Figure 6-20: Lightroom's Library module, showing the filmstrip, Navigator panel, Histogram pane, and Keyword List panel

Deleting an image from a collection has no effect on the original image or its location. Collections can be static or *smart*. Smart Collections contain images that fulfill specific search criteria – for example, all images that include the keyword *portrait* in their metadata. Collections can contain additional static and smart subcollections.

Folder or collection views can be further refined using additional filters and search criteria.

6.3.1 The Lightroom Workflow

Lightroom is designed to fit in with a photographer's workflow and supports the following major workflow phases:

▸ Image import, renaming, rating, keywording, and management
▸ Image optimization
▸ Image presentation (slideshow, Web gallery, or print)

Lightroom doesn't have the same direct export and printing facility that Aperture or Adobe Photoshop Elements do, and it has no built-in photo

book functionality. You can, however, export and resample your images in the conventional way, allowing you to send your images to others or to process them using other applications.

You can set up other applications as external image editors in the program's *Preferences* dialog. These then appear in the Photo ▸ Edit In command. Image handover to Photoshop is very effective and includes options for passing images directly to panorama, HDRI, layers, or Smart Object dialogs (figure 6-21).

Figure 6-21: Lightroom's functionality for exporting images to Photoshop is particularly effective.

Importing Images

There are five basic options for importing images into Lightroom:

▸ Direct import from a camera or card reader
▸ Import from an existing folder (with or without copying the images to a new location)
▸ Import from a Hot Folder
▸ Import via Tethered Capture
▸ Import of images and metadata from another Lightroom catalog.* Here, you can also determine whether referenced image files should also be imported, and if so, to which location.

* Use the File ▸ Import From Catalog... command to import images from another Lightroom catalog.

Lightroom 3 can now import and play HD videos. The source file type Ⓐ is selected on the left in the import dialog (figure 6-22), copy parameters are selected in the center, and other details (including the new location) are selected on the right at Ⓑ.

When we are importing new images from a memory card, we have Lightroom save them to our predefined location and automatically rename them using the parameters defined at Ⓓ according to the criteria we listed in section 1.6. The variable part of each filename is entered in field Ⓔ. We also make automatic backup copies at the remote location defined at Ⓒ. These copies have the same filenames as the renamed files.

➜ Using the automatic renaming, IPTC data, and backup functions during image import will increase your workflow efficiency.

You can select a Development Preset for automatic application during import at Ⓕ – usually, we don't use this feature, though it can be handy. We often use the metadata preset feature Ⓖ (presets can be created in the Lightroom editor), and we usually also add IPTC copyright data. We add some universal keywords for the entire shoot at Ⓗ. Here, we have used the Destination panel to have the imported images automatically stored in a subfolder named after the date entered at Ⓘ.

➜ Lightroom's metadata presets are compatible with Adobe Bridge.

Lightroom automatically generates thumbnails and multiple preview images in various sizes (according to the size of the original image) during import.* During long import processes, Lightroom uses the title bar to indicate that a background process in progress.

The import dialog is generally very easy to use and runs glitch-free in the background.

* Generating preview images uses a lot of disk space and processing power. These processes are, however, background processes, making it possible to continue to process images that are already imported.

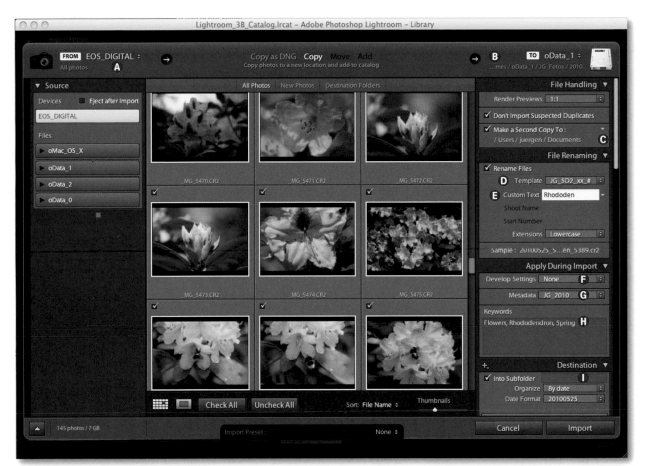

Figure 6-22: The Lightroom import dialog is clear and comprehensive, and includes effective renaming, IPTC data application, and keyword management functionality.

Browsing on the Light Table

Lightroom's *Library* module has four viewing modes:

▸ ⊞ Grid View displays freely scalable thumbnails.

▸ ▣ Loupe View automatically scales the active image to the window size or displays a 100% view. You can toggle between these two views by clicking the Navigator preview window.

➜ The Lightroom loupe has similar functionality to Aperture's loupe, but its zoom feature is not as flexible.

▸ ⊠ Compare View displays two (or more) images next to each other for comparison purposes.

▸ ▦ Survey View displays multiple images selected in the filmstrip.

You can show and hide all panels and the filmstrip by clicking on the triangle button ▷ at the edge of the panel frame. Hidden panels are automatically switched to auto show mode. Moving your mouse over the window's frame temporarily shows the appropriate panel or filmstrip.

After importing a new set of images, you typically start by viewing and rating your images and setting a *reject* flag for any images you want to trash. You can view all rejected images for a final check before deleting them using Photo ▸ Delete Rejected Photos. Here, you can decide whether to delete your rejected images from just the catalog or physically from your hard disk. Lightroom also allows you to color code your images – we use this function to indicate various image processing stages.

There are various keyboard shortcuts available in viewing mode. Double-clicking an image in Loupe mode zooms into the active image and an additional click on the preview image shows a 100 % view (you can also select other zoom factors). If the zoom factor makes the preview image larger than the preview window, you can shift the displayed detail using either the Hand tool or by moving the detail frame in the preview window with your mouse. Lightroom's loupe cannot be directly moved over the active image like Aperture's can.

IPTC data can be entered in a number of ways for single or multiple image selections. You can build keyword hierarchies and add keywords to selected images by using the Painter tool 🖊 or by typing or clicking in the Keyword List panel. Here too, you can display your images according to multiple selected criteria.

➜ Quite a number of operations that you intend to apply to several images (e.g., assigning metadata to images) can only be done using the Grid View in Library mode.

Figure 6-23: Lightroom's simple *Quick Develop* adjustment tools.

6.3.2 Correcting Images Using Lightroom

Lightroom offers four basic ways to make corrections to your images:

1. The *Quick Develop* panel in the Library module (figure 6-23). These tools have simple up/down buttons instead of sliders and can be applied simultaneously to multiple selections. Corrections can also be applied to other images using Copy & Paste or the Sync button in the *Quick Develop* panel.

 The *White Balance* pull-down menu includes various color temperature presets, and the *Saved Preset* menu includes a number of pre-defined overall image corrections.

 You can enter metadata in Library view using the *Keywording*, *Keyword List*, and *Metadata* panels.

 Lightroom automatically displays EXIF shooting data beneath the histogram in Library view.

2. The highly specialized and detailed correction tools included in the *Develop* module. We will go into more detail on these later.

3. An automatically generated copy of an image in an external program (such as Photoshop)

4. *Develop Presets* during image import or presets from the Presets panel in *Develop* mode. Presets are collections of adjustments that are either saved by the user or supplied with the program.

Image Editing in Develop Mode

Lightroom offers a number of ways to make corrections to your images. Most of them are the same as those available in Adobe Camera Raw, but they are presented using a different user interface. ACR's horizontally arranged tabs are grouped vertically in panels in Lightroom, while the tools from the ACR toolbar can be found beneath the Lightroom histogram (figure 6-24). Lightroom's panels can be expanded or collapsed by clicking the panel title. The real time histogram can display the individual color channels or combinations of R+G+B (white), R+G (yellow), G+B (cyan), and R+B (magenta). EXIF ISO value, aperture, focal length, and exposure details are displayed beneath the histogram if they are available.

The two triangular icons at top left and right of the histogram window preview highlight and shadow clipping and are the same as those found in ACR. You can perform some basic image corrections directly in the histogram window by shifting the curve's ends with your mouse. This way, you can quickly adjust the black and white points or expand or compress the shadow and highlight zones within your image.

We have already introduced the various correction tools in the Adobe Camera Raw section, so we will stick to short descriptions here. Clicking a ◢ icon expands or collapses the individual correction panels. You can set the panels to automatically collapse other panels when you expand a new one.

The ■ button allows you to temporarily deactivate a correction, and pressing the Alt key sets a correction to its default values.

The ▦ button in the tool strip starts the (non-destructive) Crop & Straighten tool. The cropping aspect can be set to original or custom sizes. To straighten an image, click the Angle icon ▬ and use the level to draw a vertical or horizontal reference line through your image. Lightroom then crops the image to fit your reference line. This is an elegant solution for a task that we perform regularly.

Figure 6-24: Lightroom 3 histogram and correction panels

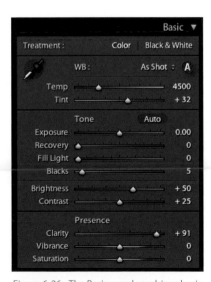

Figure 6-25: Cropping and straightening are combined in one tool with two icons.

Basic • This panel includes all the basic correction tools in a single, compact panel (figure 6-26). Here, you can find *White Balance* sliders and presets (in pull-down menu Ⓐ), the *Exposure* slider (for setting the white point), the *Blacks* slider (for setting the black point), and the *Recovery* and *Fill Light* sliders for eliminating burned-out highlights and muddy shadows in RAW images.

The *Clarity* slider is used to adjust local contrast and *Vibrance* helps adjust saturation while protecting highly saturated colors (such as skin tones). We never use the *Saturation* slider because *Vibrance* is simply more effective.

Figure 6-26: The Basic panel combines basic correction tools in a compact format.

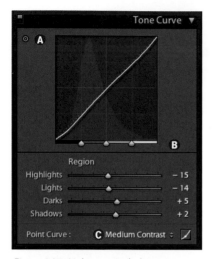

Figure 6-27: Lightroom includes parametric and point curve functionality.

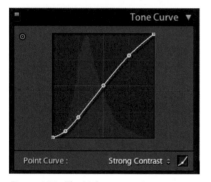

Figure 6-28: The Lightroom point curve can be freely edited.

Pressing the [Alt] key while moving the *Exposure, Recovery,* or *Blacks* sliders displays potential clipping using colored masks (as previously described for ACR). This highly practical function is also available in a number of Photoshop correction tools.

Tone Curve • Lightroom's *Tone Curve* panel includes two types of curve (figure 6-27) that function additively. The parametric curve is adjusted using the four sliders beneath the curve display. The three triangular icons at Ⓑ indicate the borders between shadow, midtone, and highlight image areas and can be shifted manually.

The pull-down menu for the point curve Ⓒ contains three fixed options. However, clicking the ✎ icon displays a freely editable curve like those in ACR and Photoshop (figure 6-28). Clicking the ✎ icon again returns you to the parametric curve view.

The *Targeted Adjustment* button Ⓐ allows you to select an image area for correction with your mouse. This automatically generates a point on the curve that you can move up or down to brighten or darken the selected color. This is a more intuitive way to make color corrections than using sliders.

HSL/Color/B&W • This panel includes selective color adjustment tools. There are eight sliders available (figure 6-29). You must select one of the main *Hue, Saturation,* or *Luminance* sub-tabs before you can make further adjustments. (See the description of the HSB color model on page 60.) Selecting *All* activates 24 sliders for adjusting eight tones each for the three base parameters (Hue, Saturation, and Luminance in one panel). The *Targeted Adjustment* button Ⓐ is also available here, and we use it to make most of our adjustments. (See the description of adjustments made using Adobe Camera Raw on page 165.)

The *B&W* option displays an RGB grayscale image and a channel mixer that is very similar to the Photoshop Black & White adjustment (see the ACR description for black-and-white conversion in section 10.6, page 402). You can also create a cross-processing effect in your grayscale image using the *Split Toning* tool.

Instead of converting a master image to grayscale, we create a virtual copy of our original using [Ctrl]/[⌘]-[T] or the Photo ▸ Create Virtual Copy command and convert that instead. Clicking the *Color* button converts the grayscale image back to color. You can decide whether to make this conversion using individual image analysis or the default values in the Lightroom Preferences dialog. The resulting image can then be fine-tuned using the available sliders or targeted adjustment.

This HSL panel is a powerful collection of tools, and we make frequent use of it when fine-tuning our images in Lightroom. As when you are making other corrections, keep an eye on potential clipping by using the histogram.

Figure 6-29: You can use the HSL/ Color/B&W panel to make fine tonal adjustments to the entire image.

Figure 6-30: Our original photo. The skin tone is too red for our liking.

Figure 6-31: The corrected skin tone, produced by reducing red saturation and shifting the hue setting.

Split Toning • *Split Toning* allows you to correct hue and saturation separately for highlights and shadows. Its main use is for toning black-and-white RGB images (figure 6-32).

If you attempt to apply *Split Toning* to an imported true grayscale image, Lightroom will automatically convert the image to RGB mode before applying adjustments.

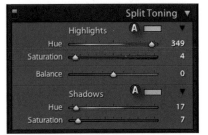

Figure 6-32: The Split Toning panel

Split Toning can also be used to reduce blue casts in shadow areas and to add a cooler tone to highlights. The *Balance* control adjusts the border between shadow and highlight areas.

You have to adjust the *Saturation* slider first, as a zero value produces no effect at all. We start by set-

Figure 6-33: Split toning applied to a grayscale image.

ting *Saturation* to about 10% before we adjust *Hue* and then finally fine-tune *Saturation*. Holding down the Alt/⌥ key temporarily applies full saturation, allowing you to better see which areas will be affected. Clicking the color field Ⓐ starts a color picker, where you can select your desired tone instead of using the sliders.

Detail • This panel contains *Sharpening* and *Noise Reduction* controls (figure 6-34). We have already described sharpening techniques in the section dealing with Adobe Camera Raw.

The preview is automatically set to 100% (i.e., 1:1), and pressing the ⊕ button at Ⓐ allows you to select an image detail using your mouse.

In Photoshop, we would here correct chromatic aberrations (which is seldom necessary) and vignetting effects. In this case, we use a low sharpening value (about 10%), set *Detail* to almost zero, and sharpen properly

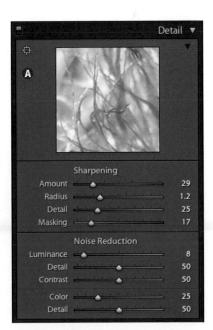

Figure 6-34: Sharpening and Noise Reduction sliders

later using Photoshop. The Lightroom *Amount* slider reacts differently than the one in the Photoshop USM filter. The *Detail* slider enhances the sharpening effect and should be used sparingly. If you want to protect soft transitions from oversharpening, increase the *Masking* value; pressing the ⎇ key then displays the masked areas.

Pressing the ⎇ key while shifting the *Amount* slider converts the preview to grayscale, also helping you to judge the effect of your adjustment.

In addition to compensatory sharpening, you can also sharpen selectively using the *Adjustment Brush* ▭. Additional sharpening is also possible during the printing and export processes.

The *Noise Reduction* tool has been greatly improved in Lightroom 3 and now allows you to adjust Luminance, Noise, and Color Noise separately.

Lens Correction • This is where you can correct vignetting effects, chromatic aberrations, and lens distortion – either automatically using profiles (in Lightroom 3) or manually (figure 6-35 Ⓐ). There is a description of profile-based correction in section 8.4.2, page 305. Once you have enabled a profile using the button Ⓐ, Lightroom displays the characteristics of the selected profile (Ⓑ). You can then use the sliders (Ⓒ) to fine-tune the corrections made by the profile or to make your own, manual adjustments.

Figure 6-36 shows a door photographed using a zoom lens set to its wide-angle 24mm focal length. The resulting image displays marked barrel distortion. Automatic, profile-based lens correction produced the image shown in figure 6-37.

The corrected image still displays some perspective distortion. We corrected this using the *Manual* tab in the *Lens Corrections* panel (figure 6-38).

Figure 6-35: Lightroom 3 includes automatic lens correction functionality.

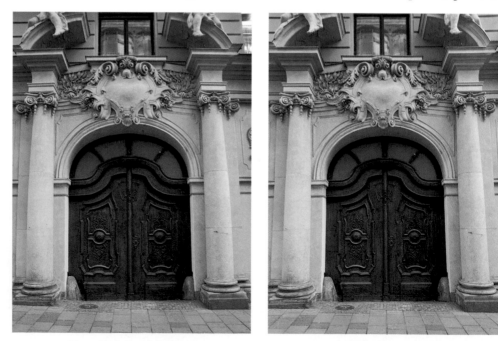

Figure 6-36: Barrel distortion Figure 6-37: Profile-based correction

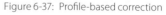

This tab includes sliders for adjusting distortion vertically and horizontally. The *Scale* slider is used to readjust the image size to compensate for changes made by profile-based or manual lens corrections. Scaling here is non-destructive, but it can cause a loss of image quality when the image is converted to JPEG or resampled for export. As in ACR, we make our basic corrections using the sliders and fine-tune the results using the mouse and the ⬆/⬇ keys. The settings shown in figure 6-38 result in the image shown in figure 6-39.

In Lightroom 3, the *Manual* tab also includes controls for manual vignetting correction, chromatic aberration correction, and defringing. If you want to use vignetting creatively as a stylistic tool, use the *Post-crop Vignetting* tool in the Lightroom 3 *Effects* panel.

We discussed correcting chromatic aberrations and fringing in the Adobe Camera Raw section. If we want to hand over images to Photoshop

Figure 6-38: The *Manual* tab also includes perspective correction sliders.

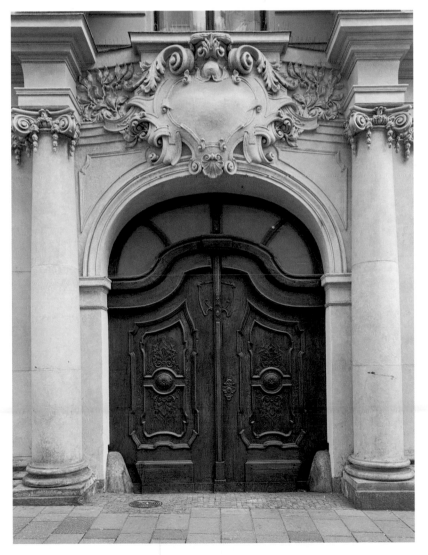

Figure 6-39:
Our image after manual perspective correction and a slight crop.

(or other applications) for fine-tuning or merging, we always correct any vignetting or chromatic aberrations first using Lightroom or ACR. The results are always better than those we can achieve later using other programs – especially those that do not work profile-based.

Figure 6-40: Wide-angle and zoom lenses set to wide focal lengths often produce visible chromatic aberrations, as shown in the upper detail. The lower detail shows reduced aberrations using Lightroom's correction tools.

Figure 6-41: The *Effects* panel contains new, creative adjustments.

Effects • This panel was introduced in Lightroom 3 and allows you to apply three different styles of vignettes to already adjusted and cropped images: *Highlight Priority, Color Priority*, and *Paint Overlay*. You can fine-tune the effects of the individual styles using the *Roundness* and *Feather* sliders.

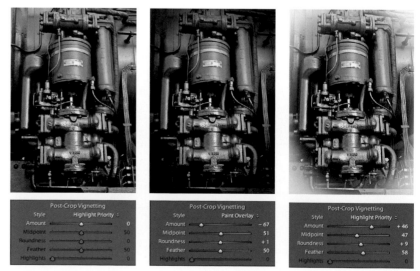

Figure 6-42: Various Post-Crop Vignetting effects

This panel also includes the *Grain* effect for simulating analog film grain in your images. This can help to reduce the overly "perfect" look of some digital images, but it is only really effective if applied to low-noise images shot using low ISO values. Grain effects cannot be applied selectively using the Adjustment Brush. (You don't want to add artificial grain to digital grain produced by the camera sensor.)

Camera Calibration • This panel allows you to make small color corrections specific to a particular camera and based on the three primary color channels. These can then be saved as a kind of camera profile (actually, a camera development preset) that can then be applied every time you are working on an image shot using that camera. (Starting with Lightroom 3, a better way is to generate your own camera profile.) If you want to correct individual images, you are better off using the HSL tools. The *Camera Calibration* tool also contains preset profiles (under the *Profiles* menu) that reproduce the JPEG look of the camera maker's output.

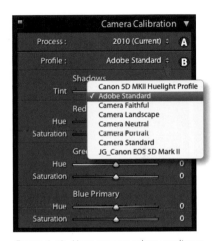

Figure 6-43: Here, you can select or adjust a specific camera's color profile.

If you have created and installed your own DCP/DNG profile using Adobe's DNG Profile Editor [31], this will also appear in the panel's *Profile* pull-down list Ⓑ (figure 6-43). Creating these camera profiles requires patience, care, and a good deal of color management know-how. You can find more information on the subject in the ACR section on page 184. The X-Rite ColorChecker Passport is also a great aid (a profiling target) for generating camera profiles (page 484).

The RAW interpretation (demosaicing) in Lightroom 3 and ACR 6 has been greatly improved, making it possible to achieve even finer details then in previous versions. This means that images you import from Lightroom 2 can appear slightly different in Lightroom 3. For this reason, Lightroom 3 allows you to choose between the old 2003 and new 2010 processes in menu Ⓐ when developing your images. You can also switch multiple images selected in the filmstrip to the new process. The new, 2010 process usually produces better results.

Figure 6-44: The Process menu offers two options for RAW processing: and an older 2003 version and a newer 2010 version.

Selective Image Corrections using Lightroom

The tool strip located beneath the histogram contains four selective correction tools: *Spot Removal* ⬤, *Red Eye Correction* ⬤, *Graduated Filter* ▦, and *Adjustment Brush* ▬▬▬. The Crop & Straighten tool ▦ is also located in this tool strip. These are all tools that we already know from Adobe Camera Raw, but they are more intuitive in their Lightroom versions.

Figure 6-45: Lightroom tool strip

The Spot Removal tool ⬤ has similar effects to the Photoshop Clone Stamp and Healing Brush tools, here activated using the *Clone* and *Heal* options (figure 6-46). To clone, move your mouse to the area you want to correct, then move the mouse (with the mouse button held down) to the area you want to use as your repair source. Brush size and opacity are adjustable. The Heal method uses the same technique to apply the color and texture of the source area to the target area.

Figure 6-46: You may use either the Clone or the Heal functions.

Figure 6-47: Settings for the Lightroom Adjustment Brush

Figure 6-48: Presets panel in the Lightroom Navigator

Lightroom's *Red-Eye Correction* tool ⊙ is the same as most others. It requires you to draw a circle or an ellipse around the subject's eye and then adjust the pupil size and darkness value for the corrected area. This tool does not work for the yellow-eye effect sometimes found in animal portraits.

Use of the *Graduated Filter* 🔲 and *Adjustment Brush* ▬▬▬ tools is the same as with the ACR versions, but also includes a pull-down menu of preset effects Ⓐ that you can customize to include your own presets (figure 6-47). As well as dodging and burning selected images areas, the tool allows you to enhance or subdue image colors using positive or negative saturation values. You can also use negative Clarity and Sharpness values to deliberately de-focus selected areas and, conversely, positive values to sharpen creatively. You can use the *New* button to set a new correction and combine multiple brush effects in a single image.

Unfortunately, the keyboard shortcuts for adjusting brush hardness, size, and opacity are different in Lightroom, ACR, and Photoshop. In Lightroom, you can adjust the brush size using the mouse scroll wheel. Pressing the ⇧ key allows you to adjust the *Feather* setting with the scroll wheel, and pressing the Alt key turns the brush temporarily into an eraser.

Lightroom's Presets Panel

In all modules except *Library*, Lightroom's Navigator panel includes a *Presets* panel with a preview image window (figure 6-48). The available presets are appropriate to the currently active module and can be applied to the current image with a simple click on list entries. Moving the mouse over a list entry (without clicking) shows its effect in real time in the preview window.

You can save your current correction settings to the presets list by clicking the "+" button at the top of the panel (figure 6-48). In the Develop module, the *Save Develop Preset* dialog allows you to choose which of the currently active corrections are to be included in the new preset. The list can be arranged hierarchically to help manage large numbers of presets.

If you copy Lightroom settings to the clipboard (using Ctrl/⌘- C), the same dialog appears but without the *Preset Name* field. If you then select images and press Ctrl/⌘- V , the settings on the clipboard will be applied to the selected image(s). Clicking the *Sync* button opens the same dialog, allowing you to select the settings you want to synchronize. This is useful if you want to apply the settings from a reference image to a group of similarly exposed images that you select before applying the preset. The *Reset* button sets the active image back to its original state.

6.3.3 Lightroom Output Modules

Lightroom offers built-in *Slideshow*, *Web*, and *Print* output modules. The program also allows you to hand over images to other applications for processing (using the Photo ▸ Edit in command) and to export images. Images have to be selected before you output them.

A menu in the Slideshow, Web, and Print modules (shown in figure 6-49) allows you to decide which of the currently selected images to output. *Selected Photos* is the default option.

Figure 6-49:

The Use menu for selecting your output

material

We recommend that you move your images to a new, static collection if you want to print multiple images or create a Web gallery. You can then use the new collection to sort your images before making your output settings.

Slideshow Module

Once you have selected your slideshow images in the filmstrip or the grid view, the filmstrip remains active so that you can add further images to the sequence. Lightroom slideshows include a wide range of frame, background, drop shadow, duration, transparency, and transition settings (figure 6-50).

The Preview panel includes a Template Browser with a choice of pre-defined slide formats that include EXIF metadata, slide captions, star ratings, etc. Here, too, you can define and save your own templates.

Pressing the *Play* button at bottom right plays a preview of your finished slideshow in the Lightroom preview window or the slideshow itself

Figure 6-50: Lightroom Slideshow module. The right-hand panel shows only a few of the many available options.

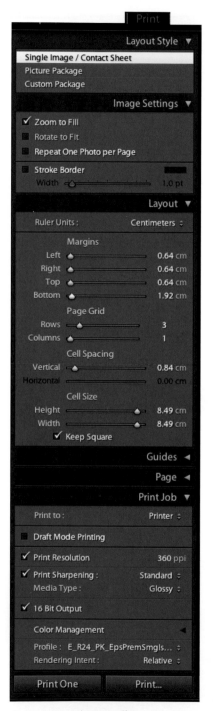

Figure 6-51: Lightroom offers a wide range
of print options (not all shown here).

in full-screen mode. You can also export your slideshow in PDF format or (in Lightroom 3) as a MP4 video file at resolutions right up to 1080p HD.

Lightroom's built-in settings allow you to create attractive slideshows but, if you want to create high-end presentations with special transition, camera pan, and music effects, we recommend that you export your images and prepare them using a specialized slideshow application.

Print Module

Lightroom has a number of art print settings that are not yet available in Photoshop, including custom margins, multiple image printing, and signatures. Figures 6-51 and 6-52 show some of the settings available in the print module. The module includes *Page Setup* and other settings that are usually found in the operating system print settings or the printer driver itself.

You can also apply print sharpening, which is added on top of the sharpening done in the *Detail* tab at the development stage. The three sharpening options are None, Glossy, and Matte (figure 6-51). Sharpening for matte media is stronger than for glossy media.

You can opt to leave color management to Lightroom or your printer driver. Before printer profiles are offered in the *Profile* menu, you must select which profiles to include in the list. For this, use the *Other* item in the *Profile* menu. Lightroom will then show a list of all profiles installed in the system. Checkmark all the profiles you intend to include in the menu list.

Lightroom's own color management offers *Perceptual* or *Relative Colorimetric* rendering intents and a choice of color profiles. Used under Mac OS X, Lightroom can even print in 16-bit mode, allowing for much finer color transitions and gradients.

The Print dialog also includes options for outputting to JPEG or (on a Mac) to PDF. Again, this module includes a Template Browser with a choice of print presets sorted as pre-defined or user-defined.

Lightroom's general print quality is good, but we nevertheless use RIPs for special print jobs (section 11.7).

Lightroom's Web Module

Using the *Web* module, Lightroom allows you to build Flash-based or HTML/CSS-based Web galleries using a range of pre-defined templates (figure 6-53 on page 234). There are also many free and commercial (mostly Flash-based) templates available on the Internet.

In order to speed up preview refresh times, we recommend that you work with just a few selected images until you finalize your design and layout. Once you are finished, you can include all the images you want to display.

We usually activate the *Selected Photos* option in the *View* menu (at the bottom of the main window) to achieve this goal.

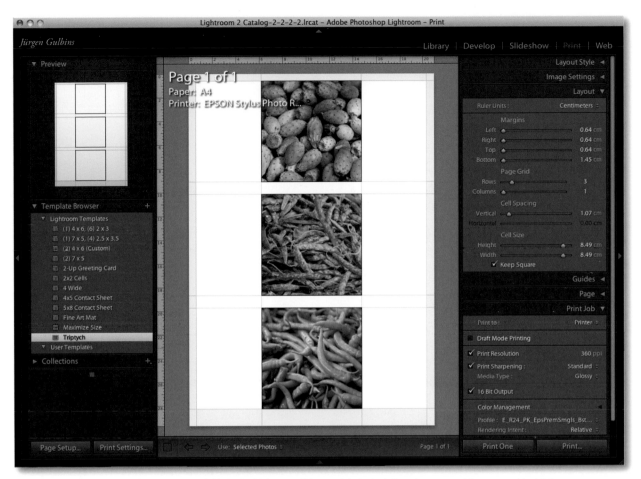

Figure 6-52: The settings available in the Lightroom Print module include just about everything we could wish for.

The same is true in the *Slideshow* and *Print* modules. By default, all the images in your current view are used to build the Web gallery. This can take a long time, if your view contains lots of images.

If the options in your selected *Web* gallery preset are not good enough for your taste, you can also edit the definition files. However, this is not easy without detailed foreknowledge. The available templates generally have very flexible color, image size, and text settings. The range of settings available varies from template to template.

You can find a number of *Web* gallery templates on the Internet and on Adobe's site at www.adobe.com/cfusion/exchange/.

The template browser generates a real time gallery preview in the main preview window in the center of the Web module screen. You can also export your Web gallery locally and preview it in your preferred Web browser. You can then use Lightroom (or any other FTP tool) to upload your gallery to the Web.

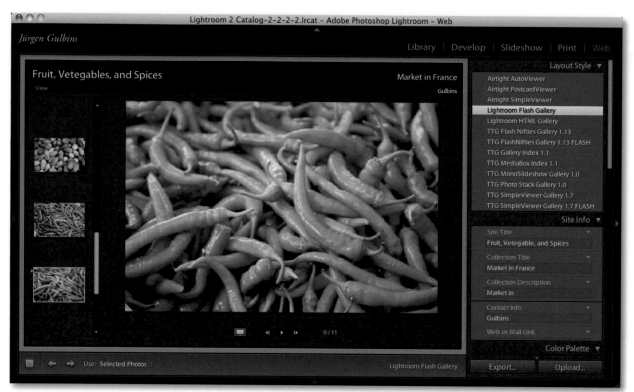

Figure 6-53: The *Web* module with the filmstrip hidden. The center preview window is currently displaying a *Lightroom Flash Gallery*.

Exporting Images from Lightroom

You can export selected images either by using the Export command in the context menu or File ▸ Export. The Export dialog is quite complex (figure 6-54) but is simple to use once you are familiar with its basic elements. The most important of these are the location Ⓐ, the filenames Ⓑ, and the file settings Ⓒ (such as file format and compression). Additionally, you can select image size Ⓓ and sharpening options Ⓔ, as well as metadata options Ⓕ.

Lightroom 3 also includes a very useful watermarking functionality Ⓖ, with options for setting text, type, shadow, positioning, and alignment. You can save your watermark settings as a preset for later use with other images.

The *Post-Processing* option is particularly interesting (figure 6-54 Ⓗ). Here, you can choose between a number of pre-defined actions* that you can apply to your images once they have been exported, such as opening them in Photoshop. As an example: for our book projects, we have created a Photoshop Droplet that automatically converts our exported images to CMYK format.

You can enhance the Export dialog using plug-ins that can (among other things) automatically upload images to Flickr and other Web photo portals. (*LR2/Mogrify*, written by Timothy Armes, is definitely worth a

* These can include scripts or Photoshop Droplets that are stored in a pre-defined folder.

LR2/Mogrify and other Lightroom plug-ins are available at:
www.photographers-toolbox.com

Figure 6-54: The export dialog looks more complex than it actually is, but nevertheless it includes a useful range of settings and options.

look. Its options include watermarking functionality that goes beyond the simple features included in Lightroom.) You can save post-processing steps as presets that then appear in the list of options in the Export dialog and in the export dialog's flyout menu. Lightroom's export functionality is powerful and easily extendable.

6.4 Bibble 5

🖥,🍎 www.bibblelabs.com

➜ Bibble is available in Lite and (more
expensive) Pro versions.

The Bibble RAW editor and converter was written by Eric Hymann of Bibble
Labs. The program is well established in the marketplace and is available for
Mac OS X, Windows, and Linux. Bibble supports a wide range of current
digital cameras. The Bibble interface is multi-language and highly config-
urable, with user-definable keyboard shortcuts.

Bibble 4 was generally classed as a good RAW converter, but the image
management functionality built into Version 5 elevates the program to all-
in-one status.

Bibble is based on a catalog concept similar to the one used by Apple
Aperture and Adobe Lightroom. The Bibble *Catalog* is the program's over-
all management container but does not have to contain the image files
themselves. Bibble can manage multiple catalogs simultaneously.

As with other all-in-ones, Bibble can import images from a memory
card into a newly constructed folder structure, or directly into a catalog. It
can also manage images from their currently saved location.

Bibble can also be used purely as a RAW editor and converter. In this
case, images do not have to be imported into a catalog. It is also possible to
drag images from other image browsers into the Bibble window for pro-
cessing. However, if you want to search through your images using meta-
data and other image-specific criteria, you have to import your images to
the Bibble Catalog first.

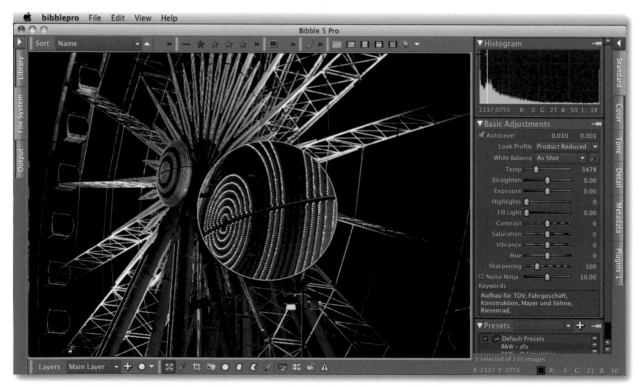

Figure 6-57: The Bibble 5 editing window, showing the Magnifier (in the center of the Preview Panel) and the Tools Panel

Bibble supports a wide range of RAW formats as well as RGB and TIFF files. It outputs to TIFF or JPEG and only supports the RGB color mode.

Bibble's browser is fast, functional, easy to configure, and allows the user to switch quickly and easily between different views. It reminds us a lot of Bridge in this respect. One of its great features is its ability to import metadata stored in XMP sidecar files. Bibble uses the same five-star rating and pick/reject flags as Bridge and Lightroom, and has five different color codes for labeling images.

The program's Import module allows you to automatically rename images and to apply keywords to all imported images, but appears to be less flexible than Lightroom or Bridge. In order to simplify image browsing and management, you can arrange images in stacks.* Bibble also stores thumbnails for previewing images that are currently offline.

* This function is also available in Bridge, Lightroom, and Aperture.

The program is fast (especially when generating previews of freshly imported images) and is constantly being expanded and updated. Bibble supports multicore computing and is supplied with comprehensive online HTML documentation.

Bibble has a built-in plug-in interface that it uses to integrate the *Noise Ninja* noise reduction tool that we know from our Photoshop activities (http://bibblelabs.com/products/bibble/plugins.html).

➔ There are many plug-ins available for Bibble 4, some of which also work with Bibble 5. We assume that the available range will continue to expand.

A camera/lens profile-based lens correction tool is also integrated into the package via the plug-in interface. A black-and-white conversion plug-in is available commercially.

The program includes all the major adjustment tools that we like to use (and some others besides), and rebuilds preview images much faster than many of its rivals.

The Tools Panel is similar to the ACR and Lightroom setups, although the tabs are arranged vertically rather than horizontally. The six basic adjustment tabs are: *Standard, Color, Tone, Detail, Metadata,* and *Plugins* (figure 6-58).

Figure 6-58: Bibble 5 Basic Adjustments panel

Figure 6-59: Settings in the Color tab

The *Basic Adjustments* tab panel (figure 6-58) has the adjustments that we already know from ACR, including *Fill Light* and *Vibrance*. A White Balance tool, controlled using an eyedropper, is included in the *Basic Adjustments* panel. This is also where the basic *Sharpening* and (very effective) *Noise Ninja* options are located. Including the *Keywords* function here in the Basic *Adjustments* panel is an unusual but practical idea. Some of the sliders found here can also be found in other tabs (such as the color temperature settings in the *Standard* and *Color* tabs), which may be surprising but is nevertheless logical.

The *Presets* panel includes a number of pre-defined options, and it is simple to add your own. As with other RAW converters, once you are used to creating and using them, presets can save a lot of time and effort in the course of the workflow. The preset tools that we find easiest to use are those built into Lightroom, LightZone, Silkypix, and Bibble 5.

Clicking the pin icon removes a tool from the tool tabs and places it above the tabs, making it visible regardless of which tab is selected. We usually pin the histogram to the Basic tab or pull it off into the desktop.

Figure 6-59 shows the *Color* tab, which includes *Curves* and *Color Balance* adjustments as well as the *Color Correction* tool for making selective tonal value adjustments. This tool allows you to make much finer adjustments than ACR or Lightroom. We would like to see some kind of targeted adjustment capability, although you can use the six additional color wells to add adjustment tones of your own – which can be very useful indeed.

Figure 6-60: The *Lens Correction* tools are especially effective and well structured.

Figure 6-61: The Tone tab is actually used to make adjustments to exposure.

The profile-based *Lens Correction* tools in the *Detail* tab are wide-ranging and effective (figure 6-60). They can also be used to make custom, manual corrections. The *Detail* or *Lens Correction* tab includes tools for correcting chromatic aberration and vignetting for the original and cropped versions of an image.

The *Tone* tab (figure 6-61) should really be called *Exposure*. The *Highlights* adjustment corresponds to ACR's *Recovery tool*.

The *Plugins* tab in our Bibble version 5.02 includes three pre-installed plug-ins for film simulation, black-and-white conversion, and color inversion (figure 6-62). We expect the large range of plug-ins that are already available for Bibble 4 to be ported to Bibble 5 in the near future. Remember, most plug-ins for Bibble are manufactured by third parties and cost extra! A list of Bibble plug-ins is available at www.bibblelabs.com/products/bibblc/plugins.html.

The program includes Crop ⬚ and Straighten ⬚ tools in the Toolbar beneath the Preview Panel. Clicking the ⬚ button uses colored masks to indicate which areas of your image are clipped. This is a standard feature in most RAW converters.

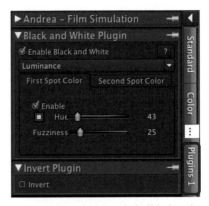

Figure 6-62: Bibble's included black-and-white conversion plug-in

Bibble 5 also supports a selective correction method similar to Photoshop's *Adjustment Layers*. Clicking the ⊞ icon in the Toolbar adds a new layer, where you can create a *Region* using the tools shown in the *Layers* window by dragging the mouse over the area you want to correct (figure 6-63). You can make circular, polygonal, spline curve, and brush-based regions. A region has an adjustable soft edge like the one we described for LightZone. It restricts a correction to the area within the region.

Figure 6-63: The Layers windows shows all defined Layers and Region tools.

Once you have defined a region, you can apply nearly all the program's adjustment tools to it. This allows you to make well-defined selective adjustments with hard or soft transitions. You can create multiple layers in a single image and switch between them simply by clicking on the layer you want to adjust. Layers can be deleted and contain multiple regions of different types. Regions can be copied and inverted.

Bibble 5's layers don't have opacity settings or blending modes like Photoshop's Adjustment Layers or LightZone's regions, but we nevertheless manage to achieve satisfactory results using them.

You can save your settings as named *Bibble Settings*, which you can then copy and apply to other images. You can choose which individual settings you want to save in the *Select Settings* dialog (figure 6-65 on next page).

Figure 6-64: Here, we used selective adjustments to warm the tones in the center of the Ferris wheel. The black spline curve defines our selected region.

Figure 6-65:
You can choose which individual settings to save in the *Select Settings* dialog.

Figure 6-66: Print and other output jobs are listed in the Batch Output panel tab.

RAW images can be singly or batch converted, and TIFF and JPEG image files can be batch resampled and exported in 8-bit or 16-bit formats. Output is controlled via the File ▸ Save File As… command.

Bibble's batch conversion functionality is well implemented and can be applied to multiple selections or entire folders. You can start multiple batch output jobs with different correction settings and add images to jobs with user-defined keyboard shortcuts. Shortcuts are listed in the *Batch Output* panel (in the *Output* tab) on the left of the Bibble window (figure 6-66). Double-clicking a list entry displays the settings it uses (figure 6-67). The conversion process itself is very fast. Print jobs are started from the Printing panel and will also appear in this *Output* panel.

Figure 6-67:
Batch Output Settings dialog

Bibble allows you to search through your image catalog using various filters, including the *Metadata Browser* found in the *Catalogs* panel.

The program's print module supports full color management and output sharpening. Our current version also includes rudimentary Web gallery and slideshow functionality that is adequate for viewing images, but that is not up to the standards offered by Aperture or Lightroom.

Though Bibble 4 supported tethered shooting for a number of DSLRs, this feature is not yet offered in Bibble 5.

Conclusions

Bibble 5 is a fast and functional all-in-one solution with great selective correction functionality that is often better than that offered by Aperture or Lightroom. We also like the soft proofing tool introduced with Bibble 5.02.

We would like to see *virtual copy* and *collection* (or album) functionality – maybe these will be implemented in future updates. There are just as many great plug-ins available for Version 4 as for Aperture or Lightroom, and the range available for Bibble 5 is catching up fast.

Camera: Nikon D1

Photoshop Layers

7

Layers are an essential part of the Photoshop workflow, and this chapter aims to make Layers one of your favorite techniques.

But what are Layers exactly? If you imagine the individual correction steps you perform on an image as a stack of perfectly aligned images where you can only see the top one, you are getting close. But Photoshop Layers can do much more than just document individual correction steps. The three most important characteristics of Layers are:

1. *They have a specific Opacity, with values between 0% (fully transparent) and 100% (fully opaque).*

2. *They can be merged with other layers using various techniques and tools.*

3. *Layer Masks allow you to apply the effects of individual Layers selectively, i.e., to precisely selected image areas.*

There are many different types of subtle changes you can make to your images using Layers. Adjustment Layers and Smart Filters even allow you to readjust your individual corrections later – also an extremely useful feature.

→ Photoshop CS1 was the first version to support 16-bit layers. Photoshop CS2 extended this functionality and also introduced 32-bit Layer support.

Layers were invented to help graphic artists with their work, but we limit ourselves here to aspects of layers that help in the course of the digital photo workflow. Layers are a powerful tool, but images that contain layers require more memory and disk space than other image files. Working with 16-bit or 32-bit layers requires even more memory and computing power.

7.1 Layers Panel

The layers "nerve center" is the Layers panel, which is activated via Window ▸ Layers or by pressing F7. The panel displays the layers contained in an image from top to bottom. The *Background Layer* (if present) is always the lowest. The most important elements of the Layers panel are shown in figure 7-1. These might appear complex at first, but we will explain their uses step by step in the course of the workflow.

The uppermost part of the panel contains the *Blending mode* and *Opacity* settings for the active layer (figure 7-2). These are both important elements of the workflow, and we will address them in detail later.

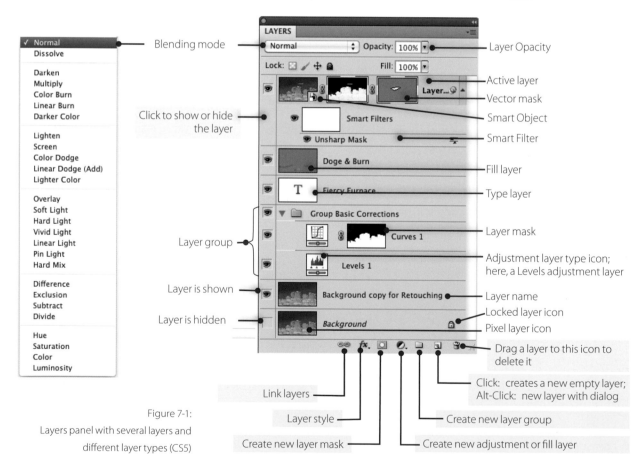

Figure 7-1:
Layers panel with several layers and different layer types (CS5)

The *Fill* and *Lock* elements are more interesting for graphic artists, so we will not go into detail on these.

Photoshop names the individual layers automatically (and sequentially according to type), but it is often better to give them your own names. This will help you retain an overview of multi-layered images.

There are several types of layers, including *normal layers*, *fill layers* and *vector layers,* as well as *Smart Filters,* which we discuss with in section 7.12.

Normal Layer • Normal pixel layers behave like stacks of more or less transparent images. Lower layers cannot be seen through layers with 100% opacity, and the edges of layers that are larger than higher layers can be seen "sticking out" from underneath. (Lower layers are visible through other transparent or partially transparent layers.) Reducing opacity makes lower layers visible through higher layers. The background layer is an exception and always has 100% opacity. The background layer is locked by default and must be released with a double click to behave like a regular layer.

Adjustment Layers • These are especially important to the photo workflow. Complex image manipulations involve large numbers of adjustments that have to be carried out in sequence. These include adjustments to tonal values, brightness, contrast, hue, saturation, and gradation curves. Adjustment layers help us to adjust individual corrections without having to repeat the other steps we have made.

An adjustment layer does not contain image data, but rather information that describes an adjustment made to the image data. The adjustments made using an adjustment layer can be changed or discarded (by deleting the layer) without having to resample the image. The pixels in the layers beneath an adjustment layer only change if you use brush tools on them. Many of the tools available in the Image ▸ Adjustments menu are also available as adjustment layers. Figure 7-3 shows the Photoshop CS5 adjustment layer types, which we will address individually later on.

Adjustment layer types are indicated by either a generic thumbnail 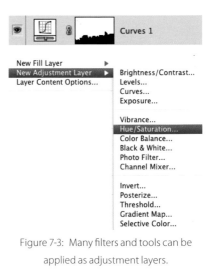 or a type-specific thumbnail, depending on the panel options you have selected. ⊞ symbolizes a Curves layer, ⊞ a Levels adjustment layer, and ⊞ a Hue/Saturation adjustment layer.

Not all tools are available as adjustment layers. For example, Shadows/Highlights can only be applied on a regular layer, although Smart Filters can help you work around this limitation.

Fill Layers • These layers are generally filled either with a solid color, a gradient, or a pattern. The stronger a fill layer is, the more effect it will have in the final image. Fill layers can be used in different modes, but we rarely use them during the photo workflow.

Vector Layer/Shape Layer • Text created using the Type tool **T** is stored on a vector (or shape) layer. These layers contain objects rather than pixels. The objects can be individually adjusted in a similar way to the changes

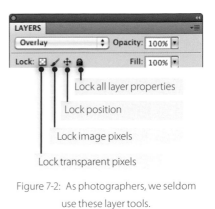

Figure 7-2: As photographers, we seldom use these layer tools.

Figure 7-3: Many filters and tools can be applied as adjustment layers.

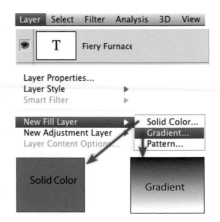

made on an adjustment layer. We won't, however, use vector layers in the course of our photo workflow.

Elements and Buttons in the Layers Panel

Show or hide layer

* A layer can be activated by clicking in the right-hand portion of the layer entry in the Layers panel.

The far left column of the Layers panel displays the layer status – either shown 👁 or hidden ▢. Clicking the "eye" icon toggles a layer between its shown and hidden states, allowing you to easily see the effect the selected layer has on the active image or the differing effects of various image versions. The active layer is signaled by the layer entry's colored background in the Layers panel.* The columns right of the "eye" icon display further layer information:

This thumbnail displays the contents of a regular (pixel) layer in the appropriate place in the active layer hierarchy.

 Instead of the contents thumbnail (see above), this icon displays the operation represented by an adjustment layer. Each adjustment layer type has its own icon. If you select the "none" option for the thumbnail display in the panel options menu, the panel will display the generic ▢ for all layers.

The chain icon indicates that the layer and its layer mask are linked. We never change this setting.

This icon indicates that the active layer has a layer mask, shown here in miniature. We will go into layer masks in more detail later.

Buttons at the Bottom of the Layers Panel

* There is an example in section 7.9 on page 270.

Most layer functions are controlled by the buttons at the bottom of the Layers panel:

Links multiple layers. We seldom use this function during the photo workflow.

fx. Allows you to define a new layer *style* or to edit the current style. This is also a function we seldom use when processing photos.*

Creates a new *Layer Mask*.

Creates a new *Layer Group*. Photoshop versions before CS2 called this function *Layer Set*.

Adds a new adjustment layer to the stack. The layer type is selected using the new layer's drop-down menu.

Creates a new layer or duplicates the selected layer if you drag a layer to the active layer icon.

Deletes the selected layer or any layer you drag here (with a confirmation dialog).

The Background Layer

The *Background layer* is a special layer, indicated by its default lock icon .
This layer cannot be moved without changing its status. If you delete pixels
on the background layer, the background color will appear instead of the
usual transparent pixels. Double-clicking the background layer transforms
it into a regular layer called "Layer 0" that you can then give a name of your
choice and manipulate like other regular layers.

→ All new images start out as a simple background layer that cannot be
 manipulated using all the operations available to other layers (such as
 blending mode or opacity value).*

 We usually leave the background layer alone and work on a copy of it
 or on other, newer layers.

* Double-clicking the background layer in
the Layers panel transforms it into a regular
layer.

7.2 Your First Layer

Here, we will use the dust speck from our example in section 4.11 that we re-
touched directly on the background layer. Using this direct method means
we have to start the entire correction process again (or reload the RAW orig-
inal) if we are not happy with the results.

We prefer to make a copy of the background layer to work on by dragging
it to the ⬛ button at the bottom of the panel (or by using Ctrl/⌘- J).

Remember to give your layer copy a descriptive name (here "Remove
dust"). You can now remove the speck using the Clone Stamp tool ⬐ (page
127). If you hide your new layer by clicking the ◉ icon, you can see that the
speck is still part of the original background layer.

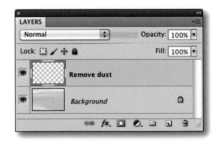

Figure 7-4: A detail of our initial image,
showing the dust spot we want to remove

Instead of using a copy of the background, you can also retouch using
the Clone Stamp on a new, empty layer (created by clicking ⬛). Make sure
that you select the *Current & Below* option in the tool's Sample menu, oth-
erwise you will not be able to apply the selected pixels to your background
layer. This is a straightforward way to perform selective corrections.

Our new *Remove dust* layer (figure 7-5) will only contain the retouched
pixels (i.e., fewer pixels than a retouched copy of the background layer).
Using a new, empty layer to perform image retouching makes it easier to
see what is going on and also saves disk space.

Figure 7-5: We use a separate layer when
applying the Clone Stamp tool.

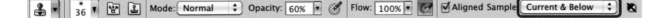

7.2.1 Changing Layer Opacity

New layers have a default opacity setting of 100% (i.e., lower layers are completely invisible). This setting can be changed to make a layer partially transparent or completely transparent (at the 0% end of the scale).

Figure 7-6: Clicking the arrow in the upper-right of the Opacity value pops up a slider that you can use to change the value.

We change opacity values often during the workflow. This setting allows us to start out applying high strength effects and then fine-tune them by reducing opacity.

Test the effect for yourself by changing the opacity value for our dust speck example. You will see how the speck appears more pronounced with decreasing opacity. We generally reduce opacity on adjustment layers to help us fine-tune the effects of other corrections, such as increased color saturation.

7.2.2 Blending Modes

Blending modes determine how the pixels and other adjustments on the active layer are sampled and merged into lower layers, and how the effect appears in the final image. The following are the most important modes for use in the photo workflow:

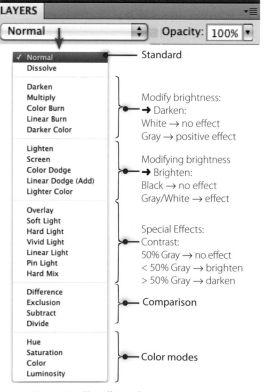

Figure 7-7: The effects of various layer modes

Normal selects only the pixels in the active layer and applies the current opacity value.

Darken, Multiply work in a similar way to the Burn tool. White areas on the top layer have a neutral effect, darker areas show moderate effects, and black applies the maximum effect.

Lighten, Negative Multiply are the opposites of the effects described above (equivalent to the Dodge tool). Black areas on the top layer have a neutral effect, brighter areas show moderate effects, and white applies the maximum effect.

Overlay selectively brightens or darkens specific image areas. A 50% gray value has no effect. Values below 50% gray brighten the relevant areas in lower layers, while higher values darken lower layers. There is an Overlay example on page 271. This is one of our favorite modes.

Soft Light/Hard Light allows you to increase color saturation. The effects of white/black/gray values in the top layer are similar to those produced by Overlay mode.

Luminosity is important for reducing unwanted color shifts. (See section 7.8, page 268 and section 8.2, page 295.) Only luminosity (brightness) is affected.

Color effects only color (not luminosity) for most details.

Saturation changes color saturation but not luminosity or hue.

Hue affects hue without affecting luminosity or color saturation.

7.3 Using Adjustment Layers

Adjustment layers are the main reason we use Photoshop Layers so much during our workflow. An adjustment layer doesn't add a new image to a stack, but instead allows you to perform corrections on the layers beneath it. Adjustments are only performed virtually (i.e., they are not resampled into the image data) until the entire layer stack is flattened to a single layer or printed.

Many (but not all) of the tools available in the Image ▸ Adjustments menu are available as adjustment layers. Adjustments applied as layers can be fine-tuned not only using each tool's own sliders, but also using layer opacity settings and layer masks. Layer masks are used to limit the effects of an adjustment to the non-masked image areas.

A new adjustment layer is created either using Layer ▸ New Adjustment Layer ▸ ... or the ⊘ menu at the bottom of the Layers panel. There are many types of adjustment layers to choose from (although we don't strictly class the first three types in figure 7-8 as such). The adjustment types marked in red in the illustration are the most important in our workflow. Once you develop your own processing style, you will want to include other adjustment types in your repertoire.

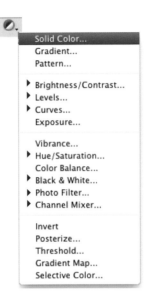

Figure 7-8: CS5 Adjustment Layer menu

We will use the Curves adjustment layer illustrated on the right to darken our sample image. Our Layers panel will then look like the one shown in figure 7-9. (If the layer entry is too small, or if you have selected the *None* thumbnail option in the panel options menu, the layer entry will display the generic ⊘ icon.)

If, for example, you make *Curves* adjustments directly using the Curves tool, any adjustments will be applied directly and irreversibly to the image pixels. If, however, you are using a *Curves* adjustment layer, clicking the ⊘ or ▦ icons in the Layers panel starts the Curves dialog as a layer component, making any adjustments you apply virtual and non-destructive.

Adjustment layers apply virtual effects that can be refined later. This way, the Layers panel also provides you with a detailed history of the corrections you have made. Additionally, adjustment layers can be dragged (and thereby applied) to other open images.

Figure 7-9: Here we use a separate layer to perform our Clone Stamp operations.

An adjustment layer uses very little disk space, as only the correction parameters (and not the actual pixels) are saved. In order to ensure that images remain compatible with other applications, Photoshop automatically creates an additional layer that contains a flattened, single-layer version of the image. This doubles the disk space the image requires, although any additional adjustment layers will only slightly further increase the file's size. You can prevent this (otherwise invisible) layer from being created if you

set the *Maximize PSD and PSB File Compatibility* option under Prefer-ences ▸ File Handling to *Never*. We don't recommend doing this, as it re-duces an image's compatibility with other applications (such as Lightroom). Selecting this option does, however, reduce the disk space used by the im-age file. Disk space requirements also grow if you use layer masks, as de-scribed in section 7.4. However, layer masks consist of 8-bit grayscale val-ues, and therefore use less disk space than RGB or CMYK pixel layers.

> If you save an image that includes pixel, vector, type, or adjustment layers to PSD, PSB, Photoshop RAW, TIFF, or Photoshop PDF formats, the lay-ers will remain intact. These formats also preserve alpha channels (usu-ally saved selections) and ICC color profiles.
>
> JPEG, PNG, and GIF cannot save layers or channels. These formats automatically flatten images to a single layer before saving.[*]

* See table 4-1 on page 98.

You can also save disk space by compressing the layers in an image. Since CS1, Photoshop allows you to compress layer data using either RLE or ZIP. ZIP usually produces smaller files but requires more processing power and takes longer.

Figure 7-10:
You can select separate compression methods for an image and its layers.

Once you get the hang of working with adjustment layers, you won't want to work without them.

Switching Between Adjustment Layer Dialogs

As of CS4, Photoshop is capable of nonmodal, layer-based processing. Earlier program versions required you to explicitly close adjustment dialogs (by clicking OK) before you could activate or edit another layer. Now, you can leave multiple dialogs open. Dialogs no longer have their own OK but-ton, but can nevertheless be closed to save space on the desktop (figure 7-11). You can then switch to another dialog simply by clicking on the appropriate layer in the Layers panel. This functionality makes working with multiple layers a lot simpler.

The dialogs you see if you make an adjustment using an adjustment layer are slightly more compact than those displayed if you make an ad-justment via the Image ▸ Adjustments menu, but they still contain all the same functionality.

Figure 7-11: Sample adjustment layer dialog
(here, for a Curves adjustment)

Other buttons in adjustment dialogs include: ⟳ resets all parameters to their default values, ◉ displays the original (uncorrected) image, and 👁 toggles between showing and hiding the effects of your manipulations. Clicking ◉ limits the effect of the active layer to the layer directly beneath it. This setting is indicated in the Layers panel by the presence of an arrow ↴ next to the layer icon (figure 7-12). This function is only relevant if the next layer doesn't completely cover the layers beneath it, so we don't end up using it very often in the course of our workflow.

Figure 7-12: The effects of this type of layer are only applied to the next layer down.

The 🖳 button in figure 7-11 switches between large and compact dialog displays. Further (sometimes adjustment-specific) functions are included in the menu at Ⓑ, which you can display by clicking the ▾≣ symbol at top right.

The ◁ button opens a new panel (figure 7-13) containing a range of icons (Ⓐ) for creating new adjustment layers and a list of adjustment layer presets (Ⓑ). Each preset contains a drop-down menu of variants. For example, the Curves presets menu contains various predefined curves for producing different levels of midtone contrast.

Clicking an adjustment layer icon creates a new layer with default values and clicking a preset creates another layer with adjustable preset values. This allows you to quickly set up and fine-tune your adjustments using the appropriate dialog settings.

You can also create a new adjustment layer by clicking ◉ at the bottom of the Layers panel or by using the Layer ▸ New Adjustment Layer command. You can then load presets using the adjustment layer menu (figure 7-11 Ⓐ).

You can save your current setting as a custom preset using the Save Current Preset… command in the panel menu ▾≣.

Figure 7-13: Adjustments panel offering different adjustment layers and their presets

Figure 7-14:

Most adjustments allow you to save settings for application later.

Your new preset will now appear in the preset menu Ⓐ in the adjustments panel (figure 7-11), as well as in the preset menu Ⓑ in the appropriate adjustment layer dialog (figure 7-13) and the preset menu for the Image ▸ Adjustments command.

The Save dialog (figure 7-14) suggests standard locations for saving presets, but you can also select your own location. This means you can save your presets in a location that won't be deleted if you reinstall the software. If you use this option, you have to enter the location manually in the Photoshop Preferences dialog. The adjustment layer ▾≣ menu (figure 7-15) also contains the Load *xxx* Presets command for loading previously saved presets (only if a adjustment layer is selected).

Figure 7-15: The ▾≣ menu contains a selection of layer adjustments.

7.4 Making Selective Adjustments Using Layer Masks

Adjustment layers are a great tool, and *layer masks* make them even more powerful. Masks make it possible to selectively adjust the image areas an effect is applied to and the intensity with which it is applied. Without a mask, the entire image will be affected.

Figure 7-16: Our initial image

We will use the rock formation in figure 7-16 as an example. In order to increase contrast on the rocks, we first select the sky using the Color Range tool and then invert our selection (figure 7-17 and figure 7-18).

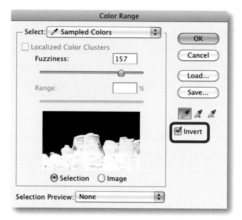

Figure 7-17:
Selecting the sky and then inverting the selection selects the rocks in this image.

We then create a new *Curves* adjustment layer for the active selection, which automatically generates a layer mask (figure 7-19) with the selection shown in white and the nonselected areas in black.

Figure 7-18: The inverse selection

Figure 7-19:
The new adjustment layer with its automatically generated layer mask

An Alt-click (Mac: ⌥-click) on the mask icon displays the mask instead of the image in the preview window (figure 7-20). A second Alt-click reverts the display to normal.

It is clear from figure 7-20 that the Color Range selection tool hasn't created a perfect mask. We don't often need such complex masks in the course of our workflow, but if you are interested in the intricacies of masking, we recommend books on the subject by Martin Evening [13] and Katrin Eismann [12].

Figure 7-20: The preview displays the mask rather than the image.

Figure 7-21:
The mask (in red) is shown as
an image overlay. You get this
view by ⇧-Alt-clicking the
mask icon.

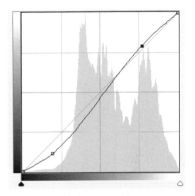

For less complicated situations, you can use a range of other Photoshop tools to improve your mask, as we will show you later.

In order to increase contrast in the rock formation, we now create a conventional "S" curve in the Curves dialog (figure 7-22). The layers mask ensures that the effect is only applied to the rocks, and the result is shown in figure 7-23. Increasing the contrast has also increased color saturation; so we change the adjustment layer mode to *Luminosity* instead of *Normal*, creating the result in figure 7-24. Figure 7-25 shows the resulting layers stack.

Figure 7-22: We used this curve to
increase contrast in the rock formation.

Figure 7-23: Contrast is improved, but saturation is now too high.

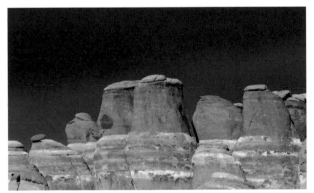

Figure 7-24: Using *Luminosity* blending mode reduces the color shift.

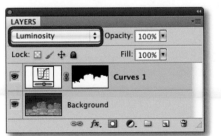

Figure 7-25:
The layer stack after switching to
Luminosity blend mode

You can also create a layer mask for an adjustment layer by making a selection in a pixel layer and clicking ▣. The active selection is then automatically used to create the mask.

7.4.1 Understanding Layer Masks

A layer mask is, in fact, an 8-bit grayscale image. The adjustment applied using the mask is 100% effective in the white areas and becomes less and less effective right down to 0% in areas where the mask is black. The most important parts of the scale are usually somewhere between the two extremes in the gray parts of the mask.

A black-to-white gradient allows us to produce a soft transition. We can adjust the mask's other characteristics (and with them its effect) selectively using brushes and filters.

Blending Images

If you apply a layer mask to a regular layer, the portions of the mask that are white completely cover the parts of the layer directly beneath them (with opacity set to 100%). The black portions of the mask allow the layer beneath to show through. Gray areas are partially visible. You can use this effect to superimpose identical images while using a gradient to ensure smooth transitions between light and dark areas.

Let's look at the sample images in figures 7-26 and 7-27. They show exactly the same scene but with differing exposures. To blend them together, we open both and copy and paste the second image into a new layer above the first one. We can also select and open multiple images as layers directly from Bridge or Lightroom.* At first, we can only see the upper image with its correctly exposed sky.

* Lightroom uses the Photo ▸ Edit in ▸ Open as Layers in Photoshop command (section 7.11).

Figure 7-26: The castle is correctly exposed, but the sky is too bright.

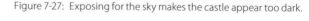

Figure 7-27: Exposing for the sky makes the castle appear too dark.

The two photos were shot handheld, and therefore need to be aligned before we blend them together. To do this, we select both layers and use the Edit ▸ Auto-Align Layers command* (with *Perspective* selected). Finally, we then use the Crop tool to cut away any excess, nonaligned borders.

* This function was introduced with Photoshop CS4.

The next step involves selecting just the upper layer and using Select ▸ Color Range to select the sky (figure 7-28). Here, we use the eyedropper to click in the sky and adjust *Fuzziness* until we like the resulting selection. Clicking *OK* then activates our selection.

The selection is, however, still too sharp for blending; so we use the Select ▸ Refine Edge dialog (figure 7-30), introduced with CS4, to feather the edges of our selection by 2.2 pixels. The size of a soft border will depend on the image resolution and the type of selection you are adjusting.

Clicking the layer mask button with our selection active now creates a layer mask from the selection. If necessary, we can further refine our selection using brush tools.

Here, we used the brush to mask the lake and finish our virtual merge. The result is shown in figure 7-29. Figure 7-31 shows the layer stack the process created. The sky portion of the mask is gray, which means that the sky wasn't entirely blended into the finished image. We like the result anyway!

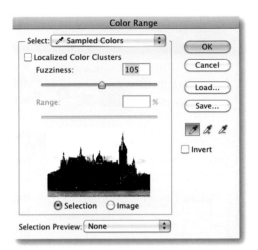

Figure 7-28: Selecting using Color Range makes selecting just the sky easier.

Figure 7-29: The result of using a layer mask to blend two layers containing figures 7-26 and 7-27

Figure 7-31:
The layer stack for figure 7-29

Figure 7-30: Refine Edge allows you to make a number of subtle improvements to your selection. The function has been further enhanced in CS5.

Instead of the blending method, we could also have used Hue/Saturation or Curves adjustment layers to improve brightness and color in our sky selection.

Disable Layer Mask

Delete Layer Mask
Apply Layer Mask

Add Mask To Selection
Subtract Mask From Selection
Intersect Mask With Selection

Refine Mask...

Mask Options...

Figure 7-37: Select the layer mask and
call up the context menu (right mouse
button) to see a number of mask options.

If you want to apply a single mask to multiple layers, group the appropriate layers (section 7.13.3) and apply a mask to the resulting group (i.e., to the entry in the layers panel with the ▢ icon).

Masks can be adjusted using most Photoshop tools and filters (e.g., Curves for contrast or Gaussian Blur for soft focus effects). They can also be applied to regular layers using the layer's context menu. The layer's pixels are then transformed into transparent pixels according to the distribution of black areas within the mask. The mask itself is then deleted.

Masks Panel

The Masks panel was introduced with Photoshop CS4 and is activated using Window ▸ Masks. The panel contains most of the basic mask tools, including edge refinement and *Color Range*, as well as the ◎ button for applying a mask as a selection, the 👁 button for deactivating a mask, and the 🗑 button for deleting an active layer mask.

The *Density* mask slider, also introduced with CS4, allows you to reduce the blackness of a mask, thus reducing the strength of the mask's effect on an image.

Clicking ⬙ applies a mask to a regular layer and then deletes it. We avoid using this function, as we prefer to be able to readjust our corrections later. It does, however, save the disk space used by the deleted mask.

Figure 7-38: The Masks panel contains
a number of useful tools.

CS4 Color Range Enhancements

Figure 7-39: When *Localized Color Clusters* is
checked, the Range slider controls the size of the
selection around the eyedropper tool.

The Color Range selection tool was extended in its CS4 version to include the *Localized Color Clusters* option. This option takes into account the location of the eyedropper tool in the image and activates the *Range* slider. The selection (still controlled by the *Tolerance* setting) is now applied to the selected color range and in the physical area selected by the eyedropper. The *Range* slider functions like a radius setting – a 100% setting selects the entire image, whereas a lower value selects a smaller area around the click point. The result is a selection that ignores identical tonal values outside the selected area. You can also make multiple selections that are then automatically combined into a single selection. You can use either the plus/minus eyedroppers (and) or the ⇧ or Alt/⌥ keys to refine your selection.

7.4.2 Paths and Vector Masks

Photoshop also allows you to create vector masks. Vector masks have precise, pixel-perfect edges* and can be scaled, rotated, and transformed manually without loss of detail. Vector masks generally use less disk space than pixel masks.

> * Vector masks can also have soft edges (figure 7-38, page 260).

Vector masks function just like pixel masks. If an image has both a pixel mask and a vector mask, all detail that is covered by both masks will be protected. A vector mask is a kind of closed curve, or *path*, and a path is a scalable graphic object that limits the boundaries of a selection. Paths consist of multiple complex curves (or *splines*) that can be combined to form virtually any shape you can imagine. They are therefore very useful for making complex selections and masks.

Figure 7-40: A path around the lid of my tobacco box

Path/pen tools

Path selection tools

Paths can be selected in Photoshop using either the Direct Selection Tool or the Path Selection Tool.

You can use the path tools to create an open-ended curve or a closed form that can then be used to perform a number of operations. These can be selected using a right-click within the image, appropriate keystrokes, or the Paths panel (figure 7-47, page 262):

Figure 7-41: A filled path

▸ **Load path as a selection**. Photoshop can convert selections into paths using the *Load path as a selection* button at the bottom of the Paths panel. Such selections can also be saved as masks or alpha channels.

▸ **Fill path** fills the selected path with the current foreground color.

▸ **Stroke a path** using any selected tool. This function follows the selected path with the chosen tool.

▸ **Save as a vector shape** for later use.

Figure 7-42: The vector mask isolates the lid of the tobacco box by masking the rest of the layer.

▸ **Save as a vector mask.** This only works on non-background layers and mask areas outside the path.

▸ **Transform (using conventional transform tools).** You can transform the entire path or just selected anchor points.

▸ **Save as a path** for use with other images.

Paths can be adjusted by moving, deleting, adding anchor points, or shifting direction lines. Paths can be named like layers, and individual paths or anchor points can be adjusted using selected tools.

You only need to apply a few anchor points to form a complex spline curve (figure 7-40). Finding and placing the right points requires practice. Readers who already have experience using Adobe Illustrator or other

7.8 Auto Color Correction for Better Contrast

Figure 7-62: The sample image detail used for our Auto Color Correction experiment

Generally, you shouldn't trust any correction tool with the word *Auto* in its name. Although the quality of Adobe's Auto tools is constantly improving, your own eyesight and judgement will usually produce better results. There are exceptions to this rule, and one of them involves using Auto Color Correction on a layer to improve image contrast. The process consists of five separate steps that we will demonstrate using the unsharpened image detail in figure 7-62:

1. Create a new Levels adjustment layer. The dialog in figure 7-63 then appears.

2. Select Auto Options in the dialog menu ▾≣. The dialog in figure 7-64 pops up. Adjust the default settings as follows:
 – Check the *Enhance Per Channel Contrast* option
 – Set *Shadows* and *Highlights* clipping values to 0.20%

Figure 7-63: The initial histogram for our image

The default values are often unsuitable, so you will have to experiment to find out which settings suit your particular image. You can save your settings as the new defaults by checking the *Save as defaults* option.

Figure 7-64: Target clipping values for the Auto Color Correction function

3. Click *OK* and then click on *Auto* in the panel dialog.

Clipping tonal values generally has a negative effect on an image but, as shown here, you can achieve useful results with appropriate settings. Don't be put off at this stage by the colors in figure 7-66.

These settings clip the shadows and highlights by 0.2% for all channels. The automatic function settings tend to clip each channel slightly differently, resulting in visible color shifts.

The histogram in figure 7-65 shows only the red channel, so take the time to look at the blue and green channels as well. Our result (figure 7-66) looks pretty awful to begin with.

Figure 7-65: The histogram after applying Auto Color Correction

Figure 7-66: Auto Color Correction with heavy color shifts (in Normal blend mode)

→ As mentioned, Auto Color Correction can produce completely unusable images!

The following steps will help to sort things out.

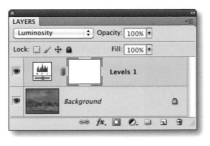

Figure 7-67:
Set blending mode to Luminosity

4. We select *Luminosity* blending mode (figure 7-67). This starts to shift the colors back to normal levels (figure 7-68).

 Luminosity mode is designed for use with layers on which detail contrast is adjusted, but where colors remain largely unchanged.

5. The contrast visible in figure 7-68 is still a little high due to the tonal value clipping. What do we do if a layer effect is too strong? We reduce that layer's opacity! 30% opacity produces the desired effect in our example (figure 7-69).

6. A little sharpening then completes our processing, producing the result shown in figure 7-70.

The image in figure 7-70 could be further improved by applying local contrast adjustment as described in section 8.12, page 334.

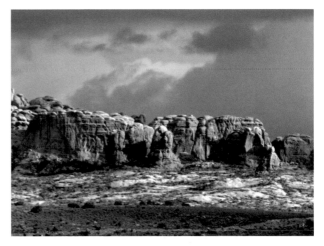

Figure 7-68: Contrast is still too high.

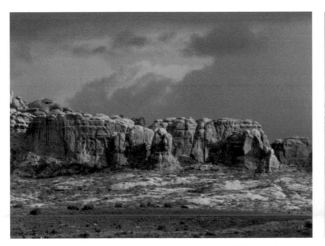

Figure 7-69: Contrast with reduced opacity

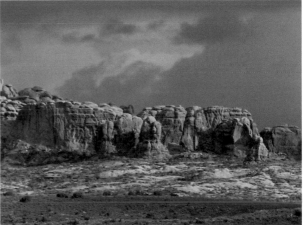

Figure 7-70: The finished (sharpened) image

Figure 7-76: Original image Figure 7-77: Finished, dodged image

Instead of using the 🔍 and 🖐 tools, you can also use black and white soft brushes with low opacity to selectively brighten or darken specific image areas.

7.11 Loading Image Files into a Stack and Aligning Layers

Photoshop CS3 introduced functionality for loading and aligning multiple files on separate layers. This can be useful if you want to merge differently exposed images of the same scene. The loading command can be found under File ▸ Scripts ▸ Load Files into Stack and displays the following dialog:

➜ Lightroom also allows you to select multiple Lightroom image files and open them directly in separate Photoshop layers.

Load Layers

Source Files
Choose two or more files to load into an image stack.

OK
Cancel

Use: Files ▼

DWF_007.tif
DWF_016.tif
DWF_018.tif

Browse...
Remove
Add Open Files

Ⓐ ☑ Attempt to Automatically Align Source Images
☐ Create Smart Object after Loading Layers

Figure 7-78:
In the File ▸ Scripts menu, Photoshop allows you to load multiple images on separate layers and align them.

Use the *Browse* button to select your images and add them to the list in the dialog. The automatic alignment function (Ⓐ) is enabled as soon as you select more than one image. You can also create Smart Objects in the new layers if you check the *Create Smart Object* box.* If you decide to use the alignment option, the dialog in figure 7-79 is displayed. This is essentially the same dialog used by Photoshop's Photomerge automation tool (section

* For Smart Objects, see section 7.12.

9.2.2, page 351). The *Auto* projection type usually produces great results, and *Reposition* is also reliable for sequences consisting of almost identical images.

➜ Auto-Align not only aligns your images, but also automatically scales and rotates them, and even corrects some perspective distortion.

Figure 7-79:

CS4 Auto-Align Layers dialog

We are going to use Auto-Align to extend the depth of field of a macro photo. It is important to select the smallest possible aperture when shooting in macro situations, although too small an aperture can cause additional blur due to refraction from the aperture blades when light enters the lens.

Figure 7-80: Three macro source shots of an unrolling fern. Each has a slightly different plane of focus.

To increase depth of filed, we are going to merge three shots of the same subject to get the best possible depth of field. We shot our source images using manual exposure (to keep the aperture and shutter speed settings identical) and manual focus (to adjust the plane of focus slightly for each shot). The results are shown in figure 7-80.

The source images are loaded into layers and aligned as previously described. Figure 7-81 shows the resulting layer stack.

We now select all three layers and navigate to the Edit ▸ Auto-Blend Layers command. Photoshop then asks whether you would like to make a panorama or a stack (figure 7-82). Here, we select *Stack Images*.

Figure 7-81: Our layer stack after loading and aligning the layers.

Figure 7-82: Selecting the Blend Method

Photoshop then automatically selects the sharp areas of each image and creates masks to eliminate the unsharp areas. This process can take some time, depending on the number and resolution of the images you are merging. The merged layer stack now looks like the one in figure 7-83 and the finished image has the combined depth of field of all three source images.

This technique, called *Focus Stacking,* was introduced in the Photoshop toolbox with CS4. The tool isn't perfect but nevertheless produces usable results, as figure 7-84 shows. You can also use the layer masks automatically produced by Photoshop to perform other corrections and fine-tune your image.

If you no longer need the masks, you can flatten the new image to the background layer as described in section 7.5. It is often necessary to crop merged images, as the automatic alignment process tends to produce slightly transparent overhang at the edges of combined images.

Figure 7-83: Layer stack after blending

Figure 7-84:
The finished, increased depth-of-field image

→ Our book on Multishot Techniques [18] addresses the subject of focus stacking in more detail.

Helicon Focus [76] is a specialized program that produces better focus stacking results than Photoshop. If you take a lot of macro (or microscopic) photos, it may well be worth investing in a copy.

7.12 Smart Objects and Smart Filters

Smart Objects

Adobe introduced *Smart Object* functionality with Photoshop CS3. Smart Objects are regular pixel layers or other pixel-based objects (such as RAW image files or Illustrator graphic files) that Photoshop embeds separately in another object. The embedded object and its layer remain unchanged (i.e., is edited non-destructively), even if filters or other corrections are applied to the rest of the image. In order to do this, Photoshop creates a locked, temporary layer on which the selected operations are performed.

If you import a Smart Object into Photoshop,* it appears like a regular layer that can be manipulated using adjustment layers and other tools. However, double-clicking a Smart Object opens Adobe Camera Raw (if the Smart Object is a RAW file) where you can perform adjustments that are automatically transferred to the object in Photoshop. In a layer stack with several adjustment layers, you can even replace the bottom Smart Object with another file (Smart Object). All corrections that have been applied as higher layers are then automatically applied to the new image.

This is a great way to combine TIFF or PSD images with RAW files for saving or sending as attachments. The resulting file will, however, be quite large, as it contains the RAW file plus the TIFF file (with all its layers) packed into a TIFF container. **

Double-clicking a RAW image that you have opened as a Smart Object reopens the image in Adobe Camera Raw (including the most recent adjustments embedded in the image file). Any corrections you now make will be automatically transferred to the Smart Object once you confirm them in ACR by clicking OK. Smart Objects don't need to be converted.

Smart Objects are useful if you want to scale, transform, or rotate selected pixel areas. To do this, simply cut and paste the required pixels into a new layer and convert the resulting layer into a Smart Object. This helps to avoid the rounding errors that occur if you repeatedly transform a particular area on a regular layer. (Rounding errors occur especially when objects are distorted or heavily scaled.) Only the Smart Object itself is adjusted, not its presence in the combined image.

Copying Smart Objects in Photoshop

Copying a Smart Object (either by using Ctrl-J or by dragging it to the ▣ button at the bottom of the Layers panel) creates a further reference to the object. All instances of the object are then updated simultaneously if one of them is changed in any way. If you need a separate, identical copy of the object that isn't automatically updated with all the others, use the command Layer ▸ Smart Objects ▸ New Smart Object via Copy.

Editing the Contents of a Smart Object Layer

If your Smart Object is a regular pixel layer, you can simply use the Edit Contents command (in the layer panel menu ▼▤) to open a new window where you can edit your layer in the normal way. Saving the altered object (using Ctrl-S) also automatically saves any changes back to the embedded object.

If your Smart Object is a RAW image file, double-clicking the layer entry automatically opens the image in Adobe Camera Raw.

Some pixel-level corrections (such as erasing or brush strokes) can only be applied to a RAW file Smart Object if it is first converted to a regular

* Lightroom includes the Edit in … ▸ Open as Smart Object in Photoshop command in the context menu for RAW files. ACR allows you to open a converted image in Photoshop as a Smart Object.

** You can also use PSD images instead of TIFF. Table 4-1 on page 98 provides more information on different file types and their characteristics.

➡ You can load RAW files as Smart Objects in various Adobe programs:

A) Directly in Photoshop, using File ▸ Open As Smart Object

B) From Bridge, using File ▸ Open As Smart Object

C) From Lightroom, using Photo ▸ Edit in ▸ Open as Smart Object in Photoshop

* You can do this using the Edit Contents command in the layers panel menu.

(rasterized) layer.* The converted object no longer has Smart characteristics, so it is better to use a copy of the object for this type of operation.

Although they are typical pixel-level corrections, transformations (such as rotating, scaling, perspective transformations etc.) can be performed on Smart Objects. This is a great aid to processing, as transformations often don't turn out perfectly at first and resampling regular pixel layers reduces image quality. We recommend that you always convert pixel layers to Smart Objects before performing transformations.

The initial transformation is performed and displayed in the image window, but all subsequent transformations automatically generate a new window where the results are displayed. Closing a new window applies the transformation to the original image, which is then displayed in the preview window.

Smart Filters

We always try to work non-destructively on our images, and we use adjustment layers as often as possible. Unfortunately, many pixel-level operations (including the sharpening that we apply to virtually all our images) cannot be applied to adjustment layers. In such cases, we use the Smart Filter functionality that Adobe introduced with Photoshop CS3.

Figure 7-85: The Layers panel menu (CS3 and later) includes the Convert to Smart Object command.

1. If our uppermost layer is an adjustment layer, we start by creating an interim pixel layer using ⇧-Ctrl-Alt-E (section 7.13.5). If our uppermost layer is already a pixel layer, we skip this step.

2. We apply Convert to Smart Object (in the Layers panel menu ▼≡) to turn our new layer into a *Smart Object* (figure 7-85). We then apply our sharpening (or other) filter to our new Smart Object. Not all filters can be converted into Smart Objects, but for sharpening purposes Unsharp Mask and Smart Sharpen can. The resulting Layers panel entry then looks like figure 7-86.

Figure 7-86: Here, we use Unsharp Mask as a Smart Filter.

This process enables us to reactivate our sharpening filter later without having to discard, recreate, and reapply our sharpening adjustment layer. A double click on its Layers panel entry reactivates a Smart Filter – in this case the *Unsharp Mask* entry.

Other tools, such our *DOP_EasyD_Plus_DetailResolver* script cannot be used as Smart Filters and reactivated later in the workflow. Many third-party filters are also not yet compatible with Smart Objects/Filters. For these cases, we use a trick that Uwe discovered:

Adobe delivers a script called *EnableAllPluginsForSmartFilters.jsx* on the CS3 and later Photoshop CD. This can be loaded manually into the scripts folder (usually …/*Adobe Photoshop CSx/Presets/Scripts*). Once installed, you can use the script via the File ▸ Scripts ▸ EnableAllPluginsForSmartFilters command. Photoshop remembers that the script is installed and makes a number of otherwise incompatible filters Smart-capable.

Akvis Enhancer and Uwe's own *DOP_EasyD_Plus_DetailResolver* are examples of programs that benefit from the Adobe script.

We have also had cases when Smart-enabled filters have caused Photoshop to crash. Try to check compatibility, before loading a filter or an important image.

Converting Smart Objects

Once you are sure you have finished processing your image, you can save a lot of disk space by converting Smart Objects back to regular layers using Layer ▸ Rasterize ▸ Smart Object.

7.13 Organizing Layers

Once you start to work with layers, you won't want to go without them when processing your images. Sometimes, however, the number of layers in an image can get out of hand. There are various Photoshop options available to help you keep your layer processes manageable:

Figure 7-87: Select your preferred icon size in the Layers panel Options dialog.

1. Thumbnail size options
2. Layer naming (the more descriptive, the better)
3. Linking and grouping layers
4. Merging and flattening layers

7.13.1 Layers Panel Options

The *Layers Panel Options* menu at the top of the panel (▼≡) contains options for adjusting the layer entry thumbnail size and various other display parameters.

The more layers your image has, the smaller you need to set your thumbnails to keep an overview in the Layers panel. Figure 7-87 shows the options we usually use. You might prefer a different set.

7.13.2 Naming Layers

Photoshop names new layers automatically according to a default pattern of layer types and sequential numbers. We find it useful to explicitly mention a layer's function in its name, e.g., "Brighten" or "Increase contrast". We sometimes even enter the filter name and the parameters we used, e.g., "USM 150/0.9/8" for a pixel layer sharpened using Unsharp Mask. This can be very useful when you are fine-tuning your images and need to adjust a layer that is way down in the stack. If you delete a layer or change its purpose, you can change its name at any time.

7.13.3 Layer Groups

Photoshop allows you to create groups of layers that can be shown or hidden as a group. For example, if you group all processing steps associated with printing, you can hide (deactivate) the entire group if you need to prepare your image for alternative presentation (e.g., on a monitor or using a projector).

You can create a new layer group either by clicking the *Create a new group* button at the bottom of the layers panel (▭) or by selecting multiple layers (by ⇧-clicking their layer entries) and applying the ▾☰ ▸New Group from Layers command.

Newly created layers are automatically included in the currently active layer group. Grouped layer entries are indented in the Layers panel view and can be hidden as a group by clicking the group 👁 icon. Clicking on the empty icon ▢ reactivates the group. You can also activate individual layers within a group.

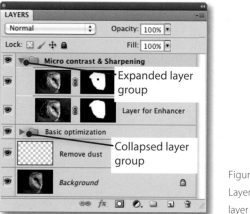

Figure 7-88:
Layers panel showing two
layer groups

A group can have its own group layer mask that limits the effects of all layers in the group to the areas defined by the mask. If layers within a group have their own masks, your chosen effects will only be applied where the layer mask and the group mask intersect.

Clicking the ▼ button collapses a group in the Layers panel view and a repeat click expands the view. Groups can be deleted by dragging them to the Trash 🗑 the same way as individual layers. Individual layers can be dragged from one group to any position in another group or outside a group using the mouse.

Layer groups are automatically set to the *Pass Through* blending mode, which means that the group has no blending properties of its own. You can, however, change this setting using the pull-down menu in the Layers panel. We recommend that you keep the default setting, as other settings can have unpredictable effects on an image.

7.13.4 Restricting Layer Effects to a Single Lower Layer

We have already used opacity, layer masks, blending modes, and layer styles
to limit the effect of image manipulations. It is also useful to be able to re-
strict the effect of an adjustment layer to the layer immediately beneath it,
especially if the lower layer is a partial layer. As of CS4, Photoshop includes
a button for doing just that ⬢ at the bottom of the Adjustments panel. The
following is an example of how to use it.

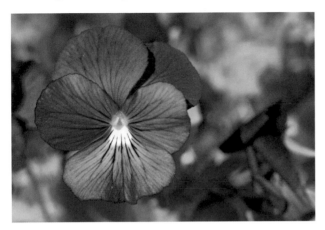

Figure 7-89:
The foreground and
the background are
heavily saturated
due to the effect of
the Hue/Saturation
layer.

Figure 7-90: The Hue/Saturation effect will
only be applied to the layer directly below it
(Layer 1).

We cropped the foremost viola bloom in figure 7-89 and copied it to its own
layer, where we used a Hue/Saturation adjustment layer to increase color
saturation. Since the increased saturation affects all lower layers, we use the
⬢ button at the bottom of the Adjustments panel to clip the effect to the layer
immediately beneath our adjustment layer (figure 7-92). The uppermost
layer appears indented with the ⬐ to indicate the change (figure 7-91). A re-
peat click on the ⬢ button reverses the change.

Figure 7-91: The adjustment now only
affects the next layer down

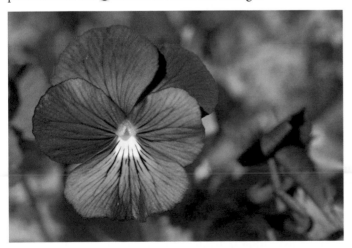

Figure 7-92:
The Hue/Saturation layer only
affects the next layer down, leaving
the background paler.

You can achieve a similar effect by creating a layer mask from the transpar-
ent parts of the lower layer and applying it to the uppermost layer, although
the final effect might not be exactly the same.

7.15 Getting a "Layer Feeling" without Using Layers

You can simulate some layer effects (opacity, blending mode, or selective correction) without actually using Layers. The key to this approach is the Fade command. We use this a lot for print sharpening, but it can also be applied to most other types of corrections.

First, we apply a strong correction (e.g., using Image ▸ Adjustments or a filter such as Unsharp Mask) and then navigate to Edit ▸ Fade before making any other corrections. The *Fade* dialog is shown in figure 7-95.

The *Opacity* slider in the Fade dialog allows us to completely (or partially) reduce the effect of the last correction and apply a different blending mode. Checking the *Preview* option makes changes visible in the preview image in real time. We already know that using *Luminosity* mode reduces the probability of producing sharpening artifacts, as our example shows.

The Fade command helps us to simulate layer effects without the increased memory and disk space demands of layers, but the changes thus made cannot be undone or subsequently altered.

Figure 7-95: Edit ▸ Fade allows us to reduce the effect of the previous correction and to apply a new blending mode.

7.16 Selective Adjustment Using U Point Control Points

One example of a third-party selective correction tool is the *Viveza* Photoshop plug-in manufactured by Nik Software [75]. This program is based on the U Point technology used by Nikon in its Capture NX RAW editor, and by Nik in its own Color Efex, Silver Efex, and Nik Sharpener Pro tools. The program's name is the Spanish word for "liveliness". Viveza is available for Windows and Mac. It is compatible with Photoshop CS2 and higher, as well as with Photoshop Elements 4 and higher.

The modus operandi of the *Control Points* software is much more difficult to describe than to use. Basically, it allows the user to make intuitive, selective corrections to various aspects of precisely defined parts of an image. The effects are similar to those you can achieve using Photoshop selections and layer masks.

After applying control points within the image frame, you then use the individual sliders to change various aspects of the pixels around that point. The effect is applied to the entire image but drops off in a circular pattern with increasing distance from the control point. While Photoshop adjustment layers can only be used to influence a single aspect of an image's appearance, a single control point can be used to adjust a wide range of parameters.

The basic adjustment sliders are always visible when a control point is activated, and an extended range of adjustments can be shown in expanded mode (figure 7-96 and figure 7-97). Figure 7-97 lists the effects of the various sliders.

Figure 7-96: A U Point in its compact and expanded versions

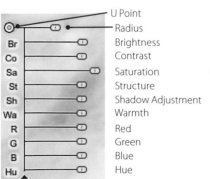

Figure 7-97: The various U Point sliders and their effects

A freshly-placed control point registers the color and tonality of the pixels surrounding it. The pixels nearest the control point are those most strongly influenced by it. A control point works in a similar way to Photoshop Hue/Saturation adjustments but is much more flexible. A control point's default settings make no changes to an image.

The radius slider is used to regulate the extent of a control point's effect, and you can set multiple control points with different parameters that influence each other's impact. There is an example of control point use in figure 7-98 to help you visualize its functionality.

Like all filters, Viveza applies its effects to a single pixel layer. If you have already performed other layer-based adjustments on an image, you

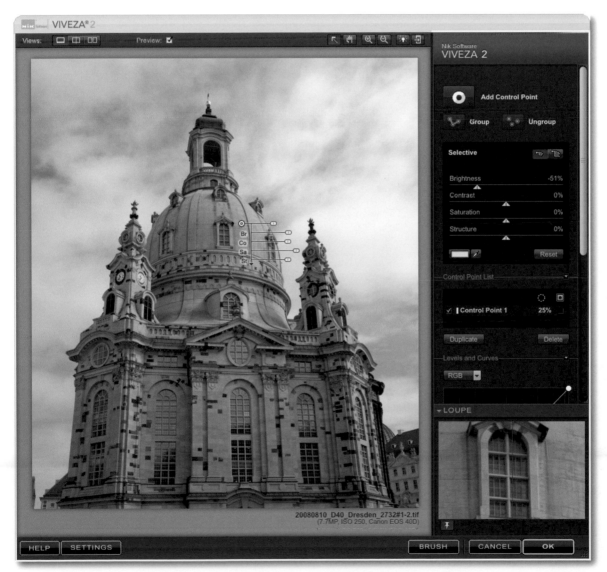

Figure 7-98: : Viveza preview window. The control point dialog is on the right

* If you are working with CS3 (or later) you can convert this object into a Smart Object using the Layer ▸ Smart Objects ▸ Convert to Smart Object command. The effect can then be reloaded and adjusted without having to start again.

** This slider can also be used to reduce saturation.

will have to merge those layers (using ⇧-Ctrl-Alt-E or ⇧-⌘-⌥-E) to a single layer before setting control points.*

Once installed, Viveza can be found under Filter ▸ Nik Software ▸ Viveza. The plug-in includes a preview window that can be switched to full-screen mode, making it simple to judge the effects you produce (figure 7-98).

We will use an image of the Church of Our Lady in Dresden, Germany as an example. We want to intensify the color of the sandstone that appears slightly dull due to the lack of sunshine. To do this, we set a control point on the dome of the tower and increase saturation.** The Navigator Loupe at bottom right displays an enlarged before/after detail of the preview image.

The ▢ ▯ ▯▯ icons at top left change the display mode from single preview to split or side-by-side, while the other buttons at the top of the frame allow you to zoom, select, and pan within the image or alter the background color.

You can delete or deactivate individual control points using ☑ in the list on the right of the window. Clicking on the empty box at the right of the control point entry displays a selection mask that previews the effect. Clicking the ◉ button at the top of the list displays a selection mask that shows the effects of all control points for the current image. Figure 7-99 demonstrates the mask for the first control point in the list and clearly

Figure 7-99: Selection display for the first control point

Figure 7-100: Two additional control points reduce the effect of the initial control point on the sky.

shows how the point's effect diminishes with distance from the place it is applied. Viveza doesn't actually create a mask, but instead displays a pixel-based visualization of the point's effects.

If you want to restrict the effect locally, reduce the radius. Increasing the radius increases the range of the effect, although it's still only applied to the color at the control point's location. We can reduce the effect of the initial control point on the sky by setting two additional control points to the left and right of the tower.* These not only limit the saturation in the yellow of the tower, but also darken the sky. This also slightly darkens the sky reflected in the church windows. Two duplicate control points set slightly lower further darken the sky.

As already mentioned, it is much more difficult to describe working with Viveza than it is to actually use it. Viveza is flexible and intuitive, and allows you to fine-tune individual colors using the individual RGB or *Warmth* sliders. The plug-in also includes a Brush tool for making finer corrections (although it's is unfortunately not compatible with Smart Objects or Smart Filters). The Brush tool uses a conventional Photoshop layer mask to apply its effects, but control points are so effective it is seldom necessary to use it.

➜ As long as the Viveza window remains open, you can select, move, delete and copy control points either using Alt+drag or by clicking the *Duplicate* button.

* See the selection display in figure 7-100.

Figure 7-101: Original image Figure 7-102: Viveza-tuned image

7.17 More Tips for Working with Layers

We have only touched on the possibilities offered by layers, Smart Objects, masks, and paths. Graphic artists use these tools much more intensively than most photographers ever will. Paths can be used to insert graphic objects into pixelated images made up of multiple vector layers, which can then be transferred to other layer types where they can be colored and contoured. You can also achieve similar effects by importing Adobe Illustrator objects as Smart Objects.

Clicking the *Link* button 🔗 between a pixel layer and a layer mask unlinks the two and allows you to move them independently You can shift the mask's boundaries separately from the layer using the ✛ tool.

Layer Styles

Double-clicking a layer entry reveals the *Layer Style* dialog. In addition to the *blend mode* setting (which we have already discussed), the dialog contains a number of other settings that are sometimes useful during the photographic workflow. These include the Drop Shadow tool, which separates an image optically from its background for printing.

We need to increase the canvas size to apply a drop shadow, and if our uppermost layer is not a suitable pixel layer, we use ⇧-Ctrl-Alt-E to combine our layers into one.

If our image consists only of a background layer, we create an empty, white layer beneath it and increase the canvas size using Image ▸ Canvas Size (figure 7-103).

Figure 7-103:
Creating a quarter-inch border around an image

We add a contour by setting the *Contour* option to a three-pixel width in the Layer Style dialog (Layer ▸ Layer Style), then activate the *Drop Shadow* option and check the *Preview* box to help us judge the effects. You can see the results of our experiments in figure 7-104.

Figure 7-104:
Our image with a thin black contour, a
drop shadow, and a white border

Here, as well as checking the box, it is necessary to click on the option name
to make its effects visible.

The applied effect is then displayed indented in the Layers panel (figure
7-105). The *fx* ▼ button toggles the effect list on and off. Applied effects can
be adjusted by double-clicking the appropriate entry in the list.

Figure 7-105:
Applied effects are displayed
in the Layers panel.

Combinations of style effects can be saved by clicking the *New Style* button
in the *Layer Style* dialog. Once you have saved your style using a suitable
name it is available for all images in the *Styles* panel. You can set the panel
to display style names or icons.

Figure 7-106:
Saving layer style
options produces a
New Style preset.

Using Keyboard Shortcuts to Speed up Your Work

If you work regularly with masks, a "crib sheet" of keyboard shortcuts for tools and specific corrections is a great aid to keeping your workflow smooth and efficient. Switching between tool states (e.g., between path ➤ or direct ➤ selection) is also quicker if performed by pressing the Ctrl (⌘) key rather than by navigating via the tools panel.

→ Pressing the Alt (or ⌥) key while using the brush temporarily converts the tool to an eyedropper that you can use to sample colors.

If you press the D key with your mouse over the *Set foreground color* tool button, the foreground color is automatically set to black and the background color to white. Pressing the X key then reverses this setting.

Selected layers can be grouped using Ctrl-G, and Ctrl-E flattens all layers to the background. ⇧-Ctrl-E merges all nonhidden layers into one. One of the keystrokes we use most often is ⇧-Ctrl-Alt-E for creating a new combined layer consisting of all visible layers including and below the currently selected layer.

The following is a summary of brush settings and keystrokes that we use regularly when working with layer masks.

→ The Eraser tool ⌧ has almost the same settings as the Brush ttol but the opposite effect, removing pixels whereas the brush adds them.

Brush Tool Controls

The Brush ✎ is our favorite tool for fine-tuning layer masks during the photo workflow. Lightroom and ACR use almost identical Brush tools for applying selective corrections.

The most important brush settings in the photo workflow context are *Size, Hardness, Opacity, Flow,* and *Airbrush* mode: ✎. For photographic corrections, *Mode* is usually set to *Normal*. Each setting can be adjusted to suit the size and resolution of the current image. The shape and type of brush tip you use can also be varied (figure 7-107). We usually use a soft, round brush in *Normal* mode to create our masks.

Figure 7-107: The fly-out (or context) menu allows you to adjust brush width, hardness, and shape.

The *Size* setting is self-explanatory, and *Hardness* determines the softness and width of the brush tip.

A *Hardness* value of 100% makes the brush behave like a pen, producing strokes with hard edges. 0% *Hardness* produces extremely soft transitions between strokes. The] key increases and the [key reduces brush size. Pressing ⇧-] increases and pressing ⇧-[reduces hardness in 20% steps.

→ You can assign different shortcuts using Edit ▸ Keyboard Shortcuts. You can also use this command to assign shortcuts to tools and tasks that have no default shortcut.

As of Photoshop CS4, you can adjust brush hardness more intuitively using the Alt key and the right mouse button (Windows) or by pressing Ctrl-Alt (Mac) and dragging the mouse to the left or the right. Hardness can be adjusted by pressing ⇧-Alt and the right-hand mouse button (Windows) or pressing Ctrl-⌥-Alt (Mac) and dragging the mouse to the left or the right. These two maneuvers also work for other Photoshop painting tools, but not ACR or Lightroom.

Opacity is also self-explanatory. 0% opacity produces no visible effect, and higher values increase the intensity and coverage of the color you are painting. We often use brushes with low opacity values to successively intensify the effect of a mask. This technique does, however, increase the risk of producing color runs of the type shown in figure 7-108. It is often safer to work with a fixed-value gray tone than with a reduced-opacity black or white brush.

Opacity values of various tools can also be changed using the ⓪ key to select 0%, ① for 10%, up to ⑨ for 90%. You can also enter other values using number key combinations.

The *Flow* value controls the rate of application of an adjustment. The longer your brush stroke, the fainter it will become toward its end. 100% flow produces a stroke that never fades, and lower values fade more quickly. We always use a 100% value when we are manipulating Photoshop masks. We also use reduced *Flow* values in ACR and Lightroom to simulate opacity functionality.

If you pause your cursor movement (but continue to hold the mouse button down) in *Airbrush* mode 🖌, the tool continues to add color until the soft edges of the stroke are filled out, at which point the color will continue to "bleed" further.

If you want to paint a straight line, click on the start point of your line, release the mouse button and then ⇧-click your desired end point. This accelerates the process of producing straight edges enormously.

If you use Photoshop regularly, it is worth investing in a graphics tablet. A tablet allows you to work more precisely than with a mouse – opacity and flow can be controlled directly using finger pressure.

Figure 7-108: Various brush strokes: top left is a hard (100%) brush, while top center has 20% hardness – both are set to 100% opacity. The lower stokes have 50% opacity. The two crossed strokes at bottom right show how colors can "run" when you use lower opacity values.

Advanced Photoshop Techniques

8 *Photoshop Layers, with their adjustment layers, Smart Objects, and selective correction tools are a great way to perform complex, non-destructive image corrections outside of your RAW editor. This chapter describes how to further refine some of these techniques and introduces a number of other tools that we use regularly in the course of our workflow. These ideas include new variations on themes we have already discussed. By the time you reach the end of this chapter, we hope that you will be able to work even more effectively with Photoshop's extensive tool kit of correction and optimization tricks. Many imaging challenges can be solved in a number of different ways, so you will need to find the tools and techniques that best suit your working style and, of course, your budget.*

8.1 Correcting Saturation Selectively

Sometimes, color saturation in digital photos needs tweaking, and there are many actions and filters available for doing just that.

Analog films like Fuji's Velvia often produce highly saturated, "larger-than-life" colors that drown out other more subtle, natural-looking colors. If you compare two otherwise identical photos, the one with more highly saturated colors will always draw your attention. But does that imply it's better? Not necessarily. Always consider adjusting contrast before you increase saturation. Applying S-curves is a great way to reach this kind of compromise.

What is the best way to go about increasing saturation in situations that absolutely demand it? Ben Willmore's article, "Saturate Your World" in *Photoshop User* magazine has an excellent tutorial on the subject that has certainly changed our views on color saturation. Ben's "Use selective saturation in Photoshop" message sounds pretty obvious but addresses a technique that is fairly complicated if you approach it without his guidance. His writings provide a wonderful practical tutorial on how to master the art of selective saturation.

Any article by Ben Willmore is worth checking out:
www.digitalmastery.com/companionsite/magazine/psuser34.pdf

Global saturation enhancement is often inappropriate, and the following example shows how to apply saturation enhancements selectively:

Our initial image is shown in figure 8-1. Here, we want to increase saturation in the upper part of the image and leave the lower part as is.

Figure 8-1:
Grand Canyon Mather Point

* Select it and use Ctrl-J.

As usual, our first step is to duplicate the background layer.* We then create a Hue/Saturation adjustment layer and add a layer mask like the one shown in figure 8-2 (with a gradient in the lower third). The black area protects the image from the effect of our Hue/Saturation adjustments.

In the Hue/Saturation dialog (figure 8-3 Ⓐ), we leave the Master setting untouched. We then gradually increase the saturation of the red tones by selecting *Reds* (Ⓑ) and increasing the *Saturation* value. Experiment to see how the various sliders affect the colors in your images.

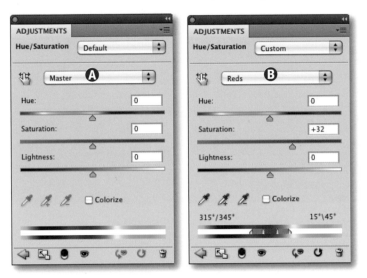

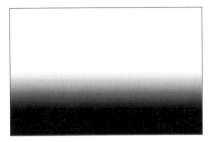

Figure 8-2: Our layer mask for the Hues/Saturation adjustment layer, drawn using the Gradient tool

Figure 8-3:
We increase saturation for the red tones using a *Hue/Saturation* adjustment layer. The layer mask means this adjustment is only applied to the upper part of the image.

Figure 8-5 shows the result of this operation, which is still a little too heavy-duty. We could simply reduce the saturation setting but instead we reduce the *Opacity* of the adjustment layer to about 43%, giving us the result shown in figure 8-6 on page 294.

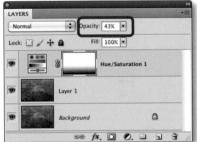

Figure 8-4: The Layers stack after our adjustment using *Hue/Saturation* with a gradient layer mask and reduced *Opacity*.

Figure 8-5:
The image with increased saturation in the upper part of the frame

Figure 8-6:
Image with selectively increased saturation

The difference is subtle, but that is precisely what selective correction is all about.

8.2 Some Tricks for Improving Saturation and Contrast

All photographers know that nothing beats the right light. In our book *California Earthframes**, we had to choose from images shot in three types of light:

* See www.outbackphoto.com/booklets/
dop9001/DOP9001.html.

▸ Midday sunlight with harsh shadows and burned-out highlights
▸ Evening sun with better light but longer shadows
▸ Overcast skies with flat light

We like the third alternative best. Overcast situations provide light similar to that from a good light box. Cloudy skies deliver images with flat lighting directly from our RAW converter.

Figure 8-7: We start with a flat image.

We could process these images using our RAW converter (and we sometimes do), but we prefer to do this type of work using Photoshop Layers. This enables us to reactivate and fine-tune our corrections later, if necessary. Our source image for the next example is shown in figure 8-7.

The first step often involves using a Levels adjustment layer. As you can see in figure 8-8, we moved the white point only

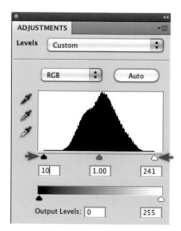

Figure 8-8: Our moderate *Levels* adjustment

slightly in order to avoid making the photo too bright and to keep the whites white. The result of this adjustment is shown in figure 8-9.

Now, we improve contrast by applying a Curves adjustment layer with a moderate S-curve. This gives us the result shown in figure 8-11. S-curves tend to induce slight color shifts. We avoid this by changing the layer's blend mode from *Normal* to *Luminosity* (figure 8-13).

The difference between figure 8-11 and 8-13 is subtle but effective. The Layers stack that results from this operation is shown in figure 8-12.

Figure 8-9: After applying *Levels*

Figure 8-10: A moderate S-curve improves contrast.

Figure 8-11: After applying a moderate S-curve

Figure 8-12:
Layers panel after applying our Curves adjustment layer. We set blend mode to Luminosity.

Figure 8-13: Blend mode set to *Luminosity*

If you still want to increase saturation and tweak contrast, there are various approaches you can take. We like a technique explained to us by Katrin Eismann, author of the book *Photoshop Masking and Composition* [12]. It consists of just two steps:

1. We create a new Curves adjustment layer (without changing any of the default Curves settings) and set blend mode to *Hard Light*. Our first result, shown in figure 8-14, still displays unnatural color saturation.

2. We reduce the Opacity of the top layer to produce more natural-looking colors. In our example, 33% Opacity produced the result shown in figure 8-15.

This technique can produce overly dense shadows – an issue we could address using our curve, but there is also a more elegant solution:

Open the *Layer Style* dialog (via ▾☰ ▸ Blending Options), and move the *Underlying Layer* slider Ⓐ to the right. The settings shown in figure 8-16 mean that pixels with luminosity values below 46 are no longer taken from the lower layer, but instead from the upper layer.

Figure 8-14: Blend mode set to *Hard Light*

Figure 8-15: *Hard Light* at 33% Opacity

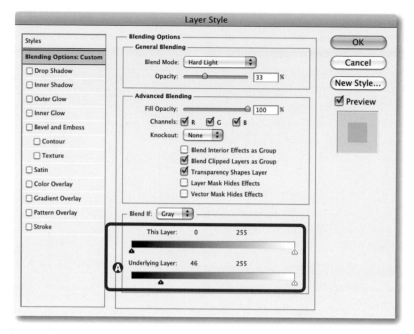

Figure 8-16:

In the *Layer Style* dialog you can define which tonal values in the underlying layer are influenced by those in the selected layer using the sliders at Ⓐ.

The result is still not quite what we want, as the transition this setting produces would be visible. If you look carefully, you will see that the slider markers are split. You can separate them by pressing the Alt key while moving the two halves left or right (figure 8-17).

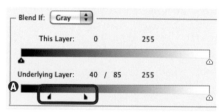

Figure 8-17:

Separating the slider helps to produce smooth transitions. Press the Alt key to split the slider into two.

Now, all shadows with luminosity values below 40 are protected from our *Hard Light* adjustment layer, and there is a smooth transition zone up to a value of 85. The layer effect is fully visible at luminosity values above 85. These values belong to the general luminosity scale from 0 to 255.

Soft Light Blend Mode

You can achieve a similar effect using the *Soft Light* blend mode. This makes the final effect a little less dramatic, as you can see in figure 8-18.

Be careful not to make your photos too dramatic-looking. Contrast that is increased using higher saturation settings can make your images look flat. Nowadays, we are bombarded with large numbers of oversaturated photos. Some critics call this type of saturation the "Heavy Metal" of digital photography.

Figure 8-18: Using the *Soft Light* blend mode with 100% opacity

Figure 8-19 once again shows the original image, and the result of the adjustments described above using the *Soft Light* blending mode is shown in figure 8-20. The opacity in figure 8-20 was reduced to 60%.

Figure 8-19: The original image

Figure 8-20: The result of using *Soft Light* blending and 60% Opacity

8.3 **Correcting Perspective Distortion**

Architectural photos shot with 35mm Full-frame (or wider) lenses usually produce images of buildings that appear to be tipping due to the low viewpoint. This can make a roof appear much farther away than it actually is compared to other floors of the same building. If the same photo is also not shot straight-on, we have to deal with two simultaneous types of perspective distortion: horizontal and vertical distortion. Photoshop offers various ways to correct these errors:

A) Transform command This command is quick and easy to use, and it includes various sub-commands, such as Scale, Rotate, and Skew (figure 8-21). We generally use the Free Transform command that is controled using various keystrokes and that produces transformations of all the listed types.

B) Lens Correction filter. This filter is more powerful than a simple transformation. It enables you to correct pincushion, barrel, and perspective distortion. The filter is relatively complex to use and updates the image preview much more slowly than the *Transform* tool.

There are also a number of plug-ins and third-party programs available for performing these corrections, and we will discuss them later on.

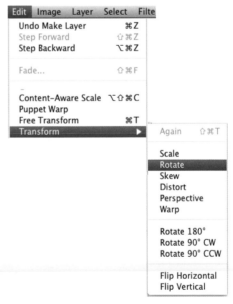

Figure 8-21: The Transform command offers a number of different options.

Figure 8-22: The original perspective-
distorted image

8.3.1 Simple Perspective Corrections

These corrections are quick and easy to apply, even to large image files. Figure 8-22 is the source image for our first example. Prepare your image as usual – possibly (but not necessarily) including some pre-sharpening. Figure 8-23 shows how the process works:

1. Enlarge the canvas to form a margin around the image area. You might have to zoom out to do this.

2. Select the entire image using Ctrl-A / ⌘-A.

3. Select the Edit ▸ Transform ▸ Perspective command.

4. Drag the top left handle to the left until you like the result.

5. Photoshop will quickly display a low-quality preview. Don't be put off by the preview image quality – your actual results will be much better.

6. Once you are satisfied with your results, press Enter ↵. Photoshop will now *render* the final image.

7. Deselect your selection using Ctrl-D / ⌘-D.

8. Finally, you may have to crop your image.

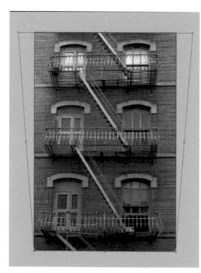

Figure 8-23: Dragging one of the upper
handles to correct distortion

Figure 8-24: The original image is on the left, and the corrected version on the right.

If your correction doesn't turn out as you planned, it's best to undo it using Ctrl-Z and start again. If you reprocess an already corrected image, rounding errors will further reduce the quality of the final image.

8.3.2 Fine-Tuning Perspective Corrections

Figure 8-25: The original image, showing significant distortion

Figure 8-26: The corrected image

Prepare your image in the usual way and repeat steps 1 to 5. This produces the result shown in figure 8-27 from the original image in figure 8-25. Do not click OK (or press ⏎), as we are going to correct the right-hand of side of the image separately.

6. First, we navigate to the Edit ▸ Transform ▸ Skew command.

7. We then drag the top right handle to the right in order to make the vertical lines on the right parallel (figure 8-27).

8. We then drag the handle slightly upwards to align the upper parallel lines (figure 8-28).

Once Step 8 is complete, we press Enter ⏎ to complete processing. Photoshop now resamples the finished image.

9. We deselect our selection and crop the image edges to give us the result in figure 8-26.

This is a much easier way to correct architectural shots than using individual *Transform* operations (scale, skew, distort etc.). Table 8-1 and figure 8-29 (page 300) list the possibilities when using Free Transform instead. The guidelines we used here help us to align the image.

Figure 8-27: The first stage is complete

Figure 8-28: Correcting the horizontal lines

➜ We already described how to correct perspective distortion using the Crop tool on page 101.

Table 8-1: Photoshop Free Tansform keystrokes

⊞	⌘	Function
Esc	Esc	Cancel transformation
Drag inside the frame		Move
Drag outside the frame		Rotate (using ⇧ in 15° steps)
⇧-Ctrl	⇧-⌘	Skew
Drag a hanlle		Scale
⇧	⇧	Scale proportionally
Ctrl	⌘	Distort
⇧-Ctrl	⇧-⌘	Symmetrical distort
⇧-Ctrl-Alt	⇧-⌘-⌥	Perspective

Table 8-2: Photoshop cursor symbols when using the Transform command:

Move: ⤹

Rotate: ↱

Stretch, Scale: ↔

Skew: ⤾

A More Complex Example of Perspective Correction

Architectural photos are especially prone to perspective distortion if the camera is tipped upwards during shooting. One way to correct this type of error is to shoot using expensive tilt/shift lenses.

Although shooting nondistorted images is always preferable, a cheaper approach to correcting perspective errors is to use Photoshop's built-in tools to make your corrections. The Lens Correction filter (introduced with Photoshop CS2) is a fairly slow multipurpose tool. Using the Free Transform command gives you more creative freedom and simpler handling for correcting perspective errors.

As usual, we perform our correction (as usual) on an interim layer created by merging all lower layers using ⇧-Ctrl-Alt-E, as explained in section 7.5. We then select the area we want to correct and use the Transform command. We recommend that you always enlarge the canvas before performing these types of corrections, as *Transform* marquees often stretch beyond the edges of the image area.

Figure 8-29: Transform offers a number of transformation variations.

Of the various transformation tools available in Photoshop, Free Transform (activated either using Edit ▸ Transform ▸ Free Transform or Ctrl/⌘-T) is the most versatile. This tool allows you to rotate, scale (with or without preserving image proportions), skew, and yaw your image, as well as correcting perspective distortion (figure 8-29). Table 8-1 lists a number of keystrokes for use with the Free Transform command.

Moving the mouse over a marquee's corner turns the cursor symbol into a ↱, which you can then use to rotate your selection.

Placing the cursor within the selection and pressing the mouse button allows you to shift the entire selection.

If you want to select a single corner handle (instead of move it together with the opposite corner), press the Ctrl key (Mac: ⌘) while making your transformation.

You can use the Skew command to scale a selection while preserving the selection's resolution. Pressing the ⇧ key while scaling preserves the selection's proportions.

The currently active operation is indicated by the cursor symbol. These symbols are listed in table 8-2 on the left.

Instead of using the mouse to perform transformations, you can also enter numerical values in the tool's options bar (see next page).

We will use the image in figure 8-30 to demonstrate the Free Transform tool. The 28mm wide-angle lens and the low camera position produced an image with a number of distortions.

First, we make a copy of the background layer (or of our already corrected layer, as described above) and enlarge the canvas to give us some transformation leeway. We then rotate the entire image so that the building appears horizontal (figure 8-31).

We then skew the image (quite heavily) using Free Transform to make the building and the trees appear vertical (see figure 8-32). This involves dragging the upper corner handles to the side and upwards, using the free canvas space we produced earlier.

Figure 8-30: Skewed, distorted source image

Figure 8-31: The grid helps us align the image.

Figure 8-32: Dragging the upper corner handles straightens the building and the trees. This operation requires a lot of free canvas space outside the image area.

The final step involves cropping the top edge of the image. Rather than cropping too much, we fill the empty white spaces at the bottom edge using the Clone Stamp tool. With CS5, you could also select the empty area and use Content-Aware Fill to fill this space (section 8.13, page 340). Figure 8-33 shows our finished image.

This is a fairly extreme but nevertheless realistic example. Instead of the grid, you can also use guides pulled out of the Photoshop Ruler to help you align individual image elements.

Figure 8-33: The finished image, slightly cropped at the top

8.4 Correcting Lens Errors

Unfortunately, Photographic lenses are seldom perfect. They produce some optical errors due to refraction caused by different wavelengths of light, different types of glass, lens construction issues, and other factors. Lens errors are stronger in some lenses and weaker in others, and often depend on the focal length and aperture of the lens being used. Zoom lenses especially represent a compromise between versatility and optical quality, with the most obvious errors occurring at large apertures and at the extreme ends of the zoom scale. The three most common types of lens error are:

▶ **Distortion**

> "Equivalent" here means relative to the 35mm sensor format (24 × 36 mm). The effect is evident at shorter focal lengths for smaller sensors.

Wide-angle lenses (with equivalent focal lengths of 35mm and less) are particularly susceptible to barrel ◯ or pincushion ⬜ distortion. High-quality lenses tend to produce distortion that is at least symmetrical relative to the center of the image. Photoshop's Lens Correction tool (introduced with CS2) and a range of third-party tools and plug-ins are available for correcting distortion errors.

▶ **Vignetting**

> You can also produce vignetting effects if you use a sunshade that is too narrow for your lens. Be especially careful when using sunshades with zoom lenses set to wide-angle focal lengths.

This effect causes a falloff of image brightness toward the edges of the frame. With high-quality lenses, vignetting can usually be counteracted by closing the aperture down one or two stops. Most RAW editors include vignette correction functionality, as described on page 181. This is usually the best way to correct vignetting in RAW images.

▶ **Chromatic Aberration**

These types of errors have various causes, including refraction caused by the different wavelengths of different colored light sources, and occur primarily at the edges of the image area. Aberrations usually take the form of blurring or color smears, and they are more evident in consumer-level cameras than in cameras with professional-grade lenses. Some chromatic aberrations are difficult to see with the naked eye and are most obvious at high-contrast object edges.

All current RAW editors include functionality for reducing chromatic aberrations, and the Photoshop Lens Correction tool can also be used to eliminate these errors.

Lens error corrections (especially distortion correction) always involve rounding errors and therefore a loss of image quality. Always perform lens error corrections using a RAW editor or on 16-bit images if you can. There are two basic approaches to correcting lens errors:

▶ **Judging corrections visually**

This a simpler, more universal approach. Zoom in to your image (50% or 100% is a good starting point) and adjust it until you are happy with

the result. Most lens error software tools include a preview window for displaying a selected image detail, but we recommend that you activate the full-frame preview feature if your software has one. A large (or a second) monitor is useful for this type of work.

This is the principle used by most RAW editors, the Photoshop Lens Correction tool, Power Retouche's *Lens Corrector* [83], Richard Rosenman's *Lens Corrector PRO* [100], and Grasshopper's more expensive *ImageAlign* [95].

▸ **Using camera and lens profiles**
This approach uses profiles based on the recorded optical characteristics of specific cameras and lenses to correct image errors. This method makes it possible to correct lens errors automatically without having to experiment with each image individually. The profile creation process in itself is complex, as it involves measuring the characteristics of every camera/lens combination. Ideally, a camera/lens profile will include characteristics for different aperture settings,* and for zoom lenses, measurements for different focal length settings. If you purchase a new lens, you will either have to create your own profile or wait until the manufacturer of your correction software includes it in the range of supported lenses.

PTLens [92], LensFix [93], DxO Optics Pro [68], Canon Digital Photo Pro [41], Adobe Camera Raw (since 6.1) and Adobe Lightroom all work on this principle, as does Photoshop CS5. Nikon Capture NX includes profiles for correcting distortion caused by Nikkor fisheye lenses. Bibble introduced lens correction tools in version 4. We expect more software manufacturers to enter this market segment in the near future.**

→ Always correct lens errors as early in the workflow as you can, and always before you crop your image or perform selective color or contrast corrections. You should also correct lens errors before correcting perspective distortion. These types of filters assume that any distortion present is symmetrical and covers the entire image.

If your RAW editor includes lens correction functionality, use this in preference to third-party tools. Profile-based lens corrections are preferable to other types, although you still might have to fine-tune the results they produce manually.

* Especially when correcting vignetting effects

** There is a correction example using PTLens in section 12.5, page 478.

8.4.1 Correcting Distortion

Figure 8-34: Source image with a slight lens-based distortion

Some lenses (especially wide-angles) produce pincushion or barrel distortion at the edges of the frame.

Before Photoshop CS2 was introduced, our standard lens correction tools were either the Power Retouche Lens Corrector [83] or PTLens.

We corrected the barrel distortion in figure 8-35 using a value of 10 and cropped the image to eliminate the resulting white borders. The final result is shown in figure 8-36.

As ever, our intention is not to produce a perfect image, but instead to simply remove elements that could distract the viewer.

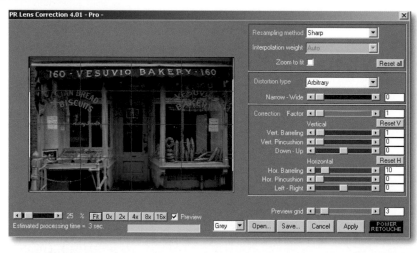

Figure 8-35:
The Power Retouche *Lens Corrector*
dialog (www.powerretouche.com)

Figure 8-36:
The corrected version of the image from
figure 8-34. Note the absence of distortion
at the edges of the frame.

8.4.2 Correcting Lens Errors Using Photoshop

Photoshop CS2 introduced the powerful Lens Correction filter (Filter ▸ Distort). This tool combats vignetting, lens distortion, chromatic aberrations, and even perspective distortion. The fact that all these functions are pulled together in one dialog indicates that they use a single resampling algorithm. This means that performing multiple corrections with the tool shouldn't cause exponential rounding errors. As of CS5, you will find the function under Filter ▸ Lens Correction.

Figure 8-37: Typical wide-angle barrel distortion

Here, we will use the tool to correct the barrel distortion in figure 8-37. The image was shot using a zoom lens set to its widest focal length, causing obvious barrel and perspective distortion. Using Photoshop's built-in grid helps when judging results.

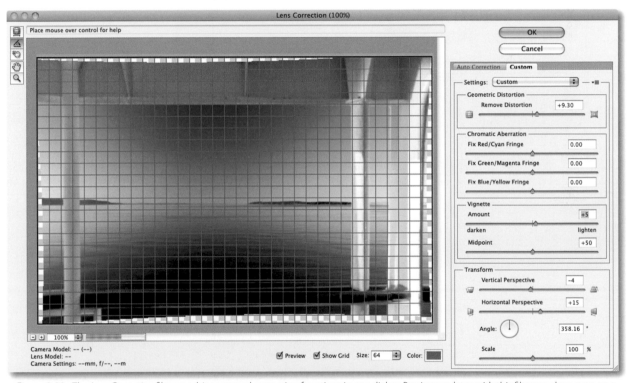

Figure 8-38: The *Lens Correction* filter combines several correction functions in one dialog. Preview updates with this filter are slow, even on a fast computer. This screenshot shows the Photoshop CS5 version of the filter.

After some tweaking, the image is still not perfect, but it looks much better in the preview shown in figure 8-38. The tools at top left of the filter window include the Straighten tool ⟁ that enables you to align the image to a horizontal or vertical line drawn along an edge within the image (e.g., the horizon). While the option *Show Grid* provides a grid for visual alignment help, the hand 🖑 allows to reposition this grid. 🗔 is the distortion correction tool. Once activated, it adjusts the image according to the position of your mouse relative to the center of the frame.

➡ These operations are quite complex, so the preview update can take some time. There is a preview update progress bar at the bottom of the window.

It is quite difficult to achieve satisfactory distortion correction using just the tool's sliders, so we prefer to use the dialog boxes to enter numerical values that we then adjust incrementally using the ⬆ and ⬇ keys.

Auto Lens Correction in CS5

Photoshop CS5 introduced profile-based lens corrections. A number of profiles are included with the program, and more are available on the Internet. The number of profiles available is sure to increase in time, and you can even create your own using the Adobe *Lens Profile Creator* at *http://labs.adobe.com/downloads/lensprofile_creator.html*.

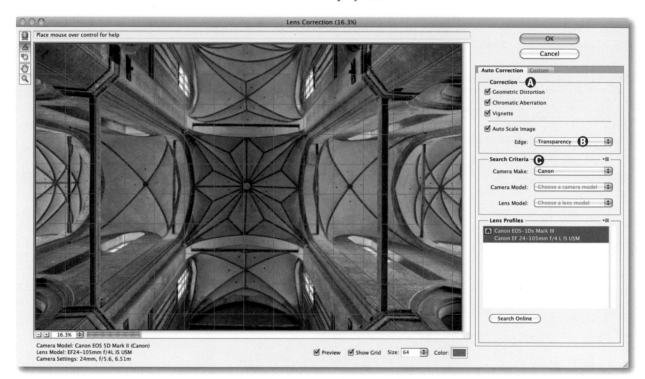

Figure 8-39: If you haven't yet cropped your image and you have a profile that matches your specific camera/lens combination, Photoshop CS5 can automatically correct geometric distortion, chromatic aberration, and vignetting.

Here, we applied the filter's *Auto Corrections* feature to an image shot with a zoom set to its widest angle (figure 8-39).

Photoshop extracts the camera brand, camera model, lens model, and focal length settings from the EXIF data embedded in the image. If this information cannot be extracted or is simply not available, you can enter it manually in the *Search Criteria* pane. Photoshop will then automatically correct all the error types you have checked at Ⓐ. Additionally, you can straighten the image using the ⬛ tool and manually correct distortion using the ⬛ tool as described on page 305.

If Photoshop doesn't have a suitable built-in profile*, you can select a profile for a different camera with an identical image sensor from the same

* This is not the same as an ICC color profile. Rather, this type of profile describes the known geometric distortion, chromatic aberration, and vignetting caused by a specific camera/lens combination.

manufacturer. If there are still no profiles available, you will have to switch to the *Custom* tab and make your corrections manually, as described on page 305.

If possible, we prefer to correct vignetting and chromatic aberration early in the workflow using a RAW editor (e.g., see chapter 5).

The *Auto Scale Image* option provides a number of ways to fill image areas that are left empty once distortion has been corrected. We usually use the *Edge Extension* variant.

Figure 8-40: The Auto Scale Image handling options.

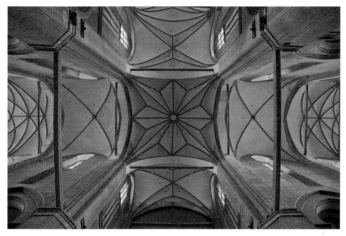

Figure 8-41: Shot with a zoom lens at its widest angle, this photo suffers from barrel distortion and vignetting.

Figure 8-42: The same photo, corrected using the Photoshop profile-based Lens Correction tool in Auto mode.

Along with Photoshop and the *Lens Corrector* program that we have already mentioned, we recommend the following alternative programs for correcting lens errors:

▸ ImageAlign by Grasshopper [95]. This is a powerful (but expensive) Photoshop plug-in for correcting perspective and lens distortion.

▸ PTLens by Thomas Niemann [92]. This is a value lens error correction plug-in. It offers an enormous number of camera/lens profiles. We recommend it, if your RAW converter doesn't offer profile-based lens corrections or if you are shooting JPEGs and did not yet upgrade to Photoshop CS5.

Some RAW editors also support profile-based lens corrections. These include DxO Optics [68], Adobe Camera Raw starting with version 6.1, Lightroom 3, and (with some restrictions) Nikon Capture NX [47] and Canon's Digital Photo Pro. (CNX and DPP only support Nikon and Canon lenses, respectively.) Bibble includes a plug-in to perform profile-based lens corrections.

Silkypix can also be used to correct perspective and lens distortion manually. We expect Apple Aperture to have profile-based lens distortion, vignetting, and chromatic aberration correction tools in the near future.

8.5 Correcting Color Casts in Shadows

Shadows often display strong blue casts that become even more obvious when printed. Daylight photos are generally lit by two main light sources:

▸ Direct sunlight
▸ Blue sky

Shadows are lit mainly by light reflected from the sky and therefore have a blue tint.

8.5.1 Using Photoshop Tools

Figure 8-43 shows a detail of a photo with a pronounced blue cast. We correct the cast using the following steps:

1. We create a new Hue/Saturation adjustment layer.

2. In the Color Range menu, we select *Blues* and click on the sky using the eyedropper. We then make sure that we have corrected the appropriate colors by temporarily increasing *Saturation* to 100%.

Figure 8-43: The source image with its blue cast

The preview in figure 8-44 shows that only the shadows are affected by our adjustment. If necessary, we can fine-tune the affected tones with the sliders.

3. In order to brighten the shadows and reduce the blue cast, we reduce *Saturation* and increase *Lightness* for the selected tones (figure 8-45).

Figure 8-44: Increasing *Saturation* to 100% Intensifies the selected shadow tones.

The Hue/Saturation sliders allow us to make extremely fine adjustments to the affected tones. We can also precisely define the transitions from color range to color range. For a description of how to do this, see section 4.9.4, page 119.

Figure 8-46 shows our finished image detail.

Figure 8-46: Our image detail after adjustment using *Hue/Saturation*.

Figure 8-45: Reducing Saturation and increasing Lightness for our blue tones.

8.5.2 Color Correction Using Color Mechanic Pro

Our favorite tool for making selective color corrections in Photoshop is Color Mechanic Pro [66]. This is also the best tool we know for removing blue casts from shadows. Here's how:

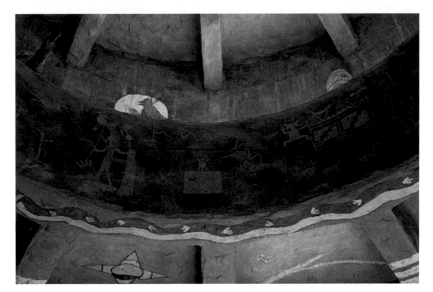

Figure 8-47:
Decorations at the Grand Canyon
Desert View Watchtower

The shadows in this image have a heavy blue cast. We switch Color Mechanic Pro to 16-bit mode in order to get the best results.

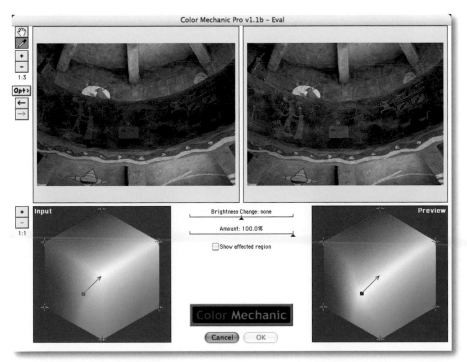

Figure 8-48: Color Mechanic's Input/Preview view (shown here on a Mac)

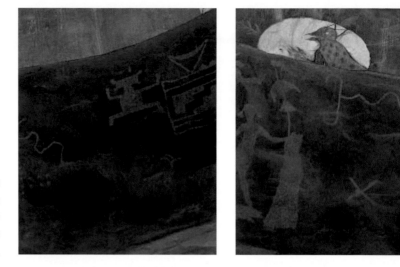

Figure 8-49:
The blue tones on the right look more
natural than the those on the left (these
are details from the view shown on the
previous page).

Figure 8-50: The arrow shows the direction
and magnitude of the color shift
we have made.

We click on the blue shadow and correct the color cast using the color cube
settings shown in figure 8-50.

The initial click sets a color reference point within the color cube. We
then select our desired color by dragging the mouse to the appropriate
place within the cube while keeping the mouse button pressed. The pre-
view image updates in real time. The program adjusts color ranges in a
similar way to the Photoshop Hue/Saturation command.

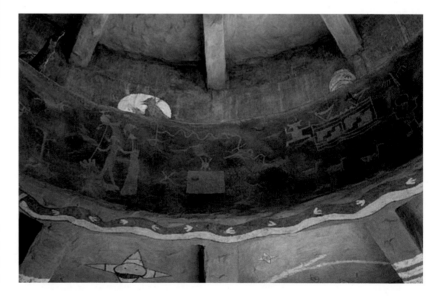

Figure 8-51:
The image already looks much
better after the first correction run using
Color Mechanic Pro

The corrected version shown in figure 8-51 looks much more natural but
now displays a slight magenta cast. We repeat the same steps to correct this,
too, and end up with the result shown in figure 8-54.

Figure 8-52:
Correcting the magenta cast

This technique makes the shadows more transparent but reduces shadow contrast. We can combat this side effect by applying an S-curve.

Figure 8-53: Settings we used to eliminate the magenta cast

Figure 8-54:
The final version of our image

8.6 Using Masks to Increase Luminance

We learned the following technique for increasing image brilliance (*luminance*) from Katrin Eismann. As we have already seen, a mask is nothing more than a grayscale image, and a luminosity mask is actually a monochrome image created from an existing color image using grayscale values that represent the colors present in the original. A luminosity mask is easy to create.

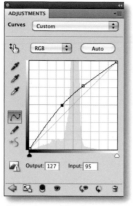

Figure 8-67: The Curve we
used to brighten the image

Figure 8-68:
The image is now too bright.

2. We select the white layer mask from our new layer and invert it to black
 using Ctrl/⌘-I (figure 8-69).

The black mask prevents the adjustment layer from being brightened, so we
work selectively on the mask using a soft brush and the following settings:

▸ Painting color white
▸ Opacity set to 15%
▸ Hardness set to between 0% and 10%.

We make a few soft brush strokes over the dark part of the chick's face and the
darker parts of its body and legs using 15% opacity. You will need to experi-
ment with different opacity values to get a feel for the way this effect works.

Figure 8-69: Our Layers stack showing the
inverted (black) mask

Figure 8-70:
The chick's head and parts of its body are
now brighter. The corresponding Layers
panel is shown above.

A look at the layer mask itself (Alt/ ⌥-click the layer mask thumbnail) re-veals the secret of this technique (figure 8-71) – the brightening effect is only applied where the mask is white.

This is a great multipurpose technique for applying selective adjust-ments to various types of layers, for example:

▸ A layer containing a sharpened version of an image
▸ A layer containing a reduced-noise version of the image
▸ Hue/Saturation adjustment layers
▸ Curves adjustment layers

Figure 8-71: Our finished layer mask

We already demonstrated a variant of this method in section 7.9, page 270, where we used *Overlay* blend mode while applying selective adjustments.

8.8 Advanced Sharpening Using Photoshop Layers

Almost all photos require sharpening before printing. We always sharpen our images using a separate layer for the following reasons:

A) Layers can be more heavily sharpened and the final effect more finely regulated using layer Opacity. If we are not happy with the result, we can simply start again without changing the original image data.

Figure 8-72: Our initial Layers panel

B) We can switch our sharpening layer to *Luminosity* blend mode and thus prevent unwanted color shifts during sharpening.

At the start of our sharpening sub-workflow, the Layers panel looks some-thing like the one in figure 8-72.

1. If the uppermost layer is a pixel layer, we duplicate it using Ctrl/⌘- J or by dragging the layer onto the ⬚ icon at the bottom of the Layers panel. We then jump to step 3.

2. If the uppermost layer is an adjustment layer or an incomplete (or re-duced opacity) pixel layer, we create a combined interim layer us-ing ⇧-Ctrl-Alt- E (Mac: ⇧-⌘-⌥- E). The resulting Layers panel is shown in figure 8-73.

Figure 8-73: Combining the separate layers into one

3. Usually, we then convert the combined layer into a Smart Object (via Layer ▸ Smart Objects ▸ Convert to Smart Object), giving us a Layers panel that looks something like the one in figure 8-74.

4. We can now apply any of our favorite sharpening techniques and tools to the new layer/Smart Object. In our example, we use the Smart Sharpen filter (figure 8-75, page 318). A radius value between 0.8 and 0.9 usually produces acceptable results for 8–12 megapixel images.

Figure 8-74: The combined layers converted to a Smart Object

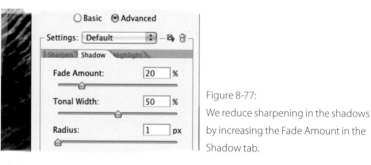

Figure 8-75:
We used the Smart Sharpen filter for this
example. The filter enables us to
sharpen selectively for shadows, highlights,
and midtones.

Figure 8-76: Here, we applied Smart
Sharpen to a Smart Object layer and fine-
tuned the effect by reducing *Opacity*.

If we are using Smart Sharpen, we usually set the *Remove* option to *Gaussian Blur*. For images shot at high ISO speeds, we often reduce shadow sharpness slightly using the *Fade* slider (found under the *Shadow* tab, figure 8-77), helping to combat the increased noise that sharpening often produces in the shadows.

Figure 8-77:
We reduce sharpening in the shadows
by increasing the Fade Amount in the
Shadow tab.

5. Slight oversharpening is usually not a problem, as the effect can be reversed by reducing layer opacity.

 If individual areas are oversharpened (as is often the case for blurred image details), we create a new layer mask and mask the oversharp areas with black or gray.

 If we are sharpening a Smart Object and we don't like the results, a simple double-click on the sharpening entry in the Layers panel reactivates the sharpening dialog.

8.8.1 Sharpening Using Enlarged Images

Some sharpening techniques are more effective if applied to enlarged images, although larger images can significantly increase processing time.

In our example, we begin by upsizing our image to 200%:

➜ Sharpening produces less obvious
artifacts if applied to a softer image that has
been enlarged to 200% of its original size.

1. If necessary, we create a combined layer using ⇧-Ctrl-Alt-E (Mac: ⇧-⌘-⌥-E), select the content of the top layer (Ctrl/⌘-A), and copy it to the clipboard (Ctrl/⌘-C).

2. We create a temporary, empty image using Ctrl/⌘-N and paste the contents of the clipboard (Ctrl/⌘-V) into it.

3. We then upsize our temporary image to 200% using the Photoshop Bicubic Smoother interpolation method (figure 8-78).

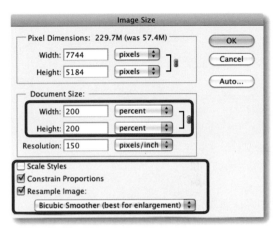

4. The next step is to sharpen the image strongly using any conventional sharpening tool.

5. We then downsize our image by 50% using Bicubic Sharper interpolation, producing a sharpened image that is the same size as our original.

6. We select the entire image (Ctrl/⌘-A), copy the selection to the clipboard (Ctrl/⌘-C), and close our temporary image without saving it (we no longer need it).

7. Finally, we paste the contents of the clipboard into the uppermost layer of our source image using Ctrl/⌘-V.

Figure 8-78: The settings we use to upsize our image to 200%.

8.8.2 Correcting Sharpening Halos

Many sharpening techniques produce color errors and artifacts at object edges. These are known as halo effects. Bright edge artifacts usually irritate the viewer more than darker artifacts. The following steps will help you eliminate halo effects.

1. Create a new sharpening layer and apply your preferred sharpening tool.

2. Duplicate the sharpened layer (Ctrl/⌘-J).

3. Set the lower layer to Darken blend mode, and reduce *Opacity* to about 75% (figure 8-79).

4. Set the upper layer blend mode to Lighten, and reduce *Opacity* to about 25% (figure 8-80).

5. Now, simply adjust the *Opacity* of both layers until you achieve the result you want.

We usually create these two layers using a custom Photoshop action (*100percent_dark_bright*; see section 8.8.4, page 322) and turn them into a layer group. This way, you can vary the strength of your sharpening effect by adjusting *Opacity* for the group.

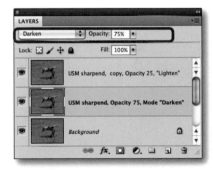

Figure 8-79: The lower layer's blend mode is set to *Darken* and *Opacity* to 75%.

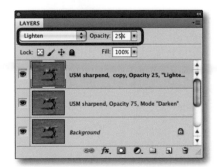

Figure 8-80: The top layer's blend mode is set to *Lighten* and *Opacity* to 25%.

Figure 8-81: The image we want to sharpen.

Figure 8-83: Find Edges creates an
edge mask.

8.8.3 Sharpening Edges

Often, only the edges of a subject need sharpening. The method we describe
here is one of many that you can use to sharpen edges, and it's effective and
easy to apply.

1. If necessary, combine your currently visible layers into a new top layer
 (using ⇧-Ctrl-Alt-E, Mac: ⇧-⌘-⌥-E).

2. Select the new top layer and the
 Green channel in the Channels
 panel (see figure 8-82). The green
 channel usually contains the most
 image data – if a different channel
 shows more detail, use that one.

Figure 8-82: Selecting the green channel

3. Navigate to Filter ▸ Stylize ▸ Find
 Edges. This filter looks for edges
 by comparing the contrast of
 neighboring pixels and creates a
 monochrome image from the re-
 sults (figure 8-83).

4. Increase contrast on the same layer by using Image ▸ Adjustments ▸ Levels
 (figure 8-84).

5. Use Filter ▸ Blur ▸ Gaussian Blur to create a smooth transition between
 sharpened and unsharpened areas (figure 8-85). Use a Radius setting be-
 tween 3 and 7 pixels, depending on your image size.

Figure 8-84: Use Levels to further sharpen
the edges.

Figure 8-85:
Edge mask after smoothing using
the Gaussian Blur filter

6. In the Channels panel, select the mask channel established in step #2 and
 load it as a selection by clicking the ○ button at the bottom of the panel
 (figure 8-86).

7. Invert your selection (Select ▸ Invert Selection or Ctrl/⌘-⇧-I). All
 black areas of the mask will be sharpened while the white areas will re-
 mained protected and unsharpened.

8. Save your selection (Select ▸ Save Selection) and apply a descriptive name (figure 8-87).

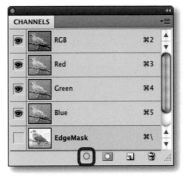

Figure 8-87:
Use a descriptive
name when saving your
selection.

Figure 8-86: Select the newly created
"Edge Mask" channel in the Channels
panel and create a selection by
clicking the Load Channel as Selection
icon.

9. Select the RGB channel in the Channels panel, switch to the Layers panel, and delete the top layer (the one containing the inverted contour layer).

10. Finally, deselect your selection (Ctrl/⌘-D).

The purpose of these initial steps is to create an alpha channel containing an edge mask of the image (figure 8-88). This mask can now be applied (normally or inverted) to any image layer.

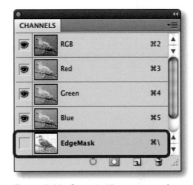

The actual sharpening steps are as follows:

1. Duplicate your previous top layer (if it's a pixel layer) or, once again create a combined pixel and adjustments layer.

2. Load your edge mask as a selection (Select ▸ Load Selection).

Figure 8-88: Steps 1–10 create an edge
mask in the Channels panel.

3. Select the top layer in the Layers panel (the one containing the image you want to sharpen) and click the Create New Layer icon 🗔 at the bottom of the panel. This creates a new layer mask using your current selection (the edge mask in figure 8-89).

Any sharpening is now only applied to image areas where the layer mask is white. The sharpening effect is weaker where the mask is gray.

Now you can really go to town with your sharpening tool and fine-tune the results using the *Opacity* setting for your sharpening layer. This process is, admittedly, a little complex, but nevertheless universally applicable.

You can automate the preparation of an edge sharpening layer by recording the steps we have described as a Photoshop action.

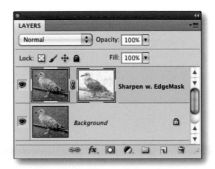

Figure 8-89: The result from being
sharpened is a sharpening layer that protects
everything except the subject's edges.

Figure 8-90: Uwe's
dop_sharpening_frame action set

Figure 8-91: Our sharpening helper actions

Figure 8-93: Layers panel after applying
100percent_dark_bright

Figure 8-94: Our 200% maskless
sharpening action

8.8.4 Uwe's DOP Sharpening Frame Action

You can use Uwe's dop_sharpening_frame actions as a basis for trying out our methods or for developing your own. The actions can be downloaded from: http://books/outbackphoto.com/DOP2010_03/

This action set is designed for use with your own preferred sharpening tool and consists of two subsets:

1. help_sharpening_100percent
2. help_sharpening_200percent

Simply select the Unsharp Mask step, record your favored sharpening tool into the action, and then deselect the USM step.

We use the help_sharpening_100percent action when we want to sharpen without enlarging our image.

The help_sharpening_200percent action upsizes the image to 200% before applying your chosen sharpening tool and downsizing the image back to its original size. This action is designed for applying strong sharpening effects.

The following is a short description of the individual actions in each:

1. **100_percent_edgemask**
(figure 8-92) creates an edge mask and uses the 100% sharpening process. The Levels dialog appears during this action.

2. **100_percent_dark_bright**
(figure 8-93) uses the 100% sharpening process on a set of layers aimed at bright or dark object edges. This action does not create an edge mask.

Figure 8-92: Creating the edge mask

3. **200_percent_no_edgemask_dark_bright** (figure 8-94) doesn't use an edge mask. It simply upsizes the image to 200% and performs the 200% sharpening process.

4. **Clarifier** This is an additional action that uses mild sharpening in conjunction with a large radius value. This combination improves microcontrast. It is basically a simplified version of the technique we explain in section 8.12, page 334.

Download our actions and start experimenting! The actions are compatible with all newer Photoshop versions.

8.8.5 Sharpening and Defocusing Using the Same Filter

We will use the photo of a dandelion shown in figure 8-95 to show you how to:

A) Sharpen the dandelion, and

B) Defocus the background in order to emphasize the subject.

These are the steps we take:

1. We start by duplicating the selected background layer (Ctrl/⌘-J or by dragging it to the ▣ icon at the bottom of the Layers panel). As usual, if we have already made layer-based adjustments, we create a new, combined layer using ⇧-Ctrl-Alt-E (or ⇧-⌘-⌥-E on a Mac). In order to be able to manipulate our layer, we then convert it into a Smart Object (Layer ▸ Smart Objects ▸ Convert to Smart Object).

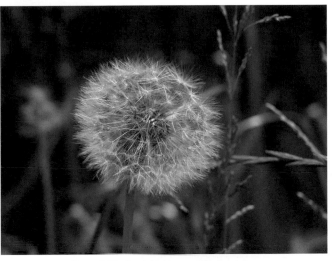

Figure 8-95: Our initial image of a dandelion

2. Now, we apply Filter ▸ Other ▸ High Pass to the Smart layer. This filter reduces the layer's tones to neutral gray and then looks for edges the same way the Find Edges command does (figure 8-96).

 The best Radius value to use depends on the degree to which we want to sharpen (i.e., strengthen our edges), the textures in our image (fine textures require lower Radius values), and its size and resolution. Generally, values between 1.5 and 2.5 do the trick. You can see our result in figure 8-97.

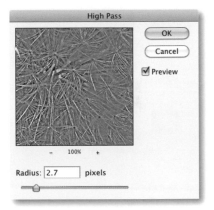

Figure 8-96: The High Pass filter produces an edge relief image.

Figure 8-97:
Our High Pass image
(exaggerated for printing)

3. To perform the actual sharpening, we set the layer blend mode to *Hard Light*. If the result is too harsh, we either reduce Opacity for the sharpening layer or double-click the *High Pass* icon in the Layers panel to open the filter and reduce the Radius value. It is also worth testing the effects of the other, similar blend modes in the *Hard Light* group (such as *Vivid Light, Linear Light,* or *Overlay*). Here, we found that *Vivid Light* and 82% opacity produced the best result (figure 8-98).

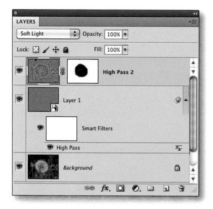

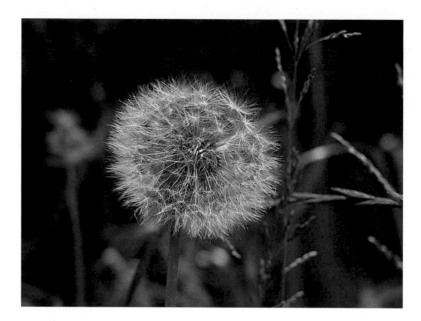

Figure 8-98:
Our dandelion, sharpened by combining the
High Pass filter with *Vivid Light* blend mode.
The Layers stack for the sharpened image is
shown above.

4. In order to defocus the background and increase emphasis on the subject, we again create a new, combined layer (⇧-Ctrl-Alt-E or ⇧-⌘-⌥-E on a Mac) and use the High Pass filter, but this time we set Radius to a value between 15 and 25 pixels.

5. We invert the freshly created relief layer (Ctrl/⌘-I) and use the *Soft Light* blend mode. The background is now pleasantly blurred.

6. To keep the dandelion in focus, we create a layer mask using soft black brush strokes.

 The mask and the original image are shown in 8-99. Here too, we can regulate our layer effect by adjusting layer opacity. Figure 8-100 shows the resulting Layers stack.

Figure 8-100: The Layers panel after
softening the background

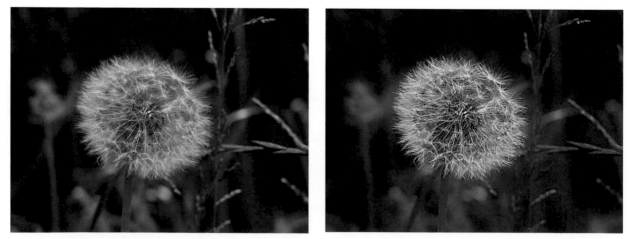

Figure 8-99: The original image is on the left. The right-hand image shows the result of sharpening the subject and blurring the background

Defocusing Using the Lens Blur Filter

The Lens Blur filter is possibly even better than the steps 5 and 6 described above for defocusing selected image elements. It has additional features for fine-tuning blur effects.

5. To use Lens Blur, we create a combined layer and a layer mask in which the areas we want to protect are colored black.

 The mask is critical to the success of this method, as it not only protects certain image elements from the effects we apply, but also determines the distance between the focal plane and the affected areas within the filter's depth-of-field simulation. Here, the filter's various settings turn our mask into a complex tool.

 To get a better view of the mask we are painting, we switch to Quick Mask mode by ⇧ Alt clicking our layer mask. This displays the mask as a red image overlay.

6. We select the image (but not our layer mask) in the Layers panel and navigate to Filter ▸ Blur ▸ Lens Blur. We begin by selecting *Layer Mask* in the *Source* menu Ⓐ (figure 8-101).

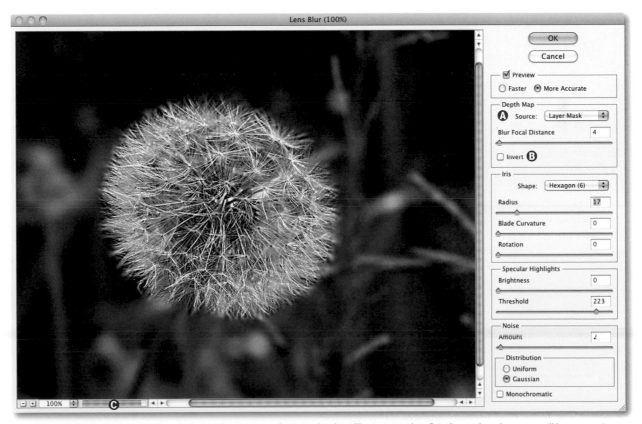

Figure 8-101: This filter is quite complex, and preview updates can be slow. The progress bar Ⓒ indicates how long you will have to wait.

Provided an image is not blurred due to camera shake, the shape and size of the lens aperture determine the degree of blur in the resulting image. These characteristics are collectively described as the *Bokeh* of a lens. The Lens Blur filter includes settings for the shape and position of its own virtual aperture opening in the *Iris* panel. It is worth experimenting with different combinations of settings – we find an octagonal iris produces the most pleasing bokeh effects. This setting is less important in images that have little or no background light sources. The same is true for the *Specular Highlights* settings. If you are adding a high level of blur to your image, it can help to introduce some artificial noise to soften the hard transitions that blur can cause.

8.9 Adding Digital Sunshine to Your Photos

The quality of the ambient light plays a significant role in the success of a photograph. Too much sunshine can produce harsh contrast and strong shadows. Cloudy skies produce more balanced light but also lifeless-looking shadows and colder tones – problems that cannot always be circumvented by adjusting white balance settings.

Figure 8-102:
A landscape photographed under
a cloudy sky

The image in figure 8-102 would benefit from a little additional contrast and warmer colors. The following steps describe how we add a little "digital sunshine" to our image.

1. We create a Photo Filter adjustment layer to warm up the colors (figure 8-103). Here, we check the *Preserve Luminosity* option.

2. Now we add a Curves adjustment layer to the top of our stack that we then use to brighten the image (figure 8-104).

Figure 8-103: This filter adds warmth
to the colors in an image.

Figure 8-104:
This curve will brighten
midtones slightly.

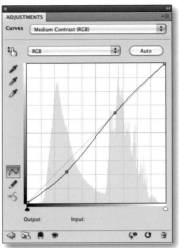

3. We then use an additional Curves layer to enhance midtone contrast using a classic S-curve (figure 8-105).

 You can see the results in figure 8-106. However, the image still lacks punch, so we use another of Katrin Eismann's tricks to pep it up a little:

Figure 8-105: This S-curve improves
midtone contrast

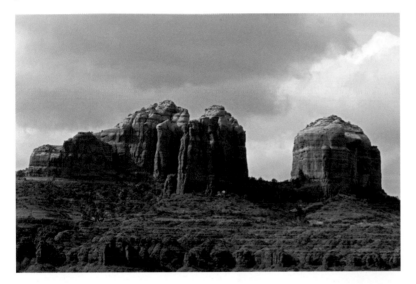

Figure 8-106:
The image now looks warmer, thanks to the
Warming Filter (85) effect.

4. We create yet another Curves adjustment layer, this time set to *Overlay* blend mode. Figure 8-107 shows that applying this layer alone overdoes the effect we are looking for.

5. Reducing layer opacity to about 30% gives us the result you can see in figure 8-109.

This use of multiple adjustment layers allows us to refine and readjust our corrections at any time. Double-clicking the effect icon in a panel entry automatically opens that layer's settings dialog.

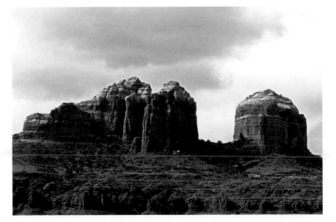

Figure 8-107: Using *Overlay* blend mode improves contrast but
strengthens the colors too much.

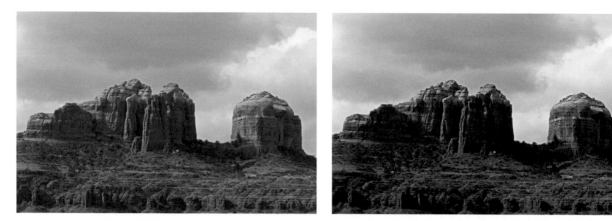

Figure 8-108: Original image Figure 8-109: Same image with added digital sunshine

8.10 **Brush Off Noise**

Image noise often only affects certain parts of an image, as our example in figure 8-110 shows. To clarify the effect we are trying to achieve, we have reproduced the noisy image detail enlarged and slightly brighter in figure 8-111. We will use a layer mask to selectively remove this noise.

Figure 8-110:
This image displays heavy noise in the shadow area indicated by the dotted line.

You can use your noise reduction tool of choice for this type of correction. We recommend *Neat Image* [79] or *Dfine* [75]. (For more information, see section 12.3, page 475.)

1. First, we copy the background layer (either by dragging it to the ◰ icon in the Layers panel or using Ctrl-J/⌘-J).

2. We now reduce noise on the new pixel layer, usually using either *Noise Ninja* [80] or *Dfine* [75], although the Photoshop *Reduce Noise* filter also produces perfectly adequate results.

 The noise-reduced version of our image now covers the original version but has lost an unnecessary amount of detail in non-noisy areas.

Figure 8-111: There is heavy noise evident in this image detail.

3. To make our effect selective, we create a new, black layer mask for the noise-reduced layer by ⌥-clicking the ▢ button at the bottom of the Layers panel or by filling the existing white layer mask with black using the Paint Bucket ◇. This results in only the original, noisy image being visible.

4. We now remove the noise, either using the Eraser or a soft brush with 15% opacity. The finished mask then looks like the one in figure 8-112.

 The noise-reduced image layer becomes visible where the eraser produces white areas in the mask. We have now combined the non-noisy parts of the original image with the selected, noise-reduced parts of the new layer. The resulting slight blur is not important in the darker parts of the image.

Figure 8-112: The finished "noise erase" layer mask. The white areas un-protect the noisy parts of the image and make the appropriate parts of the noise-reduced image visible.

These steps represent just one of many different approaches to reducing digital image noise. Nik Software's *Dfine* [75] supports working directly in layer masks, theoretically saving a step – although the *Dfine* mask also has to be created using a brush.

Figure 8-113:
Noise has been significantly reduced.

Figure 8-114:
The top layer contains the noise-reduced image and a layer mask.

Photoshop's Reduce Noise Filter

Adobe introduced a noise reduction filter with Photoshop CS2 (Filter ▸ Noise ▸ Reduce Noise). If applied selectively to the darker parts of an image, the filter generally preserves brighter image details. This process also requires you to create an interim layer, either by duplicating the uppermost pixel layer or by combining the existing layers into one (using the keyboard shortcut ⇧-Ctrl-Alt-E or ⇧-⌘-⌥-E). The Reduce Noise filter is then applied to the new layer.

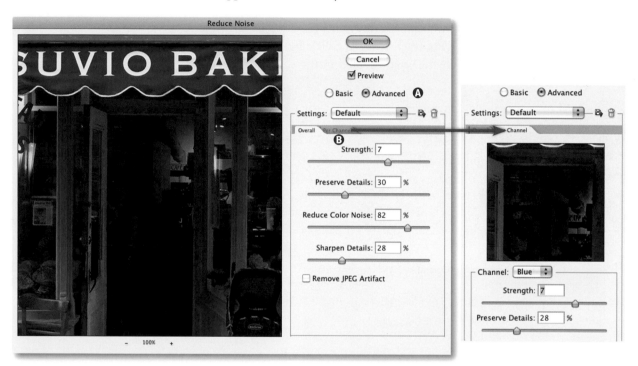

Figure 8-115: The *Advanced* option enables you to apply different settings to individual channels.

Figure 8-116: Here, we applied Reduce Noise as a Smart Filter.

The *Advanced* option Ⓐ enables you to apply different settings to individual color channels. Usually, the blue channel contains more noise than red or green, making it prudent to apply stronger noise reduction to the blue channel. This is achieved by activating the *Per Channel* tab Ⓑ and selecting the appropriate channel (figure 8-115).

You can convert your layer into a Smart Object (as explained in section 7.12, page 274) and apply the filter to the new object, allowing you to readjust your correction at a later stage. You can also use layer masks to apply the filter effect selectively (figure 8-116).

8.11 Enhancing Midtone Contrast

We have already used a classic S-curve many times to improve image contrast. This is generally a reliable method as long as it doesn't produce dense shadows or over-bright highlights. Midtone contrast is generally the most important aspect of this type of correction.

Figure 8-117:
Mono Lake. Increased midtone contrast would certainly improve this image.

The image in figure 8-117 displays typically low midtone contrast. Using the Photoshop Shadows/Highlights command, we set the *Amounts* sliders for *Highlights* and *Shadows* to zero and move the *Midtone Contrast* slider to "+34" (figure 8-118). (The *Highlight* sliders are not shown in figure 8-118.)

We perform this correction on its own layer, allowing us to fine-tune the effect by adjusting layer opacity. Unfortunately, Photoshop doesn't include a Shadows/Highlights adjustment layer, so we have to apply the command to a combined adjustment layer (page 264) that we then convert into a Smart Object. The result of our correction is shown in figure 8-119 on page 332.

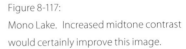

Figure 8-118: The Photoshop Shadow/Highlights command helps to improve midtone contrast.

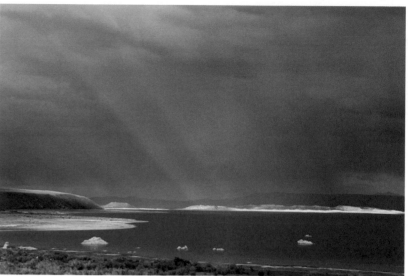

Figure 8-119:
Our image after applying Shadows/
Highlights using *Normal* blend mode. The
Layers stack above shows the effect being
applied to a Smart Object.

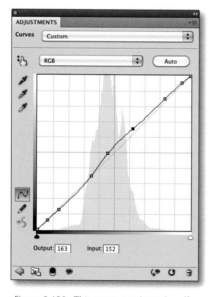

Figure 8-120: This curve simulates the effect
of the Shadows/Highlights command.

Here, we want to simulate the Shadows/Highlights effect using a curve, as Curves can be directly applied on adjustment layers. We set anchor points to lock (protect) the shadow and highlight parts of our image when we adjust the curve's midtones (figure 8-120). Figure 8-122 shows the result of applying this curve.

S-curves tend to shift colors when they are used to adjust image contrast – an effect that is not always welcome. We can avoid this problem by setting the layer blend mode to *Luminosity* instead of *Normal*. The result of doing things this way is shown in figure 8-123.

Figure 8-121:
The Layers stack showing our Curves
adjustment layer with blend mode set
to *Luminosity*.

We like the effect of the color shift enough to want to keep it – at least partially. In order to partially preserve the effect, we duplicate our new Curves layer and set the blend mode to *Color,* allowing us to regulate the intensity of the color shift by adjusting the layer's opacity. The effect produced by a 50% value was our favorite.

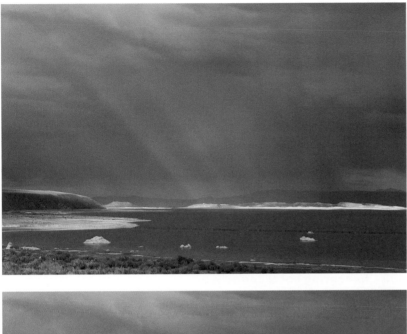

Figure 8-122:
The result of applying a Curves adjustment
set to *Normal* blend mode

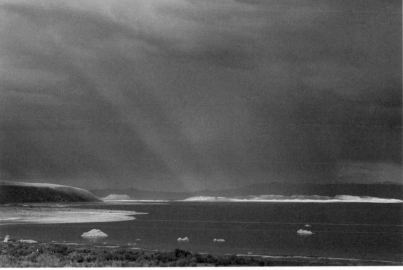

Figure 8-123:
The result of using *Luminosity* blend mode

Figure 8-124 shows the corresponding Layers panel and figure 8-125 the finished image.

The final step now is sharpening. We prefer to sharpen images before applying this type of correction – which is why you can see an EasyS Plus sharpening layer in each stack. This way, we can fine-tune contrast and color of the lower layers precisely by adjusting Opacity and Curves midtones.

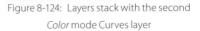

Figure 8-124: Layers stack with the second
Color mode Curves layer

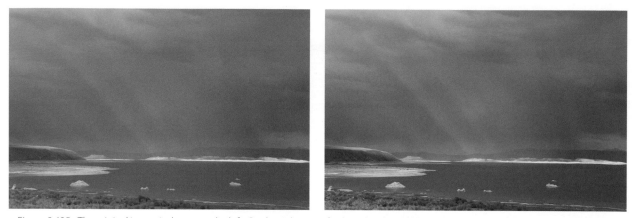

Figure 8-125: The original image is shown on the left. On the right is our final result, achieved by using a second adjustment layer set to *Color* blend mode and reducing Opacity to 50%.

8.12 Enhancing Local Contrast

Many images appear more punchy if improvements are made to local contrast (also known as microcontrast). Most contemporary RAW editors have microcontrast tools built in. ACR and Lightroom use the *Clarity* setting in the *Basic* adjustments panel to adjust microcontrast, and the effect this produces is very different from that produced by conventional contrast tools.

➜ This technique can cause unwanted alterations to saturation. You can avoid these by applying USM sharpening to a separate layer and setting its blend mode to *Luminosity*.

You can achieve similar effects in Photoshop by using the Unsharp Mask filter with a low *Amount* setting (between 20 and 40) and a large *Radius* value (between 30 and 60).

Figure 8-126 shows an example of this technique. You will need to adjust the Amount and Radius settings according to the size and resolution of the image you are working on. As usual, if you apply this type of correction on an adjustment layer, you can regulate its strength by adjusting layer opacity.

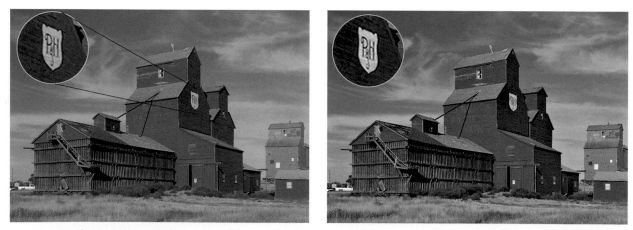

Figure 8-126: The original image is on the left. The version on the right was corrected using USM: Amount =30, Radius = 34, and Threshold = 0.

Sharpening Blurred Images

Applying the technique described above repeatedly, using decreasing *Amount* values and increasing *Radius* values, can produce astonishingly good sharpening effects. We learned this trick in Lee Varis' book *Skin* [26]. You can even use this technique (known as *Octave Sharpening*) to save images that initially appear to be irreparably out-of-focus.

The technique involves duplicating the image you want to sharpen four times on consecutive layers. You then set these layers' Opacity to decreasing values between 100% and 13% and sharpen them using the Unsharp Mask with the values shown in figure 8-127. To avoid unwanted color shifts, set the blend mode to *Luminosity for all layers*.

Grouping the four sharpening layers in a layer group allows you to control the strength of the overall effect by adjusting the Opacity consistently for the whole group. You can also use a layer mask on the group to exclude areas you don't want to sharpen.

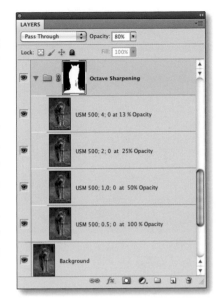

Figure 8-127: *Octave Sharpening,*
as practiced by Lee Varis [26]

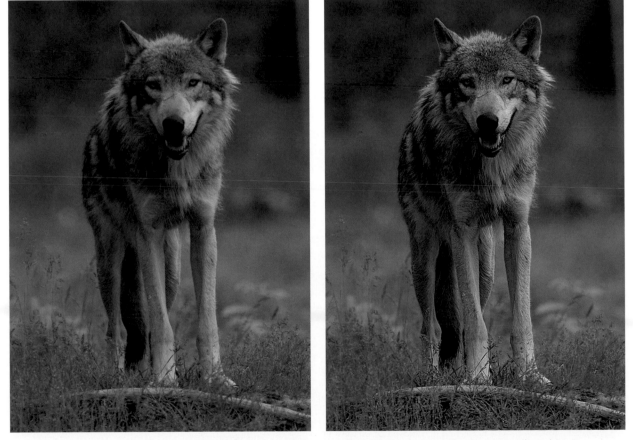

Figure 8-128: The unsharp original is on the left, and the corrected version using *Octave Sharpening* is on the right.

Figure 8-129: Fine-tuning the mask (shown here in red) with a soft, narrow, black brush in Quick Mask mode

➜ The *DOP_EasyD_Plus_DetailResolver* script was developed by Uwe Steinmüller (co-author of this book) and is available at his website [67].

In the example in figure 8-128, we want to exclude the background from being sharpened. Without the help of the group mask, the noise in the blurred background would become too pronounced.

We create our mask by making a Color Range selection on the active background layer (Select ▸ Color Range) using the Quick Selection tool 🖌 (available from CS3 onwards). With this selection active, we select the *Octave Sharpening* layer group and click the mask button 🔳 at the bottom of the Layers panel. We can now fine-tune the resulting mask (if necessary) using a brush.

This sharpening technique can lead to halo effects at pronounced edges – here, for example, at the top of the wolf's ear (figure 8-128). Because of this, we use a small, soft brush to adjust the mask so that it slightly impinges on the outline of the wolf (figure 8-129). In order to make this very fine adjustment, we select the group layer mask, activate Quick Mask mode (by ⇧-Alt-clicking the mask), and zoom right in.

Microcontrast Plug-ins

Specialized plug-ins are the best tools for enhancing microcontrast. We use either Akvis *Enhancer* [55] or our favorite – Uwe's own *DOP_Easy_DPlus_ DetailResolver* script, which we use nowadays on most of our images.

This script not only enhances microcontrast, but also includes an option for improving shadow detail. The script has a settings dialog but no preview window, so you have to make a few attempts with different settings before you get a feel for the effects it produces in different situations. You can save settings as presets; the script remembers the last settings you made and suggests using them as a starting point the next time you run it. The script also automatically creates a combination layer and names it after the currently active adjustment settings.

As when sharpening creatively, you should protect the areas you want to leave untouched with a layer mask when using Uwe's script.

Images that contain fine textures such as grass, leaves, or wood grain benefit most from the use of the script. The same is true for textiles and portraits in which hair plays a dominant role, although, you will need to mask the face in order to avoid emphasizing your subject's pores. The script positively accents eyes and eyelashes.

Once installed, the script can be found under File ▸ Scripts ▸ DOP EasyD Plus DetailResolver.

After you have performed your other corrections, you can apply the script simply by selecting the uppermost layer, selecting your parameters, and clicking OK. Then all you have to do is wait while the script works its magic.

The following is a short description of the script's sliders and their effects (figure 8-130):

Detail+ determines the strength of the applied microcontrast enhancement. The default value (5) is suitable for most situa-

tions. Setting this value too high can cause shadow noise (recommended values: 5–12).

Figure 8-130: DOP EasyS Plus DetailResolver script dialog

Light Halo suppresses the halo effects that are sometimes caused by higher *Detail+* and *Definition* values. It does this by emphasizing the bright side of an edge less than the darker side. This is useful in images that contain fine, dark structures, such as tree branches photographed against the sky. (Halos are color and highlighted smears that can appear at high-contrast edges after some image corrections (especially sharpening) have been applied.)

Definition is similar to the *Detail+* parameter. Higher values increase the effect but can make the relief textures appear less three-dimensional.

Shadow Brighter does exactly what it says. A zero value has virtually no effect, while higher values increase shadow detail (but run the risk of increasing shadow noise).

➜ If you set the *Shadow Brighter* value too high, you risk increasing noise and producing duller-looking images.

Noise Mask creates a mask designed to suppress additional noise. We recommend that you always activate this option.

Clipping- helps to avoid highlight and shadow clipping during sharpening. We recommend keeping this option activated. This option is especially useful if you plan to print your results.

Shadow wide extends the range of shadow tones that are brightened in a similar way to Photoshop's Shadows/Highlights command. Do not use with noisy images.

The script is most effective when used subtly, with relatively low *Detail+*, *Definition values*, and *Shadow wide* option. Inspect your image carefully (using a high zoom factor) for edge halos and shadow noise artifacts after running the script. You can reduce unwanted effects by reducing the opacity of your adjustment layer, or simply discard the new layer and run the script again using different parameters.

We applied DOP_EasyD_Plus_DetailResolver with its default settings to the left-hand image in figure 8-132 and produced the right-hand image as a result. Figures 8-133 and 8-134 show the script's effect in detail. The new layer generated by the script is automatically named using abbreviations of the names of the applied parameters (figure 8-131).

Figure 8-131: The script includes the active parameters in the new layer's name.

This script is not only a standard element of our daily workflow, but also very suitable for use with monochrome RGB images. For this type of work, be sure to mask any soft grayscale transitions before applying it.

Figure 8-132: The original image is on the left. The image on the right is the result of applying *DOP_ EasyD_ Plus_ DetailResolver*
using its default settings.

→ You will only need to apply about half the usual dose of creative or out-
put sharpening to your images once you have applied the script!

Sharpening in its various forms is an art, from compensatory or creative
sharpening using a RAW editor, to output sharpening for export or print-
ing, or the microcontrast enhancements described above. Sharpening re-
quires experience, intuition, and the use of specialized tools. The optimum
settings will take into account the image subject and composition, the out-
put format and materials (matte or glossy paper), output type (monitor or
print), the intended use, and, of course, your own personal taste.

There is no substitute for experience, so don't be afraid to experiment.
When it comes to printing, you should test print some or all of your im-
age on your chosen paper at the planned size. Inspect your printed output
carefully once it has dried thoroughly.

Apart from compensatory RAW sharpening (or automatic in-camera
JPEG sharpening), sharpening should be your last image optimization step,
as most other optimization tools change the detail or contrast parameters
that are affected most by sharpening processes.

Figure 8-133: Detail of the original image, printed at 300 dpi

Figure 8-134: Same detail after applying the script

As we have already mentioned, the best sharpening results are always achieved if applied selectively using brushes, masks, or selections – anything else would be too easy!

Avoid unnecessary or repeated sharpening. Every sharpening step increases contrast, but at the price of lost detail and tonal nuance. Sharpening can emphasize existing artifacts and even produce new ones.

Multishot Techniques

9

Digital imaging technology allows us to employ photographic techniques that were either prohibitively expensive or simply too complicated for use with analog equipment – for example multi-shot techniques, which use multiple source images to produce a single, finished picture. There are various things you need to look out for while shooting that make merging your source images easier, or even possible in the first place.

Panoramas are the most popular way to use multiple images to photograph everyday scenes.

High Dynamic Range (HDR) images merge multiple images shot using different exposure values to form a single image with increased dynamic range. HDR images often must be "tone mapped" in order to be satisfactorily displayed or printed.

The third major multishot technique involves shooting multiple images using different focus settings. These can then be merged using appropriate software to form an image with increased depth of field. This technique is called "Focus Stacking".

You can also use multishot techniques to produce images that have greater resolution than your camera can actually capture in a single shot, or to reduce image noise at high ISO values by averaging the tonal values of multiple source images. The last two techniques are described in detail in our book on multishot techniques [18].

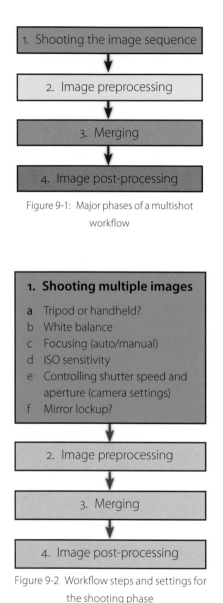

Figure 9-1: Major phases of a multishot workflow

Figure 9-2 Workflow steps and settings for the shooting phase

* This is, of course, not the case when shooting for focus stacking.

9.1 Common Steps in a Multishot Workflow

Although each individual technique described in this book has its own workflow, there are a number of commonalities between them that we would like to touch on at this point. The typical workflow for all of these multishot techniques consists of four phases that are represented in figure 9-1:

1. Shooting the image sequence
2. Image preprocessing
3. Merging the images into one
4. Post-processing (optimizing) the merged image

Each of these phases may consist of several steps that form their own sub-workflow. The following paragraphs will discuss each major step individually.

9.1.1 Shooting the Image Sequence

The first phase in the process offers a number of opportunities to make decisions which will later allow you to achieve optimum results. While technical aspects (such as the camera's shutter speed and aperture settings) differ from camera to camera, other aspects of basic technique are generally the same for all multishot techniques. You can assume, for instance, that for all of the techniques we describe, the use of a tripod will improve your results – even if it is possible to shoot Super-Resolution, HDRI, and panorama sequences without one. It's difficult to shoot focus stacking sequences without a tripod and basically impossible to shoot macro photos hand-held.

While shooting photos for use with all of these techniques, it is best to use a preset white balance setting. This is less important if you are shooting in RAW format, because RAW allows you to adjust the white balance later when converting your images into other formats. In processing the RAW files, you can adjust the color temperature without sacrificing image quality.

It is important to note that when a camera is set to automatically meter the color temperature of a shot, it embeds the resulting information directly into the image data (with RAW files, in the EXIF data). Later, when you process your images using a RAW converter, you have to remember to set them all to the same color temperature (unless you're using the same program to both convert and merge your images).

It's also crucial to all multishot techniques that the focal distance remains consistent throughout the image sequence* – and you can only be sure that this is the case if you focus manually. If your subject is sufficiently far away, and there are no objects in the foreground to confuse the camera, you can sometimes use autofocus to shoot panoramic or HDRI sequences. It is also important to retain a constant ISO speed setting throughout each sequence. We recommend using a preset ISO setting and not the Auto ISO feature built into many newer cameras.

Table 9-1: Recommended Settings for Various Multishot Techniques

Technique	Super-Resolution	Focus Stacking	Panorama	HDRI
Shutter speed	variable	fixed	fixed	variable
Aperture	fixed	fixed	fixed	fixed
Camera exposure program	manual or Av bracketing*	manual or Av	manual	Av bracketing*
ISO speed	fixed	fixed	fixed	fixed
Subject distance	fixed	manual	fixed	fixed
Focal length	fixed	fixed	fixed	fixed
White balance	fixed	fixed	fixed	fixed
Tripod	optional	always	preferable	preferable

* Using bracketing varies one of the camera's shooting parameters during a sequence of shots. Av bracketing varies the shutter speed for a fixed aperture, according to your AEB (Auto Exposure Bracketing) settings.

Manual exposure settings are usually the best choice when shooting for multishot processes. There are, of course, exceptions, such as shooting for HDRI, or using Av bracketing to vary the shutter speed automatically. Av bracketing can also be used to shoot images for super-resolution applications. Av mode (or "A" mode, as some camera manufacturers call it) can also be used for a super-resolution shoot.

When taking shots that require slow shutter speeds, it is necessary to use a tripod. Mirror lockup, a useful tool built into many DSLR cameras, prevents motion blur caused by the mirror's movement. Mirror lockup is not suitable for high-speed bracketing sequences, but some cameras allow mirror lockup for entire bracketing sequences, and you should use this feature if your camera has it.

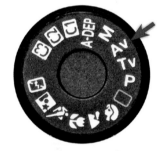

Figure 9-3: To shoot images for HDRI and Super-Resolution applications, use your camera's aperture priority (Av or A) setting.

9.1.2 Image Preprocessing

The first few steps of a multishot workflow are no different from the steps involved in our overall workflow (section 1.6). We download our images, rename them, tag them with basic metadata, inspect them, and delete the images we don't want to keep. We then add more metadata to the remaining images, either individually or by sequence.

We usually create stacks for our sequences in Bridge or our all-in-one program with the most eye-catching image on top. This helps us to keep a clear overview of our image stock and helps us to find individual sequences more easily.

Due to the usually short time intervals between individual shots in super-resolution, HDRI, and panorama sequences, grouping images is usually quite simple. However, we sometimes have to group focus-stacking sequences manually.

Figure 9-4: Workflow steps for the preprocessing phase

Figure 9-5: A sequence of three panorama source images. On the left are the images shown as an unfolded stack, and on the right the collapsed stack (this is a screenshot of an Adobe Lightroom stack). The number indicates how many images are in the stack.

Figure 9-7 Image thumbnail showing part of the IPTC data. We included the image numbers from the HDRI sequence in the caption (shown here in Adobe Lightroom).

For panoramic and focus stacking shoots, you will often find yourself working with a variable number of shots rather than fixed group sizes. It is common practice to take a shot of your hand between sequences (figure 9-6). This creates a simple partition which can be deleted later. An empty, black frame can also serve the same purpose.

This practice works well for most other techniques but is impractical for bracketing sequences.

Figure 9-6 Sequence shot for a panorama. The image on the far right indicates the end of the sequence.

We have found that manually recording the image numbers in the image description can help when organizing our photos. For example, this technique can be applied to all images in a single panorama or a stack, like the example in figure 9-7.

We also give our photos a keyword that describes the type of sequence; e.g., *HDR*, *Pano*, *FS* (focus stacking), or *SR* (super-resolution).

Preprocessing Images for Merging

How you go about preparing images for merging depends on which format your camera uses to save images, and which formats your application supports. If your program can import RAW images directly, you won't have much initial processing to do. However, if you shoot in RAW and your image processing program only supports TIFF or JPEG, then you need to convert the RAW data (to either TIFF, JPEG, or DNG) before further processing can take place.

The standard process for converting RAW files involves converting all the images in a sequence using the same basic settings. The most important settings to consider when converting are white balance, aberration correction, and vignetting. It can also be helpful to adjust the exposure slightly at this point (but not for HDR images). For example, if the horizon is slanted in a panorama sequence, it would make sense to correct this now. Most merging applications, however, only support the merging of images

with identical pixel dimensions. So, if you decide to straighten and crop your RAW files before merging, make sure that all the files have the same pixel size. For most multishot techniques, it is usually better to crop and straighten your images after they have been merged.

When converting sequences of RAW images to TIFF or JPEG, start by optimizing the reference shot, and subsequently apply the same changes (where appropriate) to the rest of the sequence. Such settings usually include white balance, cropping, noise reduction, and slight sharpening.* It is usually better to make corrections to panoramas in general, to lighting or color saturation, and to contrast after the photos have been merged.

Your *reference shot* should be the one which is most similar to your desired result. In an HDRI sequence, this will be the one with normal (medium) exposure values. For a panorama, it will be the center shot in the sequence, whereas for a focus stacking sequence, it will be the shot with the central element of your subject in sharp focus.

The method for transferring the settings used for the reference shot to the other images in a sequence varies according to which RAW converter you are using. With some converters – Adobe Camera Raw or Adobe Lightroom, for example – you simply select the remaining images and click the *Synchronize* button. In the dialog boxes that follow, you can select which aspects of the reference shot should be transferred (figure 9-8). Make sure the color temperature and image size (crop) are transferred – most merging

* At this stage you should only sharpen the image slightly, if at all. If your merging program automatically sharpens the image (as do PhotoAcute and most focus stacking programs) then it is better to leave sharpness unchanged.

Figure 9-8

The dialog boxes for synchronizing RAW conversion settings in Lightroom 3 (above) or Camera Raw (left). Here, you can choose which settings to transfer to other currently selected images in the sequence.

* Some applications (such as Apple Aperture, Adobe Lightroom, Nikon Capture, or LightZone) allow you to apply the same procedure that is used for RAW files.

applications require all images in a sequence to have the same pixel dimensions.

Everything we have said about optimizing RAW data using a converter also applies when optimizing JPEGs or TIFFs in an image editor, although transferring settings to multiple images can be more difficult.* For TIFF and JPEG files, we recommend holding off image optimization until all the shots have been merged into a single image. Only make corrections that are absolutely necessary, such as removing dust spots, chromatic aberration, or vignetting, before merging your images.

If you perform these adjustments using adjustment layers in Photoshop, it is possible to apply the same changes to other images by dragging the adjustment layers from the layer panel of your reference image to other open images. Simply select the applicable adjustment layers, hold down the Alt or ⌥ key, and drag the layer entry in the layer panel to the image you want to modify. Unfortunately, this doesn't work with most filters.

Merging Your Images

This phase varies greatly depending on which multishot technique you are applying. You will find detailed descriptions in the individual sections relating to each technique (sections 9.2 through 9.4).

Post-Processing Your Merged Image

As a rule, merged images need to be further optimized after the merge has taken place. This phase usually includes cropping, either in order to remove the parts of the final image that are poorly defined, or to aid overall composition. Some of the programs described here – especially those used for focus stacking – automatically crop the images in a sequence to include only the areas that are present in all the images used. It is usually necessary to select the areas to be cropped by hand when stitching panoramas.

If you are cropping to enhance the composition and general feel of your image, other factors, such as personal taste and the intended use of the image, will influence your decisions. When shooting photos for multishot sequences, it is always important to shoot a larger area than you wish to appear in your final image. That way you can compensate for potential shifts and distortions, and for any cropping you do while post-processing.

Depending on the technique you are using, a number of different anomalies can occur. These can include rounding errors caused by compression, expansion, rotation or distortion, and blurring caused by the averaging of highlight values. Most optimization scenarios require a local contrast improvement (section 8.12, page 334) and a final sharpening of your image. It might also be necessary to burn or dodge some parts of the final image. You will find descriptions of the necessary techniques in section 8.7, page 315. You should also correct lens distortion and some types of perspective distortions before you increase contrast or sharpen your images.

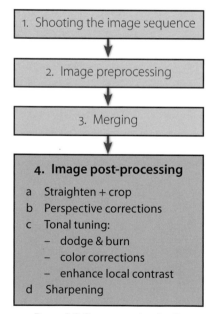

Figure 9-9 Post-processing details

➜ Lens distortion can be corrected before merging in some RAW editors, or later using the Photoshop Lens Correction filter (section 8.4, page 302).

9.2 Increase Your Angle of View Using Stitching Techniques

There are various situations in which panorama (or "stitching") techniques are useful:

▸ You want to capture a scene that is much broader or higher than the camera's shooting format, and you don't want to lose resolution by cropping.

▸ You can't get far enough away from the subject to photograph it in a single shot.

▸ You need to produce greater resolution than the camera can nominally capture, for example, for a large-format print.

Although these techniques are not all panorama techniques in the strictest sense, we call them all "stitching" to keep things simple.

We use stitching techniques most often to merge multiple shots taken using our 24mm or 35mm full-frame lenses. We use the techniques described in the following sections to make stitching as simple as possible.

Panorama photography is a complex topic, and many books have been dedicated to just that subject. Here, we address only the simplest panorama techniques.

We recommend Harald Woeste's book *"Mastering Digital Panoramic Photography"* [27]. Our book on multishot techniques [18] also covers panoramic photography in detail.

9.2.1 Panorama Shooting Techniques

The general characteristics of the component images should be as follows:

A. They should be as sharp as possible. This helps the program establish which parts of the images to overlap. A tripod will help you get better results, as it eliminates camera shake and allows for longer exposure times, smaller apertures, and thus greater depth of field.

B. All source images should be shot using the same aperture setting. We recommend setting the shutter speed and aperture manually to ensure consistent exposures. Deactivate Auto ISO if present and avoid shooting bright skies, as this usually produces burned-out highlights.

C. All source images should be shot using the same distance setting, as far as possible. We recommend using manual focus, as autofocus can too easily produce images with slightly different magnifications (section 7.11, page 272). Autofocus is also easily confused by foreground objects, which are then often falsely recognized as being the actual subject.

It is best to set your lens to its *hyperfocal distance* for landscape panoramas, as this keeps all detail from about halfway through the field of focus right up to infinity. The hyperfocal distance depends on the aperture and focal length. You can find tables for calculating hyperfocal distance at: www.dofmaster.com

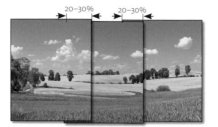

Figure 9-10: Neighboring images should overlap by about 20–30%.

Figure 9-11: A spirit level attached to the cameras's flash shoe helps to ensure that the camera remains perfectly level.

Figure 9-12: A typical 3D panorama head (Novoflex Panorama VR-System Pro)

D. Neighboring images should overlap by about 20–30% (figure. 9-10). This is the amount required for a stitching program to reliably identify congruent points and the areas which should overlap.

Make sure that the axis of rotation is parallel to the horizon when you shoot horizontal panoramas. A spirit level attached to the camera's flash shoe or the tripod head can help to avoid inaccuracies.

E. Avoid shooting by moving the camera parallel to the scene (sideways). You should generally shoot your images by panning the camera from left to right, or vice versa. Ideally, rotate the camera around its *optical center*, also known as the *no-parallax point*. This point is also sometimes (incorrectly) referred to as the *nodal point*. The *no-parallax point* is the point within the camera/lens construction where hypothetical rays of light cross at a given distance. Unfortunately, this optimum point is not usually positioned directly above the camera's tripod socket or the tripod's quick-release plate.

The best solution is to use a panorama head that allows you to rotate the camera around its own no-parallax point (figure 9-12).

If your subject is far enough away (landscapes at a distance of 60 or 70 feet, for instance), the effect of the camera being rotated around a non-ideal axis does not have a noticeable effect on stitched results. However, if you are shooting a more immediate environment, such as the interior of a room, the resulting parallax shifts can have visible negative effects.

Finding the optical center of a particular camera/lens combination is not difficult and is described in detail in our book on multishot techniques [18].

F. Try to allow as few changes as possible to take place within the frames. Moving objects such as cars, people, or clouds can cause problems if they occupy one of the overlap areas. Although today's stitching software can deal with many common image overlap problems, it is best to wait until your frame is free of passersby or cars. Stray objects outside of the overlap zones are not a problem, provided you use a short enough shutter speed. If in doubt, shoot two or three alternative versions. You can combine these later using the Edit ▸ Auto-Blend Layers command in Photoshop (section 7.11, page 272). Generally, the command automatically eliminates objects that change their form between frames.

G. Also try to make sure the lighting conditions remain as consistent as possible throughout your sequence.

The sum of all these points presents a substantial photographic challenge, especially if you want to print or project your panoramas in a large format. Don't be afraid to practice!

It is possible to shoot panoramas handheld, but a tripod usually makes it easier to shoot using long shutter speeds or to rotate the camera accurately around its optical axis.

We use a Tilt/Shift lens whenever possible[*] and shoot just three images – left, right, and center or top, bottom, and center. These types of lenses make it possible to shift the optical axis to the left or the right, or to tilt it up or down without moving the camera itself. Tilt/Shift lenses are the better alternative, but you can also shoot effective panoramas using a normal lens combined with camera movements. Always try to rotate the combined camera/lens unit around its optical center if you have to move it at all.

Merging Techniques

There are many quality stitching programs available, ranging from the open source *Hugin* [78] (for Windows, Mac OS X, and Linux) or *PTGui* [82] to commercial packages such as Autodesk *REALVIZ Stitcher* or *Autopano Pro* [57], which is our current favorite.

The Photoshop Photomerge command in CS4/CS5 version is a mature stitching tool, so we will stick to using Photoshop for our first example. If you plan to make panoramas regularly, it might be worth investing in a specialized panorama software package, but Photoshop is more than adequate for panoramas composed of four or five shots; it even achieves great results when stitching multirow or 360-degree panoramas.

9.2.2 Merging Images Using the Photoshop Photomerge Command

We usually leave the camera in landscape position when shooting panoramas; but, if we are shooting high-resolution 4:3 images, we rotate it to portrait format, leaving us more space at the top and bottom for cropping later on.

We use an *L-Plate* to make switching camera positions easier and quicker. L-Plates attach to the tripod head, usually using the Arca-Swiss standard mount. All of our cameras and telephoto lenses are equipped with Arca-Swiss tripod mounts.

We will take three shots in our example. We meter light manually and make sure that all three shots use the same settings (i.e., constant aperture, shutter speed, and focus settings, with Auto ISO deactivated). We leave automatic white balance switched on, as we generally shoot in RAW format anyway. We then perform a manual white balance (as described on page 347) for the center image and apply the same values to the other images in the sequence. If you are shooting panoramas in JPEG format, always use a single, manual color temperature value for the whole sequence (table 3-1, page 84).

We shoot our sequence from left to right and process the resulting files identically using ACR or Lightroom.

You can now start to stitch your converted RAW or JPEG images. The Photomerge command gets more powerful from version to version, and as of CS4 can handle 32-bit HDR image data.

Figure 9-13: Really Right Stuff L-Plate. An L-Plate makes it simple to switch from landscape to portrait shooting.

Figure 9-14 shows the four images that we are going to stitch together. They were shot using a 28–70mm lens set to 28 mm and a Nikon D200. The camera's crop factor of 1.5 means we shoot with a full-frame equivalent focal length of 42 mm.

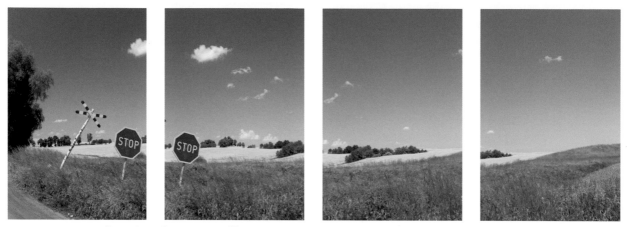

Figure 9-14: Our sequence of four panorama source images, all shot using an aperture value of f14

If you shoot in RAW format and your computer has enough main memory, leave your images in 16-bit format for merging and only reduce them to 8-bit afterwards. The Photomerge command performs a whole range of rotations, transformations, and corrections to image brightness, so it is an advantage to have as much spare image data as possible. Here are the basic steps for performing an image merge:

1. There are at least three ways to open images in Photoshop's *Photomerge*:

 A) Select your images in Bridge and use Tools ▸ Photoshop ▸ Photomerge.

 B) Select your images in Lightroom and then choose Photo ▸ Edit In ▸ Merge to Panorama in Photoshop.

 C) Open your images directly in Photoshop using File ▸ Automate ▸ Photomerge. Select your images and drag them to the list displayed in the dialog.

 Whichever method you use, Photoshop will open the dialog shown in figure 9-15.

2. In almost all cases, you should check the *Blend Images Together* option Ⓐ. This ensures that Photoshop automatically adjusts brightness in the overlapping areas between the individual images. The self-explanatory options Ⓑ and Ⓒ were introduced with Photoshop CS4. We don't know how Photoshop manages to correct lens distortion without using camera/lens profiles, but we do know that checking Ⓑ and Ⓒ improves results. If you have already corrected lens distortion and vignetting using

a different tool, uncheck these two options. (If you select *Collage* or *Repositioning*, option Ⓑ and Ⓒ are grayed out.)

Figure 9-15: Initial CS4 Photomerge dialog

The *Layout* option Ⓓ determines the type of panorama the command will produce. If the angle of view in your panorama is less than 120 degrees, *Perspective* is the best choice, but *Cylindrical* is better for greater angles of view. If you want to merge a spherical panorama, use the *Spherical* option. *Collage* and *Reposition* are useful if you are merging images shot using a tilt/shift lens or a microscope. However you obtained your images, it is always worth giving *Auto* a try.

If you are dealing with a large number of high-resolution images, it saves a lot of time if you use smaller versions for your trial merges.

4. Clicking *OK* starts the merging process, which can take quite a long time, depending on image resolution, the number of images involved, color depth, the amount of memory in your system, and the speed of your computer's processor. The result is a stack of layers in which each source image has its own layer and its own layer mask. The masks determine which parts of each image contribute to the finished panorama (figure 9-16). The images are already rotated, scaled, distorted, and brightened, but you can further modify them manually if necessary.

Figure 9-16: Our Layers panel after applying "Photomerge"

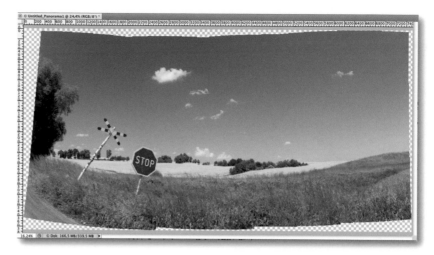

Figure 9-17:
Photoshop now displays the merged image.
The detail-free edges are a result of the
automatic alignment and transformation
processes performed by the program.

The results of using these standard parameters are often very good, but re-member to zoom in and check image detail if you are planning to print or display your image in a large format. If you decide to retouch the merged image, it is better to either flatten all layers to the background or merge them into a single layer.* It is also nearly always necessary to crop photomerged images, as the merging process rarely produces absolutely symmetrical edges.

* To flatten all layers to the background
layer, use ⇧-Ctrl-E (Mac: ⇧-⌘-E).
To merge all layers into a new top layer, use
⇧-Ctrl-Alt-E (Mac: ⇧-⌥-⌘-E).

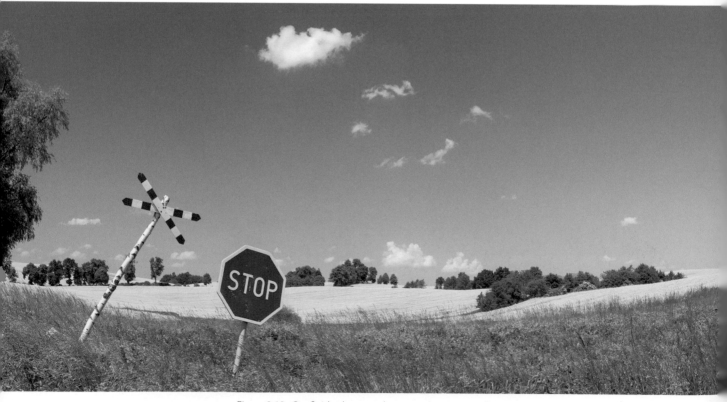

Figure 9-18: Our finished, cropped, perspective-corrected image

Our image required a number of adjustments that we applied after merging the layers into one. First, we levelled the horizon, then we corrected the perspective slightly so as not to lose too much image data while cropping the edges. Since small imperfections in landscape photos are not too critical, and since the Photoshop Lens Corrections tool is too slow, we made both of these corrections using the Free Transform command. We dragged a horizontal guide out of the ruler at the edge of the frame to help us level the horizon. We then corrected exposure, contrast, color, microcontrast. and sharpness as we would for any other image. By the way, the road signs weren't affected by lens distortion – they really were at the crazy angle you see in the finished panorama.

The final step is to crop the finished image using the ⛏ tool. We could also have levelled and perspective-corrected our image using the *Perspective* option in the ⛏ tool (page 101).

9.2.3 Stitching Using Autopano Pro 2

If Photoshop's built-in functionality isn't sufficient for your purposes, you will need to use specialized stitching software. There is a broad range to choose from, and *Autopano Pro 2* from French Kolor [57] represents a good compromise between value and versatility. The program is available for Windows, Mac OS X, and Linux. There is also a 64-bit version that noticeably accelerates the processing of large panoramas when used with an appropriate computer system.

⊞, , ⛄ www.autopano.net

Autopano Pro is available in various languages, including French, English, and German.

Autopano is available in Pro and Giga versions, with the latter being especially effective for processing large amounts of image data. We currently use the Pro 2.6 version, which supports JPEG, 8 and 16-bit TIFF, various RAW formats, and 32-bit HDR images.

We will use a simple two-image example to demonstrate some of Autopano's features. The source images are handheld shots of the BMW museum in Munich, Germany (figure 9-19).

Figure 9-19: The two handheld source images. The shadows are a little too dark, but that can be corrected later.

We shot our source images in bright sunshine, so the shadows required some brightening. However, as we wanted to process the RAW image data directly in Autopano, we postponed this step until after the merge. Corrections made in Lightroom or ACR remain invisible if you drag and drop RAW images directly into the Autopano window.

The opened images are displayed in the left-hand window, where we select them once again. A click on the ● button then starts the program's "Detection" process and produces a preview panorama (figure 9-20).

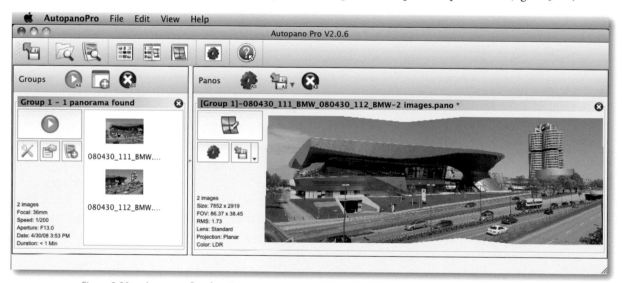

Figure 9-20: : Autopano Pro showing a preview panorama created from the two source images on the left.

Figure 9-21: Autopano Pro 2 includes four projection types.

➜ The grids shown in figures 9-22 and 9-24 can be toggled on or off.

The image is slightly dark but usable. We now enlarge the preview to have a closer look. A large monitor is, of course, an advantage when processing panoramas. We need to improve the angle of the horizon, the optical center of the image, and the perspective (especially near the tower). We could have addressed the first two points at the shooting stage, but we can sort things out in Autopano without losing too much image quality along the way.

The ▮. icon in the tool bar contains the four available projection types (figure 9-21). Except for the bird's-eye *Mercator* projection type, these are the same as the ones in Photoshop CS4/CS5. The ⊞ icon activates the Center Point tool. ⊡ is the crop tool, and ▥ is used for aligning images.

Clicking on the ⊞ icon opens a new editing window (figure 9-22) with a whole selection of tools with built-in tool tips to help you determine what they do. When you select a tool, Autopano will show a relatively detailed description of the active tool, while Ⓑ displays the applied steps and any snapshots you have made.

The program includes a Color Correction function ⊿, and the ⊞ icon starts a Control Point Editor in a separate window that you can use to select matching areas in the source images. The "Yaw, Pitch and Roll" (▦) dialog (figure 9-22) is used to correct perspective and perspective distortion – changes that can cause significant image quality loss, depending on the

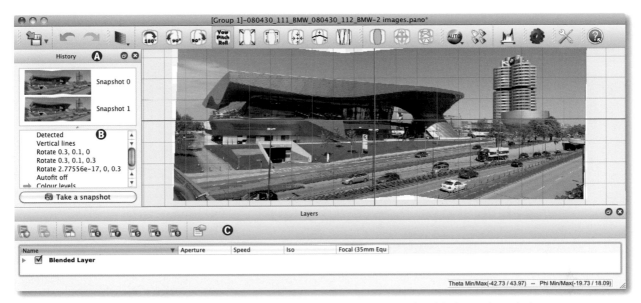

Figure 9-22: Editor window showing the general information window at top left and the history log at the bottom

degree of distortion involved.© contains a history log for returning the processed image to earlier states – similar to the Photoshop History panel (page 133). You can close all of these windows or move them to a second monitor to give you more space for your preview image.

Autopano's optimization functionality leaves little to be desired and we were able to perform the following corrections in about 15 minutes.

Our first step was to perform a basic color correction using the ⊿ tool. We then selected a new center point with the ⊞ tool in order to balance the appearance of the two buildings – the tower is now a little larger and more obvious.

Figure 9-23: Settings for correcting perspective distortion

Figure 9-24: Shifting the optical center of the panorama enlarges and emphasizes the tower.

We then used the ▥ tool to draw a vertical line along the edge of the tower and pressed ⏎ to align the entire image with it.

Some (but not all) tools require you to press ⏎ or click ✔ to complete an action and update the image preview.

There was still some black, pixel-free space at the top of the image after cropping using the ▢ tool (figure 9-25, next page) because we didn't want

Figure 9-25: The finished, rendered image, as delivered by Autopano Pro. Here, we used the "Planar" projection type.

to crop the top of the tower. We filled this space later using the Photoshop clone Stamp tool. With CS5, you could also use Content-Aware Fill (section 8.13, page 340).

You can save your steps as a project using the 🖫 tool before rendering your panorama, which makes it easier to adjust your changes later without having to start again. This is an extremely practical feature, as many imperfections are only visible once you zoom into a rendered image

The rendering dialog (figure 9-26) is activated by clicking the ⚙ button. Here, you can select your output format, image size, interpolation type, blending method, and your chosen filename. This prepares the image data for inclusion in the batch queue, where you can park multiple jobs for processing later.

Optionally, you can also use Autopano Pro as a graphical front end and transfer your image data to *Panorama Tools* for processing. Panorama Tools – or PanoTools, as it is often known – is a set of tools for processing photographic panoramas developed by Professor Helmut Dersch at Furtwangen University in Germany. Many current panorama software packages are based on his open source tools, which are available for download at [64]. Personally, we don't use this method.

Autopano Pro 2 also allows you to make Snapshots of the current editing state, which you can save and recall later at the click of a button.

Once we rendered our image, we filled the missing portions of the sky using Photoshop's Clone Stamp tool (or Content-Aware Fill) and we brightened the shadow

Figure 9-26: The Render dialog is used to set output formats and various other rendering parameters.

areas slightly using the Shadow/Highlight tool (after converting the top layer to a Smart Object). Next, we increased local contrast using Uwe's *DOP_EasyD_Plus_DetailResolver*. We then used *Unsharp Mask* to sharpen our image and made a final crop. You can view the final result in figure 9-27.

The entire process took about 15 minutes, and the moving cars presented no problems. The main subjects were all far enough away from the camera so that we didn't need to use a specialized panorama tripod head or concentrate on rotating the camera precisely around the optical center of the camera/lens assembly.

In our example, we have only touched on the possibilities offered by Autopano Pro 2. For high-end panoramas you will need to take more care in shooting (using a panorama head and precise camera alignment), and also apply more fine adjustments using the program's built-in tools. The faster your computer and the larger your monitor, the easier it will be to process complex panorama images.

Autopano Pro 2 is a fast, solid tool, especially in its 64-bit version. A plug-in for exporting images to Lightroom or Aperture would nevertheless be a great improvement.

Figure 9-27: The finished image after some fine-tuning and retouching.

9.3 Maximizing Depth of Field Using Focus Stacking

If you need greater depth of field in a photo, the usual solution is simply to close down the aperture. Unfortunately, the laws of optics mean that there are limits to the depth of field you can produce with any one lens. Stopping your lens down beyond a certain point (known as the "optimum aperture") reduces contrast as well as visible sharpness. This image quality drop-off is caused by the diffraction of light rays hitting the edges of the aperture blades on their way through the lens.

* The reproduction ratio is only relevant if it exceeds 1:1.

Other factors influencing depth of field are the size of the individual light-sensitive elements making up the image sensor, as well as the focal length and the reproduction ratio of your lens.* The optimum aperture (for producing the best possible depth of field and contrast using a standard focal length) is usually somewhere between f5 and f6 for compact cameras and between f8 and f11 for APS-C or high-resolution, full-frame cameras. This value can be even larger for medium-format cameras.

➜ APS-C cameras are those whose sensors have a 25 mm x 16.7 mm (or similar) format.

If you need to produce more depth of field than your camera allows – as is often the case for architectural or macro photos – you can use focus stacking techniques to work around the limitations of your equipment. This technique involves taking multiple shots focused at different points and merging them together using specialized software.

We already demonstrated an example of this technique using Photoshop CS4/CS5 in section 7.11, page 272. The Photoshop version of this technique is, however, still relatively new and not suitable for use in all photographic situations.

➜ The Windows and Mac versions of Helicon Focus tend not to be in step. The Windows version is more advanced.

A better alternative is the standalone program *Helicon Focus* (manufactured by HeliconSoft [76]). The program is available in 32-bit and 64-bit versions), for Windows as well as for Mac OS X.

9.3.1 Shooting for Focus Stacking Applications

It is advisable to switch off as many of your camera's automatic functions as possible when shooting photos for focus stacking, just like when you are shooting for panorama applications,

Use manual shutter speed, aperture, and ISO settings; plus use either a preset color temperature setting for JPEG and TIFF images, or automatic white balance if you are shooting RAW images. You can then set the same white balance value later using your RAW editor.

Figure 9-28: A macro focusing rail helps with precision focusing when shooting close-ups or macro photos. The illustration shows the Novoflex "Castel-Mini".

You will, of course, have to switch off autofocus, and you should shoot your image sequence in identically-sized focus steps from front to back (or vice versa). Make sure that the field of focus between shots overlaps. We recommend that you use a macro focusing rail for shooting macro focus stacking shots (figure 9-28), as it will usually enable you to focus more precisely than the focus ring on your lens.

9.3.2 Preparing Your Images for Stacking

Make sure that all images in your sequence have the same color temperature, using either a RAW editor or an image processing program. It is generally best to leave sharpening until after you have merged your images, although we do sometimes perform slight compensatory sharpening and (if necessary) chromatic aberration correction in our RAW editor before merging. We perform all other optimization steps including vignetting after merging. If, however, your RAW editor offers profile-based automatic lens corrections,* apply these corrections before merging.

* As do ACR 6.1, Lightroom 3, Canon DPP, and DxO.

Helicon Focus supports a number of RAW formats, but RAW conversion is nevertheless not one of its strengths. If we shoot our source images in RAW format, we convert them to 16-bit TIFF for merging.** If your computer has limited memory capacity, you can also try using 8-bit TIFF source material.

** Helicon Focus doesn't support ZIP-compressed TIFF files, so it is better to use LZW compression.

9.3.3 Merging Images Using Helicon Focus

Our example uses the 4.2 Mac version of Helicon Focus. Although the user interface is slightly different from the Windows version, the functionality is largely identical and intuitive to use. The program's online help is also quite comprehensive. Figure 9-29 shows our four source files of a withered tulip, which we prepared as described above.

➜ The 5.1.9 Windows version is available as of July 2010.

Figure 9-29: Four images focused at differing distances but using the same aperture and exposure values

Once the program is running, we open our images using the File ▸ Add Images command. You can also select your images in your image management program (in our case Lightroom) and simply drag them to the Helicon Focus window (figure 9-30, page 362). You can select or deselect individual images by clicking on the tick mark next to each preview image. Clicking on an image in list Ⓑ displays it in the program's preview pane. You can zoom in using ⌘-⊞ or the zoom-in button ⊞, while ⌘-⊟ or ⊟ zooms out.

As in our previous examples, you should make sure your images are loaded in the order they were shot and/or focused. And remember, only images with a checkmark will be processed.

We now activate the *Focus* button Ⓐ and set the processing parameters Ⓒ. The Mac OS version offers two processing methods (*Method A* and

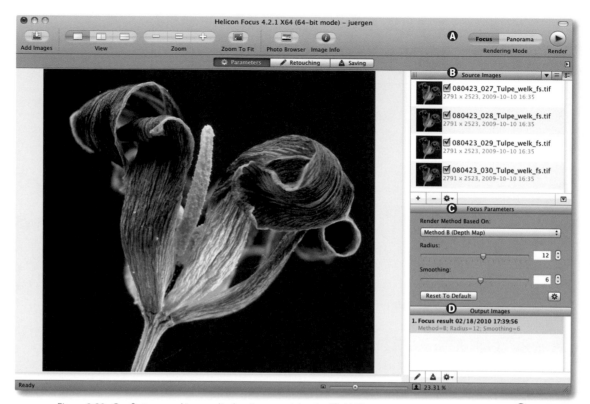

Figure 9-30: Our first merged image displays improved depth of field. This image is now included in the list ⒟.

Figure 9-31: Autoadjustment tab in the Preferences dialog. The lower two parameters are only relevant if you are processing photos shot using a microscope.

Method B). The best method to use depends on the type and content of your images. We generally achieve better results using *Method B*.

The *Radius* parameter determines the breadth of the pixel range which is considered by the program to be sharp and which is therefore included in the final, merged image. The *Smoothing* parameter determines how the program combines the focused parts of the individual images: the lower the value, the sharper the resulting image will be, but the more likely it is to display image artifacts. A larger value produces smoother transitions that tend to look "softer".

Further settings are available under the *Autoadjustment* tab in the Preferences dialog (figure 9-31). You will generally only have to make settings here when you start the program for the first time or if you are processing images that are not precisely aligned. Increasing these values can produce better results but slows down processing.

Clicking the Render icon ▶ (or pressing ⌘-Ⓡ) starts the merging process. Although we used large,

16-bit TIFF files, the process was very quick using the Pro version of the software and our 8-core Mac. The combined image is then included in the list of output images in list Ⓑ and is automatically displayed in the preview window (figure 9-30). You can then compare the merged image with one of the source images by clicking on the source image of your choice, and you can zoom in and out using the slider at the bottom of the preview pane.

Helicon Focus also allows you to retouch unwanted image artifacts using the tools under the *Retouching* tab (figure 9-33). The merged image is displayed on the right, while the selected source image is shown on the left. You can then use the Clone Brush to select the parts of the source image that you want to copy to the merged image. You can select the brush size and hardness, as well as the brightness of the applied pixels. Activating the *Show Map* option uses a black mask to display the parts of the source image that are used in the merged image. It helps to zoom right in and set a high *Edge Sensitivity* value when making these types of changes.

You can even copy blurred areas to "blot out" merging artifacts, although this wasn't necessary for our example.

Finally, you can save your results in a number of ways (figure 9-32). The formats available depend on the format of the source images. Our source images were 16-bit TIFFs, so we use a 16-bit TIFF for our output too. The Program is basically unbeatable for this type of merging application, and every serious macro photographer should own a copy.

Figure 9-32: Helicon Focus offers several ways to save images.

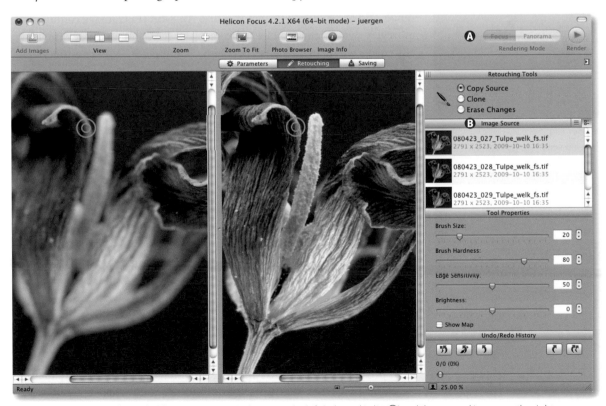

Figure 9-33: Edit mode. The source image is shown on the left (selected in list Ⓑ) and the merged image on the right.

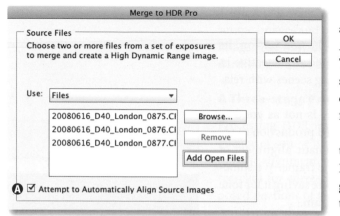

Figure 9-39: The dialog box used to select the source images for an HDR image. We recommend activating option Ⓐ.

Photoshop starts by loading the files, then aligns and merges them into a temporary HDR image. Additionally, it will generate a preview (figure 9-40). This can use a lot of processing power, and may take some time even on a fast computer. In the dialog, you can use the preview list Ⓐ to exclude selected images from the merge process.

The EVs which can be seen below each image thumbnail are either automatically extracted from EXIF data or estimated automatically by the program. The histogram Ⓒ shows the dynamic range of the merged image.

Use the slider Ⓓ beneath this histogram to find an appropriate white point. In our experience, this will be further to the right than to the left end of the slider scale.

You can select the desired bit depth (8-, 16-, or 32-bit) for the resulting image using the drop-down menu Ⓑ. We suggest to create a 32-bit image for your first attempt.

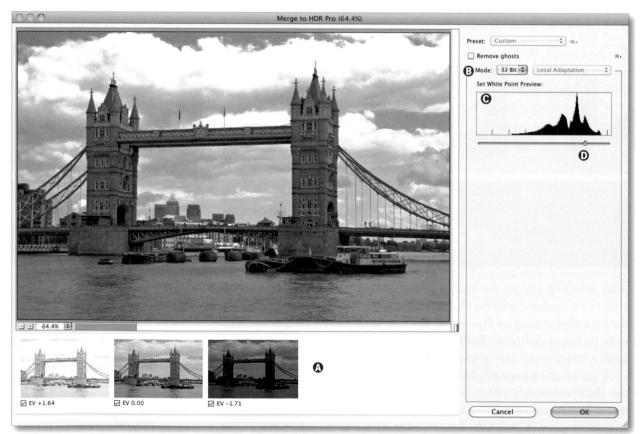

Figure 9-40: Preview of an HDR image in Photoshop CS5. The menu for selecting the bit depth of the resulting image can be seen at Ⓑ.

Clicking *OK* starts the merging process and displays the resulting HDR image (figure 9-41).

If you select 8-bit or 16-bit, Photoshop CS5 will show the Tone Mapping dialog as part of the "Merge to HDR Pro" window, similar to the one shown in figure 9-47, on page 372.

Don't be irritated by the look of the preview image. The previews shown in figures 9-40 and 9-41 have a relatively normal appearance because the scene has moderate dynamic range. For images with a broader dynamic range, Photoshop has to create a temporarily tone-mapped preview image which cannot be adequately displayed on a conventional computer monitor.

You can now adjust the brightness of the image using the slider Ⓐ (at the bottom left in the preview image shown in figure 9-41). Adjusting this value does not, however, change your actual image. It is designed simply to enhance the preview image in order to help you to make good subsequent processing decisions.

Returning to our HDR dialog in figure 9-40: if you choose the *32 Bit* option for *Mode*, you can use a number of further enhancements in Photoshop CS3, CS4, or CS5 (although, as mentioned, most 32-bit filters and tools are only available in the Extended versions of the pro-

Figure 9-41 A provisionally tone-mapped preview of our Photoshop HDR image

gram). Keep in mind that the displayed image is the result of a provisional tone-mapping process, making accurate visual judgments difficult. You have to rely on the quoted tonal values and histogram displays for reliable image information.

If you select 8-bit or 16-bit instead of 32-bit, Photoshop automatically opens the tone-mapping dialog once the images are merged (see figure 9-46/9-47, page 371). One advantage of 32-bit output is that it makes you independent of Photoshop's own tone-mapping tool and allows you to use other plug-ins, such as Akvis *Enhancer*, Photomatix *ToneMapper*, or Andreas Schömann's *FDRCompressor*. Here, we stick to the Photoshop tool for reducing our 32-bit image to a printable 16-bit or 8-bit (Web-capable) version.

The merged image looks a lot like the HDR preview image generated by the program before merging, due to the fact that your monitor cannot display the full dynamic range of the HDR image. A reproducible image exists only after the HDR image has been tone mapped to a 16-bit or 8-bit format.

➔ Unfortunately, Photoshop does *not* display histograms for 32-bit images via Window ▸ Histogram. In order to view a 32-bit histogram, you need to create a Levels adjustment layer.

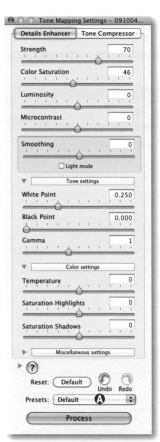

Figure 9-63: Details Enhancer
panel

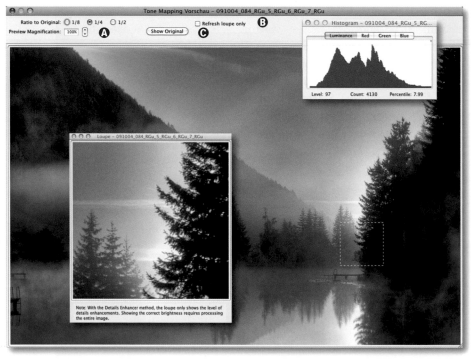

Figure 9-62 The preview of our first Details Enhancer tone mapping, showing the activated HDR Preview
window. The look of the preview image results from using a high "Strength" value.

We have found that the following method is a good way to get used to the effects of the various sliders: working from top to bottom, set the slider to its extreme left-hand position and wait for the program to update the preview. Then set it to its extreme right-hand position, followed by a central setting. Now, continue to work with increasingly small slider movements to left or right until you find the value that appears best to you. There is no "perfect" setting, and you will always encounter situations in which small readjustments are necessary. Often, you will have to go back to a slider to do some more fine-tuning.

We use the *Color settings* tab to select a suitable color temperature (figure 9-63) before we adjust shadow and highlight saturation. Slight increases liven up an image, but overadjusting saturation can quickly produce an artificial look.

Now we adjust micro-smoothing in the *Miscellaneous settings* panel (figure 9-64). *Micro-smoothing* is similar to microcontrast. You can find more information on the subject of microcontrast (also known as "local contrast") in section 8.12, page 334. A higher value for *Micro-smoothing* can help to liven up an image and make further contrast adjustment at postprocessing unnecessary. Adjustments to microcontrast in Photomatix are applied to the entire image, whereas Photoshop allows you to apply them selectively using layer masks.

Figure 9-64: Miscellaneous settings panel

If you are using high *Strength* values, you may also need to increase the level of *Micro-smoothing* to keep the microcontrast effect under control.

We now move on to the *Shadows Clipping* setting. If shadow detail is less important to the overall look of your image, you can select a high value to produce a high-contrast image with dark shadows. The best settings for your image depend on the subject itself and your personal taste. Our example uses a value of 2 in order to retain the shadow details.

Increasing the *Highlights Smoothness* and *Shadows Smoothness* values can help avoid shadow and highlight clipping by adjusting the range of highlights or shadows that contrast enhancements are applied to. Moving the loupe over the corresponding sections of the image can help to determine the best values.

We can now go back to the main settings and once again adjust the *Strength* setting. The best value to use here is also largely a matter of taste. Many published HDR images are vilified for their exaggerated and sometimes unnatural look – a criticism that also applies to some of the images in this book. However, if you set a moderate *Strength* value (50 or less), you should be able to avoid the more pronounced effects that HDR processes can produce.

Another disadvantage of higher *Strength* values is increased image noise. We therefore recommend that you keep your *Strength* values low and that you shoot at low ISO speeds whenever possible. The *Reduce noise* option (available since version 3.1 – see figure 9-55, page 377) does exactly what it says.

We now move on to the color saturation, contrast smoothing, and brightness settings, followed by a final gamma value adjustment.

We have described all these adjustments simply and sequentially, although in reality, many of them have reciprocal effects. You simply have to practice to find out which controls have which effects and how they fit in with your personal processing style.

Once you find a combination of settings that works well and might be suitable for other images, you can save it using the *Presets* drop-down menu (figure 9-63, Ⓐ). This will enable you to reuse the same values when processing similar images and save a good deal of time, even if the resulting image still requires a little fine-tuning.

Keep an eye on the histogram and check the individual color channels before producing your final image, as color clipping is not always visible in the simple luminance histogram display (figure 9-65).

As before, the actual tone mapping is activated by clicking *Process* in the tone mapping control panel. The results are then displayed in the preview window and can differ significantly from the preview image.

The second tone-mapped interpretation of our HDR image is shown in figure 9-67. This image has already been fine-tuned and slightly sharpened in Photoshop. The emphasis here is definitely on the word "interpretation", because the program's numerous settings give you a very high level of

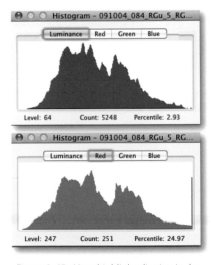

Figure 9-65: Here, highlight clipping in the red channel is not visible in the combined luminance histogram.

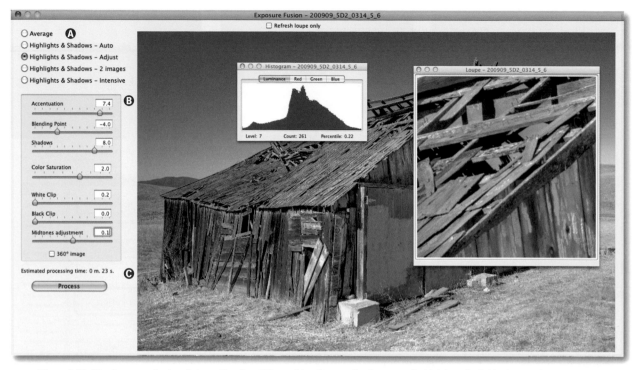

Figure 9-72: The Exposure Fusion dialog offers five different blending methods, some of which have individual control parameters.

Photomatix Pro will load the files and temporarily blend them for preview in the dialog box shown in figure 9-72. You can then select your blending method from the options offered in section Ⓐ.

The primary purpose of the *Average* method is to reduce noise. It is most useful for image sequences with largely similar exposure settings, or with small bracketing increments, or with high ISO speed settings. Here, we are only interested in the resulting low-noise LDR image. We don't generally use the *Highlights & Shadows – Auto* method, because it doesn't allow any manual control.

Our two favorite methods are *Highlights & Shadows – Adjust* and *Highlights & Shadows – Intensive*. We nevertheless recommend that you experiment with the other methods too.

Processing time can vary substantially – from a couple of seconds to nearly an hour, even using the same source files. The actual time required depends on the number of images being processed, their size, the selected blending method, and how fast your computer is. Photomatix Pro estimates the remaining processing time and displays it in the program window (figure 9-72 Ⓒ).

While the Photomatix Pro HDR function generates its HDR images from the various tonal value areas in the source images, the Exposure Blending function scans the source files to determine the source of every single pixel in the resulting image.

We already know most of the sliders/functions shown in figure 9-72 Ⓑ from *Details Enhancer. Blending Point* defines the level of brightness at which pixels are taken from either the previous or the next source image. Initially, we set *White Clip* and *Black Clip* to zero and fine-tune later. The *Shadows* slider determines how dark the shadows appear – higher values produce lighter shadows.

The Loupe view showed serious aberrations in our sample image, so we stopped the process, corrected the edge artifacts in Lightroom, and started again. We arrived at the values shown in figure 9-72 after some experimentation and clicked *Process.*

After about 30 seconds of processing time, the program produced an LDR image that we then saved in 16-bit TIFF format using File ▸ Save as*. If the source images are 8-bit (JPEGs, for example), the resulting image will also be in 8-bit format.

Figure 9-73 shows our resulting image that is slightly cropped along the bottom. This version shows better detail definition in the dark beams of the roof without losing highlight detail.

We increased local contrast using *DOP_EasyD_Plus_DetailResolver* and sharpened it slightly using Unsharp Mask after scaling to an appropriate print size. Our local contrast adjustment meant that we needed less general sharpening, allowing us to reduce the Radius setting from the usual 1.0 pixels to around 0.7 pixels.

* �Ⓐ-Ctrl-Ⓢ (Mac: Ⓐ-⌘-Ⓢ) is faster.

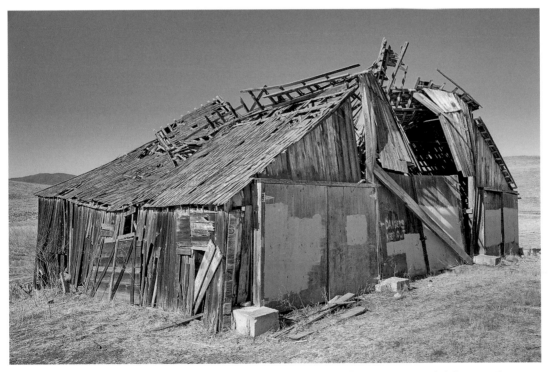

Figure 9-73: Our final image, created using "Highlights & Shadows – Adjust". The image is slightly cropped.

Figure 9-76: This image of a rainbow is a panorama made from two HDRI images, each of which consists of two separate source images.

scheme which allows us to easily refer back to our source images, regardless of where they are located.

You can define your HDR or tone mapping process more precisely using the *Settings* buttons (figure 9-74 Ⓐ). These are the same settings that we already know from conventional HDR or tone mapping processes using Photomatix Pro, and you can use previously saved *Preset* configurations, too.

Click *Start* to begin batch processing. Batch processes are run separately from the rest of the program, which means you can perform other, non-batch Photomatix operations while your batch process is in progress. The progress of the individual steps is detailed in the window shown in figure 9-77.

Finally – or as soon as the first results are ready – you can view your finished LDR images and optimize tone mapping in the appropriate HDR images if necessary. This is easier to do if you save your HDR and LDR images in their own folder, separate from your source images.

Large batch processes can take time but usually run without problems. We often use the Photomatix Pro batch process to make a "first draft" of our HDR images before further processing them using other HDRI tools.

A simplified batch processing function for single files can be found in the Automate menu under Single File Conversion. This process tone maps single HDR images located in a specific source folder and saves them as LDR images in a target folder. Here, too, you can specify the type of tone mapping to apply and the output format.

Stop at next combination

> Loading 3 images starting from
20080616_D40_London_0892.tif
> Aligning images...
> Generating HDRI from 3 LDR images

Figure 9-77 The Photomatix Pro batch processing window details the individual steps as they are carried out.

Turning Color into Black-and-White

10

Black-and-white images are still photographically relevant, even if we shoot our photos exclusively in color. The advantage and the attraction of mono-chrome images lies in their high degree of abstraction and their strong graphic appearance.

As we are not actually talking about line draw-ings here, the correct term for "black-and-white photo" is actually something like "black-and-white halftone image" or "grayscale image", but to keep things simple, we will nevertheless use the terms "black-and-white" and "monochrome" in this chapter.

If you simply convert an image from RGB format to grayscale using Photoshop, the results are nearly always disappointing. The steps necessary to produce authentic-looking black-and-white images are much more complex. The tools and techniques for doing just that are the subject of this chapter.

Let's take a closer look at the *Black & White* dialog (figure 10-26). It is similar to the Channel Mixer dialog, but has more color sliders and a Tint option for applying a colored tint to a monochrome image. The operation also preserves image luminosity (a real improvement compared with the Channel Mixer) which means you don't have to make sure that the sum of the channel values is 100%. The result of applying the command is an RGB image.

You can also adjust luminosity directly. For tis first activate the direct adjustment tool Ⓐ. Then click on your image at tonal value that you want to adjust and hold the mouse button down. Dragging the mouse to the right increases luminosity for the reference color at the point you clicked, and dragging it to the left reduces luminosity. The sliders are adjusted automatically and changes apply to all areas that have the same tonal values as the reference point.

To increase drama in the sky, we clicked on the formerly blue sky and dragged the cursor to the left. This resulted in the settings in figure 10-26 and the image in figure 10-27. This example shows that you can darken blue tones by shifting the blue slider into negative territory.

Figure 10-26: The Black & White dialog

Experienced analog photographers know that you can make skies more dramatic by using a red lens filter. The Black & White command obliges with a Red Filter effect in the drop-down menu Ⓑ. Applying this effect gives the result in figure 10-28, which we think is the best of all.

You can fine-tune to your heart's content and save your settings as presets using the options menu ▾≣. If you use the save location suggested by Photoshop, your preset will appear in the menu automatically.

Figure 10-27: The sky is darker and more dramatic.

Figure 10-28: The result of using the Red Filter preset

The *Tint* option Ⓒ does just what it says, and the default setting is a dark sepia tone. Clicking on the colored square next to the Tint checkbox opens the Color Picker, where you can select your desired tint color. You can see our tinting result in figures 10-29 and 10-32.

Figure 10-29:
Our image after
tinting using the color
shown in figure 10-30.

The dialog doesn't allow you to apply split toning to images, as do ACR, Lightroom and Nik's Silver Efex Photoshop plug-in.

Uwe has also written a script to work around this problem which you can download for free at [104]. Once you have installed the script and converted your image to monochrome (without additional toning), you can load the script using File ▸ Scripts ▸ DOP_SplitToning_Vx. The script creates a new layer group called *DOP_SplitToning_V1* with two adjustment layers (figure 10-31). These are called *Tone_Shadows* and *Tone_Highlights*.

Both layers are Photo Filter layers with particular preset fill settings for the appropriate luminosity areas. You can open both layers and select new color values. The strength of the effect is determined by the opacity of the individual layers and is preset for a subtle effect. Increase opacity slowly if you are not happy with the initial effect you. In figure 10-32, we have deliberately turned opacity up high to emphasize the effect in.

Figure 10-30: Activating the "Tint" option
displays the currently active tint color.

Figure 10-31: The Split Toning script layers

Figure 10-32:
Our image with blue-toned
shadows and sepia-toned
highlights

10.6 Black-and-White Conversion Using Photoshop Plug-ins

In addition to the built-in Photoshop tools we have already described, there are a number of plug-ins available that do a more professional job of simulating a real monochrome photographic workflow. These include Black & White Studio from Power Retouche [83] and Exposure 2 from Alien Skin Software [56]. The Nik Software Color Efex suite [75] also includes some very nice black-and-white filters.

Black-and-White Conversions Using Silver Efex Pro

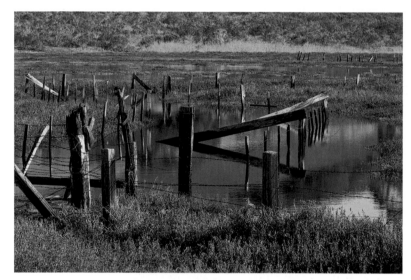

Our current favorite black-and-white conversion plug-in is Nik Software's Silver Efex Pro. We will use it to convert the photo in figure 10-33.

We optimize our color image and make sure that the top layer (where the filter will be applied) is a pure pixel layer. Selecting Filter ▸ Nik Software ▸ Silver Efex Pro opens the dialog in figure 10-34.

The interface might appear complex at a first glance, but it's quite simple to understand with some practice. The screen is divided into three main areas:

Figure 10-33: Elkhorn Slough in color—the source image for our next conversion

Figure 10-34:
The Nik Silver Efex Pro
Photoshop plug-in
appears complex, but
is relatively simple
to use after a short
orientation phase.

A) The Style Browser (which can be hidden) contains preset styles for direct application to your image. This is also where you can save and name your own styles.

B) The Preview Window where you can zoom in and out and set various before/after split screens.

C) The Control Panel contains various groups of controls for different aspects of the conversion process (figure 10-35).

The Navigator can be shown or hidden at the bottom of the control panel. This is where you can shift the zoom detail, and it's also where the application's unique zone system map is located. This tool is based on Ansel Adams' 11-zone system—clicking on one of the zones highlights all areas within the preview image with the same tonal value as the selected zone.

Figure 10-36: The navigator, with its zone mapping tool, becomes a loupe at its 100% zoom setting.

If you zoom out to a full-frame view of your image, the Navigator window serves as a loupe and displays the area around the current mouse position at 100% magnification. Clicking the Push-pin icon ★ fixes the current position of the loupe within the frame.

The major adjustment sliders at the top of the control panel are *Brightness*, *Contrast*, and *Structure*. The latter is actually a tool for controlling local microcontrast.

The *Shadows/Highlights* tool protects shadow and highlight detail from clipping and includes a histogram of the protected areas.

The *Color Filter* panel (figure 10-38) allows you to apply various simulated analog color filters, such as a red filter for darkening blue skies. You can also adjust the characteristics of individual filters using the *Hue* and *Strength* sliders that are located in the *Details* bar.

Figure 10-37: The Shadows/Highlights tool allows to protect shadow and highlight detail.

Figure 10-35: This view of the Control Panel shows all menus collapsed and the Navigator Loupe activated.

Figure 10-38: The Color Filter panel is where you can simulate analog lens filters.

Figure 10-40: You can modify the preset film filters or define your own.

The *Film Types* section includes various traditional black-and-white film looks that you can apply digitally to your image (figure 10-39).

If you can't find the look you want in the presets, you can also adjust the grain, color sensitivity, and tone curve for each individually (figure 10-40).

You can also stylize your converted image in a number of ways:

Figure 10-41:
Silver Efex offers three stylizing techniques.

You can tone your image (figure 10-42) in the shadows (here called *Silver Hue*) or in the highlights (*Paper Hue*). The tool also offers a *Vignette* section for applying a vignette effect to the entire image or for burning the edges separately.

All of the adjustments mentioned so far apply to the entire image, but you can also use the program's patented Viveza™ UPoint *Control Point* technology to place selective corrections anywhere in the image frame. We describe this technique in more detail in section 7.16, page 282. The slider functions are limited to a control set that makes sense in a monochrome context, namely *Radius*, *Brightness*, *Contrast*, and *Structure* (microcontrast) (figure 10-43).

Figure 10-43:
You can set control points for all the filters shown here.

The filter allows you to decide whether to perform your adjustments on the selected layer or on a new layer created specially for the adjustment. The *Brush* function allows you to create

Figure 10-39: Here, you can apply the looks of various analog film types.

Figure 10-42: This is the dialog for toning and adding vignettes to your image.

a new black layer mask, in which you "paint" the areas where you want the conversion to take effect. The resulting image is still in RGB mode.

This tool allows us to quickly and easily convert our image to black-and-white and to optimize it too. Once we have performed the basic optimization steps on our color image we can use Silver Efex Pro to convert and fine-tune it. The only steps we can't perform using Silver Efex Pro are scaling and sharpening for printing.

To achieve the result in figure 10-45, we brightened the image slightly and improved local contrast using the Structure slider. We used the Kodak Panatomic X (ISO 32) film type filter and activated the blue color filter with opacity reduced to 63%.

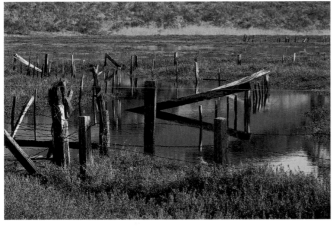

Figure 10-44: Our color source image of Elkhorn Slough

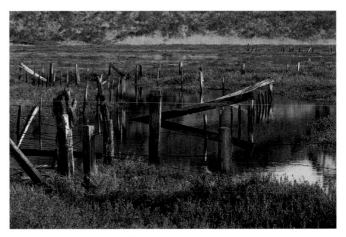

Figure 10-45: Our Silver Efex Pro monochrome conversion

Silver Efex Pro is available as a plug-in for Windows and Mac, but it only works properly with newer versions of Photoshop (CS3 and later). The software is also available as a plug-in for Apple Aperture and Adobe InDesign.

The plug-in is powerful and versatile, and the ability to save preset Styles makes working with it very efficient. The only real drawback is the $200 price tag, but even that is quickly amortized if you use the software regularly.

Other Black-and-White Filters

Nik Software offers the much simpler B/W Conversion filter as part of its Color Efex Pro [75] package. DxO [68] offers a good tool called DxO Film Pack; it does a fine black-and-white conversion by simulating a number of BW films, and is available as a Photoshop plug-in as well as an addition to the DxO Optics Pro RAW converter. Uwe's DOP B&W Resolver* is a great Photoshop script for performing black-and-white conversions. Alien Skin's Exposure 2 [56] produces very nice results with its many different film simulations and adjustment settings. The only disadvantage is the relatively high price.

* See www.outbackphoto.com/ CONTENT_2007_01/section_workflow_ basics/20090118_DOP_BW_Resolver/ index.html

Printing and Image Presentation

11

The primary reason for taking photographs and for the existence of our entire digital photo workflow is to produce images that we can present to others – either electronically or in print form. This chapter discusses how to produce various types of digital photographic output, with an emphasis on high-quality inkjet printing.

The various presentation methods involved, whether they be simple prints, high-end prints, slideshows, or websites, are all complex enough to warrant a chapter (or even a book) of their own. This chapter concentrates on the aspects that are common to all of these processes. Successful high-end printing requires foreknowledge, practice, and top-quality equipment. We aim to provide you with some of these things, but there is no substitute for your own experiments and experience.

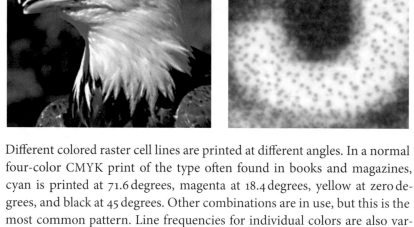

Figure 11-4:
Color inkjet and offset prints are formed
using patterns of tiny colored ink dots.
Inkjet printer dot patterns are randomized
to form *stochastic patterns*.

Table 11.1: Raster angles

Example of a color raster using a 106 lpi basic raster frequency				
	Cyan	Magenta	Yellow	Black
lpi	94.86	94.86	100.0	106.0
Angle	71.56°	18.43°	0.0°	45.00°

* The smaller the individual printed dot, the
smaller the raster cell can be.

Different colored raster cell lines are printed at different angles. In a normal four-color CMYK print of the type often found in books and magazines, cyan is printed at 71.6 degrees, magenta at 18.4 degrees, yellow at zero degrees, and black at 45 degrees. Other combinations are in use, but this is the most common pattern. Line frequencies for individual colors are also varied to avoid producing moiré artifacts. Table 11.1 lists sample values for a 106 lpi color raster.

The number of lines per inch in a print depends on:

1. The number of tonal values you want to produce. More tones require larger raster cells in order to produce a more varied tonal range.

2. The size of the individual printed dots*

3. The paper used. Newsprint absorbs a lot of ink, so news printers use wider raster cell spacing to avoid ink from individual macro-dots bleeding into neighboring dots. Raster cells can be placed closer together on coated paper, resulting in a finer print raster and finer image detail.

Table 11.2 lists guidelines for ppi image resolution and lines per inch values for different print media using fixed-raster printing techniques. Inkjet printers don't have fixed raster, and print resolution is set instead in the printer driver or RIP (*Raster Image Processor*, section 11.7.2, page 452).

When you use an inkjet printer for making high-end, fine art prints, you do not have to concern yourself much with raster line width. The dithering pattern built into your printer driver will be more complex than the one we have described. But don't worry – simply find out your printer's native printing resolution (usually between 240 and 360 ppi) and upsize your image to those dimensions. The values do not have to be precise, and the printer driver (or Photoshop) will automatically perform the necessary fine scaling. Modern inkjet printer drivers or RIPs take care of color raster angles automatically, too. These settings can be made manually in some offset printing situations and are also dealt with automatically when you use Photoshop to make color separations.

Table 11.2: Recommended raster frequencies for various printing situations

Raster width		Usage	Image resolution
53 lpi	21 l/cm	Laser printer (600 dpi, 65 levels of gray)	70–110 ppi
70 lpi	27 l/cm	Newsprint, typical rough paper	90–140 ppi
90 lpi	35 l/cm	Good quality newsprint	140–180 ppi
120 lpi	47 l/cm	Acceptable quality for books and magazines. Individual raster cell dots still visible.	160–240 ppi
133 lpi	52 l/cm	Good quality for books and magazines. Individual raster cell dots still visible.	170–265 ppi
150 lpi	59 l/cm	Good for offset and silkscreen printing. Individual raster cell dots hardly distinguishable.	195–300 ppi
180 lpi	70 l/cm	Good for offset and silkscreen printing. Very fine raster, individual raster cell dots hardly distinguishable; good quality inkjet printing, with individual raster dots no longer recognizable at reading distance (8–12 inches)	240–360 ppi
200 lpi	79 l/cm	Excellent book quality, requires very smooth paper. Raster cell dots hardly visible.	300–400 ppi

How Many Pixels or DPI Do You Really Need?

There is no catch-all solution to this question, and the answer depends on several factors:

▶ **Printing technique**
If you are using a continuous-tone printing method (such as direct photo or dye-sublimation printing) or a method that produces halftones by dithering (such as inkjet or offset printing), the necessary ppi values will be roughly the same. The printer dpi values will, however, be different, as dithering requires several dots (or ink droplets) to build a raster cell that reproduces a single image pixel.

▶ **Paper type**
If you use rough, absorbent paper (like newsprint), individual dots will bleed, requiring you to reduce the dpi frequency as indicated in table 11-2.[*] If you use high-quality, smooth coated paper, you can increase resolution to produce finer, more detailed images.

 If you use glossy or luster paper, you can reproduce even more detail using higher ppi/dpi values than matte papers or canvas allow.

* The slight increase in the dot size caused by bleeding is called *dot gain*.

▶ **Viewing distance**
Viewing distance is an important factor, as the human eye can only differentiate single printed dots up to a certain distance from the page. For a normal reading distance of about 12 inches (30 cm), the minimum dot size is about 0.08 mm (0.0032 inch). This value can decrease slightly in bright light and, increase accordingly in darker situations. Consequently,

in the image and can cause havoc if you are printing images that you have already edited. For this reason, most consumer stores allow you to deactivate the automatic optimization option when you are ordering.

2. **Photo book printers**
Here, the customer assembles his/her own photo book using special software that is provided either online or as part of your own image processing program. The results are then sent to the service provider for printing and binding. Some mass production labs also offer photo books as an option, but nevertheless farm out the actual work to a specialty lab. Photos books are usually printed using a digital printing process.

The design of these photo books is limited and there are usually only a few text formatting options. Print and binding quality can differ widely, but is generally adequate for vacation memories and the like.

Photo books are usually between 16 and 96 pages long and usually cost between $20 and $70 for properly bound versions. High-quality photo paper and leather covers cost more. There are usually discounts available for multiple orders.

3. **Specialty providers**
Digital speciality labs often grew out of an analog processing past and can cost three to five times more than mass-production labs. They can fill custom orders covering multiple paper sizes and formats (including specialty papers for monochrome prints) and deliver high-end quality. A good specialty lab offers custom image optimization for individual images and will take the time to talk with customers about their individual needs.

Larger prints are usually printed on inkjet printers. Typical maximum high-quality print widths are between 44 and 64 inches, due to the maximum paper width handled by the Epson Stylus Pro 9600. We expect larger sizes to become more widely available in the near future.

Specialty providers give information about delivery formats on their websites and usually provide their own ICC printing profiles. This fulfills two purposes:

A. It allows you to soft-proof your image on a monitor.[*]

B. It allows you to convert your image to the printer's profile (section 3.3.1, page 69.). Individual color profiles are ignored.

If your chosen provider doesn't offer information about the equipment used and the necessary profiles, look for a different provider. A quality provider will give a telephone number and the name of a person you can talk to. We recommend sending a test print before you have multiple prints made by a new lab.

* The concept of soft-proofing is described in section 3.9, page 82.

Consumer Print Services

Consumer print service providers accept JPEG (and sometimes TIFF) image files. They do not process RAW files. Their printing software ignores embedded profiles and assumes that an image is saved in RGB mode and comes from the sRGB color space. Prints are subjected to automatic optimization (as described above), which often causes some of the same problems and artifacts that Photoshop and other automatic correction tools produce.

Some typical prices per consumer print:

4 x 6 inches	$0.15
5 x 7 inches	$1.00
8 x 10 inches	$4.00
16 x 20 inches	$19.00
20 x 30 inches	$23.00

Shipping costs are extra and depend on the number of prints ordered. The minimum is usually between $1.50 and $2.50.

The image preparation and ordering process is simple:

1. Place copies of your selected images in a single folder.

2. Reduce any image layers to the background and convert 16-bit images to 8-bit (Image ▸ Mode ▸ 8 Bits/channel).

3. Select an appropriate resolution (table 11-3, page 419). Ideal resolution for photo prints is between 200 and 400 ppi, although many print services prefer between 200 and 300 ppi. 400 ppi resolution is only recommended if your image has very fine details and the printer's equipment supports such high resolutions. Otherwise, you simply end up with large image files. Posters can be scaled between 150 and 180 ppi.

 ➡ If you are using the Resample Image function in Photoshop to scale an image, use *Bicubic Smoother* interpolation for upsizing and *Bicubic Sharper* for downsizing.

4. Make sure your images are saved in one of your service provider's standard sizes. If the size of your images deviates from standard, you have to specify whether the resulting white borders should be printed or cropped.

 ➡ Virtually all the steps we describe here can be performed automatically using the export functionality built into an all-in-one workflow tool such as Adobe Lightroom or Apple Aperture.

5. If necessary, convert the color space of your images to sRGB:
 (a) Open your image in Photoshop editor.
 (b) Choose Edit ▸ Convert to Profile and select *sRGB* as your destination space.
 (c) Click *OK* and save your image.
 In order to reduce your image file size, you can now (optionally) discard the embedded profile.

6. If you have not yet sharpened your images, you should sharpen them slightly after scaling. Prints on photo paper don't need to be sharpened as much as inkjet prints, as photo printers do not use the dithering process that causes additional blur in inkjet prints.

 ➡ Lightroom offers output sharpening for glossy as well as for matte papers.

1. Give your images a 4-pixel black border (optionally).

7. Save your images in one of the formats accepted by your provider – usually either TIFF (with lossless compression) or JPEG with a low compression factor (between 8 and 10 is a typical Photoshop value). If you are submitting TIFF files, check your provider's website to see if they should be compressed or non-compressed and if TIFFs are accepted at all.

8. Assemble your order using the provider's software. Most providers offer special software for one-time download. Some provider software updates automatically, and some has to be updated manually. While most service providers offer only Windows software, a small number of Mac providers can be found.

9. Check your order and send it. Printing your order or saving a screenshot can be helpful later if you need to check the returned prints.

Ink Types

There are two basic types of ink available for photo printers:

➡ When using dye-based inks, you should use paper with either a microporous or swellable coating. Both absorb ink quickly without bleeding.

1. **Dye-based inks.** Theses are the most commonly used inks in the consumer market and can be found in almost all desktop inkjet printers manufactured by HP and Canon, as well as many cheaper Epson printers. They reproduce well-saturated colors and they provide a large color space, but they lack the lightfastness of pigment-based inks.

 HP has produced high levels of lightfastness using a limited range of swellable papers. Dye-based inks should always be used with microporous or swellable papers.

➡ The color saturation problems associated with pigment-based inks have been largely remedied in recent years using new mixtures, such as those in Epson's third- or fourth-generation UltraChrome inks.

2. **Pigment-based inks.** Here, the color consists of colored pigments whose molecules are relatively large compared to dye-based inks. They are more resistant to light and gases (such as ozone) that bleach color, making pigment-based inks very lightfast, even without using ink-encapsulating paper coatings. Pigment-based inks tend to display less color saturation and clog print heads more quickly than dye-based inks, but they can be used with a much wider range of papers. Because they don't penetrate deep into the paper or its coating, they are more prone to abrasion but less likely to smudge than water-soluble, dye-based inks. All printers that we denote as *fine art printers* use pigment-based inks.

➡ There are also UV- (Ultra Violet resistent) and oil- or solvent-based printer inks available, although they are rarely used with desktop printers.

Most desktop printers use one of these inks, while some high-end, large-format printers support both (and even solvent-based inks).

Manufacturer's Own and Third-party Inks

More so than paper, ink is the single largest cost factor in printing, and the business models of printer manufacturers assume that they will earn much more on ink than on the printers themselves. It therefore seems to make sense to choose cheaper third-party inks. While they are suitable for office documents in which color accuracy and long print life are less important, we don't generally recommend their use, especially if you are just starting out making your own prints.

ICC profiles and printer drivers provided by printer manufacturers are no longer accurate when used with third-party inks. Some printer manufacturers even threaten to withdraw their printers' warranties if they are used with third-party inks.

Lyson [118] and Pantone [50] are known for the quality of their inks. Both offer free color profiles and a range of supported printers.

This does not mean that there are no high-quality, third-party inks available, but using manufacturer's inks is usually a safer approach. Once you have gained some experience and your printer's warranty has expired, you can start to experiment with third-party inks. Magazine ink tests and user reports on the Internet can be useful during your search for appropriate materials.

Printer Resolution

This measurement is irrelevant for printers that fulfill all your other purchase criteria. Don't be confused by values that are hyped up for marketing purposes. Resolutions of 2880 × 1440 (or similar) do not produce noticeably inferior results to machines with nominal resolutions of 5680 or more. We rarely use maximum resolution settings during our print workflow because they cause the print job to take longer and use more ink without significantly improving results. Small ink droplets can reproduce finer tonal gradations, especially in lighter image areas, and a typical 1–5 picoliter droplet size is usually sufficient for most printing purposes.

➡ The larger printer resolution value relates to the horizontal direction covered by the movements of the print head, while the lower value relates to the vertical direction realized by the paper feed mechanism.

Supported Paper Sizes

Many images only convey their full impact when they are printed at a particular size. Inkjet photo printers start at letter size. Larger, tabloid-size printers for making 11 × 17-inch prints are also available but cost more (usually between $600 and $900). If you want to make a lot of prints, large printers can make economic sense due to their larger (and therefore cheaper) ink cartridges.

Thicker, heavier paper is often appropriate for high-end, art-grade prints. Here, your printer should be able to support paper thicknesses greater than or equal to 0.4 mm (or 230 g/m²). A straight paper path is an advantage when you are using thicker paper, as some heavier papers can not be bent sufficiently to fit past some rollers. For this reason, some high-end printers have a choice of paper paths.

Roll-paper support can be useful if you want to make multiple, unattended prints, although narrow roll paper usually has to be smoothed after printing. Roll paper can be cheaper than sheet paper, but printers with automatic paper cutters are usually only available in the more expensive 11-inch plus category.

Equivalent US and European paper widths:

U.S.	Metric	DIN
8.5 inches	21.6 cm	A4
13 inches	33.0 cm	A3 / A3+
18 inches	45.7 cm	A2
24 inches	61.0 cm	AI
44 inches	111.7 cm	> A0

Printer Ports

Parallel ports have now been completely replaced by USB ports. The current USB 2.0 standard is much faster than the older USB 1.1 standard and supports cables up to 15 feet in length. Some printers also have IEEE 1394 (FireWire) ports. FireWire is roughly as fast as USB 2.0 and allows you to connect a printer to two computers simultaneously. FireWire will be replaced in the coming months by the new USB 3.0 standard.

A LAN interface is useful if you want to connect your printer to multiple computers in a network, but a small, cheap, USB-compatible print server can do the same job just as well.

➡ Some printers don't function correctly if connected via a USB hub or a USB cable that is too long.

4. If we are not using print software or plug-ins that support 16-bit printing, we reduce 16-bit images to 8-bit color depth. Printing 16-bit images takes longer but usually produces softer, more realistic color transitions.*

5. Sharpen for output, depending on the output medium you are using. Matte and semi-matte papers require stronger sharpening, as they tend to produce slight ink bleed and visually reduce sharpening effects.

 Usually, layer masks are not necessary for applying output sharpening, although we do sometimes use them to protect critical image areas.

6. The final step (usually only applicable to high-end art prints) involves adjusting the tonal range to suit the paper you are using and, if required, the paper's prescribed color profile. For monochrome prints, you might also have to adjust the tonal range to suit any preset printer settings. The selected color profile and the *Black Point Compensation* print option (figure 11-12, page 438) should deal with these factors automatically, but unfortunately, they are not always up to the job.

 We describe tonal range and black point/white point adjustment in detail in our book on fine art printing [16]. You can also find more information on the subject in section 11.6.6, page 449.

Upsizing Images

If your image is not sufficiently large for your intended print size, you have to enlarge (or *upsize*) it. The following sections describe the methods we use for this critical process:

Upsizing:
www.outbackphoto.com/
filters/filters/DOP_upsizing/
dop_upsizing.zip

Photoshop *Bicubic Smoother* Interpolation • Introduced with Photoshop CS1, this method is designed specifically for image enlargement. If you shoot in RAW format and use Adobe Camera Raw (or another RAW editor), you should scale your images during RAW conversion. You can find an article on image upsizing and our free Photoshop upsizing action DOP Upsizing at the URL listed in the margin.

Reducing (*downsizing*) images is a less critical process and can be performed using Photoshop's *Bicubic Sharper* interpolation method.

Upsizing article:
www.outbackphoto.com/workflow/wf_60/
essay.html

→ If you need to apply heavy scaling, please read our notes in section 8.14, page 341,.

Genuine Fractals • This an expensive but proven tool that we use a lot for large-scale image upsizing. The tool produces natural-looking (if slightly unsharp) results.

→ There is a great article on image upsizing by Jack Flesher at [73].

People often ask us to name our favorite upsizing method. Photoshop's *Bicubic Smoother* is fine for smaller enlargements, and Genuine Fractals is our current favorite for larger print sizes. The subject of scaling is, however, hotly debated, and the only way to find the best method for your own images is to experiment. Further information on scaling can be found at: www.outbackphoto.com/contest/contest_20/essay.html.

Paper Preparation

Always store your paper in a protective sleeve and brush off dust using a soft brush before printing. Paper dust can stick to your printer rollers and print heads and also take on color during printing – only to fall off later, leaving ugly white specks on your finished print. Matte art papers are especially prone to this problem. Always brush off rag papers – glossy and baryta papers seldom require brushing before printing.

Allow your paper to adjust to room temperature and moisture before going ahead with printing.

Some fine art papers are extremely sensitive to fingerprints, so always wear cotton gloves when you are handling this type of paper. Try to avoid skin contact with the printable (and printed) surface of the paper.

Figure 11-8: Always handle fine art paper with cotton gloves and brush off dust using a wide, soft brush before printing. (Image courtesy of Monochrom [132])

11.5.1 Preparing Your Printer

Allow your printer to initialize and ensure that the connection to your computer is secure. If you are using an inkjet printer, always check the ink nozzles by running a test print on cheap paper before starting a print run. This can save time, ink, paper, and aggravation. It can be necessary to run several nozzle cleaning cycles before you start printing.

➡ Protect your printer from dust when it is not in use.

Figure 11-9:
A nozzle check pattern showing clogging in the black and blue nozzles

Please note: We recommend that you switch on your inkjet printer at least once every two weeks to force a nozzle cleaning cycle. This uses a little ink, but it helps avoid potential clogging problems.

HP and Canon recommend that you leave their high-end printers switched on in standby mode. The printer firmware then automatically cleans the nozzles at preset intervals.

Regularly remove any accumulated dirt and paper dust from your printer using a soft brush, and keep your printer covered when it is not in use.

Check that you have sufficient ink before starting a print job. Stopping during a print due to a single empty ink cartridge is annoying and usually produces color inconsistencies in the finished print.

Under Windows, most Epson printers have an ink check function under the 🛈 button on the ⚙ Utility tab in the printer driver dialog. The same function can be found under the *Configuration* button 🖨 in the printer service utility 🖨 in the Mac OS X dock.

Figure 11-10: Always check your ink levels before starting a new print job.

B. Make print settings in your application dialog (Photoshop, Lightroom etc.)

C. Set up the printer driver using its own dialog.

The individual steps here are as follows:

A. Start the *Page Setup* dialog (using File ▸ Page Setup or ⇧-Ctrl-P / ⇧-⌘-P in Photoshop). Photoshop CS3 (and later) allows you to make your page setup settings directly in the print dialog:

A.1 Select your printer (if it's not the default machine).

A.2 Select the paper source, orientation, and size.

B. In Photoshop (or whatever other application you are using), set:

B.1 Scaling and positioning options

B.2 Color handling (we usually let the application manage colors)

B.2 The appropriate ICC profile (if your application is managing color mapping), the rendering intent (usually either *Relative Colorimetric* or *Perceptive*), and the *Black Point Compensation* option

B.3 Click Print to open the printer driver dialog.

C. In the printer driver dialog, check that the page setup, orientation, and other settings match those you made in the application's Page Setup dialog. Other settings to make (or at least verify) are:*

C.1 Select the correct paper/media type, and, if available, the appropriate paper source and/or paper feed.

C.2. Select the appropriate print quality and/or DPI settings. This may include ink configuration settings.

C.3 If necessary, select the *Advanced* dialog mode.

C.4 Check your other print options (such as disabling high speed or bi-directional printing).

C.5 Select color management handling. If your application handles color management (as recommended), disable color management in the print driver.

D. Finally, click *Print* to start printing.

→ In Photoshop, the settings described here are found in the *Color Management* option in the upper drop-down menu (figure 11-12 Ⓔ, page 438).

* Check these parameters even if you are using a print preset.

→ The printer dialog changed in appearance between Photoshop CS1, CS2 and CS3. Photoshop CS4 introduced yet another new layout but preserved the same set of options. Again, in CS5, the dialog changed a bit. However, the basic principles remain the same throughout.

The ability to save print settings presets (either in your application/plug-in or in the printer driver) is extremely useful, but we recommend that you double-check your preset settings before printing. Changing a single parameter can change other settings, too.

Application print dialogs differ not only from operating system to operating system, but also from version to version. Things can also look dif-

ferent if you use a print plug-in instead of following the traditional application dialog/driver dialog route. However, the basic parameters remain the same, whichever method you use.

Print parameters often overlap, and you might, for instance, have to set your paper size once in the application dialog and again in the printer driver. If you are lucky, the application setting will automatically synchronize with the printer driver, but don't count on it! Always check that your settings match. Some printers even refuse to print if these settings don't match, or require you to make separate settings on the printer itself.

Some Epson and Canon printing applications, and Tecco's *Tecco:Print* program, are designed to simplify the print process but tend to hide or automate settings that are important when making high-end prints. These programs can be helpful for beginners but make life more difficult for experienced users.

Make your settings carefully and save them as presets. Delete flawed presets, limit your choice to a few proven sets, and use short, descriptive names to keep your collection simple. Preset names that are too long are not always completely visible in menu lists.

The following guide is based on an Epson Stylus Pro 3800 used with a Windows computer. The basic settings are the same for most Epson printers and even printers made by some other manufacturers. The Pro 3800 is still a great high-end printer, even if it is a little old. It uses eight inks per print and a choice of Photo Black for glossy and semi-gloss papers or Matte Black for matte papers and canvas. Switching black cartridges uses a little ink to clean the print nozzles, so we recommend switching as little as possible.

➡ The Pro 3800, and 3880 function in a very similar way to the R2400, and R2880 printers and to the 4800, 4880, 7600, 7800, 7880, 9800, 9880, and 11880 Pro models.

11.6.2 Photoshop CS5 Print Dialog

The Photoshop print dialog includes the same settings in Windows and Mac OS X, so we only describe it once. With a little planning, you can use the settings we make here in other print color management-compatible programs, too. Such programs include Apple Aperture, Adobe Lightroom, Bibble, and a number of other RAW editors that have their own print functionality, such as Nikon Capture NX or Canon DPP. Most RAW editors include only basic print functionality and do not offer color management support, which is critical to a successful photo printing workflow.

Photoshop CS3 Print with Preview option is replaced by the File ▸ Print command (or the Ctrl/⌘-P keystroke) which opens the print dialog similar to the CS5 dialog shown in figure 11-12, page 438. Again, check your Printer and Page Setup settings. The dialog allows you to select your printer directly in menu Ⓐ and also to switch between Landscape and Portrait mode (Ⓒ). The *Position* and *Scale Print Size* settings do exactly what they say.

page 82). Gamut warning can be activated in earlier versions of Photoshop by exiting the print dialog and pressing ⇧-Ctrl-Y/⇧-⌘-Y. If you use this option, make sure that the proof conditions are correctly set for your printer and the profile you are using (section 3.9, page 82.)

You are now done with the print dialog settings, and you can click the *Print* button to display the printer driver dialog. In Photoshop CS5, the printer driver dialog is no longer displayed, and your settings are sent directly to the printer. This means that you now have to make any driver settings **before** you make your print dialog settings using the *Print Settings* button Ⓑ. Photoshop now remembers the driver settings for each image so that they are automatically correct. This new method takes a little getting used to for experienced Photoshop users.

11.6.3 Printing Under Windows with the Epson R3880

The Epson R3880 is currently (spring 2010) the best value 17-inch, high-end printer on the market, producing great color and monochrome prints. The descriptions in the following sections can be applied to virtually all high-end Epson printers, including the R2400, R2880, and Pro 4800/4880, 7800/7880, 9800/9880, and 11880 models.

We assume that you are making a color print using Photoshop, where you already have installed and selected an appropriate color profile. Deactivate color management (figure 11-17 Ⓐ) in the printer driver dialog. You might have to click the *Print Settings* button to switch from the simplified dialog to the advanced version that includes the *Main* tab. The next step involves setting (or deactivating) color conversion in the printer driver. This, in turn, involves selecting the *Off (No Color Adjustment)* option in the *Custom* menu (Ⓐ).

You then need to set (or at least check) the following settings:

Paper Settings • Start by selecting the paper source. If you use roll paper (not possible with the Epson Pro 3880), you have to select it here.

Figure 11-17: Recommended driver settings for use with an
Epson 3800 under Windows

Figure 11-18: First, select your media source.

Size • This menu includes the international preset and user-defined paper formats that are compatible with the current printer (figure 11-19).

Clicking the *User Defined* button opens a dialog in which you can define custom paper formats (figure 11-20). These are then displayed in the *User Defined* menu.

Figure 11-19: You can either select one of the preset paper sizes or define your own.

Figure 11-20: You can use this dialog to define your own custom paper size.

Media • This is also a two-tier menu, sorted according to the classes shown in figure 11-21. If you are using Epson paper, select exactly that paper in the list. Epson printers with only one black cartridge list only the papers that work with the installed black ink (*Photo Black* or *Matte Black*). If you are using third-party paper, select the Epson paper that is most similar to the one you are using. Many third-party paper manufacturers list similar papers on their packaging.

Figure 11-21: Select either the exact paper you are using or the paper that is most similar to your third-party paper.

Color • Here you define whether you will print in color or black-and-white (figure 11-22). Our example shows the *Color* option selected. If we are printing in black-and-white, we always select *Advanced B&W Photo,* never *Black* (we explain why in section 11.6.5, page 447).

Print Quality • The available quality settings depend on the selected media, and settings that are unsuitable are either not included in the menu or are grayed out. The *Photo RPM* and *Max. Quality* settings usually produce the best results, but also take longer to print and use more ink. Try the *Quality* option first (figure 11-23) to see if it produces adequate results with your chosen paper.

Figure 11-22: In the Color menu you can select either *Color* or *Advanced B&W Photo.*

Figure 11-23: The available quality settings are also influenced by the selected media.

Paper Handling • Here, you can perform moderate scaling, but we recommend that you perform any large-scale enlargement or reduction at the image preparation stage (page 432) or using an RIP. If you want to print a multi-page portfolio but your printer has no duplex facility, first print all the *Odd-numbered pages*, then reinsert the printed paper stack and print *Even-numbered pages* with the *Reverse* option checked.

Figure 11-30: Mac OS X ColorSync tab

ColorSync • Here is where you can make settings for the Mac OS X color management system (figure 11-30). There is an option for applying the built-in Mac *Quartz* filters, but we don't recommend that you use these when printing directly from Photoshop.

ColorSync settings (Applications ▸ Utilities ▸ ColorSync Utility) are useful when printing from an application that is not color managed. The module maps colors from the image color space to the printer color space and is also where you select your printer profile. See Mac OS X Help for more information.

Cover Page • This option allows you to print a cover page – an option that is less relevant for art prints, due to the prohibitive costs involved.

Print Settings, Options, or Main Tab

This tab contains the most important settings for making art prints and is called *Print Settings*, *Options,* or (in the case of the Canon iPF6100) *Main.* The dialog is printer- and manufacturer-specific, and is similar in look and feel to Windows printer driver dialogs. Figure 11-31 shows the dialog for our Canon iPF6100 printer.

Here too, we follow our standard setup pattern, starting by selecting the print media type. For this model (and other Canon printers) the media type selected in the driver dialog must match the type selected in the printer's menu; otherwise the machine will refuse to print.

Clicking the *Get Information* button provides information about the currently loaded paper type, paper size, and selected feed.

Color ▸ Set… leads to the very important Color Settings dialog (figure 11-32).

Figure 11-31: Main iPF6100 printer driver settings

Figure 11-32 Driver color management set to *No Correction*

Figure 11-33 Page Setup tab for the iPF6100 driver

We always use the *Application Manages Colors* option in Photoshop for all our color prints, implying that all printer-based color corrections should be switched off in the printer driver (figure 11-32). We would prefer to see this control located in the driver dialog's *Main* tab or in the *Color Settings* section, rather than in its current hidden location. Using driver presets can help you avoid having to regularly navigate to this menu.

The *Page Setup* tab (figure 11-33) includes the following settings:

▸ Media Source
▸ Paper Size
▸ Print Scaling
▸ Print Centered
▸ Rotate Page 90 degrees (for some printers)

Printer Maintenance Tools

The printer's driver includes a range of additional tools and functions in the *Utility* menu (figure 11-34 Ⓐ). The *Set* button Ⓑ in the *Perform printer maintenance* section opens the dialog shown in figure 11-35, page 446.

You can also call up the *Ink/Paper Supply* information (figure 11-36, page 446) from menu Ⓐ and the *Printer calibration state* information (figure 11-37). So, it's worth getting to know all the informations which can be called up from menu Ⓐ of figure 11-34.

Figure 11-34: Selecting *Utility* displays the maintenance and ink level tools.

Figure 11-39: If it includes appropriate support, leave color management to the printer driver.

For printing in black-and-white mode, we use the Photoshop settings shown in figure 11-39. Assuming the image has already been converted to black-and-white (but is still in RGB color mode), we select *Printer Manages Colors* in the Photoshop print dialog.

We then select the media type, size, orientation, and all the other media and quality settings mentioned previously.

We activate the *Color* tab to make our specific settings for black-and-white mode (figure 11-40). Here, we activate option Ⓐ *Print in Grayscale* and select option Ⓑ *Printer manages colors*. In menu Ⓒ, we select the color profile of our source image (although the driver only offers a choice of Adobe RGB (1998) or sRGB) and finally, we activate *Advanced color adjustment* Ⓓ.

We click *Settings* Ⓔ to open the color adjustments dialog (figure 11-41). This dialog allows you to fine-tune the tint of your black-and-white print and even allows the use of different tints for highlights, midtones, and shadows. If you intend to use different tints, activate option Ⓐ. This dialog also includes a gamma slider (here labelled *Lightness*).

Figure 11-40: We recommend these settings if you want to use the HP Z3200's printer driver in black-and-white mode.

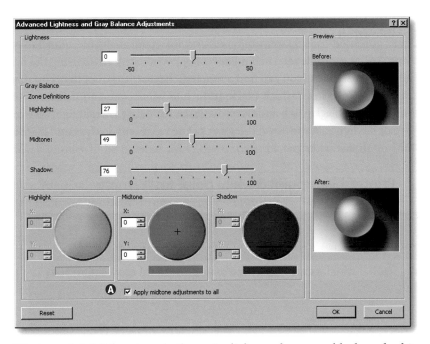

Figure 11-41:
This is the dialog for fine-tuning the tint and gamma settings for your black-and-white prints. You can even select different tints for the highlight and shadow areas of your print.

We then click OK to return to the main dialog and save our black-and-white print settings as a preset.

These settings also work – with minor variations – for the HP B9180 and B8850 printers. These models both produce good black-and-white prints, especially when used in conjunction with *HP Premium Satin* paper.

11.6.6 Finding a Printer's Black and White Point

As mentioned under point 6 in the image preparation section on page 432, one of the final steps in the image preparation workflow involves setting black and white points that take the visual characteristics of your printer and paper into account. It is too easy to lose shadow and highlight detail in prints if they use the entire range of 8-bit tonal values (from 0 to 255).

Experienced photo printers use a range of values between about 16 and 248, but a generic range can cause an unnecessary loss of tonality and contrast. The ideal solution involves finding the precise black and white points for your combination of printer + paper + ink + color profile + print settings and limiting the tonal range of your image accordingly.

This adjustment involves first finding the black and white points for your setup and then adjusting the tonal range of your image to suit. The next two sections explain in detail how this is done.

11.11 Creating Digital Slideshows

The basic image selection and conversion steps involved in creating a digital slideshow are the same as for generating a web gallery. The resulting sRGB JPEG images should be of a size that fits well on a monitor (1024 × 768 or 1280 × 1024 pixels are suitable resolutions).

* The names of IPTC data fields can differ from application to application.

If you have already saved EXIF or IPTC title and description data with your images, this can be automatically integrated into a slideshow.*

You can also create a title page with your own text and adjust the background settings the same way as we described in the previous section. Background settings are especially important for portrait-format images that don't completely fill the monitor screen.

Quality slideshow software also allows you to adjust the display duration and the transitions between slides.

Slideshows that are created in PDF format are very flexible and can be presented on just about any computer using the free Acrobat Reader. The PDF format also allows you to embed custom typefaces, and Acrobat Professional includes reliable color management functionality. Unfortunately, Photoshop sound synchronization support and transition effects are quite limited.

➜ A number of image browsers and all-in-one workflow tools include automatic slideshow functionality that display the images in a single folder or collection in full-screen mode on a black or gray background without any further intervention. This is great for taking a first look at freshly downloaded images. Usefully, some auto slideshows even allow you to add star ratings to the images during display.

Some dedicated slideshow solutions provide wide-ranging configuration options, but require proprietary playback software that isn't always available for all popular platforms.

Many image management programs and some of the all-in-one workflow tools we have already described include basic slideshow functionality. However, to produce high-end presentations, you need dedicated solutions such as Boinx *FotoMagico* [58] (for Mac), or AV Stumpfl's *Wings* [106] or *m.objects* [87] for Windows. *Wings* supports multiple parallel soundtracks and synchronized control of multiple (digital and analog) projectors. This type of software can cost anywhere between $30 and $300 dollars. Most presentation software manufacturers also offer free players for their proprietary formats.

The following is a description of how to create a simple slideshow using Adobe Lightroom:

1. Select your images in *Library* mode, orient them correctly, and group them as a collection.

2. Order your images in Grid view (figure 11-55) using View ▸ Sort ▸ User Order

3. Switch to *Slideshow* mode and select a template in the *Template Browser* panel. The Preview window updates in real time if you move your mouse over each template title (figure 11-54).

4. You can now fine-tune your slideshow using the options listed in the *Options, Layout, Overlays, Backdrop, Titles,* and *Playback* panels (figure 11-56).

Figure 11-54: Moving your mouse over a template title shows the effects of that template in the preview window.

Figure 11-55: Group your images in a collection and sort them in Grid view using View ▶ Sort ▶ User Order.

You can select just about any color for the background, the image frames, and the text labels.

Use the *Overlays* editor (right-click the arrow icon in the Identity Plate) to enter the title and other EXIF or IPTC data. You can also drag this information to any desired position in the preview window using your mouse. Enlarging the text box by dragging its corners also enlarges the type size. We prefer to position all text outside the image area, and if necessary, reduce the size of the image (using the guides in the *Layout* panel) to allow text to fit into the available space.

5. The *Titles* panel allows you to create *Intro* and *Finishing* screens and to set a single image as a background for all other slides in the show. Individual captions can be entered in the *Caption* or *Title* IPTC data field for each image (in the *Metadata* panel in *Library* mode).

6. Use the *Playback* panel to define the slide display and transition duration as well as the transition colors. Checking the *Soundtrack* option allows you to navigate to your chosen music file.

7. Clicking *Preview* starts the slideshow in the Lightroom preview panel and clicking *Play* starts the slideshow in full-screen mode.

8. A click on the *Export PDF* button (at the bottom left corner of the *Navigator* panel) displays the save options, which include the JPEG image

Figure 11-56: These are the panels used for configuring a slideshow.

quality and size, and the PDF file location (figure 11-57). You can also save your slideshow as an MP4 video file.

Export Slideshow to PDF

Save As: FranceMarket_2008

Where: 🗁 Desktop

Quality: ||||||||||| 90 Width: 1920

☐ Automatically show full screen Height: 1200

Common sizes: Screen

Note: Adobe Acrobat transitions use a fixed speed.

Cancel Export

Figure 11-57:
The PDF export dialog allows you to define JPEG compression and the pixel size of your digital slides.

9. You can now play back your slideshow (without sound) on any Acrobat Reader-compatible computer or other PDF-compatible application.

The MP4 version of your file can be played back using Apple Quicktime, Adobe Media Player, or Microsoft's Windows Media Player.

Lightroom offers flexible slideshow functionality with slight shortcomings in its support for transition effects and sound synchronization.

11.12 Other Ways to Present Your Images

Apart from the methods we have described, there are many other ways to display your digital images, including having them printed on mouse pads, T-shirts, coffee mugs and drinking glasses, or as posters and photo calendars. Many of these options are available at online print services or at drugstores for sRGB JPEG images submitted via the Internet or at a service provider's terminal at a store.

Self-print Photo Albums

This type of album allows you to print on single- or double-sided fine art papers that are preformatted for use in special albums. Hahnemuehle [128], Sihl [134], and Tecco [135] are manufacturers of these albums. They are available in a range of sizes and the formatting of the individual pages is very much up to you!

There are various binding systems on offer, including bolted or stapled spines. The bolted type (shown in figure 11-58) is elegant and simple to expand.

Figure 11-58: Direct print albums and portfolios
(Image courtesy of Monochrom [132])

You can also use hot-melt adhesive systems, such as the Unibind *Photo Book Creator* (figure 11-59). With these systems, you are limited to a maximum of 16 to 20 pages.

Digitally Printed Photo Albums and Books

Photo books are printed at high quality and are typically 16 to 96 pages long. They cost between $30 and $80 in letter or A4 format. Photo book services usually require you to download their own layout software which you can then use to configure your personal photo book. The range of parameters for text and image configuration varies from service to service, and the resulting file is usually uploaded over the Internet. Apple iPhoto and Aperture also have flexible photo book functionality built in. Simply Google "photo book" for online offers. Some of the binding options available (linen or aluminum, for instance) are extremely attractive and make great gifts.

Figure 11-59: *Unibind Photo Book Creator* system

Here too, you should prepare your images as described in section 11.3. For unscaled images, we recommend sRGB, 200–300 dpi JPEGs.

Figure 11-60: This is an example of a particularly beautiful, linen-bound digital photo book.

Useful Photoshop Plug-ins

12

This chapter summarizes the additional tools that we mention and use at various stages during the workflow. These offer either functionality not included in Photoshop or useful enhancements to existing Photoshop capabilities.

We don't intend to "sell" you these tools, but we do make recommendations based on our own experience. The range of available plug-ins is constantly increasing, and there are many alternatives to the examples we mention.

Most of the manufacturers listed here offer free trial versions for download, so you should definitely try out a tool to check whether it suits your needs and your personal style before making a purchase. We use the ⊞ and icons in the margins to symbolize the platform compatibility of each tool.

We keep a constantly updated directory of Photoshop filters at Uwe's website that includes descriptions and sample images for a wide range of software.

The manufacturer websites and some purchase addresses for the tools described here are listed in appendix A.2 from page 514 onwards.

12.1 Photoshop Extensions

Our filter directory can be found at:
www.outbackphoto.com/workshop/
photoshop_corner/filters.html

Photoshop has an enormous range of built-in tools and functions – more than most of us will ever need. Some users even consider it to be overengineered. But no single program can cover everyone's processing needs, and any attempt to build one would result in a complicated, top-heavy, unmanageable monster application. Photoshop was designed from the start to be adaptable and extendable. The open architecture makes it flexible, and it's easy to develop applications. There are currently four types of Photoshop plug-ins available:

➜ Some Photoshop plug-ins are also available as standalone programs that can be used to manipulate images outside of Photoshop. Examples are Adobe's own DNG Converter, and HDRsoft's Tonemapper.

▸ Filters (found in the Filter menu)
▸ Automation plug-ins (under File ▸ Automate)
▸ Scripts (under File ▸ Scripts)
▸ Actions (see section 4.12)

All of these types of Photoshop extension make their own demands on a system and have their own specific advantages and disadvantages.

Some complain that Photoshop is expensive enough without having to spend that much again on plug-ins. We view Photoshop as a powerful base module with a great range of basic tools. The program's extensibility is one of its best features, making it possible to enhance functionality without overreaching the program's limits. The available plug-ins range from simple freeware to seriously expensive commercially produced add-ons, and cover a huge range of build quality and functionality. Many plug-ins are available in standard and Pro versions that often include 16-bit (per color channel) processing functionality and extensive fine-tuning options.

➜ Many Photoshop plug-ins are compatible with Paint Shop Pro, Corel Photo Paint, and Adobe Photoshop Elements, but remember to check the exact compatibility before installing.

Most manufacturers of commercial add-ons offer free trial versions of their products for download, so you can usually check whether the potential improvements a plug-in provides fit in with your personal style and, of course, your budget. Often the speed and ease of operation that plug-ins offer (rather than any really unique effects) make them worth the money.

Try not to get upset when Adobe includes a plug-in function in a future version of Photoshop. Adobe, too, has to react to market pressure.

Some of the processes we use plug-ins or standalone applications for are:

➜ Check which data formats (8-bit and/or 16-bit) and color modes each plug-in supports. Also remember to check whether your chosen extension supports the 32-bit and/or 64-bit version of Photoshop.

▸ Distortion correction.* Panorama plug-ins are often included in this broad plug-in type.

* Perspective or lens distortion

▸ Monochrome conversion

▸ Local/selective contrast correction

▸ Sharpening. This area offers a wide range of filters in an equally wide range of price categories.

▸ Noise reduction. Like sharpening, the perceived necessity of noise reduction is a matter of personal taste and the size of your chosen print format.

▸ Lossless image enlargement. Photoshop's handling of this problem is getting better all the time, but specialized software, such as Genuine Fractals, is still the better option.

▸ Increasing tonal range and quality through image merging

▸ Specialized filters, e.g., for making color corrections

▸ Effect filters, e.g., for producing a sunshine effect or artificial grain in an image

▸ Framing effects

▸ HDR image creation and tone mapping

▸ Panoramas and depth of field enhancement with focus stacking

▸ Production of complex slideshows (often with musical accompaniment)

▸ Print plug-ins and RIPs (often used for specialty black-and-white applications)

Some filter effects can be reproduced using complex Photoshop actions, but using specially designed filters is often simpler and faster. Other filters include effects and algorithms that Photoshop simply doesn't offer.

Former plug-in functionality that's now part in Photoshop includes:

▸ Smart Sharpen (more comprehensive than USM)

▸ Lens Correction (for correcting lens-based errors and artifacts)

▸ Enhanced, profile-based Lens Correction, introduced with CS5

▸ Merge to HDR (for merging multiple images into a single, high-dynamic-range image and saving 32-bit per color channel image data)

▸ Load Files into Stack (for loading multiple images into separate layers and aligning them if necessary)[*]

▸ Auto-Align Layers (this function was only previously available as part of the Photomerge command)[**]

▸ Auto-Blend Layers (merges multiple layers while selecting only the "sharp" portions of each)[**]

➡ These Photoshop extensions are part of the Filter menu. The HDR functions are, however, located under File ▸ Automate.

[*] Introduced with CS3

[**] Introduced with CS4

Adobe often introduces improvements without announcing them. Auto alignment – traditionally part of many multishot techniques – has improved enormously in recent program versions. Many users now find the Photoshop Photomerge command to be just as good as many specialized panorama software packages.

Photoshop CS4's or CS5's Focus Stacking tool (section 7.11, page 272) is more than adequate for many cases, although Helicon Focus [76] is still capable of producing better results.

Some of the plug-ins described here are now available for use with RAW editors or all-in-one imaging packages such as Apple Aperture or Adobe Lightroom. These types of plug-ins don't actually interfere with the base program's architecture, but instead export the active image to TIFF or JPEG, process it, and re-import it to the original program. Programs that take this approach are Color Efex Pro, Silver Efex Pro, Viveza, Define, and Nik Sharpener Pro (all manufactured by Nik Software [75]).

12.1.1 Filter Plug-ins

SDK = Software Development Kit – a development environment that describes the program's interfaces and provides libraries of functions for constructing access points to the program's architecture. API = Application Programming Interface – a well-documented interface for calling up routines and subroutines from inside a program module.

Filters are the most common form of Photoshop plug-in. The concept is simple: Photoshop makes an interface available through its SDK/API that enables the plug-in to access the pixels of the image on the active layer. The plug-in can then manipulate the pixels according to its intended functionality and pass the adjusted image data back to Photoshop. This approach makes it possible to apply just about any algorithm to image data, and many of today's complex plug-ins started life as simple filters. A quality filter plug-in has the following characteristics:

▶ A dialog-style user interface with input boxes, options and adjustment sliders
▶ 16-bit (or even 32-bit) processing capability
▶ A preview window with a full-screen view

It is also useful if filter settings can be saved for use with other images later. We like filters that allow you to switch between "before" and "after" views of the active image.

Filters are usually programmed using C++ and can be quite complex. Unfortunately, Mac and Windows versions of plug-ins are compiled using different compilers and often look different to the user.

A Potential Problem with Filter Plug-ins

The amount of available memory is a critical factor when you are processing large image files in Photoshop. Smart filters work around this problem by dividing the active image into small units and processing these units sequentially. This type of operation is extremely complex to program, especially in filters that involve the processing of neighboring pixels. If your plug-in causes memory problems, you can adjust the amount of memory available to it in the Photoshop Preferences dialog.* This type of problem is less common in the newer 64-bit versions of Photoshop (already available for Windows in CS4 and now in CS5 for Mac OS X), but it depends on your plug-in's ability to genuinely support 64-bit systems.

* This setting can be found under Preferences ▶ Performance.

Some Photoshop filters are explicitly designed for use with 32-bit systems and simply do not function with 64-bit Photoshop. If this is the case, you will need to either obtain a 64-bit update for your plug-in or run the 32-bit version of Photoshop.

12.1.2 Automation Plug-ins

Automation plug-ins are more similar to Photoshop actions than to filters, and they are only capable of running operations made available by the Photoshop API. As with filter plug-ins, automation plug-ins are programmed and compiled in C++, and their Windows and Mac versions look a bit different.

The advantage of automation plug-ins over conventional Photoshop actions is their ability to provide a dialog-style interface with user-controllable options and parameters. They can also be programmed to make certain steps in a process dependent on other parameters (such as image size). Automation plug-ins are thus more flexible than actions that only function linearly.

Our own plug-ins (all programmed by Uwe) are automation scripts.[*] We use Photoshop actions to initialize our scripts, although we could also use the File ▸ Scripts ▸ … command. This approach allows us to create powerful functions, even if they are only based on a series of built-in Photoshop commands and tools. Developers who sell scripted plug-ins have the advantage of being able to make the individual steps invisible to the user. Such combinations also offer various functions that pure Photoshop actions cannot, such as:

* See [67] for more information.

▸ Custom dialogs
▸ Parameter input
▸ Data-dependent operations
▸ Subroutines that are dependent on preconditions

12.1.3 Automation Scripts

Photoshop's Script API is becoming increasingly popular as an automation tool. Photoshop supports three basic script types:

▸ AppleScript (only on Mac systems)
▸ Visual Basic Script (only on Windows systems)
▸ JavaScript (runs on both platforms)

➡ Photoshop actions represent their own, unique type of script.

Note: Do not confuse JavaScript with Java. Java is a mature programming language, whereas JavaScript is purely a scripting language that is much simpler but less powerful than Java. Scripts are quite easy to program, but they are only suitable for use with noncomplex applications.

We recommend that you learn JavaScript if you want to make your own scripts. Scripts are easy to copy and rewrite, although they can nowadays be compiled and delivered in binary form rather than in plain text. This makes it impossible to interpret the individual steps involved, and it's a technique used by the vendors of most commercial scripts.

12.1.4 Installing Photoshop Plug-ins, Filters, and Scripts

Several of the tools described here are available not only as standalone programs but also (or even exclusively) as Photoshop plug-ins, filters, or scripts. Installing these tools is generally simple, but you will need to have administrator privileges to implement system-wide changes. It is best to log in to an administrator account before installing any of these modules. Many of the modules install themselves automatically, but others require some computer know-how during the process.

The basic Photoshop CSx folder structure into which we will install our tools is almost identical for Windows and Mac OS X (figure 12-1.) The illustration shows only the folders relevant to this particular task.

The illustrated file structure is sometimes present in two places. The first folder tree (figure 12-1) is the Photoshop installation, located by default in Windows XP at:
C:\Program Files\Adobe\Adobe Photoshop CS5\.
For Vista and Windows 7 it's:
C:\User\user_name\Appdata\Raoming\Adobe\Adobe Photoshop CS5\.
The standard location in Mac OS X is: *Applications/Adobe Photoshop CSx/*
In both cases, the folders are located on the system drive and the modules and settings contained within them are available system-wide. A second, parallel file system stores all of your user-specific settings and extensions. In Windows this is located at:
C:\Documents and Settings\User Name\Application Data\Adobe\Adobe Photoshop CS5\.

In order to be able to see these settings files, use Windows Explorer to go to Tools ▸ Folder Options ▸ View ▸ Advanced Options ▸ Hidden Files and Folders. Now activate the option Show all files and folders.*

In Mac OS X, this structure is located in the individual user's *Library* folder, for example, at *~user/Library/Application Support/Adobe/Adobe Photoshop CS5/*, where "*~user*" represents the user's home directory.

Both structures are generally self-explanatory once you are familiar with them. Script-based add-ons such as DOP Detail Extractor are copied into the *Scripts* folder (a subfolder of *Presets*) of either the system-wide or user-specific directory tree. Filters like the FDRCompressor filter plug-in are copied into the *Filters* folder. You will find your new add-ons in varying locations within Photoshop's folder structure, depending on their type:

Filter	shows new filters at the bottom of the menu list. Many filters are registered primarily here, usually under their manufacturers' names. The actual filter is often located in a submenu which extends from the company name (e.g., Filter ▸ Akvis ▸ Enhancer).
File ▸ Automate	is where automation modules are located (e.g., File ▸ Automate ▸ Photomerge for stitching multiple shots together to make a panorama).

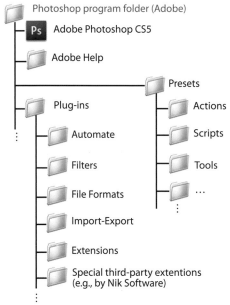

Figure 12-1: The Photoshop folder structure

* For Vista and Windows 7 use:
Tools ▸ Folder Options ▸ View ▸ Hidden Files and Folders.

➜ It is always safer to close Photoshop before installing any add-ons. Any modules you do install will only be available once Photoshop has been restarted anyway.

File ▸ Scripts is where scripts (such as DOP DetailExtractor) are located.

File ▸ Export is where specialized export modules are located.

Some add-ons are designed to enhance existing Photoshop commands and therefore appear in those modules' dialog boxes. For example, additional formats can appear in the export dialog of the Save as command, while the Open command can be extended to support new import formats (like JPEG2000), or a specific scanner can be linked to the program, which then appears in the File ▸ Import menu.

Unfortunately, there are some disadvantages to installing add-ons directly in Photoshop's own folders. If you have to reinstall Photoshop, the add-ons will be deleted, and whenever you update the program they will be ignored. To work around this, we recommend installing your add-ons (actions and scripts) in folders other than the default ones provided by Photoshop (i.e., the ones described in figure 12-1). You can set Photoshop to look for add-ons in a different location in the Preferences ▸ Plug-Ins dialog. Use the *Additional Plug-Ins Folder* checkbox to point Photoshop to the folder tree where you have stored your add-ons. This way, when you update Photoshop, all you have to do is reset that path.[*]

Actions can also be stored in a separate folder and loaded from the Action panel using Load Actions from the fly-out menu at the ▼ icon at the top of the Actions panel.

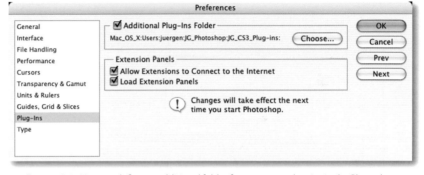

Figure 12-2: You can define an additional folder for your own plug-ins in the Photoshop Preferences dialog.

* Remember to check whether your add-ons still work when you install a new version of Photoshop.

12.2 White Balance and Color Corrections

Curvemeister • Manufactured by the eponymous company, Curvemeister is designed for making color corrections in various color spaces (e.g., HSB or CMYK) without first having to convert your image to the appropriate space. This avoids the inevitable color quality loss and color clipping that color space conversions cause. We use this tool for subtle color corrections. It is (unfortunately) only available for Windows.

iCorrect EditLab • We use PictoColor iCorrect EditLab to produce reliable white balance values for JPEG or TIFF images saved directly from the camera. The program works by simply placing the eyedropper tool in an area of the image that you want to appear neutral gray.

www.curvemeister.com

www.pictocolor.com
iCorrect EditLab is discussed at:
www.outbackphoto.com/workshop/
photoshop_corner/essay_13/essay.html

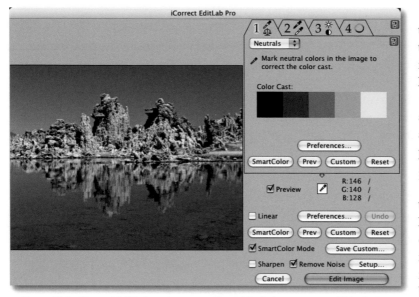

Figure 12-3: iCorrect EditLab makes correcting white balance easy, and it includes a number of other color correction functions.

The tool also includes other functions, such as one for correcting portrait skin tones. There is also a specialized portrait module called iCorrect Portrait available.

iCorrect EditLab Pro is available as a Photoshop plug-in or as a stand-alone version. We prefer to use the plug-in as it fits in better with the structure of our personal workflow.

PictoColor also manufactures a tool called inCamera for generating ICC color profiles for scanners and digital cameras. Profile generation using inCamera and other X-Rite color management tools is discussed in our book on RAW conversion [25].

www.dl-c.com
Color Mechanic is discussed at:
www.outbackphoto.com/reviews/
tools/20011025_colormechanic.html

Color Mechanic • This is a powerful and flexible tool for making selective color corrections. Simply use the eyedropper to click on an area with the color you want to change in the preview pane and then move the arrow on the color cube in the desired direction. The *Show affected region* option shows a map of the affected areas in the right-hand preview pane. This is a simple and intuitive way to adjust colors.

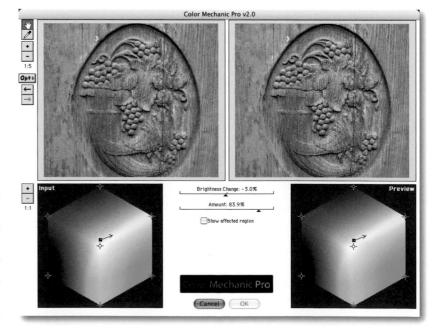

Figure 12-4:
Color Mechanic: the right-hand preview shows the corrected image. You can also set the tool to display the affected areas in the right-hand pane by checking the *Show affected region* option.
The cubes are used to set the direction of the color shift you want to apply.

Viveza • This plug-in by Nik Software is for making corrections to color, brightness, contrast, saturation, RGB values, and warmth using the patented U-Point control point technology.* Selecting multiple control points allows you to further limit the effect of a previous control point or to produce combined effects. The tool produces similar effects to layer masks but without the necessity of having to create or "paint" masks. Nik Software also uses specially adapted versions of this technology in its Silver Efex and Color Efex packages.

Nik Silver Efex • This is one of the most powerful monochrome conversion programs currently available. It's a must for all wedding photographers and black-and-white enthusiasts. As well as providing filters for simulating a number of classic monochrome film emulsions, the program offers control point technology for performing selective corrections and a wide range of monochrome processing options. The program is also available as a plug-in for Apple Aperture and Adobe Lightroom.*

Exposure 2 • Alien Skin Software's Exposure 2 is our other current favorite monochrome conversion program. This program includes filters for simulating a range of monochrome film emulsions and their associated grain structures. It also offers highly configurable curves, toning, and sharpening options. Like most quality plug-ins, the program allows you to save sets of settings as presets for repeated use later on. Exposure 2 can also be used as a Smart Filter, making it perfect for use with our workflow style. The plug-in's only potential downside is its high price (US$250).

* See our description in section 7.16, page 282.

Figure 12-5:
Control points (shown here in the compact version) are used to control selective corrections.

www.niksoftware.com

* There is a short description of the plug-in in section 10.6, page 402.

www.alienskin.com

Uwe discusses Exposure 2 at:
www.outbackphoto.com/workflow/wf_84/essay.html

Figure 12-6: Exposure 2 is an extremely powerful and versatile monochrome Photoshop plug-in.

This filter has an almost overwhelming range of settings, as the illustration in figure 12-8 shows. The program also includes a number of processing presets that are a great starting point for your own experiments.

Most RAW editors nowadays include their own noise reduction functionality, which is usually good enough for making basic corrections to noise artifacts. The problem is that noise often only becomes visible once you have applied selective brightening (or other effects) to an image. This is when you need to use more powerful, third-party noise filters.

Dfine • This professional-grade tool from Nik Software can be used to effectively and selectively reduce noise. The program starts by generating a noise profile for the active image and then offers various methods for improving the situation. The software includes control point technology (section 7.16, page 282), although this can only be used to correct color and luminance noise. The tool allows you to separately reduce noise for each color channel.

www.niksoftware.com

If you use the Brush option, Dfine automatically creates a combined layer with a black layer mask that you can model to your needs using a white brush. The plug-in is also available for use with Adobe Lightroom and Apple Aperture.

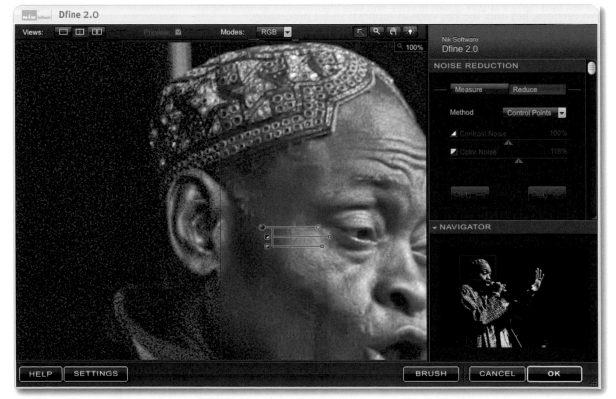

Figure 12-9: Nik Define 2.0 is a very fine, polished tool for global as well as selective noise reduction.

12.4 Third-Party Sharpening Tools

Nearly all photos (and even scanned images) need to be sharpened to a certain degree. Sharpening without losing detail is one of digital photography's greatest challenges, and effective sharpening tools are critical to the overall success of the workflow. Although Photoshop's sharpening tools are in a state of constant development, the Unsharp Mask and Smart Sharpen tools are difficult to use and could still be improved.

Nowadays, there are a great number of sharpening tools available. We don't want to repeat our online discussions ([69] and [8]) of these tools here, so we will limit ourselves to listing the ones that we have used and found to be effective.

Sharpening is certainly an art and possibly even a philosophy, and it's the subject of heated online discussions regarding individual tools, RAW editors, all-in-one workflow tools (such as Adobe Lightroom or Apple Aperture), and when and whether sharpening is necessary at all. Some tools support sharpening as part of the output process (e.g., Qimage, Adobe Lightroom, and Apple Aperture).

FocalBlade • This is a powerful but complex sharpening tool with a built-in *Novice Mode* for beginners.

→ Photoshop CS2 introduced the new Smart Sharpen filter, which is more powerful and flexible than the standard USM filter (section 8.8, page 317).

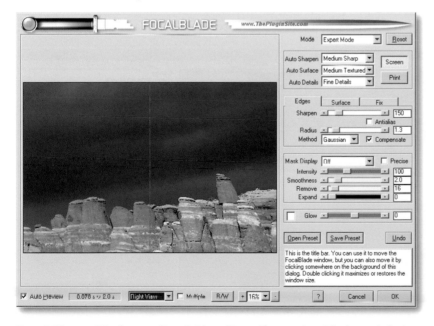

http://thepluginsite.com/products/photowiz/focalblade/index.htm
Uwe discuses FocalBlade at:
www.outbackphoto.com/workflow/wf_21/essay.html

Figure 12-10:
FocalBlade is powerful but quite complex to use.

EasyS Plus • Uwe's own EasyS Plus (Easy Sharpening Plus) module is a simple-to-use plug-in that produces negligible fringing effects. It allows various degrees and various different types of sharpening.

www.outbackphoto.com/filters/dopf003_easys_toolkit/DOPEasySPlusToolkit.html

Nik Sharpener Pro • This program has a good reputation among DSLR photographers and is one of only a few tools that integrate image resolution,

www.niksoftware.com

12.6 Tone Mapping and HDR Images

Ansel Adams is famous not only for his excellent photos, but also for the *zone system* he used while shooting and printing them. His system was based on the idea of distributing tonal values within the frame in such a way that the resulting image is not only properly exposed, but also displays extreme depth and clarity.

The photographic software industry is now busy trying to duplicate these techniques digitally, and there are various, quite promising programs available for this type of work. They include Photomatix Pro (available as the standalone *Photomatix Pro* or as the Tone Mapping Photoshop plug-in). The focus is on enhancing the tonal range of the image using the HDR merging techniques described in section 9.4.

Photomatix Pro is capable of producing great results from seemingly average-looking images, as long as the resulting image noise doesn't take the upper hand. The base module is available for free download at the manufacturer's website. The more we get to know this program, the more fun we have with it. The creative potential of HDR techniques is enormous.

www.hdrsoft.com

Uwe's report on Photomatix Pro can be found at: www.outbackphoto.com/workflow/wf_88/essay.html

Figure 12-13: Optimizing tonal values and tonal value distribution using the Tone Mapping plug-in

Full Dynamic Range Tools • Andreas Schömann's FDRTools are available as a free Basic version or as an Advanced version for approximately $40. FDRCompressor is a great value plug-in for tone mapping HDR images. The program includes three different tone mapping methods, all of which produce better results than Photoshop's own tone mapping tool. Watermarked trial versions (without time limits) are available at the FDRTools website.

www.fdrtools.com

Figure 12-14: The FDRCompressor program window when tone mapping a 32-bit HDR image

LightZone • This tool, a RAW, TIFF, and JPEG editor, manufactured by Light Crafts, concentrates exclusively on tone mapping and is only available as a standalone. The most important part of the program is its ZoneMapper module, which is loosely based on Ansel Adams' zone system and allows you to re-expose image areas with specific tonal values in a simple, intuitive way. Tonal zones selected in the input pane are mapped in yellow in the image window and can then be applied (i.e., mapped) to other zones within the output image. LightZone supports layers and masks and includes its own sharpening, white balance, channel mixing, and color correction tools. LightZone is also a great RAW converter.

www.lightcrafts.com

We describe LightZone in detail at:
www.outbackphoto.com/artofraw/raw_26/
essay.html

🪟 🍎 http://www.akvis.com
There is a comprehensive article on
Enhancer at: www.outbackphoto.com/
workflow/wf_93/essay.html

Akvis Enhancer • This tool is designed to re-expose under- or overexposed image areas in order to recover and emphasize potentially lost detail. The program offers a large preview window. We often use Enhancer together with Photomatix Pro in two separate steps on separate layers.

Figure 12-15: The Enhancer program window. The program's functionality can best be described as "color sharpening", and it gives images a more vivid, three-dimensional look.

🪟 🍎 DOP Tonality Tuning Toolkit:
www.outbackphoto.com/workflow/wf_61/
essay.html

DOP Tonality Tuning Toolkit • Uwe's own DOP Tonality Tuning Toolkit is simpler but no less useful, and consists of two basic modules:

1. A function for creating masks that use tonal values as selection criteria

2. Photoshop actions for correcting tonal values and contrast based on these masks

We often use this module in conjunction with other filters in order to perform selective corrections on specific image areas.

Figure 12-16:
Mask creation dialog in the
DOP Tonality Tuning Toolkit

12.7 More Useful Tools

DOP Upsizing • If you want to print an image in a format that is larger than the original resolution allows, you will have to enlarge (i.e., resample) it. You can effectively resize images by up to 30 percent using Photoshop's Image ▸ Image Size ▸ Resample Image command (using the *Bicubic Smoother* interpolation method). If you need to make even bigger enlargements, specialized tools are a better option. Our own DOP Upsizing tool is free and can be downloaded from the address given in the margin.

As with most other aspects of the workflow, there is a broad range of resizing plug-ins and standalone programs available for a wide range of prices. You should use dedicated software if you plan to resize an image by more than 200 percent. Genuine Fractals and pxl SmartScale by onOne Software are good examples of the more expensive end of the scale. We also recommend SizeFixer from FixerLabs.

Some print software packages also offer usable upsizing modules. Qimage [65] is a good example here, and the program also includes a wide choice of printing algorithms.

DOP Upsizing:
www.outbackphoto.com/filters/filters.
html#upsizing
An article on upsizing can be found at:
www.outbackphoto.com/workflow/wf_60/
essay.html

Uwe has written aboutGenuine Fractals (,
) and pxl SmartScale (,) at:
www.outbackphoto.com/workshop/
photoshop_corner/essay_08/essay.html
SizeFixer (,) is described at:
www.outbackphoto.com/workflow/wf_92/
essay.html

[Windows] [Apple] www.photoacute.com

→ We describe PhotoAcute Studio and a
number of other multishot applications in
detail in our book on multishot techniques
[18].

PhotoAcute Studio • This package (manufactured by Almance Inc. [81]) is something of a Swiss Army Knife among today's multishot programs, but nevertheless represents good value at around $120. The program includes the following functionality:

▶ HDRI Creation (similar to the Photoshop and Photomatix tools)

▶ Super-Resolution: The program merges four (or more) photos of a scene into a single image with four times the resolution of each of the originals.

▶ Focus Stacking

▶ Noise Reduction: The program merges multiple images with the same or similar exposure in order to reduce overall image noise.

[Windows] [Apple] www.autopano.net

Autopano Pro • This is a great value professional-grade panorama stitching tool. We use Autopano when Photoshop's own panorama functionality isn't up to the job. The program is also available in a fast, 64-bit version for Mac and Windows and in the Autopano Giga version for stitching virtual tours and gigapixel images.

X-Rite ColorChecker Passport • The X-Rite [52] ColorChecker is a standard photographer's tool for ensuring correct white balance and skin tones. You can also use these color cards in conjunction with the Adobe *DNG Profile Editor* [31] to generate DNG profiles for Adobe Camera Raw and Lightroom. We recommend the nonpaper ColorChecker models for use in the field.

Figure 12-17: The pocket-sized
ColorChecker Passport contains two
different color cards.

* See our description on page 184.

The new *ColorChecker Passport* (figure 12-17) was introduced in 2009. This version of the product contains two color cards (a conventional card and one for checking white balance and skin tones) mounted in a hard plastic case for easy transport and increased protection.

X-Rite also manufactures the Camera Calibration software package for generating scene-specific DNG camera profiles. Take a well-lit shot of the color card using the lighting you want for your chosen scene and convert it to DNG format (e.g., using the Adobe DNG Converter). If you then open your new DNG file in Camera Calibration, the program will automatically find any color anomalies and generate and save a corrected DNG profile in the ACR or Lightroom folder you have selected.

This new profile will then be available in the *Camera Calibration* tab in the *Profiles* menu in Lightroom or ACR and can be applied to selected images.*

You can also generate a DNG profile for more general use by shooting one shot of the color card with a high color temperature and another at a low color temperature lighting. Camera Calibration then combines the two to produce a new, averaged color profile.

Other Odds and Ends

As well as the tools we have already mentioned, there are countless other (cheap, expensive, or free) tools available for use at various stages in the digital photo workflow. We already addressed RAW editors in general in chapter 5 and chapter 6, image browsers and managers in section 13.1, and print software for inkjet printers in section 11.7. The following are two other tools that we use regularly:

Downloader Pro • This is a professional-grade downloader that we use for downloading our images from our memory cards when we can't use an all-in-one workflow program. The program allows us to automatically save a backup copy of each image during download and has automatic renaming functionality that can also (optionally) include image EXIF data.

Adobe Photoshop Configurator • If you use a lot of Photoshop scripts or actions, you might find that you quickly run out of appropriate keyboard shortcuts. You might also find that navigating through the (sometimes long) menu trees to locate commands that you use regularly is time-consuming and interrupts your workflow. Adobe has invented the Photoshop Configurator to help you collect your shortcuts and favorite commands in one easy-to-access panel. The Configurator is available for download for use with Photoshop CS4 and higher at the URL in the margin. Adobe provides a comprehensive 40-page online manual for the Configurator.

Downloader Pro:
www.breezesys.com/Downloader/
Uwe has written about this module at:
www.outbackphoto.com/computers_and_
more/veit_downloader_pro/essay.html

http://labs.adobe.com/downloads/
configurator.html

Figure 12-18: The Adobe Configurator allows you to create your own customized Photoshop panels.

Data Management and Backup

13

We have already touched on the recurring theme of data management at various points in the book. This chapter addresses the subject in detail and introduces a number of different image management systems. It is impossible to stress the importance of a structured image data management system enough. This includes not only a good image browser and a well-structured database, but also a solid and well-thought-out file naming system and an appropriate folder structure.

An integral part of every data management system is a working storage and backup system that you stick to, whether you think you need to or not. Our experience has shown that a reliable backup system should function completely separately from its related data management system. A busy digital photographer will need to save and back up much more than just photos and database files. Although it is late in the book, we hope that we are not dealing with this topic too late for you!

Performing Searches Based on Metadata

Ideally, you will be able to perform image searches based on EXIF or IPTC data and keywords, or any combination of them – for example, *all architectural images shot in 2009 using my Nikon D3*.

Most image management programs allow you to display EXIF data but don't necessarily allow you to use that data as search criteria. Simpler terms (i.e., categories or specific time periods) are usually sufficient for performing most searches. Search results are usually displayed either as a list of filenames or as folder full of thumbnail previews. Many browsers also allow you to use exclusion criteria in order to leave certain images out of a search.

Assigning metadata to new images is often tedious, but always necessary! You will be glad you did as soon as your collection gets beyond a certain size and searching through your folders visually takes too long.

Figure 13-3: A good search tool will allow you to combine criteria, as shown here in Microsoft Expression Media 2.

Views

→ There is no longer any significant difference between searches and views in many newer image management programs.

We addressed the use and function of views in section 1.10. Views allow you to limit the number of images you display or to further refine a search. The (static or dynamic) virtual folders described in section 1.10 are also a type of view. Good image management programs always include a "view" feature.

13.1.4 Other Image Management Functionality

Most image browsers and image management programs also include simple image optimization functionality, such as RAW conversion, image rotation, cropping, and color and saturation correction. We usually use only the rotation function (if at all), as the other functions are not generally up to the standards offered by Photoshop or good RAW editors.

We also use specialized software for performing our RAW conversions because the speed and quality are generally greater than that provided by multi-function browsers and image managers. We do, however, use image browsers and managers for generating preview images for our database. You can usually drag images from your browser to a RAW converter at the actual conversion stage. Most browsers also allow you to select which program you use to open your images. (All-in-one workflow tools such as Apple Aperture or Adobe Lightroom are an exception and include high-quality optimization tools.)

13.1.5 Workflow Control

It is often an advantage to allow your image management software to take control over your entire image processing workflow. In practice, this means using your management software to open all images and image processing programs, so that all changes are sure to be registered in the image database. This approach ensures that the database and all preview images are current, and that all new image versions are included in the database. Used this way, image management software functions in a similar way to document management systems.* This can take some getting used to if you are not familiar with this type of system, but it is essential if you want to enjoy all the advantages of your image management software to the full.

* Images that require extensive processing can be individually exported and re-imported after processing.

13.1.6 Where Are My Image Files Stored?

Some image management programs allow you to store imported images in secure memory that cannot be accessed from outside the program. We use our own (open) folder structure for storing our images and point our import process to the appropriate folders. This makes backup easier and helps us to preserve an overview of our homemade folder structure. If you take this sort of approach, remember not to rename or move files outside of your image management program – otherwise you will quickly produce inconsistencies between your image files and your database.

High-quality image management programs allow you to inform them when you move single images or image collections (e.g., when you switch computers or start using a new external hard disk).

Keeping Originals and Processed Image Versions Separate

We described a useful file storage and naming system for imported data in section 1.6.1. But where is the best place to store converted, processed, or print-ready versions of our originals? There are two basic ways to approach this question:

A) Store your newer versions in the same folder as your originals (or in a subfolder within the same folder). This keeps the basic folder structure simple, and files that belong together can be easily moved or renamed.

The disadvantage of this approach lies in the fact that it mixes changed files** with your originals, although the originals themselves have not changed since import.

** I.e., images that require constant work or ones that produce new variants (for printing or presentation, for example).

This approach also means that you will have to browse through an unnecessarily large number of images, including duplicates or ones that you have flagged for deletion later on. You can reduce this effect by using custom stacks and views.

Backups for this type of folder structure should always include the entire folder tree or branch in order to ensure copying all changed image data.

Table 13-1: Image Management Programs

Vendor/Program	Platform	Approx. Price	Comments
Enhanced Browsers			
ACD Systems *ACDSee Pro* www.acdsystems.com	Win (Mac)	$40	Widespread in Windows environments. A simple DAM system at a reasonable price.
Camera Bits *Photo Mechanic* www.camerabits.com	Win Mac	$150	Strong IPTC support, comparison of several images possible, automatic backup on second disk, multiprocessor support. Supports XMP. Quite fast.
Breeze Systems *Breeze Browser Pro* www.breezesys.com	Win	$90	Supports tethered shooting for several camera models if the camera is connected to the computer via a USB port.
Entry-level Image Management Programs			
Google *Picasa* http://picasa.google.com	Win Mac	Free	Free, but no RAW support. Only suitable for small libraries.
Apple *iPhoto* www.apple.com	Mac	$80	Limited functionality, but under constant development. It is part of Apple's iLife bundle.
H&M Software *StudioLine Classic* www.studioline.net	Win	$60	Integrated non-destructive processing functionality. CD/DVD archiving possible.
Adobe *Photoshop Elements* www.adobe.com	Win Mac	$75	Simple all-in-one workflow tool. The Windows version provides its own image database, whereas the Mac version uses Adobe Bridge.
ACDSee Systems *Photo Manager* www.acdsystems.com	Win	$110	Database-based. Includes XMP support and some image processing functionality.
Semi-professional and Professional-level Packages			
Extensis *Portfolio* www.extensis.com	Win Mac	$200	Single-user version of the same manufacturer's professional client-server database software.
Expression Media 2 www.phaseone.com	Win Mac	$200	Supports a large number of formats including RAW. Good XMP and IPTC support. Very popular.
Canto *Cumulus* (Single User) www.canto.com	Win Mac	$300	Single-user version of the professional media database. Good search features. Supports scripting.
photools.com *IMatch* www.photools.com	Win	$65	Good XMP and IPTC support. Can be used to manage offline image data.
TTL Software *ImageStore* ttlsoftware.com	Win Mac	$50	Also available in the enhanced *StudioFlow* version, aimed at studio use.
All-in-one Workflow Tools			
Apple *Aperture* www.apple.com	Mac	$200	Covers the entire photo workflow. Very resource-intensive. Elegant interface. Many plug-ins available.
Adobe *Lightroom* www.adobe.com	Win Mac	$300	Covers the entire photo workflow. RAW converter based on ACR engine. Good support for printing, slideshows, and Web galleries.
Bibble Labs *Bibble 5* www.bibblelabs.com	Win Mac	$200	Covers the entire photo workflow. Quite fast. Many plug-ins available.

Expression Media 2

Expression Media 2 used to be known as *iView Media Pro* until it was bought by Microsoft (subsequently resold to Phase One in 2009). The program is available for Windows and Mac systems and has an attractive, easy-to-use interface. It supports a wide range of photo, RAW, and multimedia formats, including TIFF, PSD, JPEG, JPEG 2000, a selection of audio and video formats, PDF, and much more. Expression Media also supports offline media and can display previews for images that are not currently loaded. The additional free Media Reader allows you to access Expression Media catalogs over a network and can also be reproduced and given away with collections burned to DVD. The program does not provide true client-server functionality, and only allows one user at a time to access and write data.

 Expression Media: www.phaseone.com

The program's preview interface is highly configurable (figure 13-4). Here too, you can rate your images using stars and color codes. You can view and sort the display according to rating, keyword, creation or alteration date, file size, category, and a range of other criteria.

The program's information panel displays general image data as well as metadata, including the filename, file size, media type, and EXIF and IPTC data (although these are not referred to by name here). The program allows you to edit IPTC data and (unusually) the image shooting date, in case the camera's date is incorrectly set.

You can save an image's IPTC data along with various other variable metadata attributes as a preset that can then be applied to other images.

Figure 13-4: Expression Media 2 browser window, showing EXIF data for the selected image

If your downloader saves backup copies of your images automatically, make sure they also have the same unique filenames as your originals.

Additionally, you should back up:

▶ All finished TIFF or PSD image files. Back up any additional versions of images (master, compressed JPEG, etc.). Processing costs time and effort, so other versions need to be saved, too.

▶ Intermediate versions of images that you want to use later as starting points for further processing

Theoretically, you can recreate your original from a processed image, but today's storage media are so cheap and easy to use that it is usually better to back up too much rather than too little data. The real work is involved in organizing your data in the first place.

Database Data

There are plug-ins available for saving database information from a running system, but these are either not available or are too expensive for use with the database tools we have described. The simplest way to back up your database is to close the application and back up your files manually. Saving database files from a running system often corrupts data and can lead to database inconsistencies.

Compressing database files can save a lot of disk space – in the case of Lightroom, this equates to a compressed file that is one quarter the size of the original! Compressing data makes it practical to save multiple backup versions from different points in time.

Working Data

Your working data changes more often than your other data, making it essential to back it up daily and for multiple points in time. By the time you realize that you have deleted something important, or that you have processed an image "to death", or that you need to compare the current state of some data with an older version, it is often too late. Versioning your data is the simplest way to ensure data integrity, but you might have to save different versions manually if your backup software doesn't support automatic versioning.

Your working data is important, so back it up either constantly in the background (as Time Machine does), or automatically at regular intervals. During the night is a good time, if you keep your system running. You can also set up your backup software to automatically start as part of your computer's shut-down process. Whichever method you use, remember to check your backup logs regularly so that you are aware of any problems that might occur.

➡ If you are on the road, we recommend that you save your images to your notebook every evening and perform a cursory inspection to weed out the trash. You can then make your backup copy (or copies). Ideally, you will have your originals on your memory card and two other copies on separate media that you then keep separately from one another (for example, if you are flying).

➡ If you use incremental backup software, such as Apple's Time Machine, we recommend that you explicitly exclude your database files from the backup schedule. This helps to avoid saving multiple, possibly inconsistent, variants of your database files.

13.2.4 Backup Software

We use backup software that produces bootable images of our operating system partitions and disks. Here, it is extremely important that you really can boot your computer from your external medium. **Test it to make sure!**

We recommend using software that can back up a running system, such as the *Carbon Copy Cloner* donationware [59] or *SuperDuper!* (both for Mac OS X). These are just two of the many alternatives available.

"Donationware" provides fully working software for free, but with an additional request for voluntary contributions to help support the work involved.

We use *Acronis True Image* [54] to back up our Windows machines, although, there are many other comparable programs available. In case your main disk fails completely and can no longer be accessed, make sure you have a bootable program CD for restoring your backups onto a new or freshly formatted disk.

We detach our backup storage media from our systems once backup is complete. This makes it impossible for viruses or other errors to be transferred to our backup data by accident.

We back up our "normal" data incrementally (i.e., only backing up the data that has changed since the last run) using external hard disks connected via USB, FireWire, or eSATA. We sometimes also use NAS systems or external file servers. SAN systems are also an alternative, but are often too expensive to make sense in a photographic context.

NAS = Network Attached Storage
SAN = Storage Area Network

The currently available transfer speeds for various types of connections are listed in table 13-2. eSATA is the fastest widely available connection type. USB 2 and FireWire will probably be superseded by USB 3 in the very near future.

NAS systems are continually becoming more efficient but are still two or three times slower than directly connected disks. They do, however, have the dual advantages of greater storage capacity and the ability to be accessed by multiple computers.

Drobo is a manufacturer of flexible, external RAID solutions connected using USB 2 or FireWire 800 that can also be used as network-based NAS storage. Drobo systems are easily scalable, and you can simply add disks as your needs grow. RAID synchronization is fully automatic, and the system is flexible enough to allow you to use different types and capacities of hard disks – an unusual characteristic for a RAID system.

Table 13-2: Data Transfer Speeds in MB per second		
Type	Write	Read
USB 2	20–30	30–35
USB 3	70–85	80–110
FireWire 400	22–32	30–40
FireWire 800	30–40	40–60
eSATA	70–85	80–110
NAS (Gigabit)	15–25	25–35

➜ RAID systems usually only use disks of the same type and size.

We use simple external FireWire, USB, or eSATA hard disk enclosures to make our *offsite* backups, which we then store with friends and acquaintances. We make offsite backups of our system and (more often) our working data at regular intervals using old disks that are either too small or too slow for everyday use. We keep a catalog of the names and locations of our various backups to help us remember what is stored where!

➜ Don't underestimate the time it takes to make backups of large amounts of data. Even at transfer speeds of up to 100 MB/second it can take up to three hours to save 1TB of data, and restoring takes just as long!

13.2.5 Backup Media

An LTO-4 tape drive costs about $5,000 and an 800 GB cartridge about $35. You can buy an awful lot of hard disk space for the same money!

Approximate storage media capacities:

CD	0.6–0.8 GB
DVD	4.3 GB
DVD double layer	8.4 GB
Blu-ray disc	25 GB
Blu-ray double layer	50 GB

➔ Our experience has shown that the second-largest capacity disks available usually offer the best value for money.

The best media to use are standard CD, DVD, Blu-ray, or hard disks. Magneto-optical discs do not have enough capacity, and high-capacity tape drives are too expensive (and usually too slow) for everyday use.

Nowadays however, CDs and even DVDs do not have enough capacity for most backup tasks!

Blu-ray discs are beginning to gain popularity, but still have relatively small capacities for dealing with digital image archives that contain several terabytes of data. Blu-ray burners are now available for around $200, but the discs are still relatively expensive at around $7 for single-layer or $15 for double-layer media. This means that external hard disks are still currently the best value (and fastest) backup media available. They are also quick to install and easy to use.

By the time Blu-ray gear is cheap and fast enough, our storage space demands will probably once again have escalated beyond their reach!

We use 1.5 TB or 2 TB external drives (2.5 or 3.0 TB drives are still too expensive), and we expect generally available drive capacities to continue to increase.

The bottom line: DVDs and Blu-ray discs are fine for small amounts of data, while (multiple, redundant) external hard disks are ideal for storing and backing up most photographers' work.

13.2.6 Storing Your Backup Media

External media need to be handled carefully and stored appropriately. Additionally, hard disks and tapes also need to be protected against the effects of strong magnetic fields. Proper storage is:

➔ The life span of the recorded data is quickly reduced if the media are subjected to high temperatures or bright light.

▸ Dry and dust-free
▸ Cool (below 28° C/82° F)
▸ Dark (CD/DVD/Blu-ray discs need to be protected against strong light)
▸ Stable, in a horizontal or vertical position

Labelling your media is essential. Use only non-corrosive felt-tip pens for writing on CDs, DVDs, and Blu-ray discs; only write on the innermost (data-free) circle of a disc. Do not use self-adhesive labels on discs – they can contract when they dry out and warp the disc. CDs and DVDs should be packed in protective sleeves; avoid touching the write surface at all costs. DVDs, with their high density write surfaces, are much more sensitive than CDs.

As already mentioned, we recommend that you store an additional copy of your most valuable data offsite as extra insurance against natural disasters or theft.

Checking Your Backup Data

If your software doesn't check the integrity of backup data automatically, you should do so manually immediately after backup. Errors that are discovered too late can be difficult, or even impossible, to rectify.

Check your current backups regularly to make sure they are still readable. This can be laborious but is nevertheless worthwhile. We recommend checking your backups randomly about once a year. If you find errors, immediately check your second copy, and if it is error-free, copy it and throw the defective version in the trash. Keeping faulty media is a false economy! There are tools available to help you check the health of your individual image files (page 498). The problem is often that files can remain readable while still containing errors.

Making Fresh Copies

If you store your data backups for long periods of time, consider making fresh copies at regular intervals. Reasons for doing this are:

▸ The life span of data recorded on some magnetic media (such as tapes) is limited. Everyday data security considerations make fresh copies essential. CDs, DVDs, and Blu-ray discs need to be renewed every five or six years. Replace hard disks every two or three years, or when their interface is superseded by a newer technology.

▸ Consolidate multiple media onto single media as capacities increase. The fewer media you have, the easier it is to store and manage them. This practice also automatically deals with the point made above.

➡ Some older disk types, such as floppy disks or SyQuest drives, are no longer available. They simply don't exist any more!

▸ Data formats change with time, and you will probably have to convert the format of at least some of your data every seven to 10 years. RAW formats are particularly short-lived.[*] Make sure you always have a converter on hand for all the formats that you use.

* DNG is a possible alternative solution.

Conclusions

Here is a summary of our thoughts on data security:

System and Program Data: Monthly complete backup to bootable external media, plus complete backup after every major update.

Image Data: Copy originals to a second backup media immediately after downloading

Working Data: Daily incremental backups while preserving older versions. If you don't work on your computer daily, back up after every session.

Keep a third copy of all your data offsite. Refresh your media at regular intervals if your other backup activities don't do so automatically!

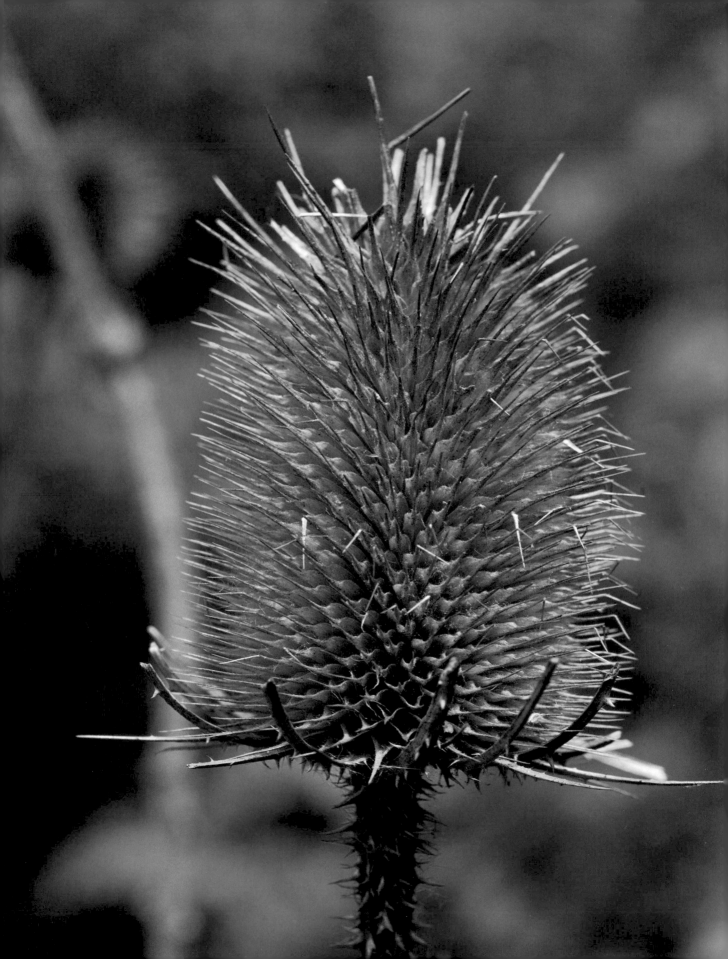

Resources

A

This is a list of the [bracketed number] references cited throughout the previous chapters. Please keep in mind that some of the URLs listed here might change or disappear over time.

Help us keep this information current by reporting missing or broken links by email to juergen@gulbins.de.

[1] **www.outbackphoto.com**

This is Uwe's website, where you can find a wealth of up-to-date information and articles on digital and analog photography. The site has several subsections, including:

[2] Photo Filters: .../workshop/
 photoshop_corner/filters.html

[3] Tools & Tips: .../workshop/
 photoshop_corner/photoshop.html

[4] Color Management: .../color_management/

[5] Printing: .../printinginsights/pi.html

[6] Black-and-White: .../artof_b_w/

[7] Photo editing techniques: .../content/
 technique.html

[8] Digital Workflow: .../workflow/

[9] Forums: .../myforum/

There are a number of free tools and tips available for download at:

[10] http://books.outbackphoto.com/DOP2010_03/

Some of these scripts, however, will not run with the 64-bit version of Photoshop!

A.1 Recommended Books

[11] Christian Bloch: *The HDRI Handbook. High Dynamic Range Imaging for Photographers and CG Artists.* Rocky Nook, Santa Barbara, 2007.

[12] Katrin Eismann: *Photoshop Masking & Compositing.* Peachpit Press, Berleley, 2005.

[13] Martin Evening: *Adobe Photoshop CS4 for Photographers: A Professional Image Editor's Guide to the Creative Use of Photoshop for the Macintosh and PC.* Focal Press, Burlington MA, 2009.

[14] Bruce Fraser, Chris Murphy, Fred Bunting: *Real World Color Management. Industrial-Strength Production Techniques.* Peachpit Press, Berkeley, 2004.

[15] Tim Grey: *Color Confidence. The Digital Photographer's Guide to Color Management. 2nd Edition* Sybex Inc., San Francisco, 2008.

[16] Juergen Gulbins, Uwe Steinmueller: *Fine Art Printing for Photographers, 2nd Edition. Exhibition Quality Prints with Inkjet Printers* Rocky Nook, Santa Barbara, 2008.

[17] Juergen Gulbins: *Digital Photography from the Ground Up.* Rocky Nook, Santa Barbara, 2008.

[18] Juergen Gulbins, Rainer Gulbins: *Photographic Multishot Techniques. High Dynamic Range, Super-Resolution, Extended Depth of Field, Stitching.*
Rocky Nook, Santa Barbara, 2009.

[19] Torsten Andreas Hoffmann: *The Art of Black and White Photography: Techniques for Creating Superb Images in a Digital Workflow.*
Rocky Nook, Santa Barbara, 2008.

[20] Jack Howard: *Practical HDRI.*
High Dynamic Range Imaging for Photographers
Rocky Nook, Santa Barbara, 2008.

[21] Harold Johnson: *Mastering Digital Printing.*
Second Edition.
Thomson, Boston, 2005.

[22] Peter Krogh: *The DAM Book: Digital Asset Management for Photographers.*
O'Reilly, Sebastopol, 2009.

[23] Rick McClery: *CMKY 2.0. A Cooperative Workflow for Photographers, Designers, and Printers.*
Peachpit Press, Berkeley, 2009.

[24] Sascha Steinhoff: *Scanning Negatives and Digitizing Your Photographic Archive – 2nd Edition.*
Rocky Nook, Santa Barbara, 2009.

[25] Uwe Steinmueller, Juergen Gulbins:
The Art of RAW Conversion.
No Starch Press, San Francisco, 2006.

[26] Lee Varis: *Skin. The Complete Guide to Digital Lightening, Photographing, and Retouching Faces and Bodies.*
Wiley Publishing, Inc., Indianapolis, 2006

[27] Harald Woeste: *Mastering Digital Panoramic Photography.*
Rocky Nook, Santa Barbara, 2009.

A.2 Tools We Use Regularly

RAW Converters and All-in-One Workflow Tools

[28] Adobe: *Photoshop CS5* (,)
www.adobe.com/products/photoshop/

[29] Adobe: *Camera Raw* (,) is included on the Photoshop CS4 or later CD, and is not available separately. It is also included with Photoshop Elements (Version 3 and later):
www.adobe.com

[30] Adobe *DNG Converter* (,) is a RAW-to-DNG converter available for free download. DNG is the best RAW format to use with PhotoAcute or Photomatix.
www.adobe.com/products/dng/

[31] Adobe: *DNG Profile Editor* (,) is free and enables you to generate and edit camera profiles for use with Adobe Camera Raw and Lightroom:
http://labs.adobe.com/wiki/index.php/DNG_Profiles

[32] Adobe: *Lightroom Product Site* (,) offers a free 30-day trial version of Photoshop and Lightroom:
www.adobe.com/products/photoshoplightroom/

[33] *Adobe Lightroom User Forum*:
www.adobeforums.com/cgi-bin/webx/.3bc2cf0a/

[34] Apple: *Aperture* () is an all-in-one RAW editor, image management and viewing tool:
www.apple.com/aperture/

[35] Apple: *Aperture Specifications*:
www.apple.com/aperture/specs.html

[36] *Aperture Support*:
Aperture FAQs can be found at:
www.apple.com/support/aperture/

[37] *Aperture Discussion Group*:
http://discussions.apple.com/category.jspa?categoryID=184

[38] Timothy Armes: *Photographer's Toolbox.*
This site includes a range of useful Lightroom
plug-ins (LR2/Mogrify etc.):
http://photographers-toolbox.com/

[39] Bibble Labs: *Bibble* (,) is a universal RAW
converter that supports a large range of camera
models. Version 5 is a full-fledged all-in-one
workflow tool:
www.bibblelabs.com

[40] Breeze Systems: *BreezeBrowser* () is a power-
ful RAW browser that supports tethered shooting
and includes the powerful *Downloader Pro* tool:
www.breezesys.com

[41] Canon: *Digital Photo Professional* (also known as
DPP ,) is a RAW converter for Canon RAW
files:
www.canon.com

[42] *Digimarc* is a manufacturer of robust, invisible
digital watermarks for copyrighting digital mate-
rial. Basic Digimarc functionality is included with
Photoshop:
www.digimarc.com/mypicturemarc/

[43] Phase One: *Capture One* (,) is one of the best
RAW converters on the market and supports a
wide range of cameras:
http://www2.phaseone.com/

[44] Ichikawa Soft Laboratory: *Silkypix Studio Pro*
(,) is a universal RAW converter:
www.isl.co.jp/SILKYPIX/english/

[45] Iridient Digital: *RAW Developer* () is a useful,
valuable RAW converter for use with the Mac
platform:
www.iridientdigital.com

[46] Light Crafts: *LightZone* (,). The standalone
version is a RAW converter that also includes TIFF
and JPEG processing functionality. It includes
particularly good tonal value optimization tools:
www.lightcrafts.com

[47] Nikon: *Nikon Capture NX* (,). A versatile
RAW converter for TIFF, JPEG, and Nikon's pro-
prietary NEF RAW format:
www.capturenx.com

Color Management Tools

[48] *Datacolor*: Color management tools like Spyder3
Pro, ProfilerPlus, PrintFIX Pro, etc. (,):
www.datacolor.com

[49] Wolf Faust: *IT 8.7 Scanner Calibration Targets.*
This is a manufacturer of high-quality, valuable
IT 8 scanner calibration targets:
www.targets.coloraid.de

[50] Pantone: Pantone makes color guides and color
management software. It also sells the *huey* moni-
tor profiling kit (,):
www.pantone.com

[51] HutchColor, LLC: *Color Management Notes.*
A great source of general color management
information:
www.hutchcolor.com/Images_and_targets.html
www.hutchcolor.com/CMS_notes.html

[52] *X-Rite*: They offer a number of color manage-
ment tools (e.g., *ColorChecker* color test charts
and profiling software like Eye-One Match and
Eye-One Photo):
www.xrite.com

Filters and Tools on the Web

[53] ACD Systems: *ACDSee Pro* (,) is a cheap and
popular image management software package
that offers RAW support and basic image process-
ing tools:
www.acdsystems.com

[54] Acronis: *True Image* () is a popular program for
making live copies of system and other computer
disks. It can also recover individual data files:
www.acronis.com

[55] Akvis: *Enhancer* (,) is a Photoshop plug-in
for enhancing image microcontrast:
www.akvis.com

[56] Alien Skin: *Exposure 2* (,) is a Photoshop plug-in for monochrome image conversion. The software simulates a number of monochrome film stocks and includes a wide range of processing tools: www.alienskin.com

[57] *Autopano Pro* (,) is a fast, effective panorama stitcher from the Kolor company: www.autopano.net

[58] Boinx Software: *FotoMagico* is a powerful application for producing digital slideshows (): http://boinx.com/fotomagico/

[59] Bombich Software: *Carbon Copy Cloner* () is a donation shareware utility for cloning Mac OS X operating system disks: www.bombich.com/software/ccc.html

[60] Camera Bits: *Photo Mechanic* (,). This is a powerful download and browsing tool with a number of image management functions. Especially versatile for managing IPTC data: www.camerabits.com

[61] Chromix: Manufactures tools such as *ColorThink Pro* (,) profile inspection, correction, and management, as well as gamut graphing: www.chromix.com

[62] ColorByte Software: *ImagePrint* (,) is a Software RIP for fine art printing. The software includes a large library of printer profiles that differentiate between lighting situations for print viewing: www.colorbytesoftware.com

[63] Curvemeister: *Curvemeister* () is a color correction Photoshop plug-in: www.curvemeister.com

[64] Helmut Dersch: *Panorama Tools* (,). Powerful, free panorama and distortion correction software tools: www.fh-furtwangen.de/~dersch/pdfpanorama/

[65] Digital Domain Inc: *Qimage* () is a cheap and versatile inkjet print management solution: www.ddisoftware.com

[66] Digital Light & Color: *Color Mechanic Pro* (). This is a very powerful tool for removing color casts and making other color adjustments: www.colormechanic.com

[67] DOP: *DOP-Photoshop-Filters* are a series of useful Photoshop filters made and distributed by the authors of this book. The filters are described in detail at: www.outbackphoto.com/filters/dopf081_filter_bundle/DOPF081_FilterBundle.html

[68] DxO Labs: *DxO Optics Pro* (,) is a tool for making profile-based corrections for various types of lens distortion. The software includes a RAW converter. DxO also manufactures the *DxO FilmPack* Photoshop black-and-white conversion plug-in: www.dxo.com

[69] *EasyS Sharpening* (,). A Photoshop action and plug-in filter for simplifying sharpening processes: www.outbackphoto.com/workflow/wf_66/essay.html

[70] *Exifer for Windows* (). EXIF/IPTC metadata management software: www.friedemann-schmidt.com/software/exifer/

[71] Extensis: *Portfolio* (,) is a great image management tool that supports RAW and a wide range of other image file formats: www.extensis.com

[72] *FDRTools – Full Dynamic Range Tools*. Andreas Schoemann offers three tone mapping tools for download: *FDRTools Basic* (free, ,), *FDRTools Advanced* (,), and the *FDR Compressor* Photoshop plug-in (,). His site also includes interesting articles and discussions on HDRI techniques: www.fdrtools.com

[73] Jack Flesher: *Uprezzing Digital Images* (,). A treatise on Photoshop image upsizing: www.outbackphoto.com/workflow/wf_60/essay.html

[74] *Jeffrey Friedl's Blog* is an interesting Lightroom discussion blog. The site also includes a number of Lightroom plug-ins:
http://regex.info/blog/lightroom-goodies

[75] *Nik Software*: Manufacturer of *Nik Color Efex Pro* (effect filters), *Silver Efex Pro* for black-and-white conversion, *Viveza* for selective color correction, *Dfine* for noise reduction, and *Sharpener Pro* for advanced sharpening. *Dfine* specializes in correcting noise and image artifacts. Some Nik products have a Lightroom, Aperture, or Capture NX interface. All plug-ins are available for Windows (🪟)as well as Mac OS X ((🍎):
www.niksoftware.com

[76] HeliconSoft: *Helicon Focus* (🍎, 🪟) is a very powerful focus stacking program avaiable in Lite or Pro versions:
www.heliconsoft.com

[77] HDRsoft: *Photomatix Pro* (🍎, 🪟) is an HDR image building tool. HDRsoft also manufactures a tone mapping and local contrast enhancement plug-in for Photoshop:
www.hdrsoft.com

[78] *Hugin* (🍎, 🪟) is an easy to use, cross-platform panoramic imaging toolset based on *Panorama Tools* (also known as *PanoTools*). *PanoTools* is an open source panorama stitching program available for download at:
http://hugin.sourceforge.net/

[79] *Neat Image* (🍎, 🪟). Photoshop noise reduction plug-in, available in Standard and Pro versions:
www.neatimage.com

[80] *Noise Ninja* (🍎, 🪟). A complex but powerful noise reduction tool:
www.picturecode.com

[81] *PhotoAcute* (🍎, 🪟) is a standalone Focus Stacking, Super-Resolution, DRI, and lens error correction package:
www.photoacute.com

[82] *PTGui* and *PTGui Pro* (🍎, 🪟) are panorama stitching programs:
www.ptgui.com

[83] Power Retouche: (🍎, 🪟). The company manufactures several Photoshop plug-ins, including *Black & White Studio*, *Lens Distortion Correction*, and *Dynamic Range Compression*:
www.powerretouche.com

[84] PictoColor Software: *iCorrect EditLab* (🍎, 🪟). A Photoshop plug-in and a very fine color correction tool:
www.pictocolor.com

[85] Roy Harrington: *Quad Tone RIP* (🍎, 🪟). A dedicated black-and-white RIP:
www.quadtonerip.com

[86] *Helicon Filter Pro* (🪟). Sharpening, noise reduction, red-eye reduction, and color optimization shareware:
www.heliconsoft.com/heliconfilter.html

[87] m.objects AV Software: *m.objects* is a high-end digital slideshow and presentation tool:
www.mobjects.com

[88] *Noiseware* (🍎, 🪟) is a profile-based Photoshop noise reduction plug-in:
www.imagenomic.com

[89] PixelGenius: *Photo-Kit* (🍎, 🪟) is a huge set of about 140 Photoshop plug-ins for simulating analog photographic filters:
www.pixelgenius.com/photokit/

[90] *Microsoft Expression Media* (🍎, 🪟) is a robust image management tool for photographers. In 2010 Microsoft sold this tool to Phase One [43].
www.microsoft.com

[91] *Rname-it* (🪟). Free batch renaming tool for Windows:
www.outbackphoto.com/handbook/cameratocomputer.html

[92] Thomas Niemann: *PTLens* (🍎, 🪟). Photoshop plug-in or standalone utility for making profile-based lens distortion corrections:
http://epaperpress.com/ptlens/

[93] Kekus Digital: *LensFix* (🍎) is a profile-based Photoshop plug-in for making corrections to lens distortion:
www.kekus.com

[94] Econ Technologies Inc: *ChronoSync* (🍎). This is a flexible and reasonably-priced utility for synchronizing files and folders between discs and systems:
www.econtechnologies.com

[95] Grasshopper Ltd.: *ImageAlign Pro* (🍎, ⊞) is available as a Photoshop plug-in or as a standalone for correcting lens errors and perspective distortion:
www.imagealign.com

[96] LaserSoft Imaging Inc: *SilverFast DCPro* (🍎, ⊞). A RAW converter for a whole range of formats:
www.silverfast.com/

[97] Microsoft: *Color Control Panel* (⊞). A Windows XP utility for installing and uninstalling ICC profiles, setting default profiles for devices, and displaying ICC profiles graphically:
www.microsoft.com/windowsxp/using/ digitalphotography/prophoto/colorcontrol.mspx

[98] Microsoft: *RAW Image Thumbnailer and Viewer* (⊞). A Windows XP utility for generating icon and preview thumbnails for a range of Canon and Nikon RAW formats:
www.microsoft.com/windowsxp/using/ digitalphotography/prophoto/raw.mspx

[99] OnOne Software: *Genuine Fractals* (🍎, ⊞). Commercial program for (almost) lossless digital image scaling:
www.ononesoftware.com

[100] Richard Rosenman: *Filters and Plugins* (⊞). A series of Photoshop plug-ins (some of which are free), including *Lens Corrector Pro*:
www.richardrosenman.com/software/ downloads/

[101] *ShutterFreaks*. Good value, scalable noise reduction Photoshop action can be found at:
www.shutterfreaks.com/Actions/Actions.html

[102] Shirt Pocket: *SuperDuper!* (🍎) Software for producing hard disk copies. System disk copies are bootable:
www.shirt-pocket.com

[103] Marc Rochkind: *ImageIngester* (🍎, ⊞) is offered in a bundle with *ImageVerifier*. *ImageIngester* downloads, renames, and copies downloaded image files, and enables you to add metadata. *ImageVerifier* produces checksums and uses them to check file integrity:
http://imageingester.com

[104] *Split Toning* is a script (🍎, ⊞) for toning highlights, shadows, and midtones in monochrome images. Available for free download at:
www.outbackphoto.com/CONTENT_2007_01/ section_workflow_basics_2009/20090120_ DOP_SplitToning/index.html

[105] Unified Color: *HDR PhotoStudio* (🍎, ⊞) and the later *HDR Expose* (🍎, ⊞) version are great HDR production tools:
www.unifiedcolor.com

[106] AV Stumpfl: *Wings Platinum* (⊞) is one of the best high-end applications for a multimedia show:
www.stumpfl.com

A.3 More Information on the Web

Organizations and Institutes

[107] *Colormanagement.org* is a site that provides links to a range of color profiles (including LStar-RGB) and useful test images (for testing monitors, channel allocation, output profiles etc.):
www.colormanagement.org

[108] *ECI – European Color Initiative.* Includes white papers on color processing themes and special ICC profiles for ECI-RGB and offset printing:
www.eci.org
Various downloads (e.g., ECI-RGB) can be found at:
www.eci.org/doku.php?id=en:downloads

[109] *ICC – International Color Consortium.* Home of information on ICC profiles.
www.color.org

[110] *IPTC* – Website of the *International Press and Telecommunication Council.* Includes information on IPTC metadata standards:
www.iptc.org
IPTC4XMPCore User Guide describes the IPTC Core data as used by the Adobe XMP standard:
www.iptc.org//cms/site/single.html?channel=CH0099&document=CMS1279131209658
See also *IPTC News Codes,* a list of the standardized codes for IPTC data fields:
www.iptc.org/NewsCodes/

[111] *ISO 3166:* A list of country codes according to ISO 3166:
www.iso.org/iso/en/prods-services/iso3166ma/02iso-3166-code-lists/list-en1.html

[112] *SWOP – Specifications for Web Offset Publications.* This is an industrial organization targeting the creation of standards for the publication printing industry in the United States:
www.swop.org

[113] *Wilhelm Imaging Research Inc.* (WIR). This institute conducts research on the stability and preservation of traditional and digital color photographs and motion pictures.
www.wilhelm-research.com

Other Information

[114] Mauro Boscarol: *Introduction to Digital Color Management.* An informative website dealing with color management in general:
www.boscarol.com/pages/cms_eng/

[115] Alain Briot: *Joseph Holmes Chrome 100 Color Space.* A paper on Joseph Holmes' color space work:
www.outbackphoto.com/workflow/wf_87/essay.html

[116] *Eric Chan* runs a website dedicated to printing with the Epson Pro 3800 printer. The site includes a number of monochrome profiles for a wide range of paper types. Eric also explains the somewhat cryptic Epson profile naming conventions and how they apply to specific paper types:
http://people.csail.mit.edu/ericchan/dp/Epson3800/index.html

[117] EFI: *Efi Designer Edition* (,).
This RIP supports JPEG, PostScript, and PDF formats, and is primarily intended for proofing press prints. EFI also sells proofing papers:
www.efi.com

[118] *Lyson* offers third-party inks for a range of Epson, HP, and Canon inkjet printers and papers. ICC profiles and instructions for use are provided with all inks and papers.
www.lyson.com

[119] Michael Reichmann: *The Luminous Landscape.* An interesting photographic website with an emphasis on landscape photography. Includes equipment tests, tutorials, and plenty of images:
http://luminous-landscape.com

[120] *panoguide.* An informative website dealing with the subject of panorama photography:
www.panoguide.com/technique/

[121] *The Plugin Site.* A website dedicated to image processing plug-ins. Covers various commercial, freeware, and shareware plug-ins, including the *Harrys Filter* freeware:
http://thepluginsite.com

[122] *The World of Nikonians.* A small collection of free Photoshop plug-in filters, including the versatile *Chrome* color-to-grayscale converter:
www.nikonians.org/html/resources/software/PhotoImage/documentation/photo_image-mk.html

[123] Clayton Jones: *Fine Art Black and White Digital Printing. An Overview of the Current State of the Art.* A highly informative site on the subject of monochrome printing:
www.cjcom.net/digiprnarts.htm

[124] OutbackPhoto: *Softproofing for B&W Images*. This article describes how to generate and use ICC profiles for monochrome printing purposes: www.outbackphoto.com/artof_b_w/bw_09/essay.html

[125] David Riecks: *Controlled Vocabulary*. This site is an excellent introduction to IPTC data and keywording. David advocates the use of a specific, limited vocabulary for keywording. The site also includes links to other information sources: www.controlledvocabulary.com
See the *Caption and Keywording Guidelines* page, where there is a good introductory overview: www.controlledvocabulary.com/metalogging/ck_guidelines.html

A.4 Inks and Inkjet Papers

[126] *Arches Infinity*: This company offers fine art papers and ICC profiles for these papers for several Epson and HP printers (e.g., Epson R800, R1800, 1280, 2200, 2400, 4000, 4800, 7600, 9600, HP 5000): www.archesinfinity.com

[127] *Crane & Co.*, now part of InteliCoat Technologies and marketed under the name of *Museo*. Produces a number of fine art products, including fine art papers for inkjet printing – e.g., the well-known *Museo Silver Rag*: www.museofineart.com

[128] *Hahnemuehle*. A maker of fine art papers. The website includes ICC profiles covering various Hahnemuehle papers and high-end printers: www.hahnemuehle.com/site/us/798/home.html
See also: *A-Z of Paper:*
A PDF glossary of general paper-related terms: www.hahnemuehle.com/index.php?mid=970&lng=us

[129] *Ilford* was well known for traditional photographic papers but now also offers digital (inkjet) papers: www.ilford.com/en/products/galerie/

[130] *Innova Art* produces fine art papers (including canvases) as well as high-quality albums: www.innovaart.com

[131] *Moab*: A maker of fine art inkjet papers. You will find ICC profiles there for their papers and different fine art printers (e.g., Epson) at: www.moabpaper.com

[132] *Monochrom*. A German supplier of high-end photographic materials with a great website and an even better (German-language) printed catalog: www.monochrom.com

[133] *Prat* manufactures professional-quality presentation materials. Its products are for sale at many online stores: www.prat.com

[134] *Sihl* coats various manufacturers' papers for use with inkjet printers. Sihl also sells their own papers: www.sihl.com

[135] *Tecco* is a European paper manufacturer producing inkjet papers for proofing purposes and a number of fine art papers at very reasonable prices: www.tecco.de/en/tecco_paper/home/index.php

[136] *Tetenal*. A maker of inkjet papers. Their website includes ICC profiles for their papers for various high-end printers: www.tetenal.co.uk

Index